MONET'S GARDEN

MONGAR

MONET'S GARDEN

Christoph Becker

Catherine Hug

Monika Leonhardt

Linda Schädler

HATJE CANTZ PUBLISHERS

Lenders

We wish to thank the following museums, collectors, and institutions:

Museums/Private Collections
Museum of Fine Arts, Boston
Szépmüvészeti Múzeum, Budapest
The Fitzwilliam Museum, Cambridge
The Art Institute of Chicago
The Cleveland Museum of Art
Dallas Museum of Art
Galerie Neue Meister,
 Staatliche Kunstsammlungen Dresden
Musée d'art et d'histoire Marcel Dessal, Dreux
Museum Folkwang, Essen
Kimbell Art Museum, Fort Worth
Musée d'art et d'histoire, Geneva
Göteborgs Konstmuseum
Musée de Grenoble
The Israel Museum, Jerusalem
The National Gallery, London
UCLA Hammer Museum, Los Angeles
The Minneapolis Institute of Arts
Musée des Beaux-Arts de Nantes
The Metropolitan Museum of Art, New York
Musée d'Orsay, Paris
Musée Marmottan Monet, Paris
Philadelphia Museum of Art
Princeton University Art Museum
Fondation Beyeler, Riehen/Basel
Musée d'art moderne, Saint-Etienne
Staatsgalerie Stuttgart
Musée Municipal A. G. Poulain, Vernon
National Gallery of Art, Washington D. C.
Österreichische Galerie Belvedere, Vienna
Kunstmuseum Winterthur
Stiftung Sammlung E. G. Bührle, Zurich
R. und H. Batliner Art Foundation
Victor Fedotov
Werner + Gabrielle Merzbacher

Archives/Foundations
Musée du Vieil Argenteuil, Argenteuil
Collection Toulgouat
Dukas/Roger-Viollet
Pierre Moign, L'Etang la Ville
Archives Départementales de l'Eure, Evreux
Giraudon-Bridgeman
Fondation Claude Monet, Giverny
Association French Lines, Le Havre
Ets Botaniques Latour-Marliac S. A.,
 Le Temple-sur-Lot
Ets Georges Truffaut, Lisses
Archives Musée Marmottan Monet, Paris
Archives Durand-Ruel, Paris
Collection Michèle Verrier, Vernon
Antique Collectors Club, Woodbridge,
 and David Joel, Hampshire
ETH-Bibliothek, Stiftung Rübel, Zurich
Geobotanisches Institut ETH Zürich,
 Stiftung Rübel, Zurich

as well as lenders who prefer to remain anonymous.

Special thanks to

William Acquavella, New York
Hortense Anda-Bührle, Zurich
Sylvain Bellenger, Cleveland
Sylvie Benedetti, Le Temple-sur-Lot
Ernst Beyeler, Basel
Christian Bührle, Zurich
Philip Conisbee, Washington D. C.
Barbara Davies
Marianne Delafond, Paris
Douglas Druick, Chicago
Bernd Dütting, Basel
Jean Edmonson, New York
Fiona Elliott, Edinburgh
Gerbert Frodl, Vienna
Lukas Gloor, Zurich
Caroline Godfroy, Paris
Walter Haefner, Zurich
Anne d'Harnoncourt, Philadelphia
Klaus H. Hoek
Hans and Doris Imholz
David Jaffé, London
David Joel, Hampshire
Cathérine Jousse, Lisses
Dorothy Kosinski, Dallas
Anne Labourdette, Vernon
Caroline Lang, Geneva
Adrian Lewis, Leicester
Claudette Lindsey, Giverny
Caroline Mathieu, Paris
Olivier Millot, Argenteuil
Nadège Monneger, Paris
Henri Neville, London
Isabelle Piquerez, Rouen
Stephanie Rachum, Jerusalem
Joseph Rishel, Philadelphia
Manfred and Karin Schoeller
George Shackelford, Boston
Susan M. Taylor, Princeton
Gary Tinterow, New York
Claire and Jean-Marie Toulgouat, Giverny
René Wehrli, Zurich
Ulrich Wille, Zurich
Claire Willsdon, Glasgow

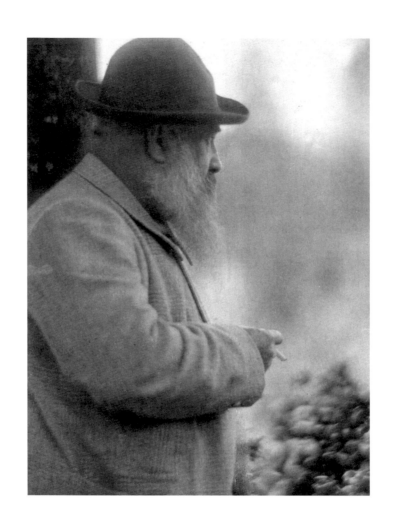

Contents

Sponsor's Greetings 8

Christoph Becker Preface 9

Christoph Becker **Monet's Garden** 13

Catherine Hug and Monika Leonhardt **Claude Monet the Gardener** 113

Linda Schädler **Biography** 159

Exhibition Checklist 195
Bibliography 199
Index 205
Photo Credits 207

Sponsor's Greetings

Art, as a collective term for all cultural achievements in the field of visual design, offers a broad field for exploration and discovery. Yet those who are interested in art are not only explorers but also conquerors and missionaries as well. To think of them only as consumers would be to ascribe to them a much too passive role and to underestimate the impact art has on its viewers. Art communicates, and what is more, it promotes dialogue and mobilizes thought processes. Our interest in and appreciation of art influence our view of the world and, in doing so, contribute to the advancement of human society. Through its commitment to art and culture, Credit Suisse seeks to promote public awareness of outstanding cultural achievements and thereby to foster social reflection and renewal.

Today, Credit Suisse looks back proudly on thirteen years of fruitful partnership on major exhibition projects with the Kunsthaus Zürich. With the exhibition "Monet's Garden," the Kunsthaus Zürich pays tribute to the grand master of Impressionist painting. This look behind the scenes reveals the true source of Monet's inspiration: nature shaped and designed by human hands. Gardens were Monet's passion, and that passion was the driving force behind his art. Again and again, he turned to the familiar setting of his garden to capture momentary moods of light and color.

We sincerely hope that you will share our enthusiasm for Monet and enjoy your stroll through "Monet's Garden." We wish you a pleasing and eye-opening experience.

Preface

The Kunsthaus Zürich has a long history of commitment to the art of Claude Monet. The foundation for the Monet collection, which now comprises more than a dozen works, was laid in the nineteen-fifties. The name of Dr. René Wehrli, my predecessor's predecessor, was entered in the annals of Giverny in 1953. As he was posing with Emil Georg Bührle for a photograph on the bridge over the water-lily pond during a visit to Monet's home, the bridge collapsed, and Wehrli landed among Monet's water-lilies. The actual occasion for the journey was a noteworthy one and culminated in a significant addition to the collection. Emil Georg Bührle purchased three monumental water-lily paintings, two of which he donated to the Kunsthaus at the opening of the new exhibition wing whose construction he had sponsored. This foundation was later enriched by a generous bequest of five paintings from Walter Haefner, by a legacy from the Johanna and Walter Wolf Collection, and by other loans and acquisitions. The brilliance of the Monet collection at the Kunsthaus owes much to these great gestures of patronage.

This first Monet exhibition presented at the Kunsthaus since René Wehrli's retrospective in the nineteen-fifties is devoted to a very special theme. Throughout his life, the painter Claude Monet remained an avid botanist and gardener, and his ambitious passion became a significant part of his life and work as an artist. Our exhibition literally goes to the roots of this interplay between cultivated nature and art. We have received invaluable support from numerous lenders from Switzerland, the Unites States, and half of the countries of Europe. I wish to take this opportunity to thank my colleagues in France and America who have dedicated major projects to nineteenth-century French art, for their extensive advice, their moral support, and their generosity.

A number of private collectors have agreed to part with their treasures for the duration of our exhibition, sometimes with a heavy heart and in response to our tenacious efforts at persuasion, and I reflect in silent gratitude on the empty spaces on their walls. Naturally, we also relied on the support of amiable colleagues at French institutions—the Musée d'Orsay and the Musée Marmottan in Paris, Fondation Claude Monet in Giverny, and several very interesting archives (into some of which no art historian had ever wandered). In every case, we encountered open eyes and ears, and we are very grateful for both the helpful guidance and the works provided on loan by these institutions. Thanks are due to co-authors Catherine Hug, Monika Leonhardt, and Linda Schädler for their essays, to all of the members of my staff at the Kunsthaus for their outstanding commitment to the success of this project, and specifically to Linda Schädler and Judith Wahl-Schöpf for their thoughtful assistance in all organizational matters.

I wish to express special thanks to Credit Suisse, the primary project sponsor, for generous and energetic support of our project and their key contribution to the realization of "Monet's Garden." Credit Suisse exemplifies the commitment to making culture of the highest quality a part of its corporate identity. I also thank the Hans Imholz Foundation for its valuable and greatly appreciated contribution.

Every individual and organization involved has helped us in our efforts to illuminate many facets of Monet's life and art. I am pleased and grateful to have had the opportunity to contribute to this wonderful exhibition and the excellent accompanying catalogue, for I wish to thank the publisher and everyone involved in bringing it to completion.

I wish our readers and visitors an enjoyable and enlightening stroll through Monet's garden.

Christoph Becker

IONOPSIS PANICULATA *Desc.*

2 *Brésil.* *Serre chaude.*

1280

RHODODENDRON COMTE CH. DE KERCHOVE DE DENTERGHEM (L. Van Houtte).

Christoph Becker

Monet's Garden

Paintings of water-lilies have become the epitome of Impressionism. And Giverny has become a synonym for the Impressionist garden—as though Monet had painted nothing but water-lilies. Visit Monet's garden (like four hundred thousand others each year) in the little town of Giverny, half an hour by foot from Vernon, and you will see a reconstruction which is just twenty years old. Aside from a small number of documents and black-and-white photographs, the original drawings which could have served as a guide to the precise layout of the garden are no longer extant. A mere two decades after Monet's death, in 1926, there was little to be seen of the original garden. Paths were overgrown, the water-lilies were rotting, the Japanese bridge was decaying. But the works of art which Monet created in this garden have proved much more resilient and are found today in museums throughout the world.

That the present garden in Giverny once belonged to Monet imbues it with a mythical aura: the creator of the water-lily pond, the painter of the water-lilies, the most renowned Impressionist—it is this interplay between cultivated Nature and masterpieces of visual art that has made this garden famous. Giverny was two things—home to a painter and a gardener. And Claude Monet embodied both. He spent almost as much time—and more money—on his garden as on his art.

Looking at Monet's work as a whole, we see that the majority of his garden paintings were made in Giverny, where Monet also spent the longest period of his life. Nevertheless, the numerous paintings of the water-lily pond, the Japanese bridge, and the rose path should not obscure the fact that Monet's interest in the craft and art of gardening dated to long before his arrival in Giverny. In view of this, two additional gardens—in Argenteuil and Vétheuil—also feature in this exhibition.

Although paintings of gardens are the main focus of the selection of works, other works have also been included which may not appear at first sight to be directly related to the theme of the exhibition—paintings of parks in London and Paris, of the landscape in Normandy, and the course of the river Seine—for it is ultimately impossible to properly examine Monet's garden paintings without also taking into account his landscapes and still lifes.

Almost by definition this exhibition is not only about art, but also about money: about the connection between Monet's artistic achievements and his material success. In order to avoid overloading this text with facts and figures, two separate documentations have been prepared for this publication; the first is a biography of Monet covering his family, his dealers, his successes, and his failures. Monet never spent very long in any one town, and any survey of the places where he lived and worked will identify a decisive turning point in his career. During the first forty years

of his life, apart from Paris, he lived in numerous places, including Ville-d'Avray, Bougival, Honfleur, London, Argenteuil, Vétheuil, and Poissy. By contrast, when he was not traveling, he spent the second half of his life (from 1883 onwards) in Giverny. In this publication, as we have already indicated, the focus is on the three places where he spent more time, where he set up home in houses with gardens: Argenteuil (1872–78), Vétheuil (1878–83), and Giverny (1883–1926). Monet's remarkable career as a gardener is the subject of the other documentation in this volume.

Since Monet's houses and gardens were always closely connected to his private circumstances, we shall briefly sketch them in here, along with the various members of his family. In 1870, Claude Monet (1840–1926) married his first wife, Camille Doncieux (1847–79), with whom he had two children, Jean (1867–1914) and Michel (1878–1966). After the death of Camille, Alice Hoschedé (1844–1911) became Monet's lover and his second wife in 1891. Alice Hoschedé brought with her six children from her marriage with Ernest Hoschedé (1837–91).[1] We will return to the details of this relationship in due course. As it turned out, two of the children shared Monet's passion for gardening: Michel, one of his sons from his first marriage, and Blanche, the wife of his other son, Jean, and daughter to Ernst Hoschedé.

The eighteen-sixties and seventies were a turbulent time for Monet. They coincided with the early stages of his new style of painting, a new understanding of art, new dealers, and new collectors. All these innovations occurred against a backdrop of tradition. In the case of the new style of painting, tradition was determined by two main institutions—firstly the Académie, where students were trained to be artists by being inculcated with rules and regulations, and secondly the official annual art exhibitions held in the Louvre with works selected by a government-appointed jury. In these so-called "salons" officially sanctioned art was presented to the critics and the public. From the point of view of some of the younger artists, the jury was a problem, because it had as much power over the public's perception of contemporary art as the stylistically sophisticated, highly influential art critics; the Salon also directly affected the art market. Or to put it in a nutshell, anyone who wanted recognition and sales had to make his way through the Salon. Anyone who did not observe the rules laid down by the Académie was rejected by the jury, barred from the Salon, and found his path to a career as a classical artist firmly blocked. In order to circumvent this system, a number of artists put on independent exhibitions, which were held at irregular intervals in a variety of venues. We will return later to these Salons des Indépendants.

Monet's early work developed against the background of Realist painting, by artists such as Gustave Courbet and Edouard Manet. In the mid-sixties, the younger painters were regularly and productively in contact with each other. In 1864, Monet

1 **Spring Flowers**, 1864
FLEURS DE PRINTEMPS
Oil on canvas, 116.8 x 90.5 cm (46 x 35⅝ in.)
The Cleveland Museum of Art
Gift of the Hanna Fund, 1953.155
W 20

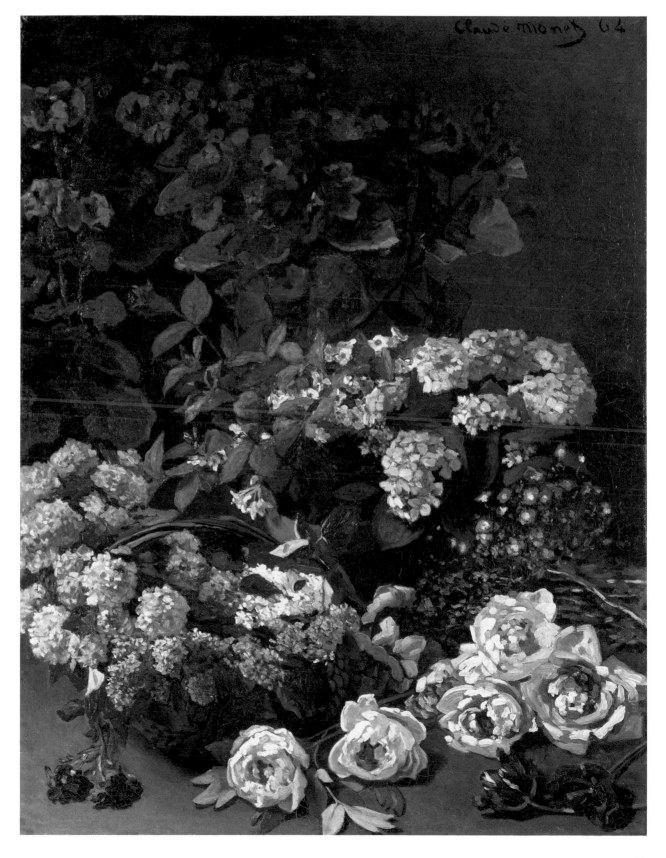

worked with Frédéric Bazille, Pierre-Auguste Renoir, and Alfred Sisley in Honfleur. It was from there that he sent his large-format still life **Spring Flowers,** 1864 (cat. 1), to the 20th Municipal Exhibition in Rouen, and wrote to Bazille that he was very satisfied with this work. He went on to suggest that his friend should try his hand at the same genre.[2] "I must tell you that I'm sending my flower picture to the Rouen exhibition: there are some really beautiful flowers about this time; sadly I've got so much to do on my outdoor studies that I dare not start on any . . ."[3] This painting is clearly influenced by Charles Gleyre, a Swiss painter who ran an "atelier libre"—a private art school—in Paris, where Monet, Bazille, and Renoir all studied. **Spring Flowers** is a carefully composed arrangement of plants, some in pots, some cut flowers, which bloom in May and June: blue and pink hortensias, geraniums, guelder roses, lilac, forget-me-nots, white peonies, and tulips striped red and yellow. That Monet and his friends were almost as skilled, in those days, in the genre of still life painting as Manet, whom they admired so much, is evident from Monet's **Jar of Peaches,** 1866 (cat. 2), with a simple yet meticulous arrangement and a color spectrum restricted to oranges, grays, and browns suggesting a highly discerning view of Nature. Characteristic of this early Impressionist art is the artist's striving for a minimum of artifice, for authenticity, closeness to Nature, honesty, and, above all, a desire to paint from life.

At the same time Monet was also working on the largest of his early paintings, his eye fixed firmly on the Salon. **Luncheon on the Grass,** 1865 (cat. 3),[4] which Monet hoped would be as controversial and influential as Courbet's programmatic composition **The Painter's Studio,** had a complicated genesis, during the course of which the bewilderment of fellow artists (Boudin talked of "bread and jam") and Monet's own dissatisfaction multiplied to such an extent that the painting was not finished by the deadline for submissions. Although it adheres to a relatively conventional compositional schema, this work is significant in the development of paint techniques in early Impressionism, since many parts appear only to be sketched in, although Monet spent a great deal of time on various details, such as the effects of light and shade and the many different green tones.[5] The **Portrait of Victor Jacquemont Holding a Parasol,** 1865 or 1867 (cat. 4),[6] is another of the plein-air paintings based on studies executed out of doors. It builds on the subtle contrasts of blues

2 **Jar of Peaches,** 1866
BOCAL DE PECHES
Oil on canvas, 55.5 x 46 cm (21⅞ x 18⅛ in.)
Galerie Neue Meister, Staatliche Kunstsammlungen
Dresden, 2525 B
W 70

3 **Luncheon of the Grass, Central Panel,** 1865
DEJEUNER SUR L'HERBE, PARTIE CENTRALE
Oil on canvas, 248 x 217 cm (97⅝ x 85⅜ in.)
Paris, Musée d'Orsay, 1987.12
W 63/2

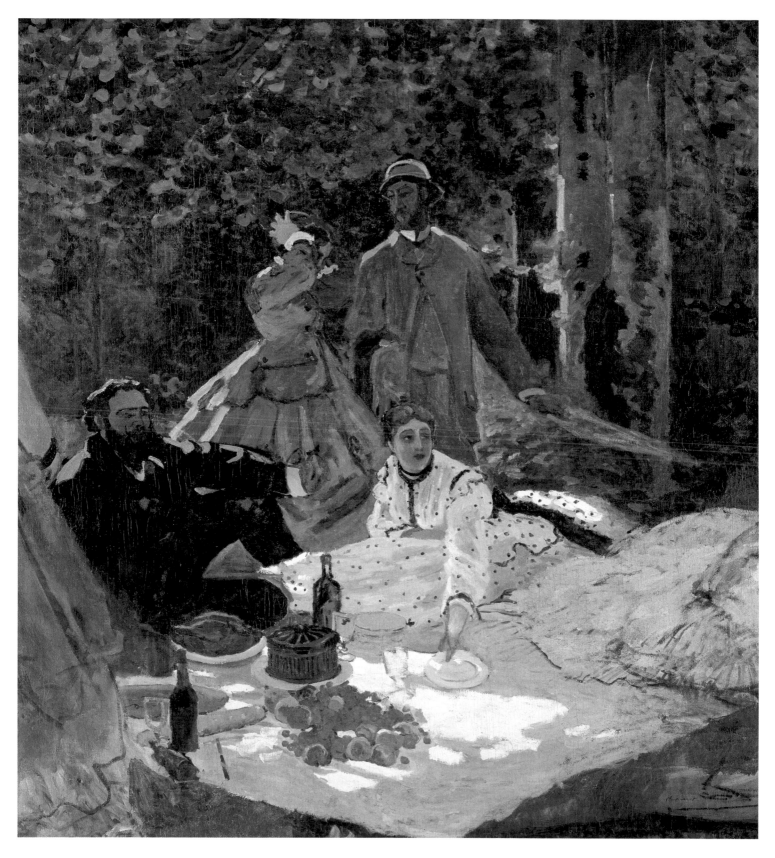

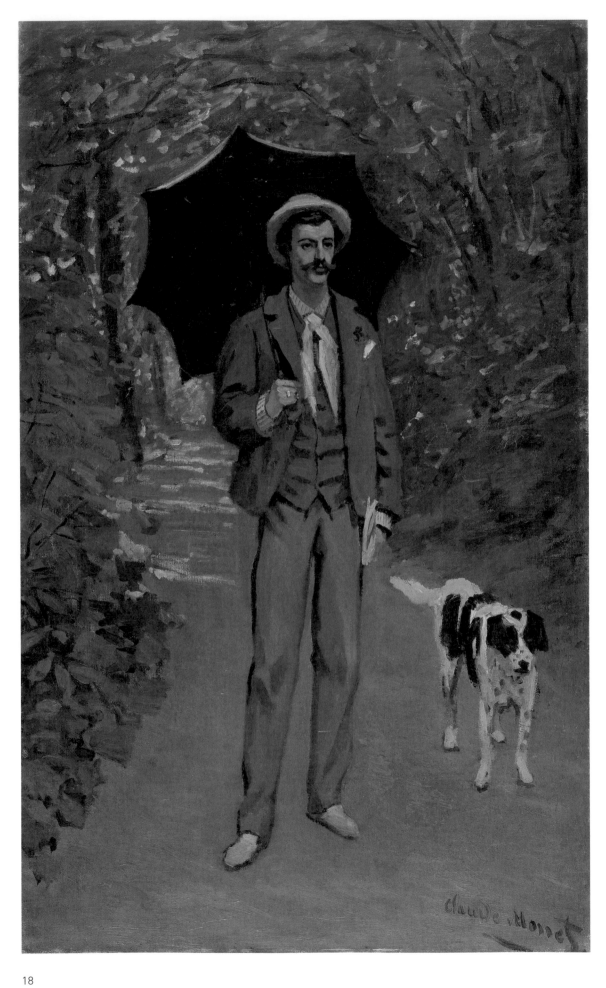

and browns in the figure, the dark contours, the alternation of dark green and yellow in the leaves of the trees, and some marked accents in white and black, which come together to create a harmonious yet powerful composition without apparent technical weaknesses, aside from the somewhat unsteady placing of the subject's feet.

At this point in his artistic career Monet was predominantly preoccupied with the light/dark contrasts that arise from strong sunlight. The desire to translate phenomena such as daylight and shade into painting is also characteristic of works such as **Forest of Fontainebleau,** ca. 1865 (cat. 5), and **The Bodmer Oak, Fontainebleau Forest,** 1865 (cat. 6), which are more than just ambitious studies.[7] They bear within them the seeds of painting no longer confined to the studio, out in the open, surrounded by Nature. Impressionism emerged against a backdrop of activity in the visual arts in mid-nineteenth-century France which was as impressive as it was varied. The young **plein-air** painters, no more than a handful compared to the many players in the art world as a whole, only figured sporadically in art criticism; the critic Paul Mantz (1821–95), writing in the **Gazette des Beaux-Arts,** praised Monet for his sensitive use of colors and tonalities and for his compositional acumen.[8] And the following year Emile Zola (1840–1902) found his attention drawn to Monet; Zola saw his paintings as "open windows looking out into Nature" and discerned in them a later stage of the Naturalism of Camille Corot, the most important landscape artist in the Barbizon School. Zola was quick to recognize a key element in Monet's art: "In the open country Claude Monet prefers an English garden to a piece of woodland. He delights in finding traces of human beings all around him, he wants to live in the midst of us. Like a true Parisian, he prefers Paris to the country, he is unable to paint a landscape without inserting finely dressed ladies and gentlemen into it."[9] The truth is that, even later on, Monet never sought out untamed, unpredictable Nature. His paintings—particularly those portraying gardens—are always colored by urban attitudes and by a highly selective interest in the finer side of Nature. As it turned out, this approach was far from detrimental to his career.

Despite a certain amount of attention from the press, in Paris Monet was still an unknown. It seems that his first exhibition took place in 1867, when the paint supplier Louise Latouche did him a favor by displaying some of his paintings at 34, rue Lafayette; legend has it that people flocked to see them but no sales ensued. In fact the sixties were extremely difficult for Monet, and by the end of the decade all his letters referred to his financial difficulties. During the early days of a career that would see Monet already comfortably off fifteen years later, and world-famous and wealthy by 1900, he was plagued by financial uncertainty and self-doubts. Life in the country, on the margins of the metropolis, crucially shaped his progress. In the initial stages of his career, between 1862 and 1872, no fewer than eleven moves to

4 Portrait of Victor Jacquemont Holding a Parasol,
1865 or 1867
PORTRAIT DE VICTOR JACQUEMONT
AU PARASOL
(Man with Parasol)
Oil on canvas, 100 x 61 cm (39 3/8 x 24 in.)
Kunsthaus Zürich, 2334
W 54

5 Forest of Fontainebleau, ca. 1865
FORET DE FONTAINEBLEAU
Oil on canvas, 50 x 65 cm (19⅝ x 25⅝ in.)
Kunstmuseum Winterthur
Geschenk des Galerievereins,
Freunde des Kunstmuseums Winterthur,
1934, 632
W 59

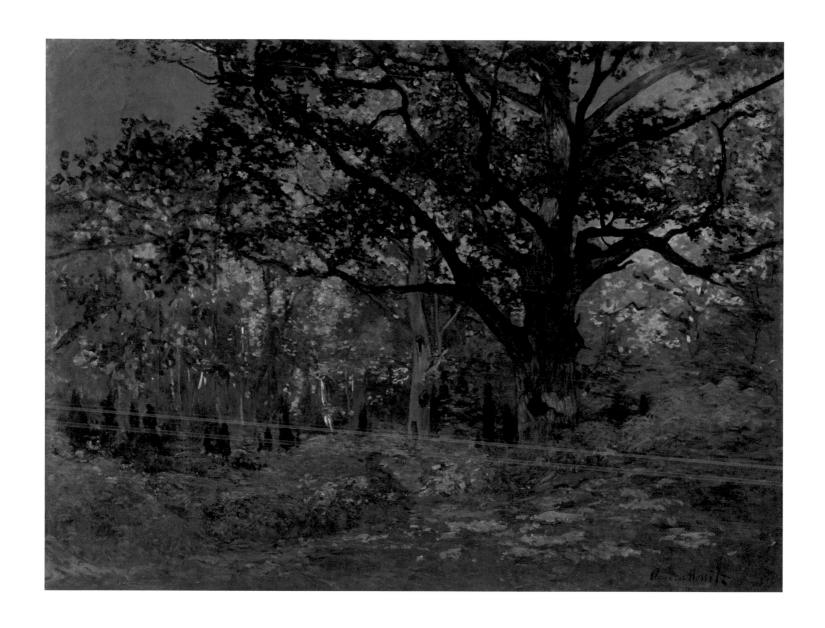

6 The Bodmer Oak, Forest of Fontainebleau, 1865
UN CHENE AU BAS-BREAU (LE BODMER)
(The Bodmer Oak, Fontainebleau Forest)
Oil on canvas, 96.2 x 129.2 cm (37⅞ x 50⅞ in.)
The Metropolitan Museum of Art, New York,
Gift of Sam Salz and Bequest of Julia W. Emmons,
by exchange, 1964, 64.210
W 60

new homes suggest just how unsettled his life was. Later, when Impressionism had been recognized as a valid form of modern artistic expression, many of its exponents cast their earlier not entirely voluntary lifestyles in a rather more positive light—"I would paint like a singing bird,"[10] wrote Monet and lauded the openness of painting which he compared to an open gaze: art as an "event for the eyes."[11]

Around this time Monet's career was interrupted by a visit to London. Following France's declaration of war with Prussia in July 1870, Monet set off from Paris for the English capital. Camille followed with their son a few months later; in autumn 1871 the family returned to Paris via Holland. Those fourteen months in England and Holland were more than just an interlude. Monet was thirty-one by now, and it was at this point that his friend Charles François Daubigny introduced him to a young art dealer from Paris: Paul Durand-Ruel (1831–1922) was already concentrating his efforts on artists whose work did not conform to the official, French notion of art, and was able

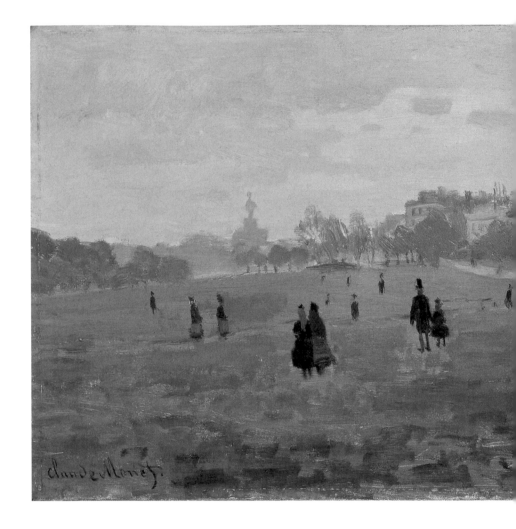

to place them in an art market that had little contemporary art to offer.[12] In New Bond Street he opened a Society of French Artists and presented work by émigré French artists, including Monet's **Green Park,** 1870 or 1871 (cat. 7), which—with its narrow format—is one of Monet's first paintings devoted entirely to a park.[13] Monet's interest in parks in major cities, and also in southern Europe, was to have a decisive influence on his own gardens—on the professional design of a piece of Nature according to certain aesthetic principles.

Shortly after Monet's return from London, he decided to move out of Paris, which was certainly not an unusual move for a young, rather impecunious family. Since the sixties, property speculators had been buying up land near to any village within an eighty-kilometer radius of the capital. Above all in places with a rail connection to Paris, small, poorly-built but inexpensive country homes were springing up which soon became popular with the middle classes.[14] Monet's choice for his new home was Argenteuil, around ten kilometers from Paris, with eight thousand inhabitants and a station. In the fall of 1871, Monet, his wife, and their son moved

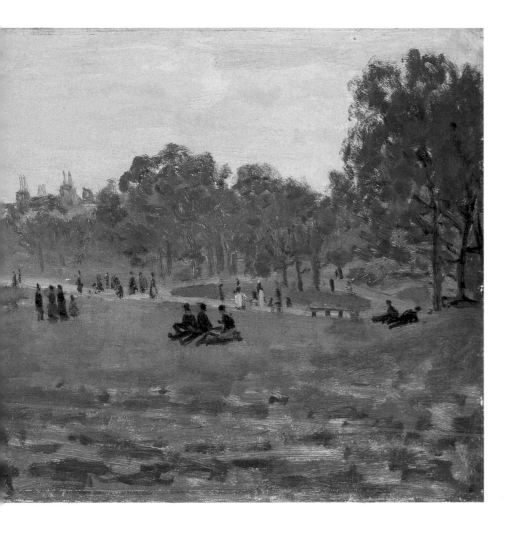

into a simple house opposite the station on rue Pierre Guienne.[15] Life largely revolved around the river and the railway line constructed in 1851 which ran from Paris to Argenteuil. The village itself was not much more than a collection of small, simple but well-kept houses and "kitchen gardens," which now mainly contained fruit trees. As a location Argenteuil had several advantages: schools for the children and a low cost of living. And then there was "this nice little house, where I can live modestly and can work so well."[16] In terms of their style, Monet's first works in Argenteuil are still reminiscent of the Barbizon School, witness the painting of the hospital garden. But they also included new themes, above all the rural surroundings and the water. The wide boat that Monet had built as a floating workspace opened up new perspectives. Of around 150 works made in Argenteuil, around half depict the water and the banks of the river.

Life was clearly relatively tranquil here, and Monet turned out to be a committed family man who enjoyed domestic intimacy. The extent to which his young family influenced his paintings is apparent from the gently ironic **Jean Monet on His Horse Tricycle,** 1872 (cat. 8), and a number of interiors. The masterpiece among these domestic portraits has to be **The Red Kerchief, Portrait of Mrs. Monet,** 1873 (cat. 9), which subtly plays with inside and outside, with the light conditions, and with the contrast of the right-angles of the window, the softly draped curtains, and the figure of Camille. The color contrasts are bold, the brushwork is resolute and sure. The composition as a whole seems simple, and in this very simplicity it is as though its real beauty softly and spontaneously unfolds before our very eyes. Behind the **Artist's House at Argenteuil,** 1873 (cat. 10), a flowerbed ran the full length of the building, with three rows of dark-blue, red, and white flowers; between the house and the flowerbed was a stretch of pale gravel with six blue-and-white glazed pots containing large marguerite bushes; to the left there was a circular shrubbery, in the background was a elderberry bush. And the plants included in **Monet's Garden at Argenteuil,** 1873, (cat. 11), are also by no means unusual. In the largest of the flowerbeds there was a bright mixture of tall yellow,

7 Green Park, 1870 or 1871
GREEN PARK
(Green Park, London)
Oil on canvas, 34.3 x 72.5 cm (13½ x 28½ in.)
Philadelphia Museum of Art,
Purchased with the W.P. Wilstach Fund,
1921, W.1921-1-7
W 165

red, white, and flame dahlias, with no particular edging and apparently planted without much ado.[17]

Monet's early botanical interests were clearly not in exotic plants, but he was interested in new breeds of indigenous plants, and since the grounds were fairly extensive, it was possible to embark on creating a particular garden design.[18] This included an oval lawn, flanked by elongated and round flowerbeds, and crisscrossed by pale gravel paths. Flowerbeds and shrubbery provided different vistas, close at hand and looking into the distance, punctuated by gladioli[19] and sunflowers. Gladioli were just becoming popular at the time, and many new varieties had been bred since the middle of the century; these particularly found favor in France and were grown throughout the country.[20] In fact, Monet's garden in Argenteuil was relatively conventional and perfectly matched the notion of a garden that one would associate with a man who had settled in the outskirts of Paris: a lawn with a herbaceous border, a meticulously edged raised bed, a green-painted bench in the shade of a tree, gravel-strewn paths. The cultivated monotony of Nature reflected the use made of just such an "informal" garden in keeping with the tastes and fashions of the eighteen-sixties. Monet accentuated the contrast between rural and urban cultivation by laying out the garden of this home in a residential area as a place for his family to spend time.[21]

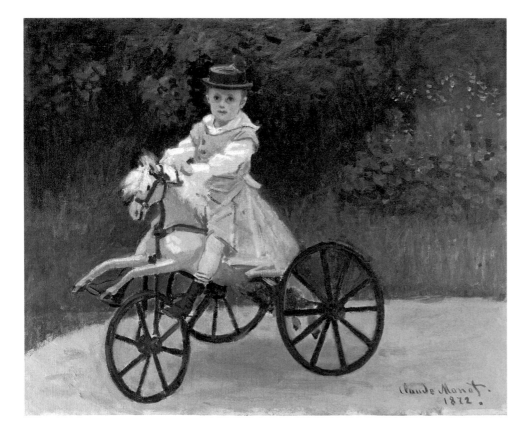

8 Jean Monet on His Horse Tricycle, 1872
JEAN MONET SUR SON CHEVAL MECANIQUE
(Jean Monet [1867–1913] on His Hobby Horse)
Oil on canvas, 60.6 x 74.3 cm (28⅞ x 29¼ in.)
The Metropolitan Museum of Art, New York,
Gift of Sara Lee Corporation, 2000, 2000.195
W 238

9 The Red Kerchief, Portrait of Madame Monet, 1873
LA CAPELINE ROUGE, PORTRAIT DE
MADAME MONET
Oil on canvas, 99 x 79.8 cm (39 x 31⅜ in.)
The Cleveland Museum of Art,
Bequest of Leonard C. Hanna, Jr., 1958-39
W 257

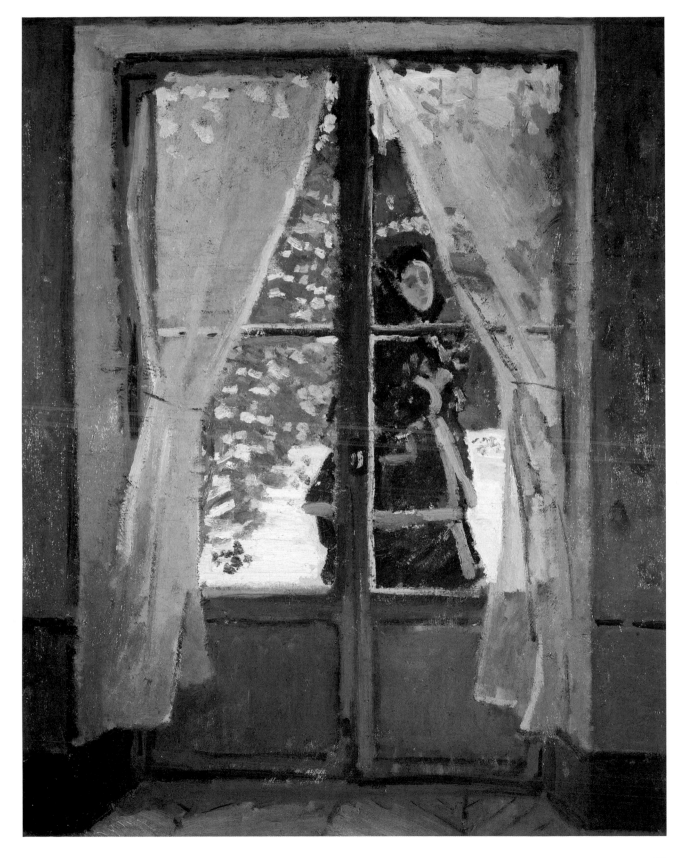

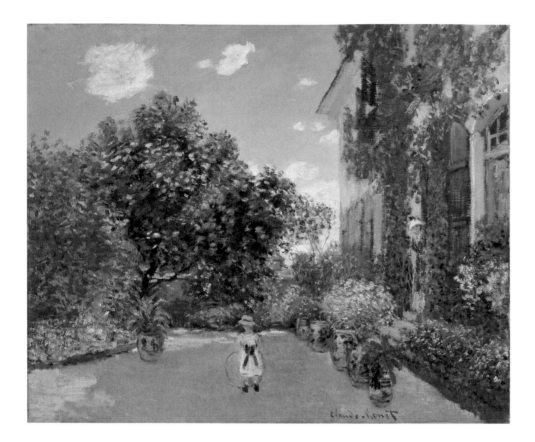

Bearing in mind Monet's letters at that time to friends and gallerists, which almost always refer to a lack of funds, the painting **Camille in the Garden with Jean and His Nanny,** 1873 (cat.12), seems just a little unlikely; the lady of the house appears so elegant and metropolitan, a parasol in her gloved hands and apparently unbothered by the boy, in the maid's care and playing with a hoop. Everything is shipshape, and neither the neatly trimmed shrubs nor the gravel path hint that just beyond the nearby hedge there are dusty country roads, wheat fields, orchards, and a factory.[22] One could be forgiven for thinking this was a park in some big city. The elegant tone of this portrait was in fact influenced by Gustave Caillebotte (1848–94), who had participated in the second Impressionist exhibition in 1876 and who had acquired a number of paintings by Monet.[23] Caillebotte, whose grand-bourgeois origins allowed him to maintain a suitably grand lifestyle had a decisive influence on Monet's ambitions as a gardener. Having studied at the Ecole des Beaux-Arts Caillebotte was himself a painter and had established contact with the Impressionists in 1876 during the second Salon des Indépendants. His parents owned an estate, including parklands, in Yerres in Ile-de-France; his own home was in Petit-Gennevilliers, on the opposite bank of the Seine to Argenteuil. Starting in 1881, he had a ten-thousand-square-meter garden laid out, which was much admired by Monet. No doubt Monet drew valuable inspiration from Caillebotte for his later garden in Giverny.[24]

10 **The Artist's House at Argenteuil**, 1873
LA MAISON DE L'ARTISTE A ARGENTEUIL
Oil on canvas, 60.2 x 73.3 cm (23¾ x 28⅞ in.)
The Art Institute of Chicago,
Mr. and Mrs. Martin A. Ryerson Collection,
1933.1153
W 284

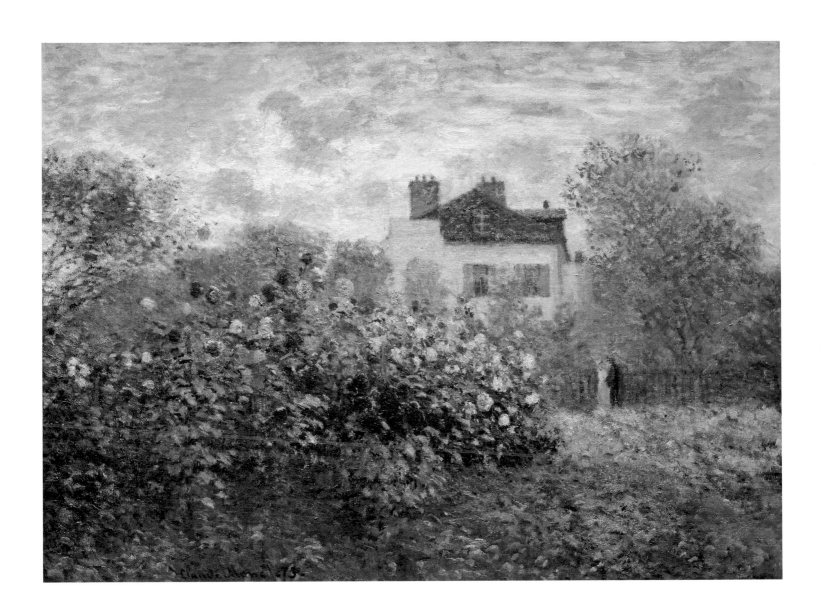

11 Monet's Garden at Argenteuil (The Dahlias), 1873
LE JARDIN DE MONET A ARGENTEUIL (LES DAHLIAS)
(The Artist's Garden at Argenteuil [A Corner of the
Garden with Dahlias])
Oil on canvas, 61 x 82.5 cm (24 x 32½ in.)
National Gallery of Art, Washington, DC,
Gift of Janice H. Levin, in Honor of the
50th Anniversary of the National Gallery of Art,
1991.27.1
W 286

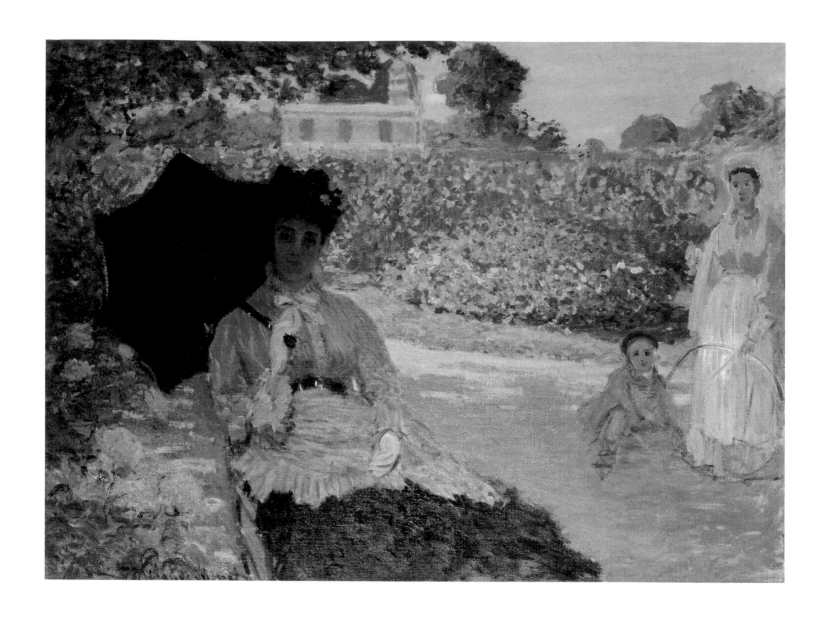

12 Camille in the Garden with Jean and His Nanny,
1873
CAMILLE AU JARDIN, AVEC JEAN ET
SA BONNE
Oil on canvas, 60 x 81 cm (23⅝ x 31⅞ in.)
Private collection
W 280

Monet's garden in Argenteuil was not his first. He had already had small gardens in Ville-d'Avray (1866) and Louveciennes (1869), but it was not until he lived in Argenteuil that he had the prime requisite for establishing a garden: time. In fact he stayed there for five years, which allowed him to work out the most important parameters for his later gardens in Vétheuil and Giverny: the interplay of axial and decorative elements, and above all bold color contrasts in the planting.[25] In October 1874, the Monets moved into a different, roomier house on the newly created boulevard Saint-Denis, just a few minutes by foot from the station. The new household included a maid and probably also a gardener who would work in the garden every so often. **Apartment Interior,** 1875 (cat. 13), is constructed like a stage viewed from three angles, taking the viewer's gaze from the bright veranda into a bourgeois ambience. In this painting, which was owned by Caillebotte, Jean is visible in the semi-darkness of the back room, framed by a decorative thicket of bamboo in large, blue-and-white patterned pots, which were presumably of Dutch origin. One of the outdoor scenes shows **Camille Monet and a Child in the Garden,** 1875 (cat. 14), at the edge of the crescent-shaped rosebed, which is seen again in another three paintings.[26] Camille, wearing a striped summer dress, is busy with the handwork lying in her lap; at her feet one of the children is playing. The quiet, very natural-looking tranquility was matched by the intimate setting of this garden, onto which the living areas on the ground floor opened. The garden of the next house in Argenteuil was a similarly carefully arranged living space, which was used just like any other of the private rooms inside the house. It had no representative function, but was primarily intended for the family's use; if anything it plays a secondary role as a pictorial motif. Nevertheless, these paintings clearly reveal the status the Impressionist painter attributed to the garden in his response to nature. It was a refuge and a possible — but not indispensable — place of work for the artist. This is the main distinction between the gardens in Argenteuil (and Vétheuil) and the garden in Giverny. The figure compositions Monet made in rural Argenteuil (and only the figure compositions) were painted from the perspective of the city dweller, as we can tell from a side view of the then newest and best-known park in Paris, near where the family rented an apartment after leaving Argenteuil.

The Parc Monceau, whose origins go back to the time of Philippe d'Orléans in the late eighteenth century, was redesigned (starting in 1852) by Baron Haussmann during the construction of the boulevard de Malesherbes. The old trees, the shady avenues, and the tempietto in the style of Ledoux remained; the winding paths were interspersed with borders and asymmetrical beds filled with plants from France and beyond. The highlight was the oval pond with water-lilies and a semicircle of Roman pillars with an architrave. When the Parc Monceau was opened to the public in 1861 and the adjacent boulevard was also finished, it became a favorite meet-

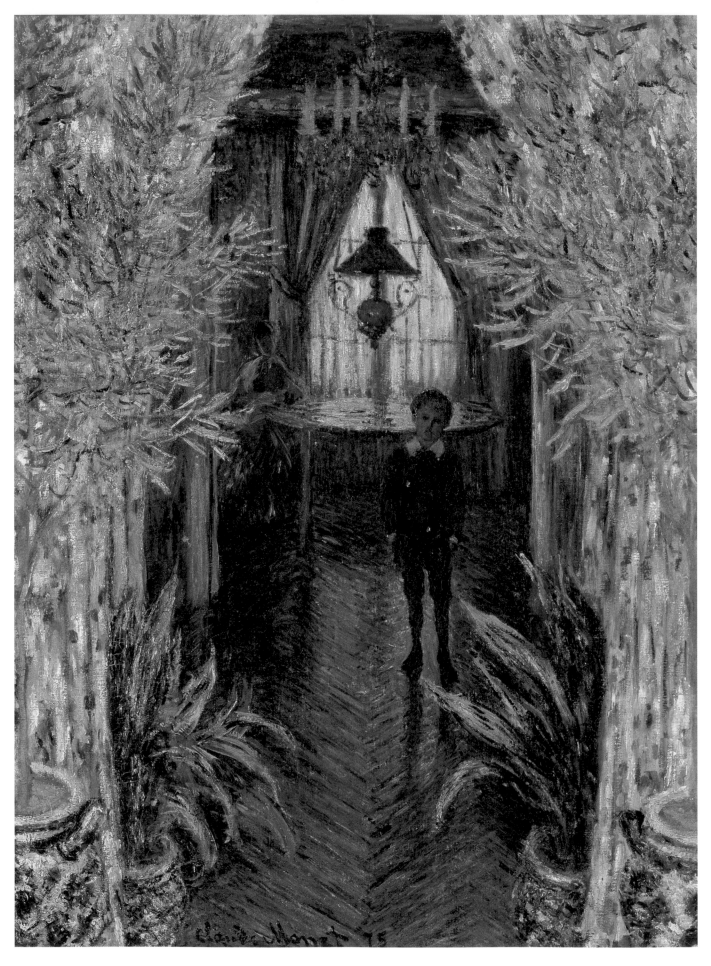

ing place for the Parisian hautevolée.[27] That Monet was particularly taken by this part is evident from two paintings, **The Parc Monceau** and **At the Parc Monceau**, both made in 1878 (cat. 15 and 16), which must be two of the most beautiful paintings of parks by any Impressionist. A comparison of the motifs and paint techniques shows that it made no difference to Monet whether he was painting the scene in a public park or in his own garden at home; he invariably conveys a sense of casual elegance and seems to take only a passing interest in botanical detail. The urban flâneur, the mixture of social strata, the feeling of being "modern" (by engaging with "Nature") tells us something of the prevalent attitudes in Paris at the time. Modernity and fashion were closely related, and the modern artist—which included the Impressionists—had a fashionable public, although this was not synonymous with commercial success. By now Monet was no longer an unknown. There were now new opportunities for artists working in the new style: besides the official Salon, which took place in one of the galleries in the Louvre, the breakaway exhibitions—the Salons des Indépendants—had also established themselves.[28] The first of these had taken place in 1874 in the studio of the photographer Nadar on boulevard des Capucines, where Monet had shown **Luncheon on the Grass**.[29]

The "Impressionists" now also figured more frequently in the press.[30] The term had been coined by the journalist Jules Castagnary: "If one wishes to characterize

13 Apartment Interior, 1875
UN COIN D'APPARTEMENT
Oil on canvas, 81.5 x 60.5 cm (32½ x 23⅞ in.)
Paris, Musée d'Orsay,
Legs de Gustave Caillebotte, 1894, RF 2776
W 365

14 Camille Monet and a Child in the Garden, 1875
CAMILLE MONET ET UN ENFANT AU JARDIN
(Camille Monet and a Child in the Artist's Garden in Argenteuil)
Oil on canvas, 55.3 x 64.7 cm (21¾ x 25½ in.)
Museum of Fine Arts, Boston,
Anonymous gift in memory of Mr. and
Mrs. Edwin S. Webster, 1976.833
W 382

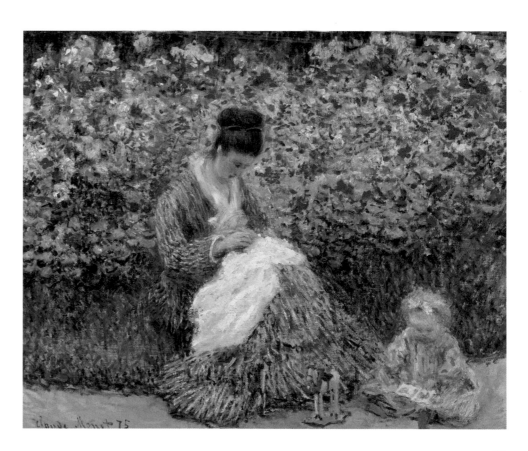

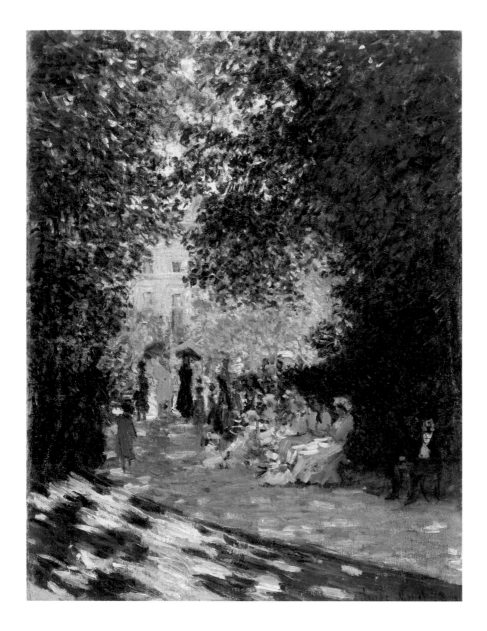

and explain them with a single word, then one would have to coin the word 'impressionists.' They are 'impressionists' in that they do not render a landscape, but the sensation produced by the landscape."[31] The second exhibition of the Salon des Indépendants, which was shown in 1876 in Paul Durand-Ruel's gallery space at 11, rue Peletier, included a number of Monet's paintings of gardens, which sold well.[32] During the first phase of Impressionism, between 1871 and 1874, Durand-Ruel paid Monet around 30,000 francs for paintings,[33] but there was only a limited market for this kind of art. The collectors who were actively interested in contemporary art could be counted on the fingers of one hand and the response to the exhibitions of the Salon des Indépendants were always divided,[34] although this was in itself a good sign for a contemporary avant-garde, which of course included Claude Monet.

15 The Park Monceau, 1878
LE PARC MONCEAU
Oil on canvas, 72.7 x 54.3 cm (28⅝ x 21⅜ in.)
The Metropolitan Museum of Art, New York,
Mr. and Mrs. Henry Ittleson, Jr., Fund,
1959, 59.142
W 466

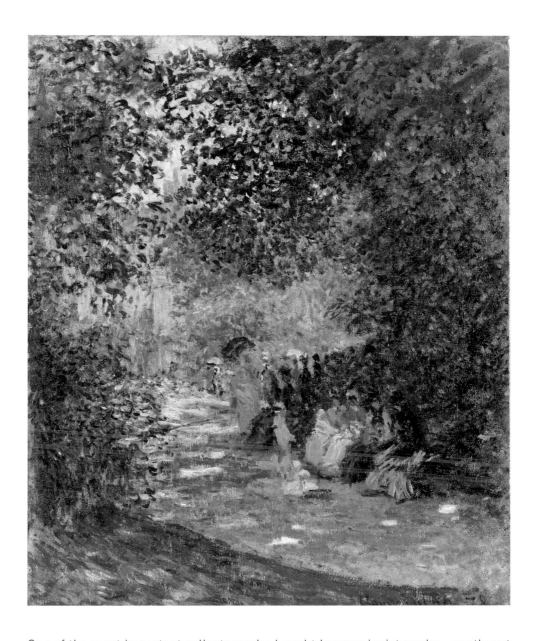

16 **At the Parc Monceau**, 1878
AU PARC MONCEAU
Oil on canvas, 65,5 x 54,5 cm (25¾ x 21½ in.)
Private collection
W 467

One of the most important collectors who bought Impressionist works—partly out of curiosity, partly as a speculative interest—was the textile merchant Ernest Hoschedé, who inherited from his uncle a considerable collection of paintings by members of the Barbizon School and who bought paintings by younger Impressionist artists.[35] Following the end of the Commune in 1871, the Hoschedé empire enjoyed a brief comet-like upsurge—only to be declared bankrupt in 1877. However, by that time the nouveau-riche business had already adorned itself in late-nineteenth-century splendor in the Château de Rottembourg in Montgeron, around twenty kilometers southeast of Paris, where Alfred Sisley and Claude Monet were often among the guests at the parties and dinners hosted by the Hoschedés. The château belonged to Ernest's wife, Alice, who had a princely income of fifteen thou-

sand francs per month and capital of one hundred thousand francs. In the summer of 1876, Monet spent some months in these pleasant surroundings and painted half a dozen pictures of the park,[36] all of which show the small lake in the grounds of the château. Ernest Hoschedé bought around twenty paintings by Monet, which were sold again far below their market value when his company folded—and some of the Impressionists found their names figuring in negative headlines, which was not necessarily disadvantageous to their future careers.

Having been declared bankrupt, Ernest Hoschedé moved to Belgium; initially his wife Alice remained where she was. Monet's private life now entered a turbulent phase. On March 17, 1878, his second son, Michel, was born.[37] Claude Monet had fallen in love with Alice Hoschedé, and his life with Camille was soon running in parallel to another with Alice. Brief mention should be made here of this "second family" which was to play a central role in Monet's garden. Claude and Camille Monet, Ernest and Alice Hoschedé now embarked on a remarkable arrangement—a joint household—which greatly increased the numbers in the Monets' house, since the two sons from Monet's marriage with Camille, Jean and Michel, were now joined by the no less than six children of Alice and Ernest Hoschedé. Monet was selling virtually nothing, and had to rely on financial help from Durand-Ruel and friends. At

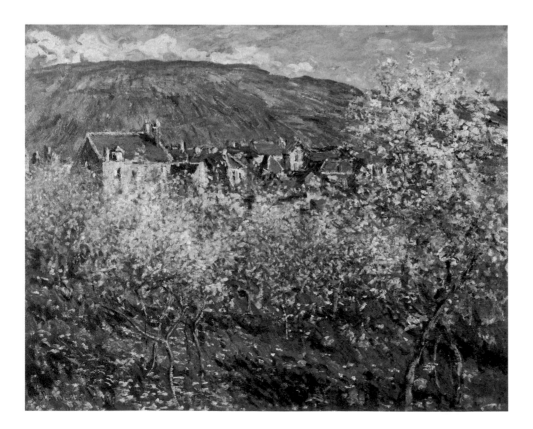

17 Plum Trees in Blossom at Vétheuil, 1879
LES PRUNIERS EN FLEURS A VETHEUIL
(Plum Trees in Blossom)
Oil on canvas, 64,5 x 81 cm (25³/₈ x 31⁷/₈ in.)
Szépmüvészeti Muzeum, Budapest, 266 B
W 520

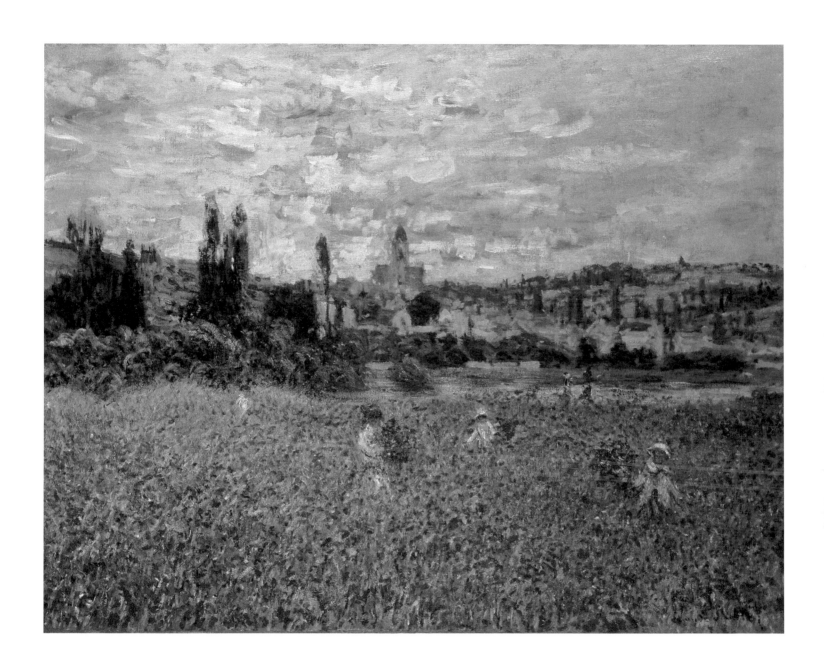

18 **Poppy Field near Vétheuil**, 1879
CHAMP DE COQUELICOTS PRES DE VETHEUIL
Oil on canvas, 70 x 90 cm (27½ x 35⅜ in.)
Stiftung Sammlung E. G. Bührle, Zürich
W 536

which point, our short biographical detour takes us to the next important stage in Monet's gardens—to a new place, a new house, and yet another garden.

On a trip to Normandy in August 1878, Monet had passed through Vétheuil, a small village on the Seine with six hundred inhabitants. There he rented a modest house on rue de Mantes for himself and Camille, Alice and Ernest Hoschedé, and the eight children; however, it turned out to be too small and in October they all moved into a larger house on rue Chantemesle-La Roche-Guyon, at the time an unasphalted country road. This property came with a piece of land on the other side of the road, an area of garden with a gentle slope down towards the Seine. Steps led to a meadow with fruit trees. Landscapes painted by Monet in Vétheuil reflect the new situation: the rural surroundings and the Seine, which gave the valley a very particular atmosphere when it was wreathed in mist early in the day or bathed in the soft afternoon light coming off the river. In compositions such as **Plum Trees in Blossom at Vétheuil,** 1879 (cat. 17), and **Poppy Field near Vétheuil,** 1879 (cat. 18), which is painted on the banks of the Seine at Lavacourt with the small island of Moisson on the left, it seems that the less pleasant aspects of the place—the dense housing and the unasphalted roads—have been quietly ignored for the sake of creating an image of an unspoiled rural idyll.

In this latest home, there was little room for Monet to work, aside from a small studio in the attic. From time to time Monet would work in the shallow chalk caves in the slope behind the house[38] or he would "launch" his floating studio.[39] In fact, at this stage in his life Monet painted outside at an easel out of sheer necessity, which greatly helped him to develop his skills as a plein-air painter. Painting outside was also advocated by certain art critics, most notably the republican-minded Théodore Duret (1838–1927),[40] who vigorously fanned the flames of the debate on the Moderns. In 1878, Duret published **Les Peintres impressionistes,** which included a vitriolic diatribe against his conservative colleagues, and in 1880, in the journal **La Vie moderne,** he acclaimed Monet as the leading "painter of light" of the time. He particularly emphasized what he described as Monet's ability to create extraordinary visual moments.[41] At the beginning of the new decade the interaction between the critics and the younger painters started to bear its first fruits; at the same time the art market also changed as a troupe of new gallerists stepped onto the stage. Since Durand-Ruel was in financial difficulties,[42] Monet also worked with Georges Petit (1835–1900), whom he had first met in 1878, and with Jules Luquet, some of whose clients were particularly interested in landscape paintings. Ensconced in the spacious, luxuriously appointed gallery owned by his father, Georges Petit was viewed with suspicion by Durand-Ruel, particularly since the younger dealer was clearly able to drive prices upwards.

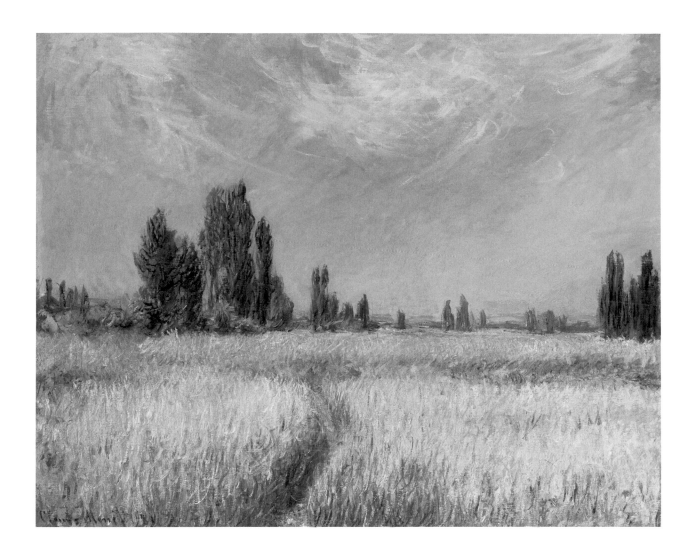

19 Field of Corn, 1881
CHAMP DE BLE
Oil on canvas, 64.6 x 81 cm (25⅜ x 31⅞ in.)
The Cleveland Museum of Art,
Gift of Mrs. Henry White Cannon, 1947.197
W 676

While the art market was changing—to the advantage of contemporary artists—their group exhibitions brought critical rather than financial success. When the fourth Salon des Indépendants was presented in 1879, Monet supplied twenty-nine paintings and sold next to nothing.[43]

Financial worries were compounded by private anxieties, for Camille had never properly recovered from giving birth to Michel and was now seriously ill. She died on September 5, 1879, having been tenderly cared for by Alice Hoschedé. Monet, who had loved Camille very much, was in despair; his artistic output almost completely dried up, and when a derisive article was published in the daily paper **Le Gaulois**—with a mock death announcement stating that Monet had broken with the Impressionists—it was impossible to ignore the crisis of Impressionism any longer.[44] Moreover, the severe frosts in winter 1880 and the floods in spring 1881 prevented Monet from working for several weeks, after which he started work on his extensive group of paintings of ice floes. In those days the Seine was an inter-

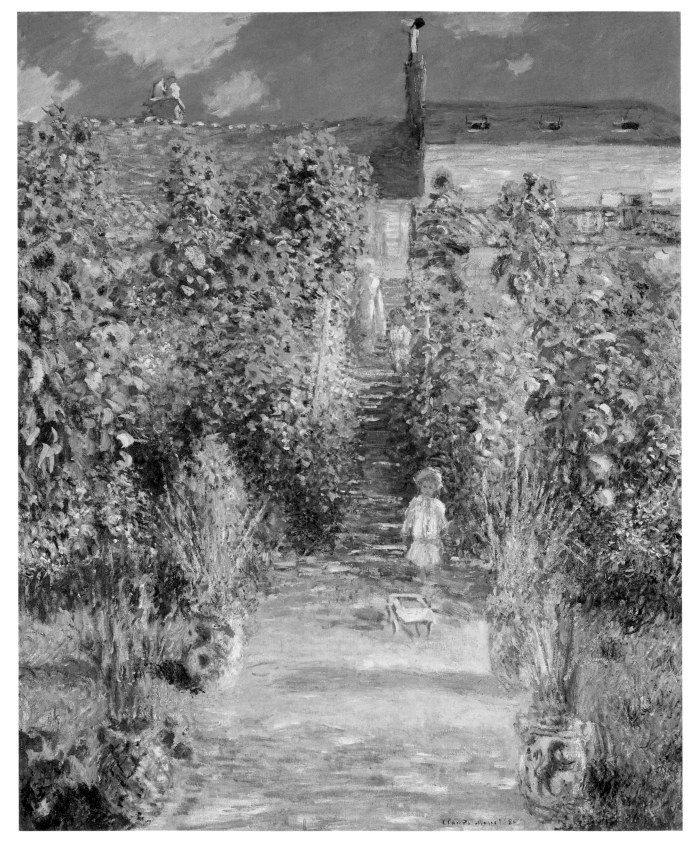

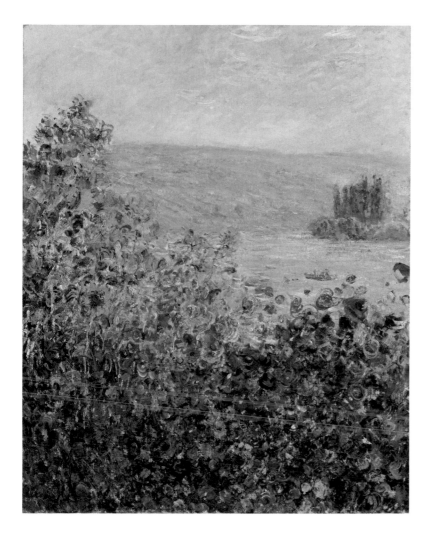

esting, but not appealing, river, for the new sewerage system designed for Paris by Baron Haussmann had the sewage converge in two huge pipelines near Asnières and Saint-Denis where it poured untreated into the river. Eighty kilometers downriver the water was still filthy, albeit full of nutrients. An impression of the lush vegetation that kept the broad river valley green until late summer may be had from the rich, late-summer colors in **Field of Corn,** 1881 (cat.19). That year Monet's garden also flourished magnificently. Anyone going to the garden had to cross the road and go through a gate at the top of a flight of stone steps leading down to a grassy area. On either side of the steps there were several rows of sunflowers which had shot up in June. On the lower steps and on the grass were the already familiar six large, blue-patterned plant-pots, densely planted with red gladioli.

Monet chose this same view four times: looking down the steps from the road with the garden path as the central axis, flanked by sunflowers — as tall as a man and at their most splendid. The largest and most important of the summer-garden paintings, **Monet's Garden at Vétheuil,** 1880 (cat. 20), has a view of the house (on the right with the darker roof). At the top of the steps is, presumably, Germaine Hoschedé, below her is Michel Monet, and at the foot of the steps is the youngest child, Jean-Pierre Hoschedé, at the age of four. The central sightline of this country garden will later return in paintings of the garden at Giverny as the main path. **Flower Beds at Vétheuil,** 1881 (cat. 21), which Durand-Ruel took that same year and sold to an American collector in 1913, shows the bend of the Seine seen from the garden. The garden pictures painted in Vétheuil are always also landscape compositions; almost all were painted in the immediate vicinity of the house and probably in the open air. The advantage of having one's own garden was that a motif could be arranged for the purpose of painting, in a carefully planned natural setting, and right by where the artist lived. When a journalist asked if he might enter Monet's studio in Vétheuil, Monet was immediately indignant: "My studio! But I've never had one, and I don't understand how anyone could shut themselves into a room — perhaps to draw but not to paint."[45] A studio out in the open air came to be regarded as the sine qua non of Impressionist painting, although painting Nature "from life" was not invented by the Impressionists. It was the art critics who distinguished between "old-fashioned"

20 **Monet's Garden at Vétheuil,** 1880
LE JARDIN DE MONET A VETHEUIL
(The Artist's Garden at Vétheuil)
Oil on canvas, 151.5 x 121 cm (59⅝ x 47⅝ in.)
National Gallery of Art, Washington, DC,
Ailsa Mellon Bruce Collection, 1970.17.45
W 685

21 **Flower Beds at Vétheuil,** 1881
MASSIFS DE FLEURS A VETHEUIL
Oil on canvas, 92 x 73.3 cm (36¼ x 28⅞ in.)
Museum of Fine Arts, Boston,
The John Pickering Lyman Collection.
Gift of Miss Theodora Lyman, 19.1313
W 693

studio painting and "modern" plein-air painting. In actual fact, when Monet painted landscapes and still lifes, he always worked in his studio.

Monet's work is rarely examined in terms of his still lifes, for the quantity of the landscapes he produced is so overwhelming that the former receive little attention. Yet Monet repeatedly engaged with this genre, above all in the early years of his career. Most of the still lifes he produced between 1879 and 1883 were specifically suggested by Durand-Ruel who showed them between 1882 and 1885 in his gallery in Paris, and who commissioned Monet to create a set of still lifes to decorate the doors and wall panels in the salon of his apartment on rue de Rome. Altogether Durand-Ruel ordered thirty-six still lifes which Monet delivered within a space of three years. After the death of Camille, Monet initially produced a number of small-format paintings, including **Nasturtiums in a Blue Vase**, 1879 (cat. 22). At first sight it may seem somewhat sketchlike, but on closer examination it reveals Monet's interest in botanical detail, for nasturtiums quickly wilt when they are cut and put in water; the painting must therefore have been executed rapidly and from life. The simple gar-

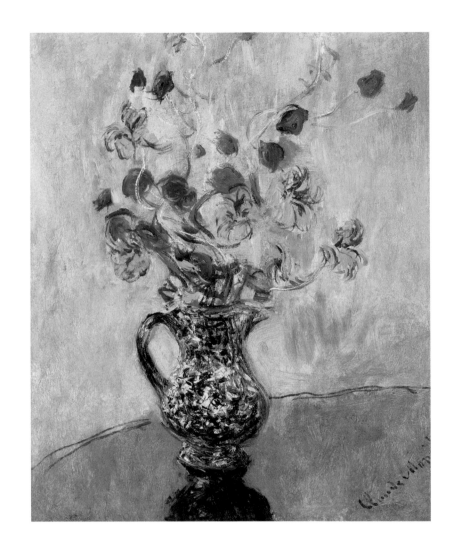

den flowers that were Monet's favorite motifs at this time feature on some large-format paintings, such as **Bouquet of Sunflowers**, 1880 or 1881 (cat. 23)—a slight misnomer since this is the smaller variety known in France as "soleil." Its botanical name is Helianthus chrysanthemum, and it is in fact a member of the chrysanthemum family. Other still lifes depict Jerusalem artichokes, mallows, and gladioli—garden flowers which Monet would paint when they were in flower, spontaneously and at speed—unlike the decorative floral arrangements he produced in the sixties. The still lifes which he mainly painted when the weather would not permit him to work outside, looked increasingly like botanical studies, as in the twig with red blossom in **Vase of Flowers**, 1882 or 1888 (cat. 24), an example of cottonweed grown in a greenhouse. This painting clearly shows the influence of the Japanese colored woodcuts that Monet was starting to collect at that time.[46]

Durand-Ruel was interested in these still lifes because they sold well and fetched higher prices than the landscapes.[47] **Dahlias**, 1883 (cat. 25), were among Monet's favorite flowers in the eighties, which may account for the fact that this is

22 Nasturtiums in a Blue Vase, 1879
CAPUCINES DANS UN VASE BLEU
Oil on canvas, 46 x 38 cm (18⅛ x 15 in.)
Private collection, Switzerland
W 547

23 Bouquet of Sunflowers, 1880 or 1881
BOUQUET DE SOLEILS
Oil on canvas, 101 x 81.3 cm (39¾ x 32 in.)
The Metropolitan Museum of Art, New York,
H. O. Havemeyer Collection,
Bequest of Mrs. H. O. Havemeyer,
1929, 29.100.107
W 628

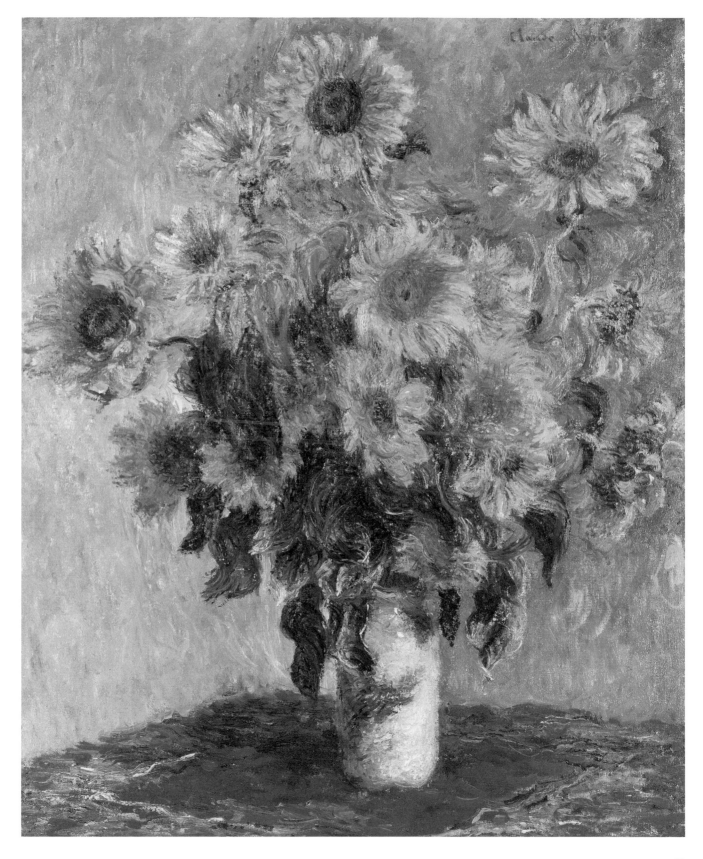

24 Vase of Flowers, 1882 or 1888
VASE DE FLEURS
Oil on canvas, 80 x 45.1 cm (31½ x 17¾ in.)
Philadelphia Museum of Art,
Bequest of Charlotte Dorrance Wright,
1978, 1978-1-23
W 810

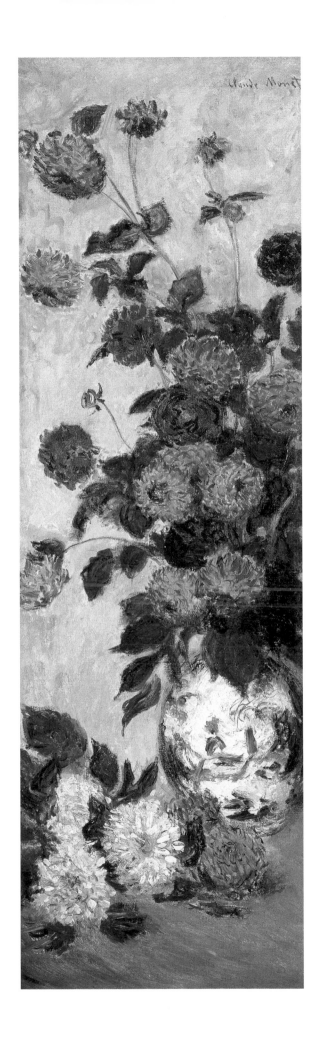

25 Dahlias, 1883
DAHLIAS
Oil on canvas, 128.5 x 37 cm (50⅝ x 14⅝ in.)
Private collection, Switzerland
W 937

the best of the panels he painted for the dining room in Durand-Ruel's apartment.[48] The still lifes came to an end with this commission, which he carried out with a certain reluctance. In Giverny Monet painted virtually no more still lifes. Although an artistically productive trip to Fécamp filled him with new energy, the financial situation in Vétheuil was still extremely trying. Monet had grocery and restaurant debts, and was in arrears with his rent. He was now almost entirely dependent on the payments he received from Durand-Ruel and bemoaned the fact that he and his family had become paupers in Vétheuil. At this stage in his career, a certain trait in Monet's character came particularly to the fore: he was as ambitious artistically as he was for material goods, and his dependence on a third party greatly irked him. The enjoyment that financial independence was to bring him in the second half of his life was all the greater, when he privately felt that in fact he was possibly receiving his just desserts for the pleasures he had foregone in his younger years.

The seventh exhibition of the Salon des Indépendants began on March 1, 1882, in a palais on rue Saint-Honoré which had been constructed to accommodate a new panoramic painting of the Battle of Reichshoffen (1870). Above the main salon there was a second salon, which is where the Impressionist exhibition took place. The presence of the obscure panorama turned out to be a stroke of luck, because when the upper echelons of this part of Paris came to celebrate its unveiling they also went up the next flight of stairs and saw the Impressionist paintings, some still barely dry. Because Pissarro, Caillebotte, Renoir, and even Gauguin had accepted invitations to participate in this show, Monet also presented no less than thirty-five works. This exhibition proved to be a breakthrough for Monet, not yet in financial terms but at least it won over the critics, and when it was over Durand-Ruel purchased paintings to the value of three thousand francs.

With the lease on the house in Vétheuil coming to an end, the family now had to look for a new home. Keen to live closer to Paris, Monet moved his family from Vétheuil to Poissy on the left bank of the Seine, with six thousand inhabitants and situated around twenty kilometers from Paris. A considerable number of paintings were ruined by the poor weather conditions during the move; others had to be left behind to cover outstanding debts. Poissy evidently had few motifs which inspired Monet to take up his brush. There is not even a painting of the pleasant view of the Seine beyond the little garden that belonged to this house. Instead, starting in February 1882, Monet embarked on a number of forays into Normandy, visiting the steep cliffs between Etretat—where he had already worked in 1864—and Dieppe, where he painted a large number of pictures.

Despite some favorable reviews, Monet still had no real luck with the critics. Albert Wolff (1835–91) wrote cuttingly in his articles, describing him as a wayward Impressionist and a dreamer, who allowed his fantasy too free a reign in his land-

26 **Winter Landscape at the Val de Falaise**, 1885
PAYSAGE D'HIVER AU VAL DE FALAISE
Oil on canvas, 65 x 81 cm (25⅝ x 31⅞ in.)
Private collection, Switzerland
W 975

scape paintings, whose talent was uneven, and who had simply taken the wrong way.[49] Regardless of the controversy among the critics, the market was steadily improving and after the mid-eighties the upward trend was making itself felt in the Galerie Durand-Ruel, whose owner had still had debts of one million francs in 1884. Monet's works were now selling better, and Cézanne remarked scornfully (and with some envy) that "Monet is making money," as it became clear that Monet was starting to overtake his colleagues in terms of financial success. By now Durand-Ruel was not the only gallerist with whom Monet regularly worked. "Les magasins du Louvre de la peinture," was Emile Zola's description of the roomy gallery owned by Georges Petit, which had successfully occupied a position on the corner of rue de Sèze and rue Godot de Mauroy since 1882. Petit had by now established himself as Durand-Ruel's rival in the field of modern art by adopting a rather different business strategy: he used to negotiate the purchase of a whole set of works for an exhibition and pay handsomely for them: ten thousand francs for the artist plus fifteen percent of every work sold.[50] In 1883, Durand-Ruel presented Monet's second solo exhibition, which elicited numerous, generally well-disposed reviews, including one by Gustave Geffroy in the journal **La Justice,** which was to become one of the publishing milestones of Impressionism.[51]

When the lease in Poissy came to an end, Monet had to find a new home for Alice and the eight children, but the whole family clearly felt little affection for this place and left it without a backward glance. At the time, while Monet was working on his first series of paintings of Rouen Cathedral, he persistently complained about the difficulty of traveling and his dependence on the weather. In fact, this interlude in Poissy is characteristic of the pattern of Monet's life and laid the foundations for the next station. Monet was now looking for a location where he could stay for a rather longer time,[52] not only for the sake of his family. In order to paint series of pictures recording changing weather conditions and light, he needed a more permanent base. He discovered just such a place on his wanderings around the little town of Vernon. A typical Normandy village, at first sight Giverny did not seem in any way remarkable. At the time it had barely three hundred inhabitants; Paris was around sixty kilometers to the southeast. In a fork in the River Epte before it flowed into the Seine, at the edge of Giverny in an area known as Le Pressoir, there was a strangely long, narrow farmhouse at the foot of a hill between the unasphalted road and the tracks of the local branch line. The house was surrounded by a large, somewhat marshy property measuring around 9,600 square meters. Separated from it by the railway track there was another piece of ground crossed by a stream, called the Ru, which joined the Epte not far away. Durand-Ruel cleared Monet's rent arrears in Poissy, and in April 1883 the family moved again. **Winter Landscape at the Val de Falaise,** 1885 (cat. 26), which shows a hamlet about a kilometer away from Giverny, up above the little valley of the Epte,[53] and **A Cottage in Normandy** (cat. 27), from the same year, give an impression of the austere beauty of this region. The picturesque, decorative ambience of the years spent in Argenteuil and Vétheuil seems almost entirely to have been replaced by raw Nature. The paint now has a noticeably flocculent texture, the brushstrokes are restless and rather broad, the colors are pale. Monet complained about the deficiencies in his handling of darker colors; and, as he wrote to Alice, his garden paintings were always more successful.

The Monets' new home was bigger than its predecessors. It consisted of a main house and a smaller house, which Monet was later to use as a second studio. The family began to settle in. First the main house was converted to meet their particular needs: a studio was created in the barn which adjoined the west wall of the house. It was around five meters high and twelve meters long with one large window that let in good light. Compared to his earlier work situations it was positively luxurious. Later on, after the addition of a second and a third studio, this first studio served as a gallery and living space. On the other side of the ground floor two rooms were converted into one large dining room, which we will return to in due course.

During that first summer Monet preferred to paint in a boathouse, moored a kilometer downriver at a small island in the Seine. In spring 1884, he went south on a painting trip, where he worked on landscape paintings in Monte Carlo and Bordighera and wrote to his wife: "Now I really feel the landscape, I can be bold and include every tone of pink and blue; it's enchanting, it's delicious, and I hope it will please you."[54] Typical of his stay in the south is his **View of Bordighera,** 1883/84 (cat. 28), which perfectly demonstrates the intense, glowing quality of Monet's colors: complementary contrasts juxtaposed in small spaces give his composition the vibrant feel of the southern light. The vivid colors of the plants in the parks and gardens that Monet visited on that trip were to recur some years later in his own garden. Back in Giverny he took up where he had left off in Vétheuil with a number of spring and summer landscapes, and with views of the poppy fields. He now also seriously turned his attention to the different atmospheric moods of the river valley. The meadow with blossoming fruit trees in **Springtime,** 1886 (cat. 29), depicts a typical example of the way the farmers used the mostly generous amounts of land around the farmhouses. The landscape **The Meadow at Giverny,** 1888 (cat. 30), portrays a rather different mood, with the fine mist close to the river blurring the outlines of the poplar trees. Monet often waited long hours for a certain atmospheric condition and could fly into a rage when the weather changed too quickly. It is said that he offered a landowner fifty francs if he would remove all the young leaves from an oak tree that featured in one of his series. In contrast to the open, careful style of these paintings, **Sunlight Effect under the Poplars,** 1887 (cat. 31), seems more judicious, almost a little contrived. It depicts the flat land that extends towards the Seine between the arms of the Epte. As a painting it brings together all the principles of mature Impressionism. Monet worked in the brightest light of the midday sun, when contours are dissolved by the heat haze. The painting itself consists of numerous individual flecks of largely unmixed paints, evoking the impression of a landscape filled with light and with the wind rustling the leaves of the poplar trees. In the middle ground we seen Suzanne Hoschedé with a green parasol and one of her siblings. The picture reflects the impression that the local farmers had of the Monets when they went out on their country walks. They used to appear in large numbers, fashionably dressed and with pale complexions; the girls wore hats and veils and carried parasols, went out on canoe trips, picnicked on weekdays, and in the afternoons took tea in the open air.

These works are representative of French Impressionism in the eighteen-eighties. Painters were now beginning to make their mark as exponents of contemporary Modernism. In April 1886, Durand-Ruel put on his first Impressionist exhibition in New York, and in 1888 he opened a gallery there. Of the more than three hundred works included in his first exhibition, fifty were by Monet. New Yorkers flocked to the exhibition, full of curiosity, and started to buy.[55] The second exhibi-

27 **A Cottage in Normandy,** 1885 or 1888
CHAUMIERE NORMANDE
Oil on canvas, 65 x 81 cm (25⅝ x 31⅞ in.)
Kunsthaus Zürich
Johanna und Walter L. Wolf Sammlung,
1984/14
W 1023

28 View of Bordighera, 1884 or 1883/84
VUE DE BORDIGHERA
Oil on canvas, 65 x 81 cm (25⅝ x 31⅞ in.)
UCLA Hammer Museum, Los Angeles,
The Armand Hammer Collection.
Gift of the Armand Hammer Foundation
W 853

tion, held the following year, was a huge success and signaled the breakthrough for Impressionist art in the New World. Monet, taking a patriotic line, was not particularly pleased. After a difficult start, Impressionism had established itself as a French invention, and a decade and a half after its birth it had become synonymous with modern art both in France and much further afield. The initial discord between certain painters, who had now long since gone their own ways, had been resolved in the market place. In the eyes of Monet, Sisley, and Pissarro, the only remaining problem was the intrusion of imitators who were turning Impressionism into an increasingly populist style. Art dealers had launched their bid to do business with the "moderns" and the market started to run riot. In February 1890, Monet turned to a government Minister, Armand Fallières, in connection with the planned sale of Manet's **Olympia** to an American purchaser. "We are anxious about the ceaseless movement in the art market, the competition that is coming from America, the only too predictable disappearance to another continent of many works that bring joy and honor to the people of France."[56] In fact the reception of Monet's art took off almost simultaneously in the United States and Europe, and nowadays — thanks to legacies from American collectors to museums in New York, Boston, and Chicago — there are numerous high-quality works by Monet in the New World. In the early nineties, Claude Monet corresponded extensively with the art critic Octave Mirbeau about the situation in the French art market, above all about the rivalry

29 Springtime, 1886
LE PRINTEMPS
Oil on canvas, 65 x 81 cm (25⅝ x 31⅞ in.)
Lent by the Syndics of the Fitzwilliam Museum, Cambridge,
Bought from the Museum's Funds with a Contribution from the National Art Collections Fund,
P.D.2-1953
W 1066

30 The Meadow at Giverny, 1888
LA PRAIRIE A GIVERNY
Oil on canvas, 73 x 92 cm (28¾ x 36¼ in.)
Victor Fedotov
W 1194

between Petit, Durand-Ruel, and Boussod. The artists' self-confidence with regard to dealers was growing and now they rarely committed themselves to exclusive contracts.[57] Participation in the Salon des Indépendants was no longer a matter of course—nor was it a necessity; of the total of eight exhibitions that took place between 1874 and 1886, Monet participated in five, twice following gentle persuasion by Caillebotte.

By the mid-eighties, Monet was as well known as a contemporary modern artist could be. His series of twenty-five paintings of haystacks, which he made in 1890 and the following year next to his home in Giverny, promised a keenly-anticipated artistic sensation. When Durand-Ruel showed fifteen of these in May 1891, there were queues outside his gallery. With the advance he received from Durand-Ruel, Monet was able to buy the property in Giverny in 1893. It had only one disadvantage—the branch line running straight through it, with the result that the future garden had two sections: one directly by the house (the "clos normand"), the other, rather more shady part, in the marshy area below the railway tracks (which was where Monet later made his water garden). Twice a day a train would steam through the middle of the property.

Monet's house had two floors. At ground level were the studio, the living area with the library, the dining room, and the kitchen. On the upper floor were the adults' and children's rooms. The main rooms downstairs were the dining room and the adjacent kitchen. The largest area—only the studio was larger—was occupied by the dining room, which had been created by knocking down the wall to the original kitchen and had a fairly low ceiling. Monet had it painted in two shades of yellow, a very light tone, almost colorless like irises, and a second more powerful yellow in the shade of sunflowers; the glazed stoneware fire-surround stood out against the yellows as did the backs of the doors which were painted in a deep shade of violet. On the walls were framed woodcuts (behind glass) by Hiroshige, Hokusai, and Utamaro. Monet had already started to collect these during his stay in Holland in 1871; while he was in Giverny he bought considerably more from two dealers in Paris. Aside from these the room contained not a single painting, neither by Monet nor by any other artist.[58]

The exterior of the house was relatively plain but perfectly maintained. The façade was painted pink and the shutters green mixed with a little yellow; a small porch was replaced by a veranda running the full length of the house, and the windows looking onto the garden were converted into doors. The central section was extended so that lunch or supper could be served there. Alice also regularly took afternoon tea there with her daughters and guests. The first studio had originally been a barn with a beaten earth floor, with no direct access from the house and with

31 Sunlight Effect under the Poplars, 1887
SOUS LES PEUPLIERS, EFFET DE SOLEIL
(Fields in Spring)
Oil on canvas, 74.3 x 93 cm (29¼ x 36⅝ in.)
Staatsgalerie Stuttgart, GVL 16
W 1135

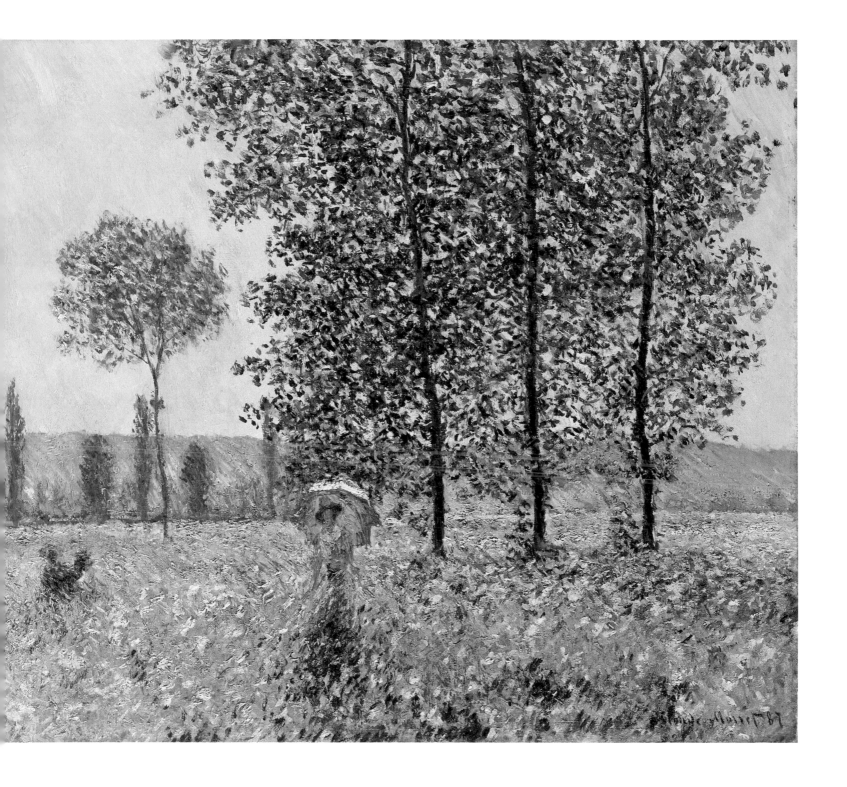

32 Peonies, 1887
PIVOINES
Oil on canvas, 73 x 100 cm (28¾ x 39⅜ in.)
Private collection
W 1142

a tall door opening onto the garden. Above the studio were two rooms occupied by Monet, where he also kept his collection of works by friends and close colleagues, including Corot, Jongkind, Fantin-Latour, Degas, Caillebotte, Pissarro, Sisley, Berthe Morisot, and twelve works by Cézanne. Once there was a direct connection between the house and the studio, the ground-floor studio — with writing desks for Claude and Alice — was used as a living space by the family, and as a rule coffee was served there at the end of meals. The second studio, which was built around 1900, was situated where a small farmhouse had once stood. It was completely separate from the main house. This studio had excellent light due to the large, north-facing window, a partially glazed roof and a series of small windows facing south which made the space very bright when the sun was shining. This was Monet's preferred workplace, and here he also received friends, dealers, and visitors when he was showing paintings. The third studio will feature later on in this narrative.

One important prerequisite for the making of the garden in Giverny should be mentioned at this point: money. It was around 1890 that Monet's earnings started to rise very considerably. In 1888, he made thirty thousand francs from sales, in 1891 and 1892 this rose to one hundred thousand per annum. After a short lull in 1893, things took a rapid upturn and in the years up until 1900 he was earning between one hundred seventy thousand and in excess of two hundred thousand francs annually.[59] He was now working again with both Durand-Ruel and Georges Petit; in the spring of 1889 the latter presented a joint exhibition of works by Rodin and Monet, which was a magnificent success.[60]

Around this time certain external events had important consequences for the new household being established in Giverny. Ernest Hoschedé, who had had virtually no contact with Alice and his children for some years, died in Paris on March 19, 1891, at the age of fifty-three; he was buried in Giverny. After a year of mourning, Claude Monet and Alice Hoschedé married on July 16, 1892. We have only scant information on the role of Alice in Monet's life, her part in the household in Giverny, and her influence on the garden, yet it must have been significant in all three cases. Like all the members of the family, she was actively involved in the garden and in its design — for unlike Monet's paintings, the garden was a constant topic of conversation, and, weather permitting, every meal was followed by a walk in the garden. In the early years, with its box hedges, a double row of conifers and numerous fruit trees it still bore a certain resemblance to a farmer's kitchen garden. The area to the back of the house had originally been the farmer's vegetable garden; its name "clos normand" was a reminder of its original purpose ("walled garden"). When the new garden design was already under way, Monet, travelling to Bordighera and Etretat, wrote home to Alice telling her how much he was longing for Giverny, "c'est le paradis à Giverny" and "how happy we would be, and how beautiful we would

make our garden!"[61] The conditional tense reflects his true situation, because at this stage the garden was still only occasionally a factor in his artistic production.[62] One of the earliest garden pictures painted in Giverny is of **Peonies,** 1887 (cat. 32), which grew as large bushes under trellises covered with clematis. The style of the painting is loosely sketchy; there are no visible corrections in the composition on a pale ground, as though this were a first impression of the future myriad of colors in the "clos normand." When he was traveling, Monet used to include practical advice for Alice in his letters, detailing what she should plant so that it would be in flower when he returned; in addition to the peonies, there were perennial dahlias and numerous rose bushes.[64] In order to have sufficient plants early in the year and to try out new varieties, in 1890 Monet had two greenhouses built, and in July 1890 Mirbeau reported to Gustave Geffroy that Monet was "gardening like a wild man."[65]

The writer Octave Mirbeau (1848–1917) had been party to both of Monet's careers — as artist and as gardener — since the late seventies. In Giverny, an intense dialogue between Mirbeau, Monet, and Caillebotte developed, which they called "our garden conversations." These were about special varieties of plants, pests, and the many joys and sorrows that all gardeners share; but they also dealt with more fundamental issues, as follows: "Dear Friend, I am very happy to hear that you are bringing Caillebotte with you. We will talk about gardening, since art and literature are mere trifles. In the end the soil is all that counts. I personally would even suggest that a clod of earth is something wonderful, and I can lose myself in one for hours on end. And compost! I love composted earth, as one loves a woman. I get my hands dirty in it, and see in the steaming lumps that beautiful forms and colors that will arise from it!"[66] Monet wrote to Geffroy that Mirbeau had also become a "maître jardinier,"[67] while the latter provided many practical tips regarding plants, or drew Monet's attention to special orchid varieties, for instance, or to an "ingenious gardener in Vaudreuil."[68]

Mirbeau became the most important chronicler of Monet's garden when — after one of his visits — he wrote a distinctly literary account of the garden albeit filled with botanical detail. This text — part of which is cited here — was the source of the legend of Giverny: "A house painted pink at the end of a garden, that is constantly aglow with flowers. It is spring. The wall flowers are releasing their last vestige of scent; the peonies, those divine peonies, are losing their color; the hyacinths are past their best. The nasturtiums[69] are already displaying their young, bronze-colored green, the California poppies[70] unfurl long pointed leaves in a precious sharp green in the broad beds that contain them; against a background of blossoming fruit meadows, the irises reveal their strange, curled petals, with crinkled white, violet, lilac, yellow, and blue, shot through with brown lines and crimson red flecks. Their complex depths evoke mysterious analogies, dreams of temptation and losing one's way, like

33 Monet's Garden at Giverny, 1895
LE JARDIN DE MONET A GIVERNY
Oil on canvas, 81 x 92 cm (31⅞ x 36¼ in.)
Stiftung Sammlung E. G. Bührle, Zürich
W 1420

those that waft towards us from those discomfiting orchids ... From the height of their supple stems the day lilies incline their scented trumpets; and the poppies on their furry stalks open wide their cinnabar red cupped blooms and entwine themselves around horizontal stakes. The generous blossoms of the clematis cover the green around them, the heaven of their immaculate white crowns seems to have been brushed by a breath of azure and pink. And the summer plants, between the fading borders — they are all anticipating the approaching moment of their flowering ..." This is followed by descriptions of summer and of autumn in Monet's garden, before Mirbeau finally draws to a close: "This is where Claude Monet lives, in this never-ending feast for the eyes. These are precisely the surroundings that one would have imagined for this extraordinary painter of the living splendor of color, for this remarkable poet of soft light and veiled forms, for this man whose paintings breathe, beguiling us, enveloping us in their scents; this man, who takes hold of what may not be held, who tells what may not be told, and whose magic — beyond our dreams — is the dream that so bafflingly reveals Nature to us, the dream that so magically pervades the divine light."[71]

Mirbeau, who described the "unsayable" more eloquently than any other, cast Monet in the role of the painter of things mysterious and otherwise unapproachable, and the object of his admiration did not protest against such hyperbole. In fact he commissioned a press service to collect anything and everything that was published on him, both at home and abroad, and regularly went carefully through the dossiers.[72] Two factors contributed crucially to Monet's future legendary status: his unwavering allegiance to Impressionism as "his" style, and his personal lifestyle in Giverny. Situated at quite some distance from Paris, Giverny was nevertheless accessible to the few "chosen ones" who were received there. With time Monet's garden became as famous as the art works, the gardener as widely known as the painter.

We are only in possession of patchy information concerning the design and landscaping of the property which must have taken considerable time and attention between 1883 and 1889. Oddly there are no documents, lists, or plans, just some rather meager notes where Monet recorded certain wishes and precise instructions. What this does at least suggest is that the garden was not planned and maintained "from the top," by the general-in-command, but rather in daily contact, with the gardeners and the gentleman of the house working together. Monet consulted gardening publications of the day and subscribed to garden magazines; he ordered from the catalogues of garden wholesalers — see the documentation in this volume for more detail on this. Yet it is nevertheless striking that so little has survived, and when pressed on this matter the present "jardinier en chef" at the Fondation Claude Monet is fairly non-committal. Much has disappeared over the years, particularly

after the death of Monet, or during the time when Blanche and Michel were running the estate. Some went astray later, disintegrated or was discarded, not least because the property lay in disrepair for over a decade before the garden was laid out again and the house was renovated.[73] In one painting of **Monet's Garden at Giverny** (cat. 33), made in late summer 1895, the figure in the middle ground is most probably Suzanne Hoschedé. The view shows the "clos normand" with several rows of dahlias in the flowerbed, staked and in full bloom. Planted in large groups in bright contrasting colors, the wealth of blooms suggests they have already been carefully cultivated for some years. The layout of the beds and paths in the "clos normand" was now complete, and Monet turned his attention to the next task.

In February 1893, as we have said, he also bought a piece of land south of the property on the other side of the railway line. The idea of creating a pond had already formed around 1890, when he had a "little puddle" dug and planted with shrubs and flowers.[74] Now a small tributary of the river Epte, a stream called the Ru, was to be diverted to create and inflow and an outflow for the pond, to create the proper conditions for cultivating water plants. Monet's correspondence with the prefect of the Eure Department in July 1893 contains some illuminating passages: "I would also like you to know that the above-mentioned cultivation of aquatic plants is not as significant as the term suggests and that it is merely intended for leisure and to delight the eye and also to provide motifs to paint. Finally, in this pond I will grow plants such as waterlilies, reeds, different varieties of irises which for the most part grow wild along our river, and there is thus no question of poisoning the water."[75] This last remark is a reference to the rumors circulating among the local farmers that the new-fangled planting of Monet's pond would pollute the water needed by the cattle. The system of sluices designed to keep the water clean and in constant, gentle motion, did not function perfectly at first and the rate of flow had to be regulated by means of additional grilles. In May 1894, Monet sent a letter to the garden suppliers Latour-Marliac and ordered water-lilies, which then arrived in four boxes at the station in Vernon.

Joseph Bory Latour-Marliac (1830–1911), who was to become the main supplier for the garden in Giverny was a specialist for hybrids and lotus flowers; he also imported bamboos and water plants, some from exotic sources.[76] In 1893 and 1894 Monet ordered large quantities of plants at great expense. He also made an important new acquaintance in 1893. When he was in Rouen, working on his cathedral paintings, he met the Director of the Botanical Gardens. "After work this morning I was able to make my visit to Monsieur Varenne at the Botanical Gardens. He's a very kind man, Monsieur Varenne, and I hope to obtain quite a lot of things from him: he offered me a cutting of that lovely climbing begonia which I'll bring back on Sunday. We visited all the greenhouses, really superb, what orchids! They're gorgeous. As

for plants for the young botanists [Monet's children], he's going to introduce me on my next visit to the head gardener who is only allowed to give plants away on Monsieur Varenne's orders, but he tells me it would be a good idea if the children were to draw up some kind of list of the species and subspecies they would like; they could work out a list with the priest."[77]

Varenne was a recognized expert in orchids. Monet's was most enthusiastic and described Varenne's orchids as "épatant" (stunning), and the friendship between them was sealed. On the advice of Varenne, who often visited Giverny in the years to come, in 1897 Monet had a second, heated greenhouse built. He started by filling it with passion flowers, two kinds of nasturtium, and a particularly beautiful variety of begonia. The seedlings arrived by rail from Rouen and grew so vigorously that they soon threatened to break through the glass roof.

The work in the garden changed Monet's creative process. Whereas he had previously always worked on several paintings at once—sometimes more than a dozen—now only a few paintings were in the making at any one time.[78] In 1893/94, after he had finished the series of cathedrals in Rouen, Monet painted alternately in the studio and outside at his easel whenever he needed motifs from the garden or the immediate surroundings.[79] The water, the reflections of trees and shrubs overhanging the bank, and swathes of mist are the theme of **Morning on the Seine,** 1897 (cat. 34), which is itself an immediate precursor of the paintings of the water-lily pond which Monet started to paint that same year. Two varieties of water-lilies had been planted in bowls placed on the floor of the pond. However, when the circular leaves and first blossoms appeared, an unfortunate phenomenon came to light: with the passage of vehicles on the dirt-track road a fine film of dust would settle on the surface of the water, covering the water-lily leaves. Monet later met half the cost of having the road asphalted. Among the first paintings of the pond is **Water-Lilies,** 1897–99 (cat. 35); rather like a still life it depicts the new plants with botanical accuracy, showing the colors and the shapes of the leaves, and their amount, correctly related to the blossoms in various stages of maturity.

The water-lilies available on the market at the time were bred from Japanese varieties selected for their suitability for the French climate. In the mid-eighteen-fifties Japan had opened its ports to new trade links with the West, and—in part aided by the World's Fairs in London (1862) and Paris (1867)—soon Japanese art was finding its way into Western cultural circles. In Paris it was sold in large quantities together with woodcuts, furniture, porcelain, textiles, and decorative household items; Pierre Loti dashed off a bestseller, his novel **Madame Chrysanthème,** in Paris and London Gilbert and Sullivan presented **The Mikado,** Puccini wrote **Madame Butterfly.** The fashion for things Japanese also affected gardens, which now boasted Japanese cherry trees and Japanese plum trees, peonies,

chrysanthemums, and water-lilies. Monet, who had been collecting Japanese woodcuts since the seventies, had less of an ethnological interest — like some of his contemporaries — than a general cultural or fashion-led interest, which was to lead to a notable addition to the garden in Giverny.

In 1895 Monet had a simple, relatively low wooden bridge with a trellis built spanning the water-lily pond. Its gentle, even curve described a shallow arc. If one wanted to find a source for the design, Japanese woodcuts would be the first place to look. At this point it is worth clarifying a misleading conjunction of two facts. Monet was a connoisseur and collector of Japanese woodcuts. And Monet created a lily-pond with a Japanese bridge. However, it would not be true to say that Monet's intention was to create a "Japanese garden," along the same lines as the gardens in the woodcuts. It is true that the water-lily pond contained certain exotic plants that Monet, the gardener, was particularly interested in, and it is fair to say that the bridge was inspired by those on the woodcuts, but it was not a copy; it was a paraphrase and an independent creation in its own right. Whatever the case, the "pont japonais" became the most famous of all the motifs in the Giverny garden. **Water-Lily Pond,** 1897–99 (cat. 36), **Water-Lily Pond,** 1899 (cat. 37), and **Water-Lily Pond,** 1899 (cat. 38), memorably demonstrate the dedication with which Monet concentrated on the lights and colors of different times of day seen from the same standpoint. A characteristic combination of different elements creates the particular effect of these compositions: the shallow curve three times over, the irregular horizontal planes of expansive colonies of water-lilies, the verticals formed by iris leaves, reeds, and the branches of the weeping willow, and the precisely portrayed reflections on the surface of the water, all of which are perfectly balanced with each other. Now it became clear that the immense effort put into the garden had been worth it. The garden was more than merely a source of inspiration for new motifs, for now the series could be realized with less trouble and in an extremely perfect form. And the bridge not only served as a new motif for series of paintings but also had a very practical function; when Monet placed his easel directly on it, he was facing the widest section of the pond and had a panoramic view of the various colonies of water-lilies. In March 1900, he wrote Alice, telling her that he was spending his time working in the garden whatever the weather, so that he could paint the plants in all weathers, in all kinds of light conditions, and he reported that he had finished around sixty-five canvases and that he was working on another fifteen concurrently.[80] When these paintings were shown in late 1900 by Durand-Ruel they were a huge success, exceeding all expectations.

34 Morning on the Seine, 1897
MATINEE SUR LA SEINE
(Branch of the Seine near Giverny [Mist] from the
"Mornings on the Seine" series)
Oil on canvas, 89.9 x 92.7 cm (35⅜ x 36½ in.)
The Art Institute of Chicago,
Mr. and Mrs. Martin A. Ryerson Collection,
1933.1156
W 1475

35 Water-Lilies, 1897–99
NYMPHEAS
Oil on canvas, 130 x 152 cm (51⅛ x 59⅞ in.)
Private collection
W 1508

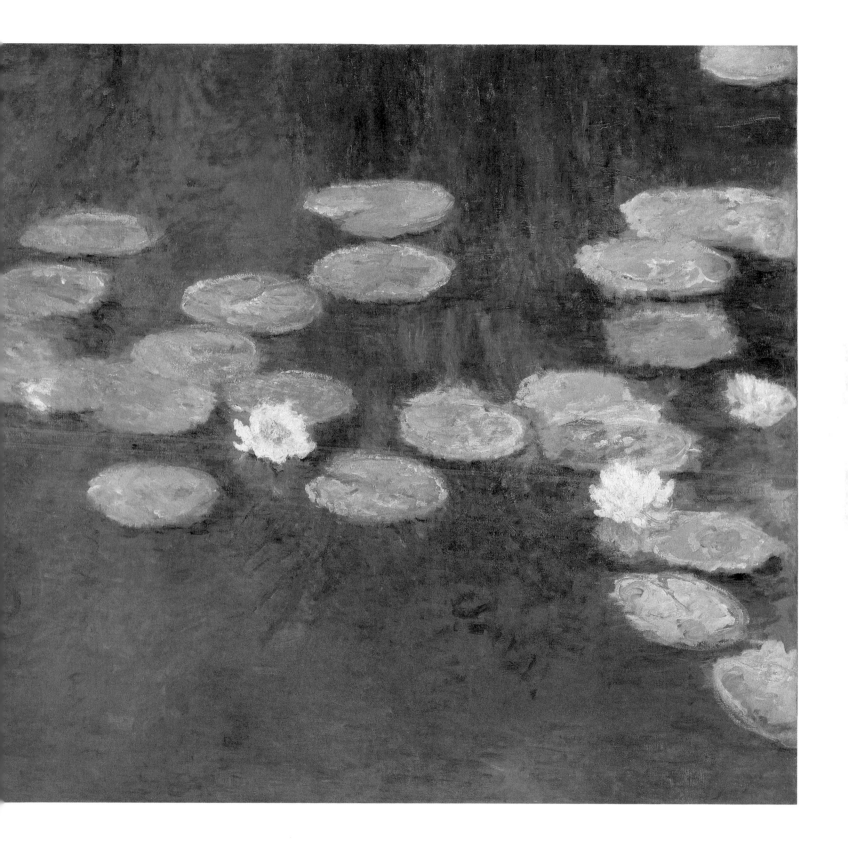

The first decade of the new century also brought with it success outside France, above all on the American East Coast,[81] and Monet's international fame changed life in Giverny. Following the decision of some the members of a private painting school in Paris, the Académie Julien, to settle in Giverny, within a few years it was home to an artists' colony with more than forty studios, guest houses, boarding houses, and small hotels. Tourists came — most notably from the United States — in order to observe landscape painters at work, whom they would find sitting outside under parasols to protect them from the glaring sun, painting in the already legendary "open-air studio."[2] The new residents were socially active (it seems that English was the lingua franca) and Monet's children joined in. Only old Monet kept out of sight and only a very few visitors had a chance to really to see "the house of the master, the light green shutters, and the delightful garden."[83]

After 1900, whenever Monet turned to his garden for inspiration, he mainly painted two groups of motifs: one being the water, the water-lilies, the bridge, and the weeping willow; the other the flowerbeds in the "clos normand," seen from different angles. Apart from a small area of seating, the garden had no other built attractions. There were neither labyrinths nor sunken lawns, neither pavilions nor grottoes; instead it was dominated by the simple forms of the flowerbeds and the trellises. While the garden next to the house had a certain rectilinear regularity, the water garden was asymmetrical in its layout, so that the two parts of the garden made very different impressions. Unlike Argenteuil, where the house and garden together made up a single functional and decorative unit, the house and the garden in Giverny were carefully separated. Consequently the links between the different areas were all the more important, and once the water-lily pond had developed so extraordinarily well, the gardener and painter turned his attention to the connecting paths. In the late spring of both 1899 and 1900 Monet painted in the "clos normand," which was now fully planted. Two paintings from 1900 depict the view looking diagonally towards the house. **Irises in Monet's Garden** (cat. 39) shows that the full length of the beds running perpendicular to the house were planted with a single color (in this case violet irises); in the background we see narrower beds in contrasting colors. **The Garden** (cat. 40) is painted from the same standpoint, yet it is by no means an exact replica, because the perspective is rather different, the paint technique is looser and the increased use of white and red makes for a more expressive color scheme.

The continual interaction between the two parts of the garden turned out to be a stroke of good fortune. The carefully laid central axis of the "clos normand" considerably raised its status. It now became the prelude to the main feature which was the water garden, and the path which had found little favor at first was now

36 Water-Lily Pond, 1897–99 or 1899
LE BASSIN AUX NYMPHEAS
(Waterlilies and Japanese Bridge)
Oil on canvas, 90.5 x 89.7 cm (35⅝ x 35⅝ in.)
Princeton University Art Museum,
From the Collection of William Church Osborn,
Class of 1883, Trustee of Princeton University
(1914–1951) Given by his Family, Y 1972-14
W 1509

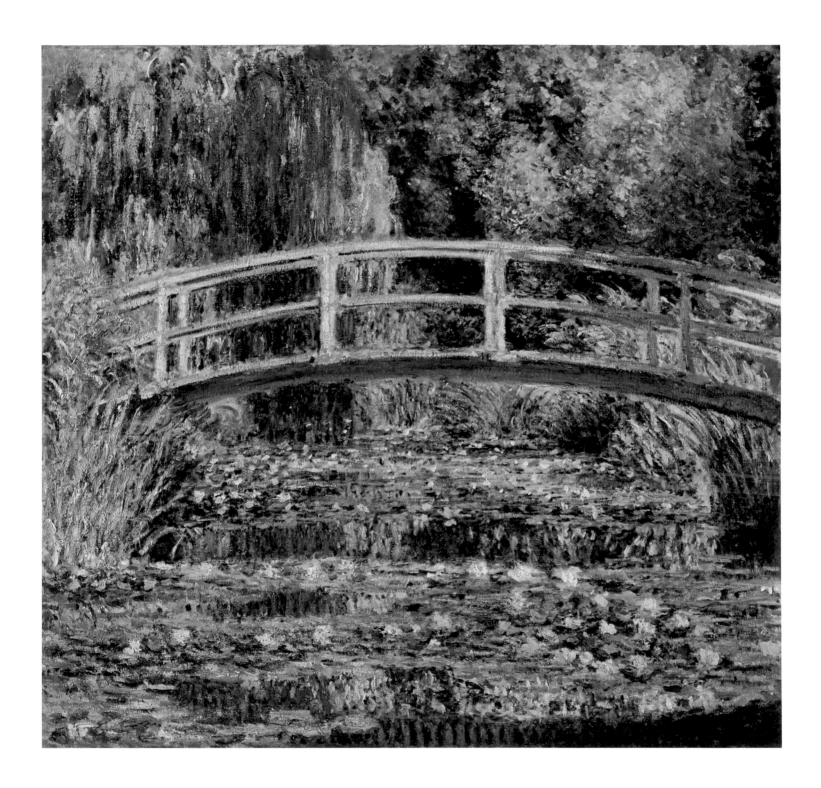

rethought and redone. Monet painted it twice: once in 1900 and again two decades later as part of a larger group of works. **Main Path through the Garden at Giverny,** 1901–02 (cat. 41), portrays the central axis in the garden, flanked by flowerbeds planted from end to end with violet irises.[84] Amid this opulent blanket of color, the central path was only visible for two to three weeks in May/June. The selection of plants in the parallel beds meant that from spring until late autumn the combination of flowers changed several times. In addition there were also abundant plants in wooden containers and an optical boundary in the shape of shrubs along the edge of the garden.[85] The garden had a large number of highly differentiated faces, which could to a certain extent be selected and controlled. Around 1900, there were at least three gardeners, known to us by name, working under the head gardener Félix Brueuil; in reality, however, there were probably five or six gardeners in total. Monet spoke to Breuil on a daily basis about the plants and their care, and when he was abroad, he used to include detailed instructions in his letters.[86] From 1902 onwards the garden was fertilized with sulfate mixtures and large amounts of potash, following the same regime as farmers on the land.[87] Since most of Monet's

37 Water-Lily Pond, 1899
LE BASSIN AUX NYMPHEAS
(The Water-Lily Pond)
Oil on canvas, 88.3 x 93.1 cm (34³/₄ x 36⁵/₈ in.)
The National Gallery, London, NG 4240
W 1516

38 Water-Lily Pond, 1899
LE BASSIN DES NYMPHEAS
(Bridge over a Pool of Water Lilies)
Oil on canvas, 92.7 x 73.7 cm (36¹/₂ x 29 in.)
The Metropolitan Museum of Art, New York,
H. O. Havemeyer Collection, Bequest of
Mrs. H. O. Havemeyer, 1929, 29.100.113
W 1518

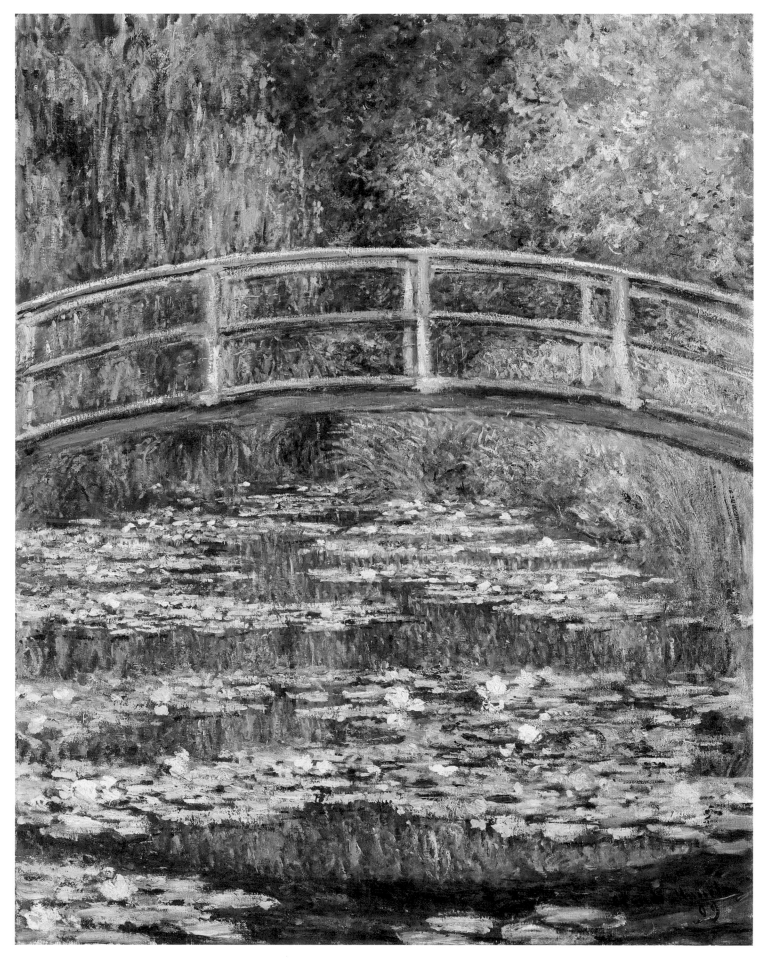

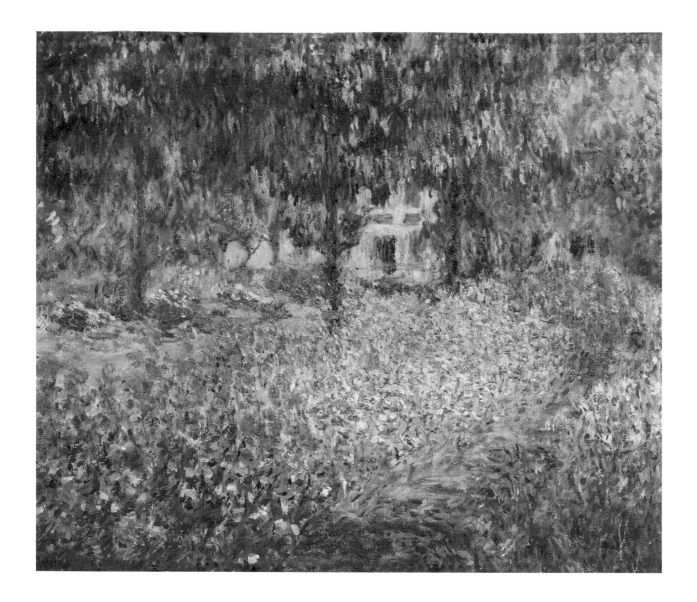

notes to his head gardener have clearly been lost, just one example from February 1900 may suffice to give an impression of his approach. In it he orders "300 pots Poppies — 60 Sweet pea — around 60 pots white Agremony — 30 yellow Agremony — Blue sage — Blue Waterlilies in beds (greenhouse) — Dahlias — Iris kaempferi" and gives detailed instructions as to where and when these are to be planted.[88]

By 1900 the pond had become the main feature of the garden as a whole; in winter 1901/02 it was enlarged, necessitating the removal of some of the water-lilies. In 1904 Monet ordered a substantial number of water-lilies, some exotic and all expensive.[89] The new colonies took two years before they had grown sufficiently for him to paint them. As with the building of the bridge, he now turned his full attention to the new attraction in his garden. Surprisingly, Monet was once again not

39 Irises in Monet's Garden, 1899 or 1900
LE JARDIN DE MONET, LES IRIS
(The Garden of the Artist in Giverny)
Oil on canvas, 81 x 92 cm (31⅞ x 36¼ in.)
Paris, Musée d'Orsay, RF 1983-6
W 1624

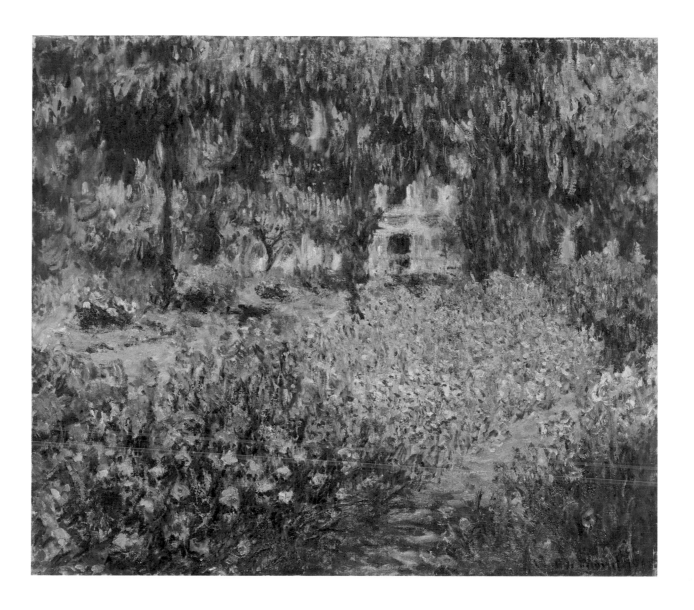

40 The Garden, 1900
LE JARDIN
Oil on canvas, 81 x 92 cm (31⅞ x 36¼ in.)
Private collection
W 1625

entirely certain of the quality of his latest works and cut up a large number of paint-ings. An exhibition was the last thing on his mind,[90] but having scarcely painted any-thing in the first half of 1908, in August he wrote to Gustave Geffroy: "You must know I'm entirely absorbed in my work. These landscapes of water and reflections have become an obsession. It's quite beyond my powers at my age, and yet I want to suc-ceed in expressing what I feel. I've destroyed some . . . I start others . . ."[91] By now Monet was increasingly often referred to in the press as a "painter of water,"[92] and it is true that after 1910 the vast majority of his Giverny paintings are of the water-lily pond.

Once the water-lily pond had been enlarged Monet found motifs in the small-est of spaces: contrasting colors in the vegetation, differentiated light effects, reflections of the sky, and the vegetation on the surface of the water. The so-called

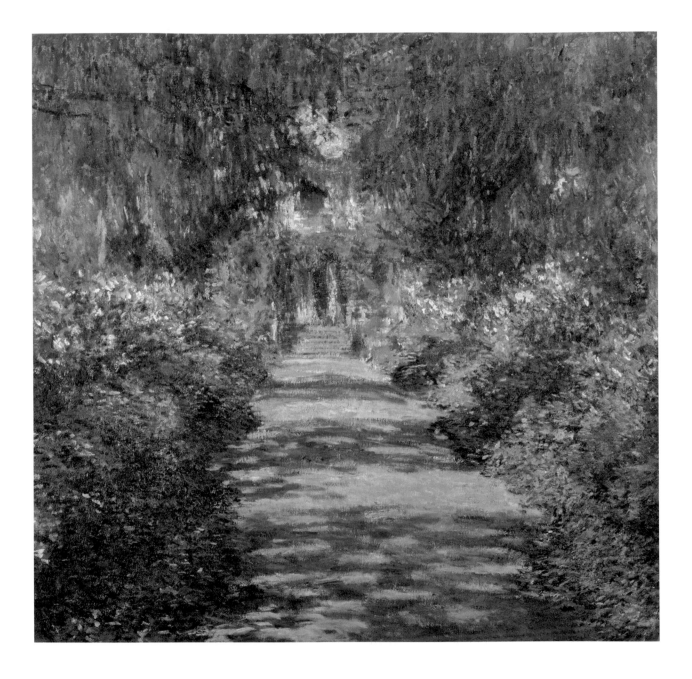

tondi look like slightly odd experiments with circular picture formats. In the three **Water-Lilies** of 1907 and 1908 (cats. 42, 43, and 44) the notion of an artistic "detail" is taken to an extreme. The directionless of these compositions will later feature again in Monet's last monumental paintings. At the beginning of this stages, Monet still used to paint out of doors and the earliest works, including the **Water-Lilies** of 1905 (cat. 45), depict the extraordinarily colorful wealth of the different varieties. The appeal of these paintings rests on the introduction of a new motif: large-scale reflections of the sky and the trees on the surface of the water, which give the island-like colonies of water-lilies an additional compositional tension. This is further heightened in the group of vertical-format water-lily paintings from 1907 and 1908 (cat. 46 and 47), which tell us a great deal about the standpoints Monet used to choose. Depending on the motif, he would take up a certain position; there he would remain, waiting for a particular light in order to capture the reflection of the sky on the surface of the water. Immediately by the pond there were two medium-sized weeping willows, whose branches almost touched the ground and the surface of the water. In 1918 and 1919 Monet painted two audacious versions of **Weeping Willow** (cat. 48 and 49), for which he again chose a restricted view as he had done for the water-lilies. Restless vertical S-shaped brushstrokes create a sense of luxuriant vegetation; the gradation of blues and greens to yellows and ochres suggests light falling diagonally across the background. Monet returned to this motif once more In 1920. Now the forms of the **Weeping Willow** (cat. 50) are amorphous, the paint technique is gestural and expressive, and the green is shot through with violets and reds. The complementary contrast of green and red—like the long, twisting brushstrokes—suggests an inner unease, in stark contrast to the first water-lily paintings. At the edges of the canvas the pale ground is still visible acting as a foil for the spontaneous, denser painting in the center of the composition.[93] One of the paintings of the weeping willow (cat. 49) was bought by the Japanese dealer Kuroki and his wife, Princess Takeko Matsukata, who brought gifts with them from Japan: tall peonies, different varieties of lotus flowers, and water-lilies, including a red-violet variety. Monet must have made their acquaintance around this time, perhaps before, and was flattered that his reputation as an artist had even spread across the world to the Far East.[94]

Around 1920, Monet created a group of extraordinary paintings showing a section of the end of the pond with the bank. The grounds, with various kinds of reeds growing round the edges, had tall shrubs and trees on one side and a dense bamboo grove on the other. Monet set groups of red rose bushes against the saturated greens; in the smooth water we see the rare red-violet water-lily. Two paintings **The Water-Lily Pond at Giverny** (cat. 51) and **The Water-Lily Pond** (cat. 52), made during 1918 and 1919, combine the pond and the surrounding vegetation and probably give

41 **Main Path through the Garden at Giverny,**
1901–1902
UNE ALLEE DU JARDIN DE MONET, GIVERNY
(Path in Monet's Garden in Giverny)
Oil on canvas, 89 x 92 cm (35 x 36¼ in.)
Österreichische Galerie Belvedere, Vienna, 540
W 1650

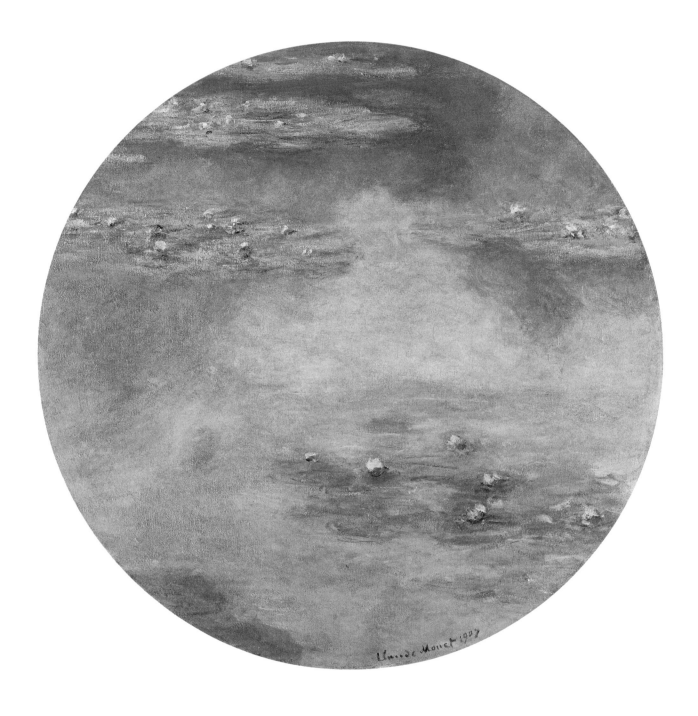

42 Water-Lilies, 1907
NYMPHEAS
Oil on canvas, ⌀ 81 cm (31⅞ in.)
Musée d'art moderne, Saint-Etienne, 924
W 1701

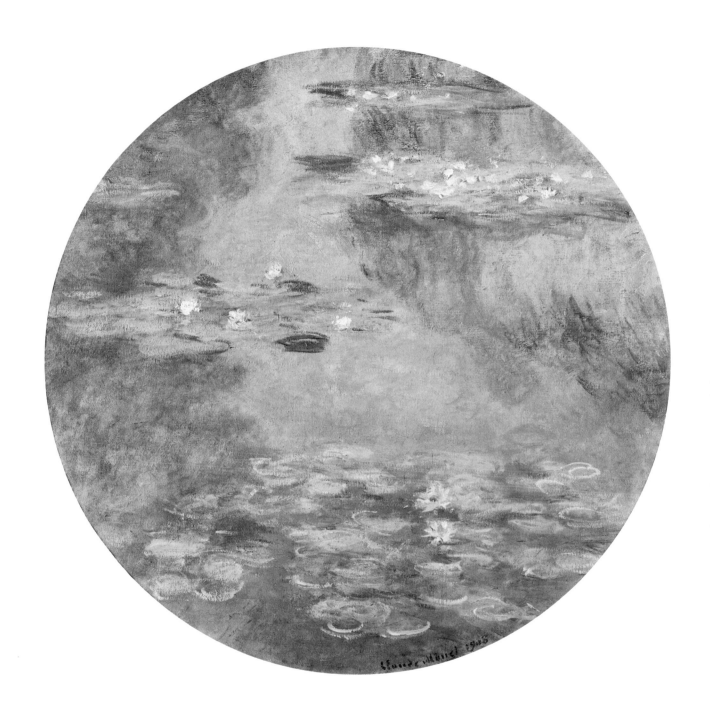

43 Water-Lilies, 1908
NYMPHEAS
Oil on canvas, ∅ 90 cm (35⅜ in.)
Musée municipal A. G. Poulain, Vernon, 25.4.1.
W 1724

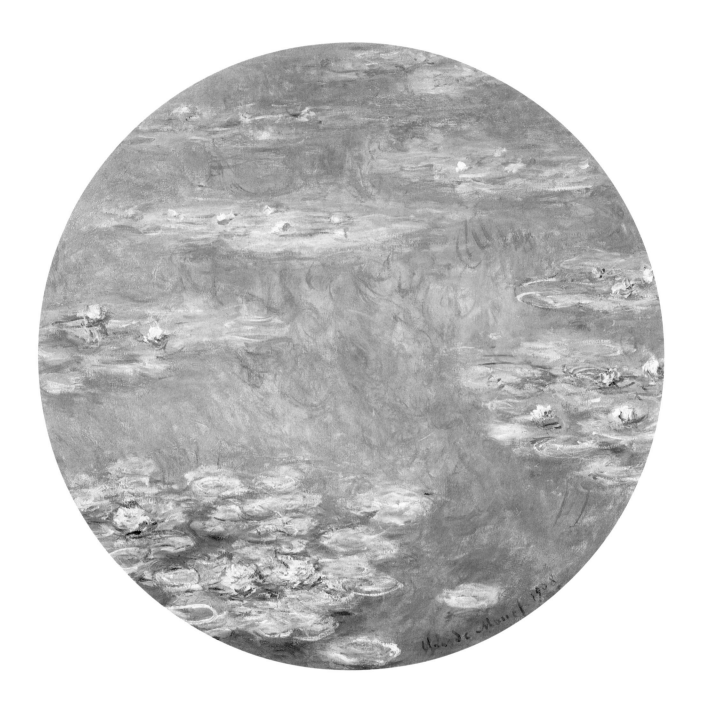

44 Water-Lilies, 1908
NYMPHEAS
Oil on canvas, ⌀ 80 cm (31½ in.)
Dallas Museum of Art,
Gift of the Meadows Foundation Incorporated,
1981.128
W 1729

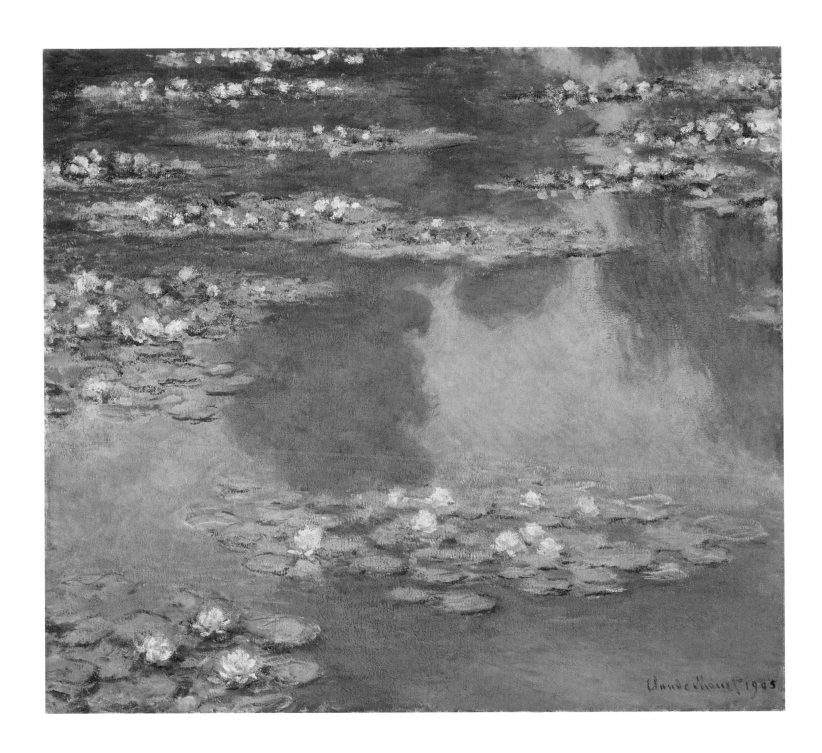

45 Water-Lilies, 1905
NYMPHEAS
Oil on canvas, 89.5 x 100.3 cm (35¼ x 40½ in.)
Museum of Fine Arts, Boston,
Gift of Edward Jackson Holmes, 39.804
W 1671

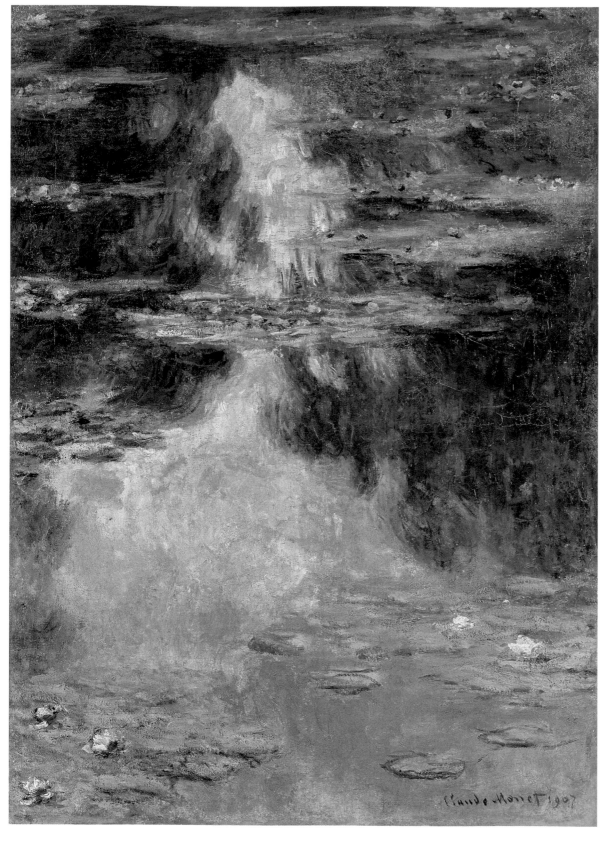

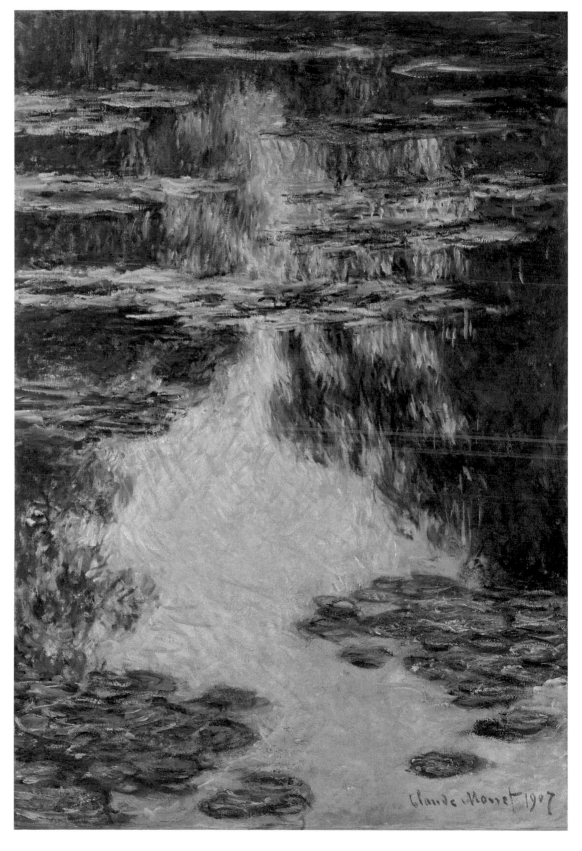

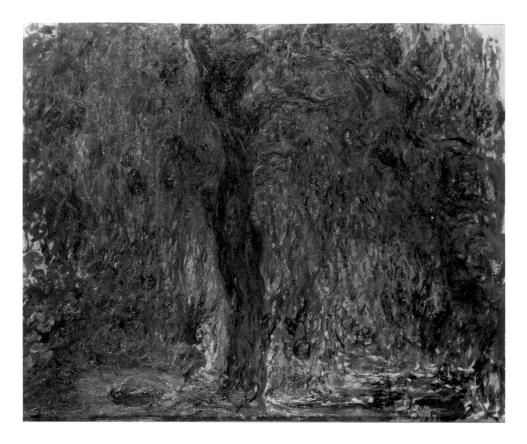

Page 76
46 Water-Lilies, 1907
NYMPHEAS
(Pond with Water Lilies)
Oil on canvas, 107 x 73 cm (42⅛ x 28¾ in.)
The Israel Museum, Jerusalem,
Bequest of the Sam Spiegel Collection,
B 97.0483
W 1710

Page 77
47 Water-Lilies, 1907–08
NYMPHEAS
Oil on canvas, 105 x 73 cm (41⅜ x 28¾ in.)
Göteborgs Konstmuseum, Gothenburg, Sweden,
GKM 2232
W 1716

the most accurate impression of the water garden. Against a dark, dense back-
ground of shrubs and willows we see individual herbaceous plants, with clear out-
lines and glowing blooms; at the edge of the pond the leaves of the water-lilies
stand in dark contrast to the light green of the bank. Greens and blues dominate
the compositions, accents are set in red and pink. These paintings convey some-
thing of the complexity of Monet's horticultural creation—and the wealth of colors
and motifs that this generated. The storm of colors on what is presumably the
last of these paintings, **The Water-Lily Pond at Giverny,** 1918–19 or 1919 (cat. 53)—
related in terms of its style to the late weeping willows—is the ultimate synthesis
of Monet's dazzling technical skill. The composition is laid down on the canvas with
deft brushstrokes. The pale ground which is still visible in the center accentuates
the sketchlike feel of the work as a whole—which is nevertheless also a perfectly
balanced composition executed with complete painterly certainty. The harmonious
coherence of all the various details was not a virtue of the painting alone, for the
vegetation in the water garden was already a precisely designed and carefully
tended scenario of shapes and colors which, as Georges Clemenceau remarked,
was the outcome of Monet's own strict instructions: "... it seems clear that he
designed it as his eye told him to, little by little, searching to satisfy his need for
color. When I report that Monet's garden is crossed by a road, the railway line from

48 Weeping Willow, ca. 1919
SAULE PLEUREUR
Oil on canvas, 100 x 120 cm (39⅜ x 47¼ in.)
Private collection,
Courtesy Galerie Beyeler, Basel
W 1874

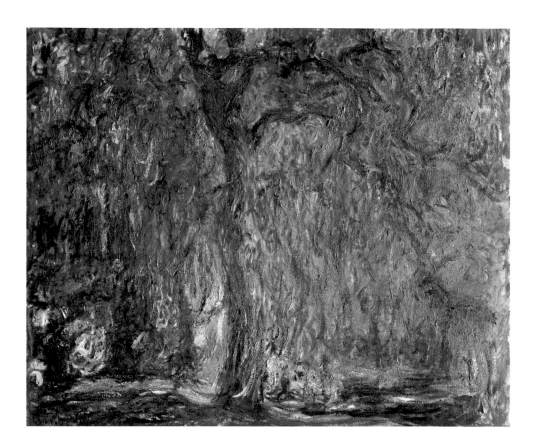

49 Weeping Willow, 1918–19
SAULE PLEUREUR
Oil on canvas, 100 x 120 cm (39 ⅜ x 47 ¼ in.)
Kimbell Art Museum, Fort Worth, Texas
W 1876

Gisors and a tributary of the River Epte, one might be forgiven for thinking that harmony could not be the dominant feature of this garden. What could one compare it to? Everything and nothing. Without the road, without the railway line, without the river that attracted the fishermen, one might perhaps have found a secluded spot here."[95] The crucial criterion was the standpoint chosen by the painter, determining the view of the property. If one examines a substantial number of the paintings produced in Giverny, it becomes clear that Monet returned to the same positions year after year and only changed them now and then. Ultimately it was due not least to the natural rhythm of the plants and their flowering that his work bore certain recognizable stamps: the bridge and the pond, the weeping willow, reflections on the surface of the water.

After Alice's death in May 1911, a lengthy period without artistic creation ensued, before Monet returned again to his most successful subject matter. The last decade of his life was again dedicated to water-lilies. For **White and Yellow Water-Lilies,** ca. 1916 (cat. 54), he used horizontal brushstrokes for the leaves (which take the form of compressed ovals in the lower section of the painting) and short vertical strokes for the water. Depth is created by a higher density of pointed ovals in the top third of the painting, creating the impression of their being relatively close to the surface

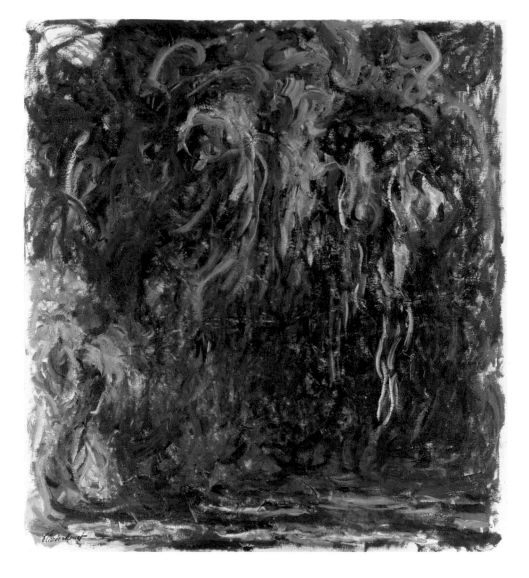

50 Weeping Willow, 1920–22
SAULE PLEUREUR
Oil on canvas, 110 x 100 cm (43¼ x 39⅜ in.)
Paris, Musée d'Orsay,
Collection particulière; donation sous réserve
d'usufruit à l'Etat français, 2000, RF 2000-27
W 1942

51 The Water-Lily Pond at Giverny,
1918–19 or 1917
COIN DE L'ETANG A GIVERNY
Oil on canvas, 117 x 83 cm (46⅛ x 32⅝ in.)
Musée de Grenoble, MG 2168
W 1878

of the water. The different colors on blooms and leaves point to the different varieties growing in the pond, and the individual colonies appear quite distinct from each other. Monet now increasingly abandoned botanic details but still retained the correct overall forms and the relationship between the leaves and the blooms of individual plants. For **The Water-Lily Pond,** 1918–19 (cat. 55), Monet used a wider format, for **The Water-Lily Pond,** 1917–19 (cat. 56), he chose a narrower canvas, of a type specially made for him. The reduction of botanic detail is apparent on the water-lily leaves which are represented as abbreviated forms, while the blooms are reduced to flecks of color. The main focus of attention is on the colored reflections on the water. One cannot help but be struck by the iridescent tones achieved by layering coats of thinned paint, although Monet still retained the distinction between areas with horizontal brushstrokes and those with vertical lines.

Page 82
52 The Water-Lily Pond, 1918–19
COIN DU BASSIN AUX NYMPHEAS
Oil on canvas, 119.5 x 88.5 cm (47 x 34⅞ in.)
Musée d'art et d'histoire, Ville de Genève, 1990-46
W 1879

Page 83
53 The Water-Lily Pond, 1918–19 or 1918
COIN DU BASSIN AUX NYMPHEAS
Oil on canvas, 130 x 88 cm (51⅛ x 34⅝ in.)
Private collection
W 1880

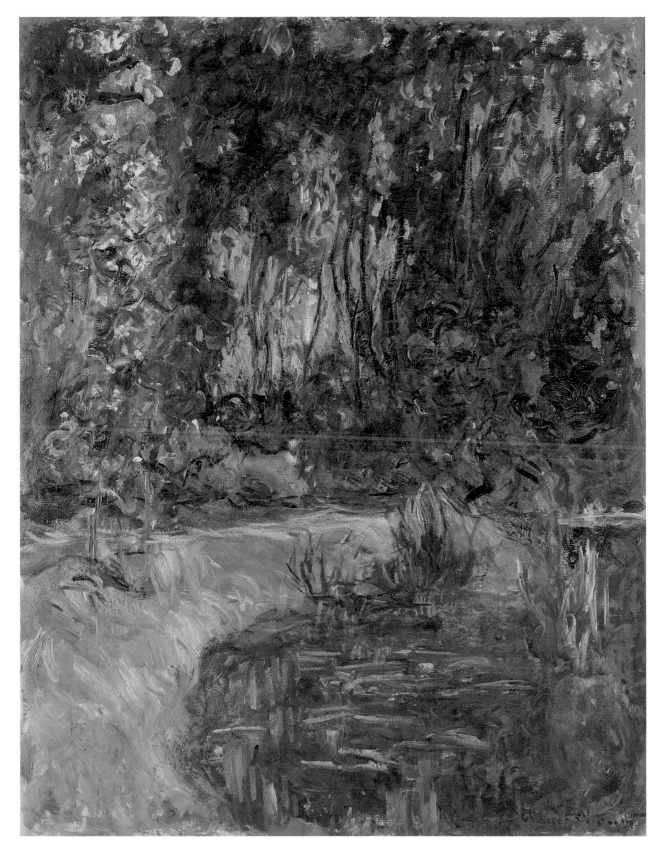

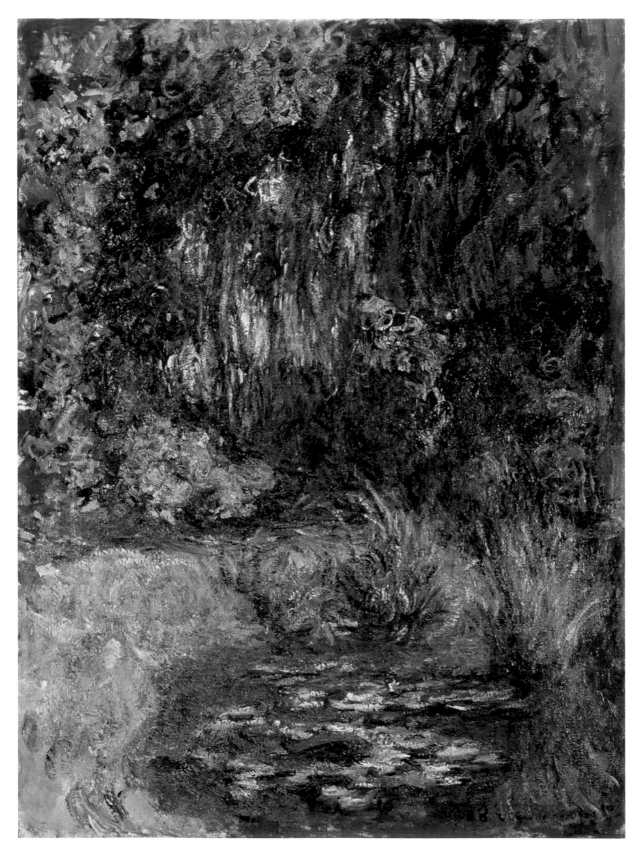

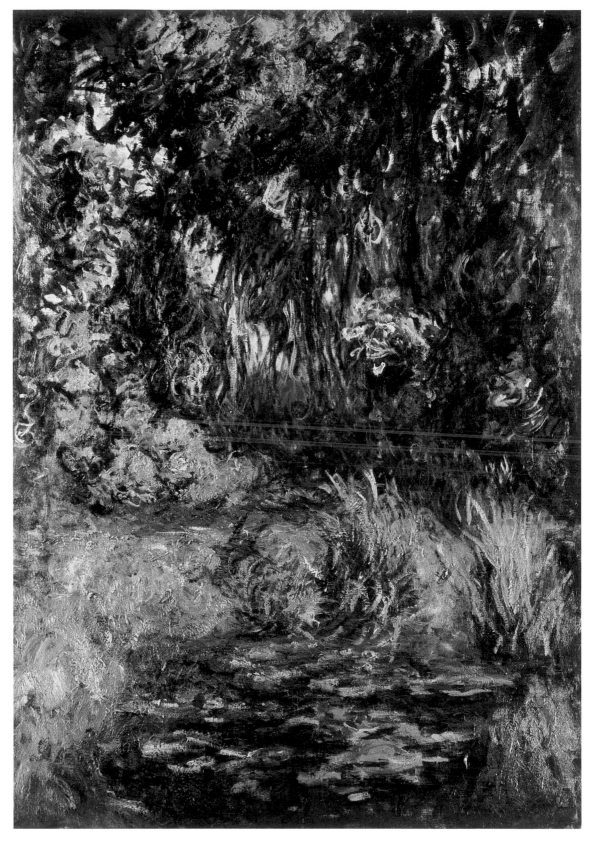

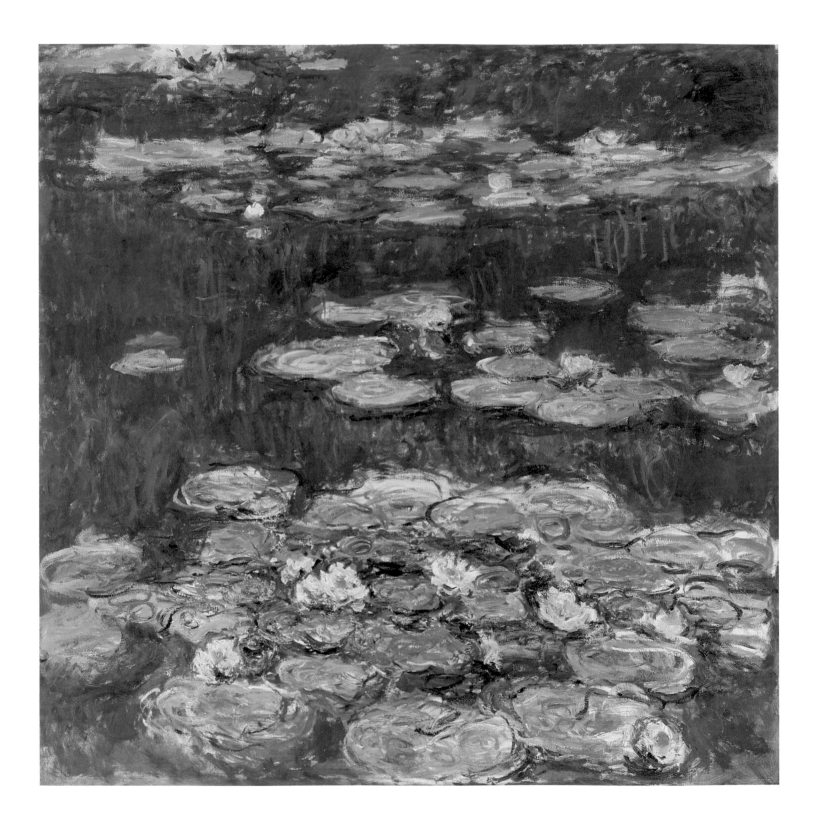

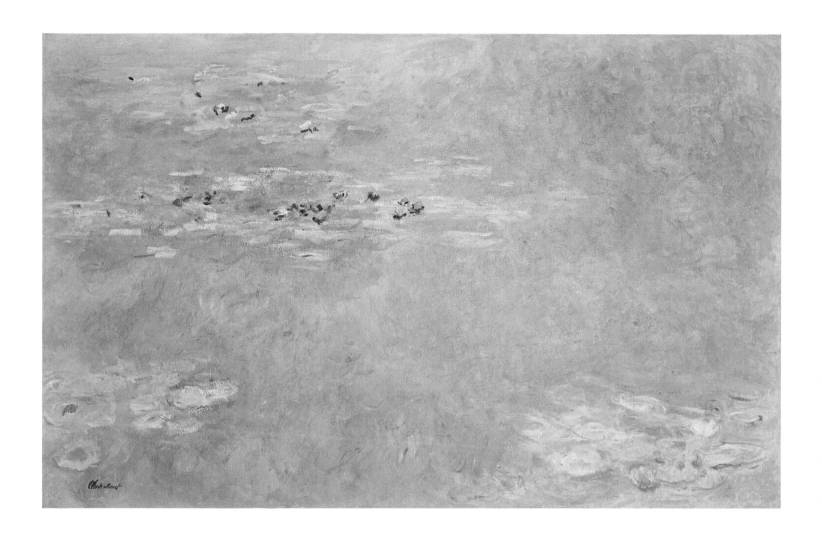

54 White and Yellow Water-Lilies, ca. 1916
NYMPHEAS BLANCS ET JAUNES
(Water-Lilies)
Oil on canvas, 200 x 200 cm (78¾ x 78¾ in.)
Kunstmuseum Winterthur,
Geschenk des Galerievereins,
Freunde des Kunstmuseums Winterthur,
1952, 813
W 1801

55 The Water-Lily Pond, 1918–19
LE BASSIN AUX NYMPHEAS
Oil on canvas, 130.5 x 200.5 cm (51⅜ x 79 in.)
Museum Folkwang, Essen
W 1883

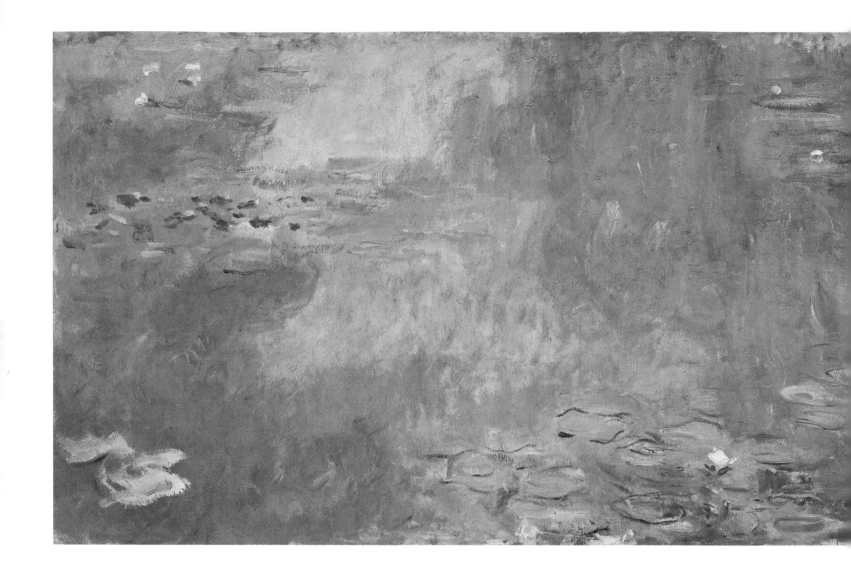

56 The Water-Lily Pond, 1917–19
LE BASSIN AUX NYMPHEAS
Oil on canvas, 100 x 200 cm (39⅜ x 78¾ in.)
Musée des Beaux-Arts de Nantes, 2233
W 1886

The extremely large-format canvases—for which Monet received special transportation permits, even during World War I[96]—set him new challenges, for these could not be worked in the open air without some difficulty, particularly since Monet's working methods—contrary to what we see on contemporary photographs—always created quite a commotion.[97] Throughout his long artistic career Monet was utterly dependent on the weather, above all on the light conditions, and a large part of his correspondence refers to unfavorable circumstances which stopped him from working. Giverny had one crucial advantage: all the motifs it inspired were always accessible, added to which, Monet the gardener had created them himself. The richer and more differentiated the spectrum of plants and their positioning, the more precise the change of scene from one time of day or year to the next. One motif would give way to the next as the growing stage gave way to the flowering stage, from spring until late in the autumn. Monet's garden was a com-

plex system with "natural variables." Since it had been planned with professional skill, the system worked perfectly and within a relatively small area. The time spent waiting for better weather, which overshadowed almost all Monet's trips and which at times turned his work into a form of torture, was so much easier to tolerate in the garden. However, by now he increasingly left the open-air studio for a heated room indoors, and resisted the misguided notion that in order to be a "good Impressionist" one had to work exclusively outside.[98]

Since these canvases—measuring two by three meters—were too large for the studio, in 1914 a new separate studio was built according to Monet's instructions, measuring twenty-four by twelve meters internally, so that he could work on several paintings at the same time. Six large canvases (in the format of the picture in the Folkwang Museum) were ordered in May 1916, and a dozen canvases measuring one by two meters each were added in April 1918. The paintings that the later editor of the oeuvre catalogue, Daniel Wildenstein, assumes were painted outside—directly by the water-lily pond—also included the beautiful depiction of **Wisteria, 1917–20 (cat. 57)**, which had started on either side of the bridge and had grown together in the center. The direction of growth of the plants, the interplay of light greens in the young foliage and the pale whites and violets of the blooms are painted with great precision, although the painting has a consistently sketchlike feel. The spontaneity with which Monet uses painterly shorthand to portray the plants can only lead us to conclude that he was working here without preparatory sketches or drawings.[99] This in turn makes the bare margins and the areas where the ground is gleaming through all the more noticeable. On the large-format **Water-Lily Pond, 1917–19 (cat. 58)**, whose insular colonies of water-lilies call to mind the smaller formats of 1905, four-fifths of the surface is taken up by dark green reflections of the weeping willow, and it is only on the left edge of the painting that we see the reflection of the sky. This section is rapidly sketched in: large areas of ground remain visible and are accentuated with light blue. The unfinished air of this work tells us a great deal about the production of these canvases, which must have been painted within a relatively short space of time and were a remarkable physical achievement on the part of the nearly eighty-year-old painter, whose astonishingly spontaneous painting by now has a masterful clarity. He himself described these paintings as "rough sketches," which is less a reference to the finish than an indication that he had some much greater project in mind.

Monet was now operating outside the stylistic parameters that had formed the basis of his art for almost half a century. His paint technique may still have been described as Impressionist, but his works now had nothing more to do with plein-air painting—they were made in the studio. The large canvases made between 1916

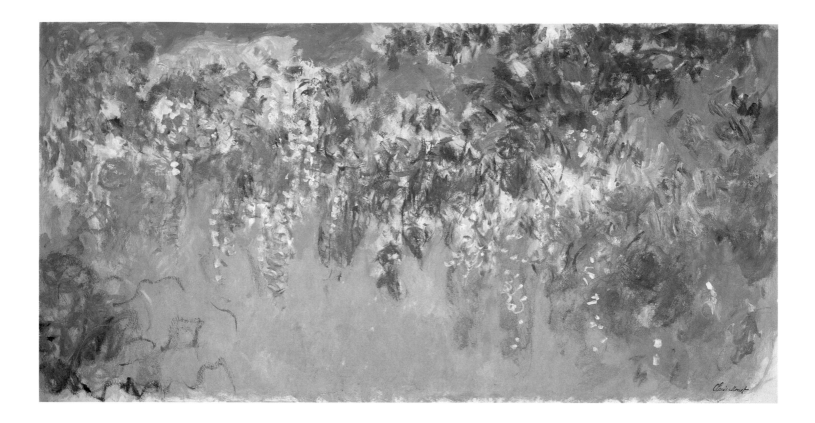

and 1920 mark the start of a new series—huge formats which are commonly known as the **Grandes Décorations**.[100] Much has been written about this project. For the sake of completeness we shall include certain facts and name certain personalities who were relevant to the genesis of Monet's late works. Among the main players was Georges Clemenceau (1841–1929), whom Monet first met in 1863. The two came across each other again in 1895 on the occasion of an exhibition in Durand-Ruel's gallery,[101] and Clemenceau soon became a friend of the family. Clemenceau started his professional life as a physician before being elected to the National Assembly in 1871. He was Minister President from 1906 to 1909, and again from 1917 to 1920. In addition he was also active as a journalist and the editor of the journal **L'Aurore** (published between 1880 and 1897 as **La Justice**). Later on the relationship between the Monet family and Clemenceau was still close and friendly,[102] although when it came to gardening matters there was a palpable rivalry between the two men-pursued with some zeal on both sides.[103]

In his old age, Monet—in an almost proverbially understated manner—cultivated the image of the reclusive artist living in his garden, who avoided social interaction and did not even travel to Paris when fourteen of his paintings went to the Louvre following a bequest by a collector.[104] The sketchily incomplete **Self-Portrait** (cat. 59), that Monet painted in 1917 and gave to his friend Clemenceau is a fine record of his state of mind at the time. Although the obligatory half-smoked ciga-

57 Wisteria, 1917–20
GLYCINES
(Study of Wisteria)
Oil on canvas, 100 x 200 cm (39⅜ x 78¾ in.)
Musée d'art et d'histoire Marcel Dessal,
Dreux, France, 286
W 1905

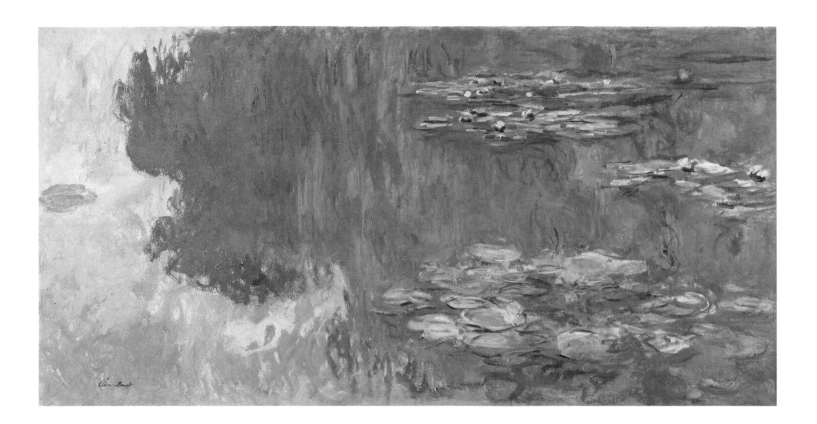

58 The Water-Lily Pond, 1917–19
LE BASSIN AUX NYMPHEAS
Oil on canvas, 100 x 200 cm (39⅜ x 78¾ in.)
R. und H. Batliner Art Foundation
W 1899

rette is missing, the white beard and relaxed features would appear to suggest a character at peace with itself—which does not quite reflect the facts. Throughout his life Monet always had the capacity to be moody or taciturn, and his letters reveal a character that is, if anything, pessimistic, a man who could easily flare up and become distinctly unfriendly when the "wrong" people came to visit. At the same time he could also be a charming conversationalist. Unlike Alice, he almost always wore rather more casual clothes; a waistcoat with lapels and an ordinary shirt without an awkward stand-up collar and without starched cuffs. In addition he wore a cravat, shapeless trousers, and a crumpled felt hat on his head when he went outside, which usually meant that he could be found somewhere in the garden. Sensible shoes were essential for a gardener who could be seen outside whatever the weather.

His day began at dawn, when he would read the papers and the gardening magazines he subscribed to.[105] This would then be followed by an extended rather un-French breakfast with eggs, ham, cheese, a baguette, and preserves. Between six and seven he would go to his studio where he would stay for several hours. Lunch was served punctually at eleven thirty, when much was made of the quality of the dishes and Monet's preference for a simple Sancerre. This would be followed by a walk in the garden and a rest before returning to the studio or to an easel out of doors. This regular routine was occasionally interrupted by excursions in the car. In

December 1900, Monet had given one (!) painting to the gallerist Bernheim in exchange for a car made by Panhard-Levassor. Michel Monet was a skilled engineer and developed a motor-driven four-wheeled vehicle.[106] Monet loved speed — and had his chauffeur drive him through the village at such speed that the mayor asked him to restrain himself somewhat. Michel Monet also introduced photography into the Monet household, and Monet was fond of having his photograph taken in the garden; yet there are no indications that he used photographs when he was working on his paintings. After a light supper the lights generally went out at half past nine.[107]

The avid subscriber to garden magazines owned a whole library of botanic titles, including a number of standard works, such as the twenty-six volumes of **La Flore des Serres et des Jardins d'Europe,** which first started to appear in 1845. (The illustrations between the contributions in our publication are taken from volume twenty-two, published in 1877). Monet was in constant contact with gardeners and suppliers, and was willing to devote a great deal of time to acquiring special rose varieties and water-lilies.[108] The bulk of his orders were for plants and seeds bred in France, above all tea roses, dahlias, gladioli, and geraniums. Names of flowers and plants were recorded in the sketchbooks. Not surprisingly, the most important criterion was the color of the blooms. Combinations were selected or rejected with meticulous attention to detail, and when the result did not meet with expectations, the plants whose development did not satisfy the painter's rigorous eye were ruthlessly removed. Other members of the family also became garden experts. In 1898, Monet's stepson Jean-Pierre Hoschedé and the priest in Giverny, Abbé Anatole Toussaint, together published a book entitled **La Flore de Vernon et de la Roche-Guyon.** Monet was interested in crossing varieties[109] and advised friends and acquaintances on gardening matters. Charlotte Lysès, for instance — the partner of the author and actor Sacha Guitry — received advice from him when she wanted to create a garden with special varieties of roses.[110]

It seems that, naturally enough, in Monet's later years the garden developed more dynamically than his artistic work. This is certainly true with respect to his choice of themes, for after 1920 Monet returned to the same motifs time after time: the water-lily pond, the bridge, and the central path through the "clos normand." Having started as an artistic strategy, for Monet the series was now a principle that he used to explore one enduring topic — the effect of the paint on the canvas. In so doing he remained faithful to one of the basic tenets of Impressionism right to the last. The real fascination of his last paintings is the freedom with which he was now working. The paint seems to detach itself from the natural forms and to lead a life of its own; the swirling formulations are only dimly reminiscent of the vegetation they "depict." At the same time the sheer amount of pictures Monet produced in his last years

59 Self-Portrait, 1917
AUTOPORTRAIT
(Portrait of the Artist)
Oil on canvas, 70 x 55 cm (27½ x 21⅝ in.)
Paris, Musée d'Orsay,
Don de Georges Clemenceau, 1927, RF 2623
W 1843

bears witness to an astonishing creativity and physical endurance on the part of a man not far short of eighty.

One day **The Japanese Bridge,** ca. 1918–24 (cat. 60), would appear entirely in shades of green, as we see here, on another it would take on a glowing orange, rust red, or violet (cat. 61). It might be dominated by yellow-oranges, dark turquoise, and bright yellow (cat. 62), sunk in a colored jungle (cat. 63). The comparison with works from the years around 1900 (cats. 36 and 37), which also depict the bridge, clearly shows how Monet, as a younger man, was using color perspectives to create the effect of spatial depth and deployed the arc of the bridge to give rhythm to the compositions. This earlier perspectival layering now gives way to planar zones; the central zone with the bridge, the outer zones with the water and the sky are treated so similarly that they can barely be distinguished. The forms are looser and patchy, the horizontals and verticals of the earlier paintings are now circular brushstrokes that accumulate as islands of color, stabilizing the picture at the corners. Stylistically this group is related to the above-mentioned **Weeping Willow** (cat. 50). Monet painted those works "by heart," in the studio, and it was the same when he painted the central path in the "clos normand," which now had six iron arches planted with climbers, above all roses and clematis. Following the removal of the conifers which had previously lined the path on either side, the climbers had plenty of light and grew magnificently. At first sight, the late works—with either the central path or the bridge—look so similar that it almost seems the motif is of secondary importance to the colors.

This also applies to **The Path under the Rose Arches,** ca. 1920 (cat. 64), which has become a whirling thicket of color, with the impasto brushwork creating a channel in the center and a glowing orange at the far end. While the more open brushwork of **The Path under the Rose Arches, Giverny,** 1920–22 (cat. 65), only indicates a few blooms at the upper edge, **The Path under the Rose Arches,** 1918–24 or 1920–22 (cat. 66), specifically differentiates the climbing roses that are clearly just about reaching the topmost point of the arcades. But the trellises are positioned such that the roses are prevented from completely growing together, so that the sunlight can still catch the gravel path. Common to all these works is the arc of the trellis, which seems like a variant on the bridge motif which itself melts into the oval of the water-

Christoph Becker

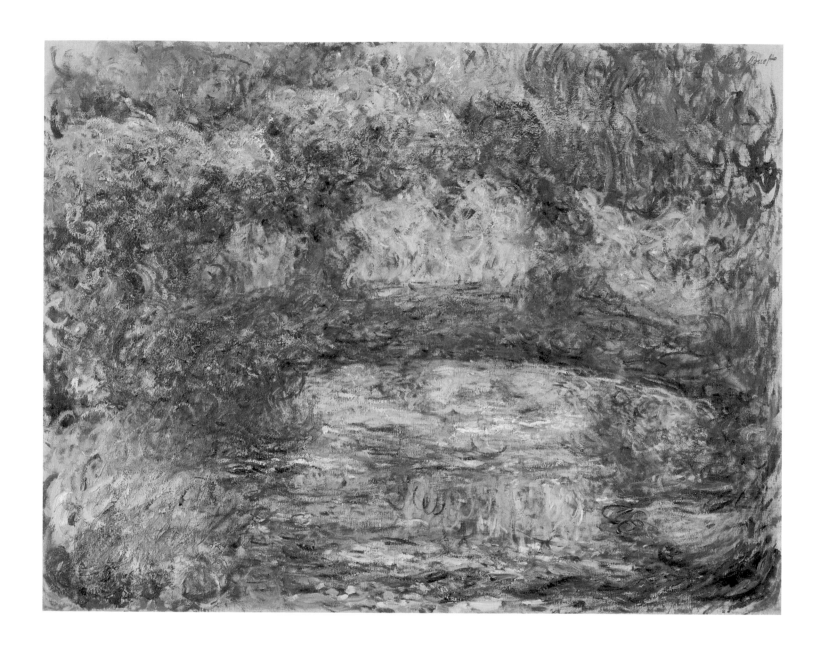

60 The Japanese Bridge, ca. 1918–24
LE PONT JAPONAIS
Oil on canvas, 89 x 115.5 cm (35 x 45½ in.)
Fondation Beyeler, Riehen/Basel
W 1921

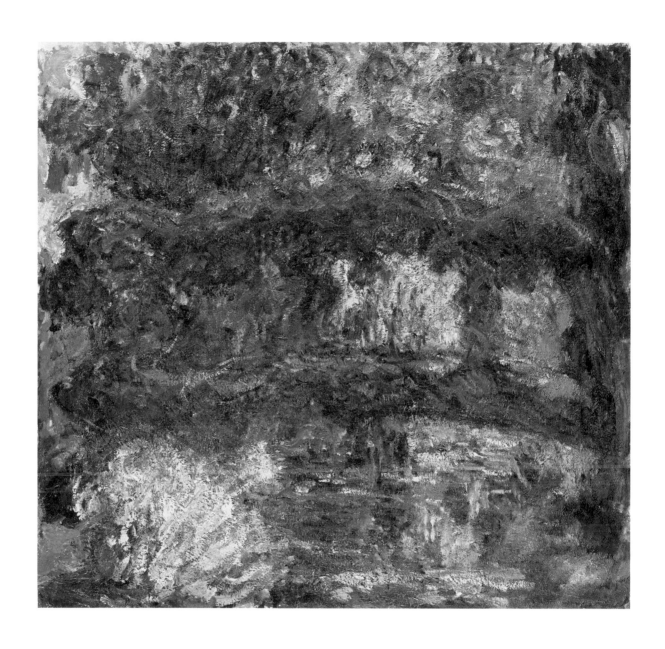

61 The Japanese Bridge, 1918–26
LE PONT JAPONAIS
(Nympheas, Japanese Bridge)
Oil on canvas, 88.9 x 92.7 cm (35 x 36½ in.)
Philadelphia Museum of Art,
The Albert M. Greenfield and
Elizabeth M. Greenfield Collection,
1974, 74.178-38
W 1930

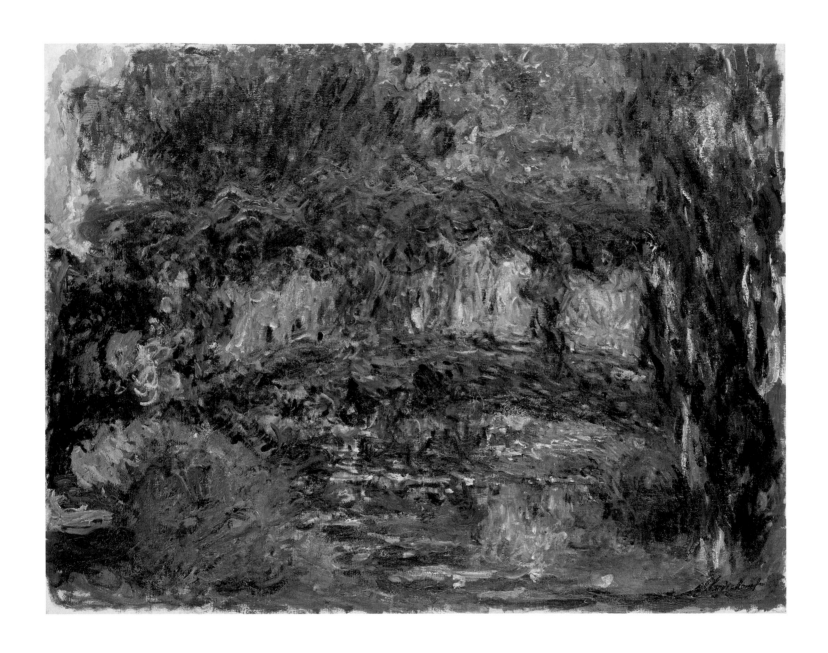

62 The Japanese Bridge, 1923–25
LE PONT JAPONAIS
Oil on canvas, 88.9 x 116.2 cm (35 x 45¾ in.)
The Minneapolis Institute of Arts,
Bequest of Putnam Dana McMillan, 61.36.15
W 1931

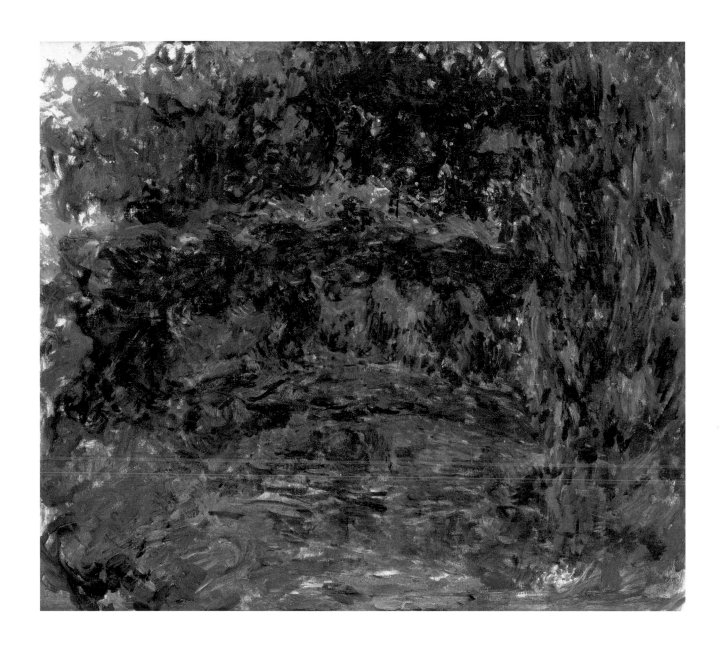

63 The Japanese Bridge, ca. 1918
LE PONT JAPONAIS
Oil on canvas, 89 x 100 cm (35 x 39⅜ in.)
Musée Marmottan Monet, 5091
W 1924

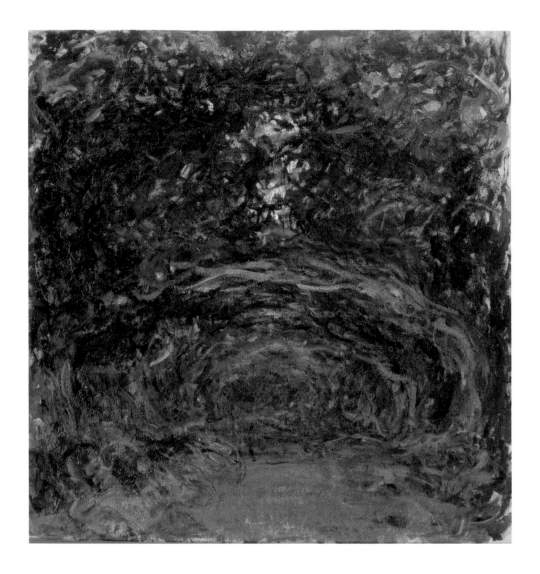

64 The Path under the Rose Arches, ca. 1920
L'ALLEE DES ROSIERS
Oil on canvas, 92 x 89 cm (36¼ x 35 in.)
Musée Marmottan Monet, Paris, 5104
W 1938

lily colony. It seems that all seven pictures of the Rose Path were painted in the summers of 1920 and 1921, that is, very quickly after each other.[111] Monet used hard, trimmed brushes and small spatulas to create small and medium-sized flecks, although in various places he did "paint out" a certain color towards the edge of the painting before applying the next. The sketchlike character of these paintings is further heightened by the irregularly bare edges of the canvases. The color red, as the complementary contrast to green, has an important function in Monet's late work. Around 1915 it still appeared in a whole range of tones, right through to dark violet (the irises); in these later paintings it is either unmixed or restricted to a very narrow spectrum of bright, glowing tones, which dramatically heightens the contrasts. Contemporary viewers found this disconcerting. The Duc de Trévise described them as "powerful, bewildering studies," and saw "the confusion of related color tones as bizarre combinations of self-absorbed forms, which no other eye could

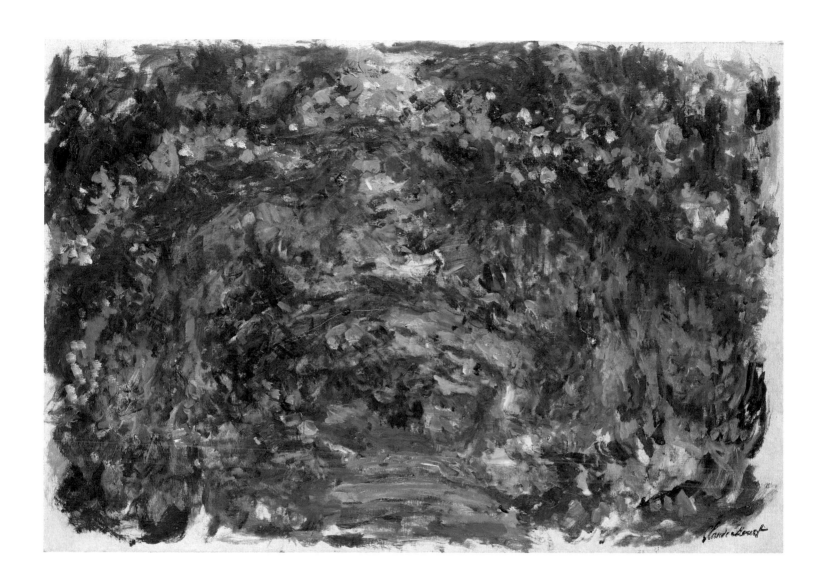

65 The Path under the Rose Arches, Giverny, 1920–22
L'ALLEE DE ROSIERS
Oil on canvas, 73 x 106,5 cm (28¾ x 41⅞ in.)
Private collection, Switzerland
W 1940

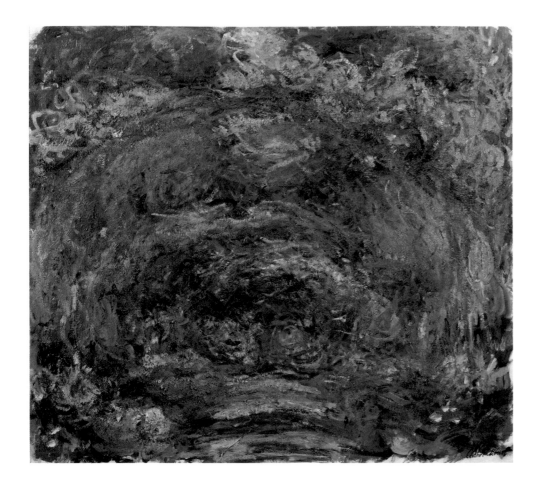

possibly disentangle."[112] Was the aged painter's mind wandering, might his eyesight have been impaired, or—most importantly—was everything entirely intentional?

In the impetuous rendering of **The Artist's House, Seen from the Rose Garden,** 1922–24 (cat. 67), linear perspective has been abandoned for the sake of color. Monet must be imagined sitting under the lime trees in the southwest corner of the garden (the "clos normand" is on the right of the picture) looking towards the façade largely covered with wild vines and clematis. We can make out the central gable end of the house. Although red specks in the middle ground indicate roses and geraniums, in fact the picture as a whole is free of representational associations. Aside from the normal restrictions that come with old age, Monet was in good physical health and his mind was as alert as ever. This painting may have been made after the cataract operation that he had to undergo. This initially led to xanthopsy (where both eyes see yellow) which became cyanopsy in 1923 (where the eyes see blue); this could be partially remedied with color-tinted glasses. Monet's sight problems only partially explain his vivid use of color, for he had too much experience to make basic mistakes with pigments and tubes of paint. These works are the outcome of a number of physiological factors—and of a free, deci-

66 The Path under the Rose Arches, 1918–24 or
ca. 1920–22
L'ALLEE DE ROSIERS
Oil on canvas, 89 x 100 cm (35 x 39⅜ in.)
Private collection, Switzerland
W 1936

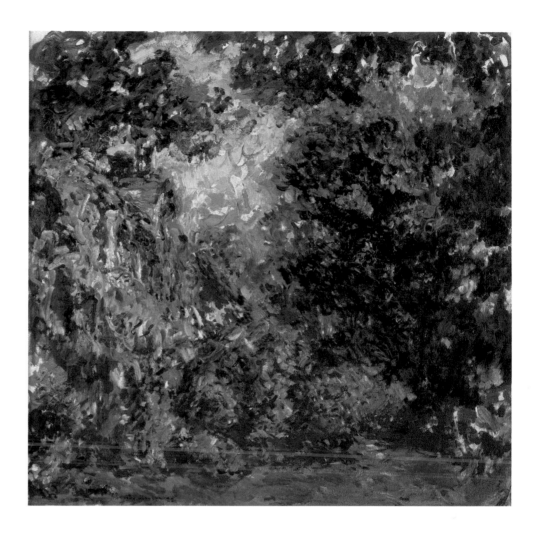

sive artistic will. They occupy a unique position with regard to the rest of his oeuvre, since they fundamentally ignore — or even oppose — the standards of beauty so richly explored in the garden paintings, and in effect quantitatively defined in those paintings.

By 1920 Monet's work was still far from over. The last project completely destroyed the metric parameters of his work hitherto. Twice before he had considered the question of full-wall decorations: once at the outset of his career at Montgeron, the château owned by Hoschedés, and again in 1892 when Auguste Rodin put his name forward in the context of a competition for the decoration of the newly built Paris Town Hall.[113] The external conditions were in place by 1915, when he moved into his new studio, which cost fifty thousand francs to build and which the entire family regarded as unusually ugly. From 1915 onwards, Monet started ordering ever larger formats from his frame-dealer Besnard, in Paris; the canvases he wanted no longer conformed to any existing standard sizes. In the end he was ordering fine-

weave canvases measuring two by three meters and two by 4.25 meters, grounded in semi-matte ivory white. He would then put two of these over-sized canvases side by side so that they could subsequently be sewn together to create a painting six meters long. As early as 1916 the first of these "machines"—as the family called the huge formats—was finished. Monet was encouraged and backed by his friend Clemenceau, who was later to accept the gift of two monumental paintings on behalf of the State, to celebrate the cessation of hostilities with the end of World War I on November 11, 1918. Six days after Monet had written suggesting this gift, Clemenceau and Geffroy traveled to Giverny. They came with a bolder and much bigger idea: the whole nation ought to be able to celebrate its own achievement in a huge wall painting by Monet. When Clemenceau was not re-elected President in 1920, the "state commission" was in serious danger of falling through; nevertheless he managed to convince the Ministry of Culture that the plan was worth following through and in due course the **Grandes Décorations** were installed in the Orangerie, where they are still on view today.[114]

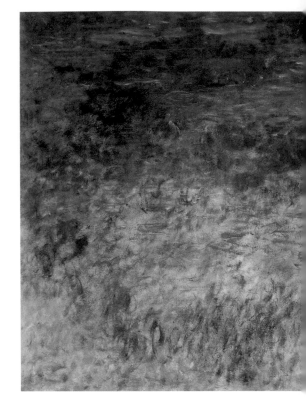

Apart from this gigantic panorama, in the studio there were a number of other large-format paintings which had found no use as such but which were also initially not for sale. These paintings, which include the next group listed here, were still standing in Monet's studio when he died; in the nineteen-fifties they found their way into museums and private collections. **Water-Lily Pond, Evening,** ca. 1916/1922 (cat. 68), consists of two three-meter canvases. The spectacular effect derives from the cyclamen color in the center which modulates into a golden-yellow zone shaped like an irregular triangle, which defines the composition; meanwhile the edges are hidden in bluish shadows. The water-lily leaves in the upper section appear turquoise; in the center they take on a cool, gleaming green. The lower edge and above all the corners have areas of violet, the color of irises. **Water-Lily Pond** of 1917–20 (cat. 69) is a vast triptych consisting of two-by-three-meter canvases, closely related to the mighty panorama of the **Grandes Décorations** and a vivid demonstration of the artist's approach to composing these extra-long formats. The left section is based on blue, the right section on green; the forms of the vegetation are extremely loose, the water-lily leaves are barely recognizable and are treated the same as the reflections of the trees on the water. The composition of the two outside sections is open-ended at the outer edges, suggesting that the line of images could potentially continue to grow laterally. The central section, on the other hand, has stronger accents in the reflection of a large patch of light blue and pink sky, which is contained within a colony of water-lilies to the left and the reflection of a weeping willow to the right. The vegetation—physically present on one side, a reflection on the other—is depicted in just the same manner, not as though the real and the non-real were meeting here on the surface of the water. The virtually all-

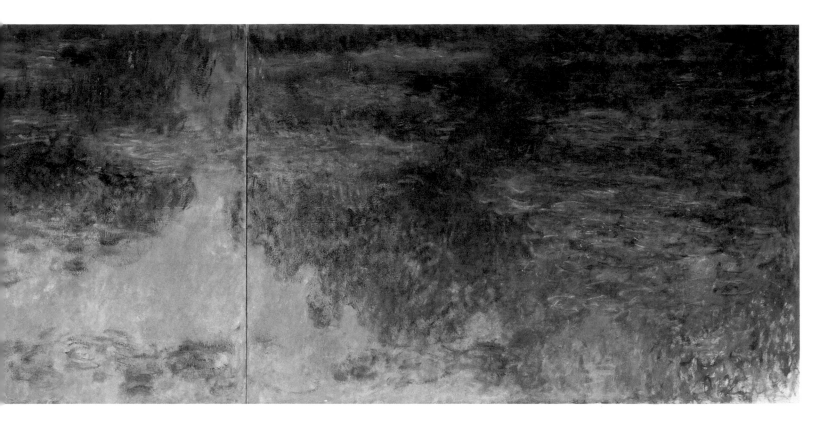

68 **Water-Lily Pond, Evening,**
ca. 1916/22
LE BASSIN AUX NYMPHEAS, LE SOIR
Oil on canvas, diptych, each panel 200 x 300 cm
(78¾ x 118⅛ in.)
Kunsthaus Zürich, 1952/64
W 1964, 1965

pervasive patchiness and the subtle shifting between blues, greens, and reds, applied in thin iridescent layers, creates a lucid, almost translucent, surface which—unvarnished—absorbs any light falling onto it.[115] Using the most refined of means, Monet explores the relationship of surface and space, and puts our perceptions to the test. Reality and semblance are no longer distinguishable from each other.

The six-meter long painting **Water-Lily Pond with Irises,** ca. 1914/1922 (cat. 70), is one of two made by sewing two canvases together. In the center is a large colony of water-lilies with pink blooms against a gray-violet ground; two more, perspectivally foreshortened, are visible further back; in the right foreground individually painted irises stand out; an overhanging branch (together with the main motif) helps to centralize the composition. The brushwork in the lower section suggests a gentle upward movement, the brushwork in the upper section suggest the opposite. The lower section, with its stronger greens, is darker and apparently lying in shadow. The middle ground is dominated by blues with yellowish and ivory white touches descending on them from above. The patchy paintwork creates the effect of reflected cloud formations such that the water and the sky seem to become one. The picture shimmers, shot through like mother of pearl with soft reds and violets. **Green Reflections on the Water-Lily Pond,** 1920–26 (cat. 71), creates a more differentiated effect. No less than eight colonies of water-lilies, with blooms ranging from

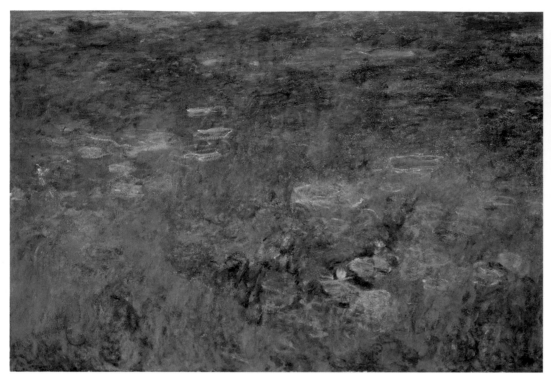
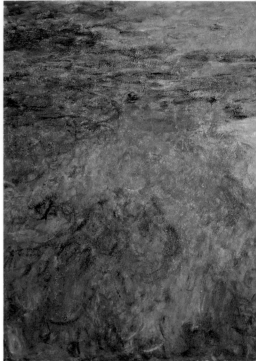

deep purple to pink-edged white, are a testament to the success of Monet's ambitions as a gardener and an expression of his ability to put together extravagant color ranges. The ground tone, a transparent blue, visibly overlaid by areas of green suggests bluish depths; blue-green shadows directly below the rose leaves create the impression that the plants are floating on water. Once again the oval is a feature in the composition, not only in the water-lilies themselves but also in their arrangement, as a large oval filled with shades of green and blue in the center of the painting. The format and the careful execution suggest that this painting was originally one of those intended for the Orangerie, which each consists of three of these three-meter canvases.

With these paintings Monet was leaving behind the natural drama of the garden, for these monumental formats made it impossible to paint in situ. In the past he had only ever painted small sections of what he saw, now it was to be the whole thing, the paradox "panorama of a stretch of water." The balance of the mutual influence of garden and painting had now shifted towards painting. In Clemenceau's view, the garden "should be counted amongst his works, since it realized the magic of adapting Nature to the work of this painter of light."[116] Or to put rather a finer point on it: it seemed that art was now loosening its ties with nature, as though the real garden had served its purpose as a model for Monet's art. Visitors to Giverny in around 1920, coming to see the aged artist, no longer describe his garden but the studio

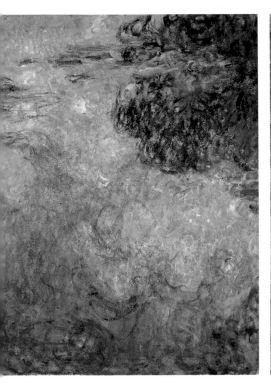

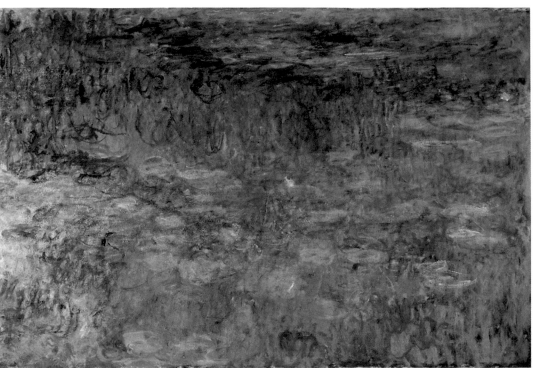

with canvases cheek-by-jowl along the walls, forming a seemingly uninterrupted frieze, as though the garden had been finally sublimated in art. Visitors had the impression that they themselves were on an island in the middle of the water-lily pond.[117]

Not infrequently artists who reach a great age become the object of philosophical speculation without their ever having aspired to that status. This is so in Monet's case. Monet had no philosophical ambitious as such. The starting point for all his art works was the visible world, and throughout his life his art had no need of history, mythology, politics, or didacticism—it could even be said to be without "meaning" in the traditional sense of the word. Interpretation was up to the viewer, who would create "meaning" by describing and writing about the work. Monet's part in this process was basically simple. He created visual events—and he strove, with great success, to make these visual events extremely complex. In so doing he actively contributed to establishing "the visible" as a cultural form in its own right. By ultimately merging the characteristics of "his art"—Impressionism—with those of abstraction, he prevented his late work from falling irrevocably into any one art-historical category—the most important prerequisite for the furthering of a legend which must, by definition, always have a timeless quality to it.

69 Water-Lily Pond, ca. 1917–20
LE BASSIN AUX NYMPHEAS
Oil on canvas, triptych, each panel 200.5 x 301 cm
(78⅞ x 118½ in.)
Fondation Beyeler, Riehen/Basel
W 1968, 1969, 1970

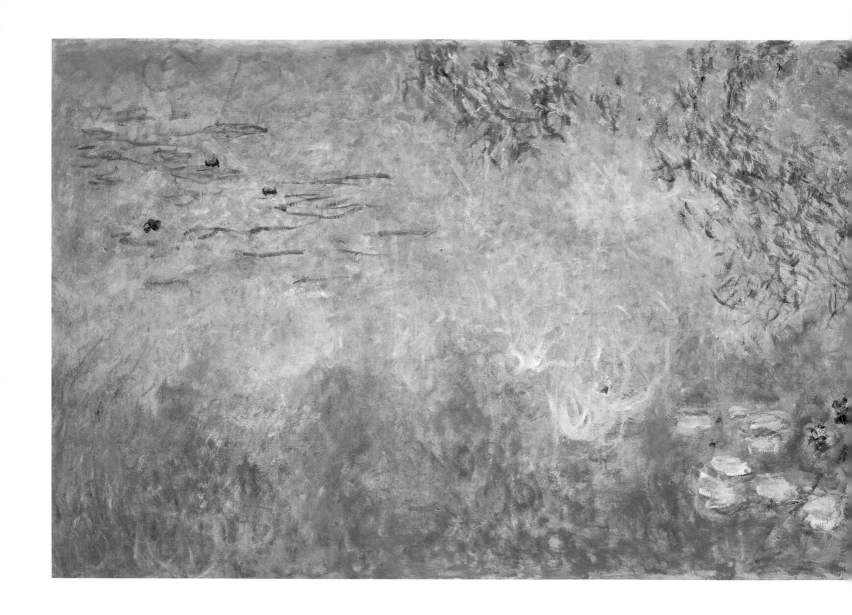

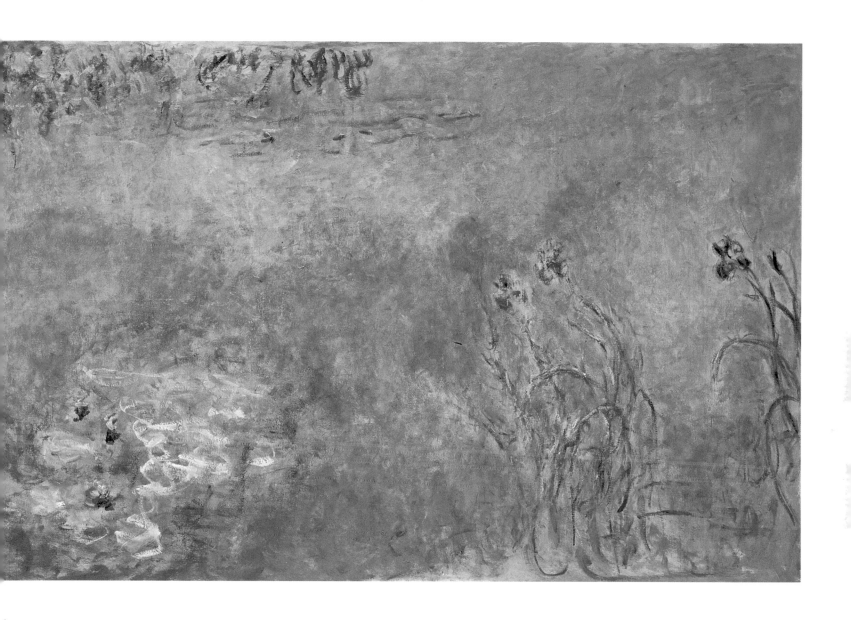

70 Water-Lily Pond with Irises, ca. 1914/22
LE BASSIN AUX NYMPHEAS AVEC IRIS
Oil on canvas, 200 x 600 cm (78¾ x 236¼ in.)
Kunsthaus Zürich, 1952/10
W 1980

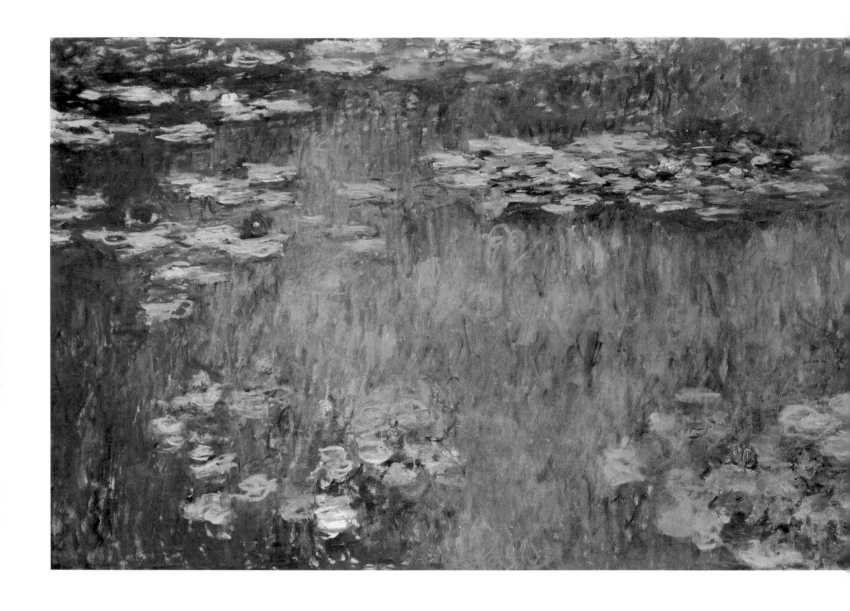

71 Green Reflections on the Water-Lily Pond,
1920–26
LE BASSIN AUX NYMPHEAS, REFLETS VERTS
Oil on canvas, 200 x 425 cm (78¾ x 167⅜ in.)
Stiftung Sammlung E. G. Bührle, Zürich
W 197

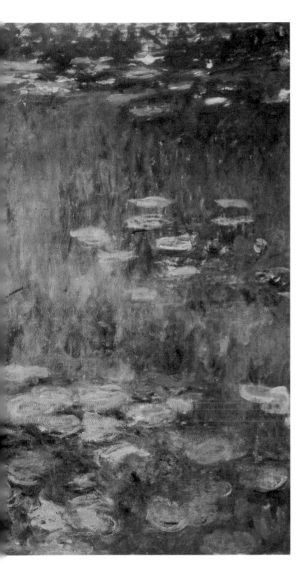

With hindsight, it may seem that certain artistic achievements in the six decades of Monet's career follow a logical development. But caution is required here, for Monet's impressive body of work does not necessarily lead to the spectacular last paintings of water-lilies, which are not the logical final outcome of a certain artistic path but arose from an artistic life in which the mutual influence of artist and nature has a strikingly pragmatic side. Claude Monet, the artist, acquired a second skill which he developed to the point of professional perfection. His gardens, above all the garden in Giverny, were not amateurish pastimes, they were designed according to the rules of the art of gardening and made sense: in the literal and the metaphorical sense, Monet's garden was his work space. It provided ideas and new impulses for his art; it provided distraction to the artist—it was a necessity and a luxury in one. A good gardener needs discipline, stamina, taste, some good luck—and a good eye that can see more than the reality before it. Then there is a chance that the garden will become a work of art. And vice versa.

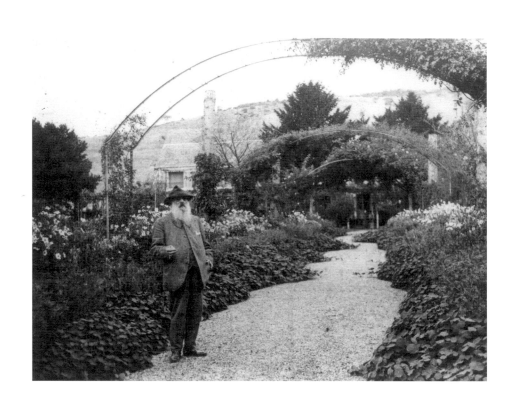

1 The Hoschedé children: Marthe (1864–1925), Blanche (1865–1947), Suzanne (1868–99), Jacques (1869–1941), Germaine (1873–1968), and Jean-Pierre (1877–1961).

2 The exhibition opened on October 1, 1864. Bazille followed his advice in 1886; Pierre-Auguste Renoir, **Calla Lily and Greenhouse Plants**, 1864, Oskar Reinhart Collection "Am Römerholz," Winterthur; the Kunsthalle Hamburg owns another version of **The Greenhouse**.

3 Letter to Frédéric Bazille from Honfleur, August 26, 1864; as cited in Richard Kendall, ed., **Monet by Himself: Paintings, Drawings, Pastels, Letters** (London, 1989), p. 21.

4 It was not possible to include this painting in the exhibition for reasons of conservation.

5 Robert Gordon and Andrew Forge, **Monet** (Cologne, 1985), pp. 19–33. After it was damaged in a fire, Monet cut it into three parts, the center section hung for the rest of his life in his studio in Giverny; illustrated in the biography in this volume (fig. 40).

6 For a long time the subject was thought to be Ferdinand Jacqemart. Letter to Durand-Ruel, January 23, 1907; Monet's address book for that time also gives the right name (now in the Musée Marmottan-Monet).

7 The oak bore the name of the Swiss painter Johann Karl Bodmer (1809–93), who settled in Barbizon in 1849 with Théodore Rousseau and Jean-François Millet in Barbizon.

8 Charles F. Stuckey, ed., **Monet—A Retrospective** (New York, 1985), p. 32. Monet exhibited in the official art exhibitions, the so-called Salons, in 1865, 1866, and 1868; in 1867, 1869, and 1870 his paintings were rejected.

9 Emile Zola, "Les Actualistes," **Mon Salon**, May 24, 1868. Reprinted in Emile Zola, **Ecrits sur l'art** (Paris, 1991), pp. 206–211, here pp. 207–208.

10 This goes back to John Ruskin, whose writings Monet used to recommend. "The Elements of Drawing" discusses the "innocence of the eye" in more detail; see **The Complete Works of John Ruskin**, ed. E. T. Cooks and Alexander Wedderburn (London 1904), vol. 15, pp. 27–28.

11 See Gottfried Boehm, "Das neue Bild der Natur: Nach dem Ende der Landschaftsmalerei," in Manfred Smuda, ed., **Landschaft** (Frankfurt am Main, 1986), pp. 87–110, here pp. 90–93.

12 Paul Durand-Ruel, "Mémoires de Paul Durand-Ruel," in Lionello Venturi, **Les Archives de l'Impressionnisme**, vol. II (New York and Paris 1939), pp. 143–220, esp. p. 179; Anne Distel, **Les collectionneurs des impressionnistes** (Düdingen, 1989), pp. 21–32.

13 As Monet painted he had his back to the Ritz, Knightsbridge is visible in the right background. An almost equally large companion piece, **Hyde Park** (W 164), is now in the Museum of Art, Rhode Island School of Design, Providence, Rhode Island.

14 For more on the darker side of the urbanization of the surroundings, see the detailed account by Timothy J. Clark, **The Painting of Modern Life: Paris in the Art of Manet and his Followers** (London and New York, 1985), pp. 148–204; on the development of Argenteuil, see esp. pp. 173ff.

15 See Rodolphe Walther, "Les Maisons de Claude Monet à Argenteuil," **Gazette des Beaux-Arts**, 108th year, 6th period, vol. 68 (1966), pp. 333–342. Letter to Victor Chocquet, February 4, 1876, in Daniel Wildenstein, **Claude Monet, biographie et catalogue raisonné en 5 volumes** (Lausanne, 1974/79), vol. I, p. 430. Before 1871 the house had been inhabited by the painter Théodule Ribot.

16 Letter to de Bellio from Argenteuil, July 25, 1876, in Wildenstein 1974/79, vol. I, p. 431.

17 For more on the dahlias see also the documentation on Monet's garden in the present volume ("Claude Monet the Gardener").

18 John House, "Monet's Gladioli," **Bulletin of the Detroit Institute of Arts**, vol. 777, no. 1/2 (2003), pp. 8–17, here p. 10. I would venture to disagree with the notion that the Monet's Impressionist style is directly linked with the "informal"—non-linear-design of his garden.

19 House 2003, pp. 9–17.

20 Ibid., p. 11.

21 A glimpse of life in Argenteuil may be seen in the large-format painting **Le Dejeuner**, 1873, in the Musée d'Orsay in Paris. Auguste Renoir painted Monet in his garden, working at his easel: **Monet Working in His Garden in Argenteuil**, 1873, Wadsworth Atheneum, Hartford, Conn.

22 The second house that Monet moved into not long afterwards is visible in the background.

23 Distel 1989, p. 245.

24 See the biography of Monet in this volume; see also Jean-Pierre Hoschedé, **Claude Monet, ce mal connu: Intimité familiale d'un demi-siècle à Giverny de 1883 à 1926**, vol. 1 (Geneva, 1960), p. 57.

25 Paul Hayes Tucker devotes a chapter to Argenteuil and the Seine in idem, **Monet at Argenteuil** (New Haven, 1982), pp. 89–124. On Monet's two residences in Argenteuil see ibid., pp. 125–154. See also the relevant documentation on Monet's gardens in this volume ("Claude Monet the Gardener").

26 W 384, W 385, W 386.

27 See Clark 1985, pp. 45–55. Clare A. P. Willsdon discusses in detail the influence of the so-called Haussmannization of Paris on Impressionism; see Clare P. Willsdon, "'Promenades et plantations': Impressionism, Conservation and Haussmann's Reinvention of Paris," in Frances Fowle and Richard Thomson, eds., **Soil and Stone: Impressionism, Urbanism, Environment** (Edinburgh and Hants, 2003), pp. 107–124; for more on the Parc Monceau see pp. 117–118.

28 The Salon des Indépendants: there were eight so-called Impressionist exhibitions: in 1874, 1876, 1877, 1879, 1880, 1881, 1882, and 1886. Monet participated in the Salon des Indépendants in 1874 (12 works), 1876 (18 works), 1877 (30 works), 1879 (29 works), and 1882 (35 works).

29 For more on this see also the biography in this volume.

30 See, for instance, Jules-Antoine Castagnary (1830–88), who occasionally wrote reviews, in **Le Siècle**, April 29, 1874; see Stuckey 1985, pp. 58–59.

31 Jules Castagnary, "L'Exposition du boulevard des Capucines," **Le Siècle**, April 29, 1874. Reprinted in Martha Kapos, ed., **The Impressionists—A Retrospective** (New York, 1991), pp. 83–86; see also Richard Schiff, "The End of Impressionism: A Study in Theories of Artistic Expression," **The Art Quarterly**, vol. 1, no. 4 (autumn 1978), pp. 328–378.

32 Including W 205, W 341, and W 381.

33 Tucker 1982, p. 47; in 1872 Monet earned around twelve thousand francs. The following year he earned twice this amount; a worker in Argenteuil earned around two thousand francs per year.

34 See Robert L. Herbert, "Impressionism, Originality and Laissez-Faire," **Radical History Review** 38 (Art and Ideology), April 1987, pp. 7–15, here p. 8.

35 Distel 1989, pp. 95–107.

36 W 417, W 418, W 419, and W 420. For more on Monet in Montgeron see Claire Joyes, **Claude Monet: Life at Giverny** (New York and Paris, 1985) (1st ed. 1975), pp. 15–16.

37 After the death of Claude Monet, Michel Monet inherited the property in Giverny and became his executor. In the early nineteen-fifties he sold a large number of paintings. His legacy which went to the Académie des Beaux-Arts in Paris forms the basis of the Musée Marmottan-Monet in Paris.

38 David Joel, **Monet at Vétheuil and on the Norman Coast 1878–1883** (Woodbridge, 2002), p. 104.

39 Monet's floating studio became famous through a series of paintings by Monet, but above all through Edouard Manet's painting **Monet in His Studio-Boat**, 1874, Munich, Neue Pinakothek; an unfinished version is owned by the Staatsgalerie Stuttgart.

40 One of Théodore Duret's best-known texts is "Les Peintres impressionnistes," 1874; reprinted in Stuckey 1985, pp. 65–67; a German edition was published in Berlin by Ernst Cassirer as early as 1909.

41 Théodore Duret, **Les Peintres impressionnistes. Claude Monet—Sisley—C. Pissarro—Renoir— Berthe Morisot,** Paris 1878; Théodore Duret, ed., **Le Peintre Claude Monet,** exh. cat. Galerie du Journal illustré La Vie moderne (Paris, 1880); see also Denys Riout, ed., **Théodore Duret, Critique avant-garde** (Paris, 1998).

42 Joel 2002, pp. 83–85.

43 Charles F. Stuckey, ed., **Claude Monet: 1840–1926,** exh. cat. The Art Institute of Chicago, Chicago 1995, p. 204. Sophia Shaw has pointed out the mistakes in the catalogue for the fourth Salon des Indépendants. It is not clear whether the stated number of works is accurate, that is, whether it represents the works actually exhibited. Shaw also writes informatively on the dealers Monet worked with.

44 Stuckey 1985, p. 69.

45 Emile Taboureux cited Monet thus in **La Vie moderne,** June 12, 1880; as cited in Stuckey 1985, p. 90.

46 John House, **Monet: Nature into Art** (New Haven, 1986), p. 43 and pp. 47–52.

47 House 1986, pp. 40–43.

48 Monet was not particularly pleased by this commission; see letter to Durand-Ruel, September 6, 1883, in Claude Monet, "Lettres à Paul Durand-Ruel, 1876–1926," in Venturi 1939a, pp. 219–465, here p. 261.

49 Albert Wolff in **Le Figaro,** June 19, 1886; as cited in Stuckey 1985, p. 126.

50 Letter to Durand-Ruel, May 30, 1885, in Venturi 1939a, p. 291. The crisis lasted until the end of the eighteen-eighties, as we can see from numerous letters.

51 JoAnne Paradise, **Gustave Geffroy and the Criticism of Painting** (New York and London, 1985), pp. 252–261.

52 On the difficulty of capturing transient or intermittently recurring "effects," see letter to Alice Hoschedé, January 27, 1884, in Wildenstein 1974/79, vol. II, W 395. On the move from Poissy to Giverny see letter to Durand-Ruel, April 6, 1883, in Venturi 1939a, p. 253.

53 There is a preparatory drawing for the painting in the Musée Marmottan-Monet, Paris.

54 Letter to Alice Hoschedé, February 3, 1884; Kendall 1989, p.109; Wildenstein 1974/79, vol. II, p. 235, W 404.

55 For more on the American collectors, including the Havemeyer family, see Frances Weitzenhoffer, **The Havemeyers: Impressionism Comes to America** (New York, 1986). The earliest collectors of Impressionist paintings lived in Chicago, Boston, and New York. On the American art market see Distel 1989, pp. 233–237.

56 Letter of February 7, 1890, as cited in Kendall 1989, p.133.

57 See, for instance, letters from April 1888, in Wildenstein 1974/79, vol. I, W 712; to Georges Petit in May 1888, in ibid., W 884; to Alice Hoschedé, Rouen, March 22, 1892, in ibid., W 1140: "... absolument néfaste et mauvais pour un artiste de vendre exclusivement à un seul marchand." (... for an artist it is wholly inauspicious and negative to sell through one dealer alone.) Letter to Durand-Ruel, July 29, 1884, in Venturi 1939a, p. 284. Among the important dealers in the twentieth century were Georges Wildenstein (1892–1963) and his son Daniel Wildenstein (1917–2001), who also compiled the exemplary catalogue raisonné (Wildenstein 1974/79, revised ed. Wildenstein 1993).

58 There have been suggestions that the colored version of the dining room has its origins in an exhibition of Whistler's work in London. William H. Gerdts, **Monet's Giverny: An Impressionist Colony** (New York, 1993), p. 222.

59 Joel 2002, p. 82.

60 Mirbeau wrote an enthusiastic article in **Figaro,** March 10, 1889, reprinted in Octave Mirbeau, **Monet et Giverny** (Paris, 1995), pp. 23–32; see also Octave Mirbeau, **Correspondance avec Claude Monet** (Tusson, 1990), pp.72–74. Monet was very aware of the effect of this article; see the letter to Alice Hoschedé, March 18, 1889; see also Wildenstein 1974/79, vol. III, W 919.

61 Hoschedé 1882–1904; letters to Alice Hoschedé, March 5, 1884, and November 5, 1885, in Wildenstein 1974/79, vol. II, p. 243, W 438, and p. 265; W 609. For an exact description of the house and the grounds by the painter and illustrator (for **La Vie moderne**), Georges Jeanniot (1848–1934), see Stuckey 1985, p.129.

62 The illustrator Georges Jeanniot visited Monet in 1888 Monet and published a report in **La Cravache Parisienne** (June 23, 1888), which referred to the connection between Monet and the landscape around Giverny; reprinted in: Stuckey 1985, p.129.

63 Clematis montana rubens.

64 Letter to Alice Monet, October 14, 1886, in Wildenstein 1974/79, vol. II, p. 281, W 712.

65 Gustave Geffroy (1855–1926), writer and art critic; his first article on Monet appeared in the journal **La Justice** edited by Georges Clemenceau.

66 Letter from Octave Mirbeau, September 27, 1890, see Mirbeau 1990, p.111.

67 Letter to Geffroy, October 7, 1890, in Wildenstein 1974/79, vol. III, p. 259, W 1076.

68 Mirbeau 1990, pp. 95–96; the gardener in question was François Marc, to whom Mirbeau devoted a text in **Figaro** on October 23, 1890, entitled "Encore un!" On the gardens and plants see also ibid., p. 97, letter written in "mi-juillet 1890"; p. 99, July 21, 1890; pp.101–102, July 25, 1890.

69 Nasturtium officinale—watercress—which blooms yellow, red, and orange from June onwards; Monet used it above all for the front edge of his flower beds in "clos normand."

70 Eschscholtzia californica, golden poppy, Californian poppy.

71 Octave Mirbeau writing in the periodical **L'Art dans les deux mondes,** edited by Durand-Ruel, March 7, 1891; as cited in Stuckey 1985, pp.158 and 159. This text also appeared in a small reprint in 1995, published by Séguier.

72 Numerous letters from the early eighteen-eighties onwards refer to the press service; see Venturi 1939a, pp. 240–241 (1882); p. 338 (1891); p. 447 (1917).

73 This took place after the death of Monet's daughter-in-law Blanche Hoschedé (1865–1947).

74 **Journal de Vernon,** May 22, 1909.

75 Wildenstein 1974/79, vol. III, p. 275, W 1219; Kendall 1989, pp.179–180. The "lilies" referred to here were various kinds of irises.

76 For more on this see the documentation on Monet's gardens in this volume.

77 Letter to Alice Monet from Rouen, February 16, 1893, see Wildenstein 1974/79, vol. III, p. 269, W 1175; Kendall 1989, p.177.

78 This is stated most clearly a letter to Alice Monet in March 1900; see Kendall 1989, p.189.

79 Weiss 1997, p.163. Previously observed by House 1986, p.159.

80 Wildenstein 1974/79, vol. IV, p. 345, W 1532 and W 1533; Kendall 1989, p.189.

81 On the first American collectors see Weitzenhoffer 1984, pp.75–91.

82 See **New York Tribune,** September 8, 1901 on "Monet tourists" from America.

83 Jean Morgan, "Causeries chez quelques maîtres," **Gaulois,** May 5, 1909 (Archives Musée Marmottan-Monet). As early as 1905 Monet's garden seemed important enough to the editor of the magazine **La femme d'aujourd'hui** to merit a long article.

84 Iris kaempferi—yellow iris, from Japan; Iris ochrolencum—giant iris, white or blue violet; see Hoschedé 1960, vol. 1, p. 59. The path was known as the "allée," even although all but two of the cypresses had been cut back so radically that all that remained of them was two-meter-high trunks, with climbing roses entwined around them.
85 The plants in the "clos normand" included tulips, peonies, wild poppies, irises, lupins, roses, pelargonias, gladioli, sun flowers, dahlias, and chrysanthemums. For more on this see the documentation on Monet's garden in this volume.
86 For more on Félix Breuil (1867–1954) see the documentation on Monet's garden in this volume.
87 Letter to Jean Monet, February 8, 1902, Wildenstein 1974/79, vol. IV, p. 360, W 1650.
88 Monet's favorite dahlia was the Star of Digoin. The order is reprinted in Kendall 1989, p. 187. See also the biography in this volume (fig. 51). For a detailed description of this rare flower see Hoschedé 1960, vol. 1, p. 67.
89 Among others, the order listed the varieties Arethusa, Atropurpurea, William Falconer, and James Brydon.
90 Letter to Durand-Ruel, April 27, 1907, in Venturi 1939a, p. 409.
91 Letter, August 11, 1908, as cited in Kendall 1989, p. 198. An anonymous article on the painter's destructive tendencies was published as "Monet's Fits of Anger" in the New York Times on June 12, 1927.
92 Pierre Mille, "En passant—Ecrits sur l'Eau," Le Temps, May 18, 1909 (Archives of the Musée Marmottan-Monet).
93 After 1910 Monet used canvases with a very pale ground, since this made the colors appear more brilliant; he now ceased to use transparent underpaintings; see Karin Sagner-Düchting, Claude Monet: Nymphéas (Hildesheim 1985), pp. 36–39. Robert L. Herbert has written extensively and in great detail on Monet's method of painting.
94 The princess's uncle, Baron Kojiro Matsukata, visited Monet in 1921 and bought a few dozen paintings. His collection formed the basis of the National Museum of Western Art in Tokyo, founded in 1959. See Haru Matsukata Reischauer, Samurai and Silk: A Japanese and an American Heritage (Cambridge, Mass., 1986), pp. 266 and 293–294.
95 Georges Clemenceau, Claude Monet, Les Nymphéas (Paris, 1928).
96 Robert Gordon and Charles F. Stuckey, "Blossoms and Blunters: Monet and the State," Art in America (January-February 1979), pp. 102–117 (part 1) and (September 1979), pp. 109–125 (part 2), here p. 106.

97 Wildenstein 1974/79, vol. III, p. 25, W 1387. For more on the process of painting see 1974/79, vol. IV, p. 34, W 1539 and p. 353, W 1606a.
98 Letter to Durand-Ruel, February 12, 1905, Venturi 1939a, p. 401.
99 Monet apologizes in a letter to an unknown correspondent that he cannot deliver any drawings, since he "draws with brush and pen"; see Kendall 1989, p. 247. In the estate held in the Musée Marmottan-Monet there are a number of sketch books, mainly relating to the late water-lily paintings.
100 Letter to R. Koechlin, January 15, 1915, Wildenstein 1974/79, vol. IV, pp. 391–392, W 2142.
101 Georges Clemenceau, Georges Clemenceau à son ami Claude Monet. Correspondances (Paris, 1993), p. 71. André Wormser, "Clemenceau et Claude Monet, une singulière amitié," in ibid., pp. 27–58.
102 Clemenceau's letters to Monet are the most detailed source of information on this unusual friendship; see Clemenceau 1993.
103 Clemenceau's was in Saint-Vincent-sur-Jard, on the Atlantic coast and mainly contained plants from the south.
104 Joyes 1985, pp. 55–57.
105 We can be certain that Monet regularly read the leading magazine Jardinage.
106 In 1900 Monet bought his first automobile, a new model made by Panhard et Levassor, which had been producing gasoline-driven vehicles under license from Daimler since 1889. Panhard won the Paris-Rouen race in 1894 and the Tour de France in 1899; However, Monet did not take the wheel himself. See letters W 1582a and W 1582b of December 18 and 19, 1900, to Alice Monet. On fast driving see W 1642 (all in Wildenstein 1974/79).
107 Joyes 1985, pp. 42–43. Marc Elder's book, A Giverny, chez Claude Monet, Paris 1924, published by Bernheim-Jeune when the artist was still alive, contains a number of very interesting anecdotes relating to Monet's life in Giverny.
108 Letter to Bernheim-Jeune, July 2, 1909, referring to a rose dealer, Madame Lévèque, in Ivry-sur-Seine; W 1902a.
109 Russell 1995, p. 33.
110 Originals in the Bernheim-Jeune Archives; W 2079.
111 On the genesis of W 1936 and W 1940 in particular, see Renate Woudhuysen-Keller and Manfred Schoeller et al., Die Rosenallee: Der Weg zum Spätwerk Monets in Giverny (Aachen, 2001), pp. 15–43.
112 Edouard de Trévise, La Revue de l'Art (January/February 1927), p. 130.

113 Marc Elder reported on numerous canvases burnt by Monet, because he was not happy with them; see Elder 1924, pp. 81–83. On the Grandes Décorations see the extensive correspondence with Georges Clemenceau; see also Kendall 1989, pp. 258ff. The project is first mentioned in 1909. Gordon/Stuckey 1979 provides the best overview, above all with respect to the political implications of the project.
114 In 1900 Monet was not sure whether he wanted to participate in the World Exhibition in Paris, since he didn't want to see his art displayed "alongside Zulus and Negroes"; see Venturi 1939a, p. 376. On the signing of the deed of gift of the Grandes Décorations, see Clemenceau 1993, p. 101.
115 On Monet's treatment of the surfaces of his paintings see House 1986, pp. 167–182.
116 Clemenceau 1928/1989, pp. 45–54.
117 Gordon/Stuckey 1979, p. 115.

STATICE BOURGEAUI Webb.

♃ Iles Canaries. Serre froide.

Catherine Hug and Monika Leonhardt

Claude Monet the Gardener

Claude Monet's gardens are not just works of his artistic and horticultural inspiration. In this documentation we intend to show that the gardens in Argenteuil, Vétheuil, and Giverny were also products of contemporary developments in garden design. The "English garden versus French garden" dichotomous model of explanation was much more closely linked to the construction of national identities at the time Monet's gardens were created—the last quarter of the nineteenth century—than to the actual practice of garden design. Other things are more important for understanding Monet's gardens: Paris was radically remodeled by Baron Haussmann (1809–91)[1] during the reconstruction work of 1851–68, and engineers were the driving force behind this exceedingly expensive reorganization of the city and its parks. Engineers such as Jean-Charles Adolphe Alphand (1817–91) redefined the profession of garden designer and landscape architect. Alphand, a "jardinier-ingénieur," was appointed in 1852 by Hausmann, who knew him as a road and bridge engineer from when they both worked in Bordeaux. He was responsible for redesigning the parks and reordering the water supply system, and in 1889 he was made Commissionaire Général of the World's Fair. Alphand's predecessor was a "jardinier-paysagiste" who had not come to terms with the tasks entrusted to him.

The restructuring of the city had advantages and disadvantages—for the first time parks created large open public spaces for relaxation, their purpose being to give city residents an experience of nature. At the same time private gardens within Paris were being eliminated so that new roads could be built, giving many city-dwellers an increasing need for their own, private piece of "nature." The garden, like the park, became a place of leisure activity. Beginning in around 1830 there was a flood of magazines and treatises dealing with gardens, and horticultural societies were founded.[2]

In his treatise **Les Promenades de Paris** (1867), in the chapter about garden art, Alphand himself detected a remarkable change in landscaping through the use of an abundance of different plants and flowers: "These exotic plants have given the cultivated areas variety and splendor, they have changed the appearance of gardens and increased people's pleasure in studying plants."[3] Indeed, in the last third of the nineteenth century there were more different species of garden plants than ever before, and nurseries such as Vilmorin-Andrieux & Cie. and Georges Truffaut developed into large companies at

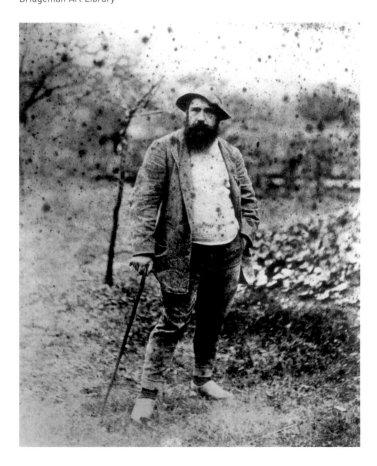

Fig. 1
Claude Monet as gardener, photograph attributed to Theodore Robinson (1852–96), ca. 1887
© Musée Marmottan Monet, Paris and Giraudon-Bridgeman Art Library

this time. Alphand's assistant and successor Jean-Claude Nicolas Forestier (1861–1930), who was an admirer of Monet and his garden, pursued Alphand's ideas further. In **Jardins: Carnet des plans et de dessins** (1920) he spoke of the garden being a social necessity as a counterbalance to the rapid development of cities. Like Alphand, he too pointed out the new plants and the thousandfold splendor of skillful gardeners who were to decorate the private gardens, and presents plans for "quelques petits jardins" ranging in size from 1,850 to 5,000 square meters.[4] Before around 1830, garden designers would not have concerned themselves with gardens of this size at all.

Monet's gardens seem to us to be particularly successful examples of this new type of bourgeois ornamental garden. His best known garden, Giverny, is also a monument to his extraordinary abilities as a gardener.

Argenteuil: A Rising Industrial Town, 1872–78

Monet's First House in Argenteuil, 1872–74

After his return via Holland from London, where he had taken refuge in 1870–71 from the Franco-Prussian War and the subsequent uprising of the Paris Commune, Edouard Manet helped Monet rent a house from Madame Aubry in Argenteuil. Manet was a family friend of this well-to-do lady; she was the widow of a Paris notary and mayor of Argenteuil who had not survived the fall of Napoleon III's empire.[5] The small town, around eleven kilometers northwest of Paris on the Seine, nestled among hilly fields and vineyards. It was able to maintain its rural charm until the middle of the nineteenth century despite having several small local industrial firms, including plaster factories, mining companies, a silk mill, and a smithy. The population around 1850 was about 4,700. In 1851, Argenteuil was joined to Paris

Fig. 2
Street plan of Argenteuil around 1875
A. Monet's house and garden from 1871 through 1874, landlady: Madame Aubry-Vitet
B. Monet's house and garden from 1874 through 1878, landlord: Flament
C. House where Madame Aubry-Vitet lived, with garden
D. Former property of the Aubry family

Source: Rodolphe Walter, "Les maisons de Claude Monet à Argenteuil," **Gazette des Beaux-Arts**, 108th year, 6th period, vol. 68 (1966), p. 334

Fig. 3
Claude Monet's first house at 2, rue Pierre Guienne in Argenteuil, photographed by Louis Boucher, a teacher from Argenteuil, ca. 1899. Monet lived in this house from December 1871 through June 1874. It was probably built in the eighteenth century and was torn down in 1913. On the Aubry map (fig. 4) it is on the plot on the corner.
© Musée du Vieil Argenteuil, Frankreich

by a railroad line and was now just a twenty-minute train ride from the Gare Saint-Lazare, which was to change the town substantially. Argenteuil had always been a popular destination for day-trippers from Paris, and now the population doubled within two decades, because the good rail link drew many city-dwellers in search of fresh air and quiet to settle in Argenteuil, or to have a second residence there. At the same time the number of industrial firms in the town multiplied as the France economy developed. In particular the Joly ironworks grew from a small workshop into one of the largest ironworks in all of France, that instead of horseshoes and cast-iron fences now produced huge metal bridges, boats, and iron girders for buildings, including for the Parisian market halls. Nevertheless, Argenteuil around 1870 still offered many rustic, idyllic views unspoiled by industrialization.[6]

In these years the Aubry family still owned a considerable amount of land in Argenteuil, including sites along the street opposite the railroad station and the rail line. Madame Aubry herself, sister of the historian Ludovic Vitet (1802–73),[7] lived on her property estate at 1 and 3, rue Pierre Guienne, whose park and gardens reached down to the Seine. There is no evidence of her having met the then still rather unknown artist Claude Monet. She was an art-lover, but her preference was for artists of the older generation such as Eugène Delacroix (1798–1863) and Ernest Meissonier (1815–91)—even pictures by Edouard Manet, a friend of her family, were not to be found in her estate.[8] Opposite the property where she lived she owned a separate house at 2, rue Pierre Guienne, not far from the station, which was attached to a large undeveloped site of 2,663 square meters (figs. 2 and 3). It had probably been the servants' quarters or gardener's lodge of the Aubry estate. It faced onto rue Pierre Guienne and from there, from the street side, there was a view down to the Seine in the distance.[9] At the rear of the building the large plot began that is referred to as the garden (figs. 3 and 4). The artist Théodule Ribot[10] lived here before Monet rented it for the family, which consisted of himself, Camille, and their four-year-old son Jean. (The house no longer stands, as it was replaced by a new building in 1913.) Eugène Boudin, Monet's childhood friend from Le Havre, came to Argenteuil for the housewarming on January 2, 1872.[11] The house and garden can be seen on several of Monet's paintings—**The Artist's House at Argenteuil,** 1873 (cat. 10), shows the entire rear façade with the pale-yellow rendering and the brownish window shutters, and **Lunch,** 1873 (W 285), shows part of the rear façade and the garden. The garden in

particular is the subject of other paintings, too, so we have a good idea of what it looked like.

Casual Meals Outdoors

Behind the house on the garden side there was an area covered with compacted yellowish sand or gravel that extended along the entire length of the house and even further. It was furnished with a green garden bench (1873, W 281), and sometimes a round table was set here for meals outdoors (1873, W 285). The area was large enough for little Jean to play there. Directly at the wall of the house and along its entire length there was a narrow bed with border plants in different reds that had a green enclosure. The area was decorated with several pot plants in large, Dutch style white-and-blue tubs, including an oleander (1873, W 282) and a bush fuchsia in a square green wooden box. Such containers were usual in those days so the plants could be readily transported to their winter location, an orangery for example. The wall of the house was covered with a climbing plant, perhaps Virginia creeper, that grew without a trellis, and there were window boxes too. Other bush fuchsias, which are rather labor-intensive because they must be protected from frost in the winter and require several years of cultivation, can be seen in **Camille Monet at the Window,** 1873 (W 287).[12] This picture shows what looks like honeysuckle in the climbing plant next to the windows, and the fuchsias are planted in the white-and-blue tubs that belonged to Monet, since they went with him when he moved —

Fig. 4
Aubry map, cadastral survey of Claude Monet's first house in Argenteuil.
Courtesy Musée du Vieil Argenteuil, France

they are also in the pictures of the second house in Argenteuil, and in Vétheuil as well. In winter they were taken inside the house (1875, cat.13; 1880, cat.20).

In the compacted gravel or sand area there was at least one "carpet bed" (1873, cat.12), a manner of planting that was common and fashionable in the late nine-teenth century, and was first to be seen in public parks. In **Royal Parks and Gardens of London** (1877) Nathan Cole describes the carpet beds he laid out in Victoria Park in London, which are still tended today, and also recommends this kind of planting for private gardeners.[13] These beds were usually round or oval-shaped, plants with very strong and contrasting colors were used, and larger and lusher plants were used towards the middle — Indian shot **(Canna indica)** could be put there, for exam-ple.[14] Carpet bedding only became possible in the second half of the nineteenth cen-tury with the advent of the greenhouse, since the huge number of annuals required could only be grown there[15] — they all had to flower at the same time in order to achieve the desired effect. For private gardens this meant that in most cases the plants required had to be bought from large nurseries.

In Monet's garden (1873, cat.12) a small hill was raised for the carpet bed, that was only planted with one or two sorts of flowers, probably different kinds of gera-niums, and was bordered with lawn. Carpet beds of very similar kind can also be seen on paintings by Gustave Caillebotte,[16] for example in **Park of the Caillebotte Estate at Yerres** from 1875 and **Garden at Yerres** from 1876,[17] each also planted with geraniums **(Pelargonium zonale),** which are particularly dependent on cultivation in greenhouses. In contrast to the former flat "parterres," whose best effect was when seen from some raised vantage point, carpet beds catered better to the visitor — they could be seen from a distance and could be walked round and admired.[18]

Dahlias from Mexico, Lilacs from Lorraine
Other beds also adjoined the area behind Monet's house, for example ones with dahlias (1873, W 282). Dahlias were imported in the seventeenth century from Mexico and became the fashionable flower of the nineteenth century. First hybrids were developed in France and Germany in 1803, and gardeners discovered the plant's strong colors and endless variability. Dahlias are also very easy to grow from cuttings, if the same type is desired, or from seeds, if different varieties are to be grown.[19] A bright scarlet dahlia imported from Mexico in 1872 and named **Dahlia juarezii** in honor of the Mexican president was soon hybridized to create totally new strains — cactus dahlias.[20]

A little further back from the house there were flowering fruit trees (1872, W 202), in a different corner there were lilac bushes like in the pictures **Lilacs, Gray Weather,** 1872 (W 203) and **Lilacs in the Sun,** 1872 (W 204). At the same time as Monet was painting the lilac bushes in his garden, the plant breeder Victor Lemoine[21] in

Nancy was producing new varieties of lilac with richer colors and fuller flowers.[22] Thanks to these late-nineteenth-century French strains, some of which are still available today, the lilac advanced to become a favorite garden plant.

A Wealthy Citizen's Garden

Monet's garden was partly bordered by a wall, but partly also by a simple paling fence, as in the painting by Auguste Renoir where Monet is shown painting in his garden (fig. 5). Monet did not only use his garden to paint in, but was also actively involved in the gardening—Edouard Manet portrays him planting a red-flowering plant in a flowerbed (fig. 43). In addition he employed a gardener from time to time.[23] Monet's garden at his first house in Argenteuil was not nearly as ornate and elaborate as his friend Gustave Caillebotte's family house in Yerres (Ile-de-France), which the very well-to-do family acquired in 1860 as a country seat in addition to its large house in Paris. Gustave Caillebotte (1848–94) met Monet, who was eight years his senior, around 1873 in Argenteuil,[24] and in addition to their enthusiasm for painting and boats, Caillebotte shared Monet's passion for gardens. Though Monet was much less comfortably off, his garden did not come across as that of an artist on the verge of poverty, but rather as a carefully-tended garden of a wealthy citizen who was informed about the latest trends in landscaping.

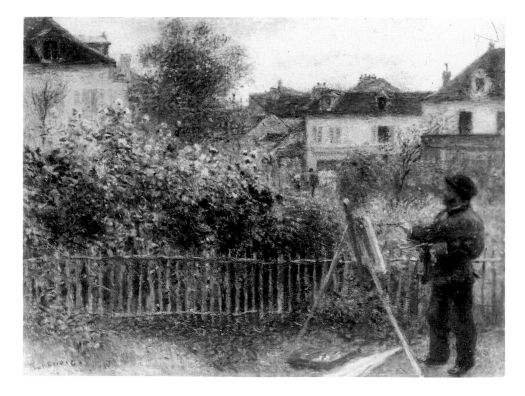

Fig. 5
Pierre-Auguste Renoir
Monet Painting in His Garden at Argenteuil
Monet peignant dans son jardin à Argenteuil
Oil on canvas
45 x 60 cm (18 x 23½ in.)
Wadsworth Atheneum, Hartford, Conn.,
Bequest of Anne Parrish Titzell
© Dukas/Roger-Viollet

Fig. 6
Claude Monet's second house, on boulevard Saint-Denis (today 21, boulevard Karl Marx) in Argenteuil. Today the house belongs to the city of Argenteuil and is the office of the Société Historique et Archéologique d'Argenteuil et du Parisis. A museum in honor of Claude Monet is to be set up there.
© Pierre Moign, L'Etang la Ville

The Second House in Argenteuil, 1874–78

The years 1872 and 1873 in particular were very successful for Monet in financial terms—his income in 1872 was equivalent to that of a doctor or lawyer, and in 1873 he doubled that.[25] He therefore planned to rent a second house to use as a studio. In 1874, however, he experienced a major financial setback, so the family had to move into the garden house he had originally intended to be his studio.[26] The picture **Camille in the Garden with Jean and His Nanny,** 1873 (cat. 12) shows this simple house or the pavilion under construction, and it still stands today at 21, boulevard Karl Marx in Argenteuil (fig. 6). The pavilion was built by Adonis Flament, the proprietor of a large joinery and cabinetmaking firm, and the site had also originally belonged to the Aubry family, although Flament bought it from property speculators. He himself lived in the center of Argenteuil and decided to rent the pavilion to Monet and his family. The tenancy agreement is dated June 18, 1874, the rent was four hundred francs higher than at Madame Aubry's. Claude Monet and his family moved in on October 1, 1874, or perhaps earlier. The painting **Apartment Interior,** 1875 (cat. 13), shows the interior of this house, painted from the veranda, and other pictures give a view of the garden, much smaller than that of the previous house, that Monet probably laid out himself. This garden is one of the favored motifs of the paintings of this time, in addition to scenes by and on the Seine. Monet pondered plantings based on color principles and wrote a color sequence in his notebook for seven rows of mallows—purple, white, red, violet, yellow, cream, and pink.[27]

Winding Paths, Abundant Flowers, Picturesque Elements Avoided

A reconstruction of this garden has been attempted (fig. 7), based on **Camille Monet and a Child in the Garden,** 1875 (cat. 14), **Resting in the Garden, Argenteuil,** 1876 (W 408), and other pictures.[28]

A round flower bed is surrounded by a garden path, in keeping with the new landscaping fashion that preferred winding paths to symmetrical ones and considered an abundance of flowers appropriate for private ornamental gardens.[29]

The plans for the Bois de Boulogne in 1864 show gardens with winding paths, and they were also represented in the Park of the World's Fair of 1867.[30] In the late eighteen-eighties, however, a critical view of this kind of garden gained currency again—it had led all gardens to now look very similar, to the point of monotony.[31] Ludovic Vitet, the brother of Monet's landlady Madame Aubry, had spoken out against the landscape garden in a work as early as 1828, and later again in 1864. In particular he criticized the use of picturesque constructions in the gardens, as Gustave Flaubert was also to do with great irony in the early eighties in his novel **Bouvard and Pécuchet.**[32]

Like Ludovic Vitet, Monet also detested the embellishment of gardens with picturesque details such as artificial rocks and fountains.[33] Vitet supported the return

to symmetrical gardens because of their simplicity. In fact, with the restoration of the legendary garden of Vaux-Le-Vicomte Palace southeast of Paris around 1890, formal landscaping in France was to become fashionable again.[34] Monet's idea of how a garden should look was certainly molded in Argenteuil by the great number of newly established gardens there that mainly catered to the recreation of city-minded dwellers. He did not turn to formal landscaping around 1890 as many professionals did. It was also unsuitable for the majority of new, bourgeois gardens—Forestier wrote that he could not recommend formal design for gardens where limited space was available.

The Difficulties of Modern Life

From his second house, that was closer to the railroad station than the first, Monet could hear the trains traveling to and from Paris, and the thriving Joly ironworks was only a few blocks away. Further industrial projects for Argenteuil, which included plans for Paris sewage disposal and another big ironworks, changed the face of the town. It was difficult to reconcile the advantages of a rural town and place for excursions with the economic upswing of a modern industrial country. As a painter of modern life, as Emile Zola described him,[35] Monet welcomed both motifs—he painted the new developments with rape fields in the foreground, and also the quiet arm of the Seine. In another picture the smoking chimneys of Argenteuil's factories form the backdrop to a magnificent bright bed of dahlias.[36]

Vétheuil: Very Rustic, 1878–81

Monet had to leave Argenteuil for financial reasons at the end of January 1878. Together with Camille, who was pregnant, and little Jean, he moved into his apartment in Paris, which until then he had used as a studio and for business appointments, and which was crammed full of pictures.[37] There was not enough space here for the family. Several weeks before the birth of son Michel on March 17, 1878, a new and fairly spacious apartment was found near Parc Monceau. Monet had discovered Parc Monceau as a motif in 1876 during a stay in Paris[38] and now painted it again (1878, cats. 15 and 16). In these paintings he takes no account of the picturesque elements of the park introduced in Anglo-Chinese style but gives back the landscape its eighteenth-century character. In August 1878, Monet left Paris and moved to Vétheuil, around forty-five kilometers to the northwest and on the Seine, that in contrast to Argenteuil had no direct rail link with the city. In those days the trip from Paris to the train station at Mantes and from there by coach to Vétheuil took almost a whole day. Monet was to keep a pied-à-terre in Paris until 1882, using it for business appointments but also as a studio and exhibition space.[39]

At that time Vétheuil was a rural town with over six hundred inhabitants. It had a doctor, a post office, and the usual shops—a baker's, butcher's, greengrocer's—

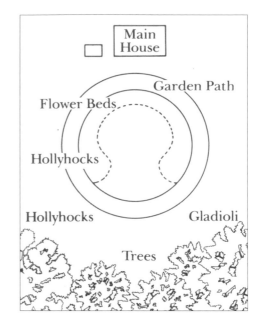

Fig. 7
Reconstruction of Monet's garden based on Argenteuil paintings
© Colin B. Bailey, Philadelphia Museum of Art

as well as a hotel and a tobacconist's.[40] Secondary schools were in Vernon, just a few kilometers away. For a few months the Hoschedé and Monet families, altogether twelve people, including eight children aged between five months and fourteen years, lived together in Vétheuil in the first house, that turned out to be too small.

Alice and Ernest Hoschedé, formerly generous patrons of Monet and other artists, had in the meantime been made destitute by a series of business setbacks. Alice Hoschedé, who looked after the seriously ill Camille and the eight children, of whom the two youngest—Jean-Pierre Hoschedé and Michel Monet—were still babies, was a particularly close friend of Claude Monet, and after Camille's death in September 1879 they became lovers. After several months living in these cramped conditions Monet found another house for the large household. More spacious and comfortable, it belonged to Madame Elliot, the widow of the English industrialist Thomas Elliot and owner of the property "La Tourelle." From the entrance to the town it was the last in a row of three houses on Vétheuil's main street, and it was quite big for the town at that time. On the first floor there was a kitchen, living room, and dining room; above them were three bedrooms, of which two were heatable, and there were additional rooms in the attic. The house also had two toilets, a rare convenience outside the big cities in those days (figs. 8 and 9). A lease, which indicated the beginning of the rental period as October 1, 1878, was signed on December 13, 1878. The annual rent of six hundred francs was considerably lower than in Paris.[41]

Fig. 8
Claude Monet's house in Vétheuil, photographed by David Joel
Published in David Joel, **Monet at Vétheuil**, Woodbridge 2002
© Antique Collectors' Club and the author

Meadows and Flowering Fruit Trees

This house had two gardens—one, which still exists today, was next to the house and extended about thirty-five meters along the street, going back around fifteen meters, and had a perimeter wall.[42] In this part of the garden there were other buildings, that served as sheds, as well as a chicken coop and rabbit hutch, that presumably contributed to feeding the large family as did the vegetable garden.[43] The main garden was on the other side of the street—it was an orchard on a gentle slope with several terraces and sets of stairs leading downwards, and extended almost down to the river, where Monet moored his boats.[44] This garden was bordered partly by a wall and partly by a simple paling fence, the entrance from the street side was through a wooden gate (1881, W 691). A house stands on the site today.

Some pictures show the lower end of this garden, where there was a view of the Seine over intermingling patches of gladioli, dahlias, and nasturtiums (1881, W 692) or other plants growing half wild and flowering bright yellow, including tufted loosestrife—a wild shrub that thrived on riverbanks (1881, cat. 21). Incidentally, the use of wild shrubs in gardens was endorsed as early as 1879 by Edouard André (1840–1911) in the widely read publication **L'Art des jardins: Traité générale de la composition des parcs et des jardins**.[45] André demanded that gardens be natural in appearance and encouraged the integration of native plants.[46]

The main motif of Monet's paintings from his years in Vétheuil are views of the town and the landscapes of the surrounding area, many of them winter scenes.

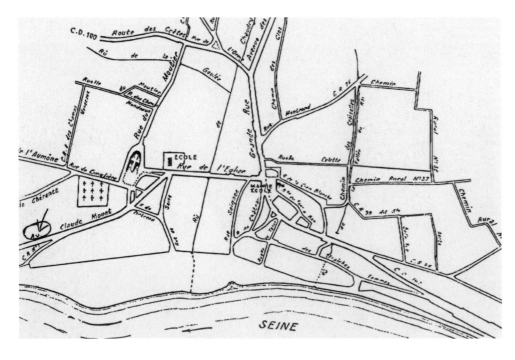

Fig. 9
Street plan of Vétheuil
Scale of 1:5000
Claude Monet's house in Vétheuil is marked; it is at 16, avenue Claude Monet (today's street name).
Courtesy Mairie de Vétheuil

There are also several still lifes with fruit and flowers, often showing bouquets of flowers. The garden is depicted less often—instead there are the flowering fruit trees and meadows of the surrounding area. A well-known picture of the garden in Vétheuil, that exists in four variants and can be assumed to mark the beginning of Monet's work with serial paintings,[47] shows the stairs in the lower garden surrounded by tall sunflowers (1880, cat. 20). The white-and-blue Dutch tubs can again be seen, this time planted with gladioli.

Gladioli were also significantly improved by the plant breeder Victor Lemoine in the eighteen-seventies. They were made brighter and hardier, and the first specimens of the new varieties came onto the market in 1875 (fig. 3).[48] Despite his financial constraints, Monet clearly kept informed about current developments in landscaping and obtained the corresponding plants whenever possible. **The Garden at Vétheuil,** 1881 (W 666) shows an astonishingly modern treatment of sunflowers, that were particularly popular at the end of the nineteenth century[49]—they were planted in large quantities on two terraces, which the garden was divided into at the time, in order to achieve two-dimensional tonality, exactly as twentieth-century garden designers would also do[50] and as was to become a significant design principle behind Claude Monet's painting.

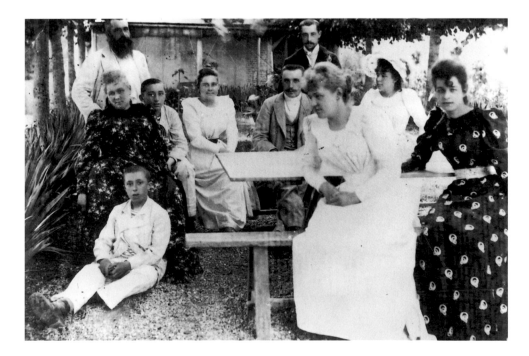

Fig. 10
The Monet-Hoschedé "patchwork" family shortly after their arrival in Giverny, 1883, from left to right: the artist, his second wife-to-be, Alice Hoschedé (1844–1911), at her feet Michel Monet (1878–1966), seated to the left of Alice her children Jean-Pierre (1877–1961) and Blanche (1865–1947), Jean Monet (1867–1914) and Jacques Hoschedé (1869–1941) standing, in the foreground Marthe (1864–1925), Germaine (1873–1968), and Suzanne Hoschedé (1868–99). Alice Hoschedé and Claude Monet had no children together.
© Musée Marmottan Monet, Paris, and Giraudon-Bridgeman Art Library

Giverny: The Garden Project, 1883–1926

Alice Hoschedé followed Claude Monet to Poissy, making the rift with her husband visible for her family and the public, and the years spent here were difficult. In 1883—Camille had died, and Ernest Hoschedé lived mostly in Paris—a suitable house was found for the ten-person household near Vernon, in Giverny (fig. 10). Like Vétheuil and Argenteuil, Giverny lies on the Seine and was two hours by train from Paris, which made it more accessible than Vétheuil. Vernon, two kilometers away from Giverny, lay on the Paris–Le Havre express-train line. Back then Giverny even had its own small station (figs. 12–14).

In April 1883 Monet rented an enormous house from the local landowner Louis-Joseph Singeot. With the house came a large piece of land, measuring 9,600 square meters in size—almost a hectare—making it about twice the size of the garden dealt with in 1920 in Forestier's garden plans. In 1890, the owner offered Monet the house and garden for sale for a favorable price; the title deed is dated November 17, 1890, just a few days after Monet's fiftieth birthday. A little over two years later the artist, who had now become quite wealthy, acquired another piece of land so as to fulfil his wish of having a water garden. The title deed for this strip of land, that lay below his first property and was separated from it by the small railroad line from Vernon to Gasny, was signed on February 5, 1893. A water-lily pond was laid out there, and after the purchase of yet another piece of land on May 10, 1901—3,900 square meters—it was considerably extended and the water area enlarged (figs. 49 and 50).[51]

Glaïeuls de Lemoine.

Fig. 11
De Lemoine gladioli.
Reproduced in Philippe de Vilmorin,
Les fleurs de pleine terre, Paris,
Paris 1909, p. 462

GIVERNY. - Les Prairies

Phot. A. L., Vernon

Fig. 12
Postcard of the village of Giverny and surroundings,
photograph by A. Lavergne, undated.
Courtesy Collection Toulgouat

Fig. 13
Postcard of Giverny station,
photograph by A. Lavergne, undated.
Courtesy Collection Toulgouat

* All documents cited here can be found in the
French original at the end of this essay.

Fig. 14
Street plan of Giverny

In addition to the water-lilies and irises, that will be dealt with in detail later, there
were many other flowering plants in Claude Monet's garden:

A list of the plants in Monet's garden:

Herbaceous perennials: Japanese anemone, aster, columbine, aubrietia,
acanthus, woltsbane, monkshood, bugloss (Anchusa), plume poppy, centaury,
border bluebells (Campanula), delphinium, leopard's bane (Doronicum), globe
thistles (Echinops), sea holly (Eringium), fleabane (Erigeron), blanket flower
(Gaillardia), elecampane (Inula helenium), sunflower (Helianthus), day lilies
(Hemerocallis), iris, gladiolus, crocus, oxeye (Heliopsis), lupins, plumbago,
rose mallow, black-eyed Susan (Rudbeckia), sea lavender, lilies, poppy, barbel
(Penstemon), various gentians, daffodil, tulip, sage, ox-eye daisies (Leucan-
themum), hydrangeas, roses, sea daffodils (Pancratium), cranesbill (Gera-
nium), ordinary and collerette dahlias, polygonum.

Annuals: Sweet pea, nasturtium, simple poppy, simple flowering garden
aster, Californian poppy (Escholtzia), foxglove, morning glory (Ipomoea), mal-
ope, snapdragon, ornamental tobacco, simple poppy (Papaver), marigold, yel-
low horned poppy (Glaucium), tree mallows (Lavatera). (doc. a)

There were a few plants Monet did not like, including balsams (**Impatiens**) and petu-
nias. In general he favored simple flowering varieties to the fuller flowering ones.[52]
No ornamental fruit and vegetables were grown in Monet's garden, as were in
Caillebotte's garden in Gennevilliers, for example, and are depicted in Caillebotte's
paintings. In addition to the flowers listed, several flowering bushes and climbing

plants were important for Monet's garden, for example wisteria, clematis, and tree peonies (figs. 16, 17, and 36). Some varieties of exotic tree peonies flowered in Europe for the first time in the Paris Jardin des plantes in 1891.[53] With roses, Monet seems not to have made the effort of immediately acquiring the newest strains, as he did with the other plants in his gardens. But he loved them very much, as shown by his rose plantings and paintings of the rose arches (figs. 15, 18, and 34; also cats. 64–66).

It was certainly an unconventional undertaking in those days in the small village of Giverny to replace a garden's vegetable beds and fruit trees with a mass of flowering plants. As already mentioned, a railroad line led through the middle of Monet's garden as of 1893. This made it possible for travelers to view the artist's garden which was becoming ever more famous but was not accessible to the public. But even during Monet's lifetime postcards of his garden were in circulation that were presumably made at the time of the great onslaught of American artists in Giverny, which was mentioned in the press in 1904 (figs. 18 and 37).[54]

Since 1966 the garden at Giverny has been in the possession of the Académie des Beaux-Arts, and Monet's house and garden are today in the responsible care of the Fondation Claude Monet. The property was made accessible to the public in September 1980 following costly restoration work, and since then it has been the most frequented garden of its kind in the world. In order to cope with the influx of visitors, the paths were compacted, and a road leads through the garden today instead of the railroad line. The curator Gérald van der Kemp based the restoration

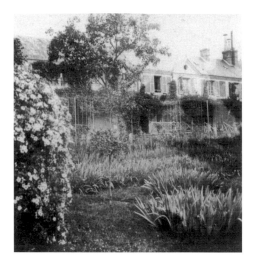

Fig. 15
View of Claude Monet's house in Giverny with a bush of mermaid roses in the foreground, undated.
© Collection Toulgouat

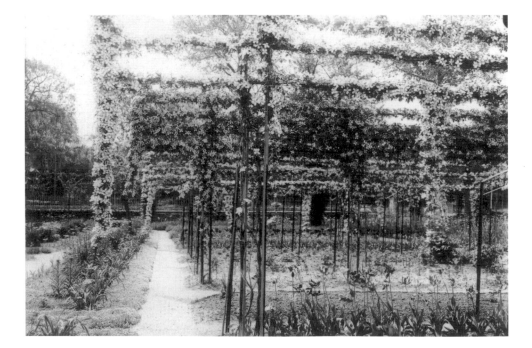

Fig. 16
"A charming use for Clematis montana with white flowers and of the variety with pink flowers on high trellises in the gardens of Giverny. In early spring it is one of the most beautiful parts of these famous gardens." Clematis montana was brought from Asia to Europe in the mid-nineteenth century, and the pink-blooming variety did not arrive from until 1902. Photographed by Gouthière (Georges Truffaut). Picture and caption: Georges Truffaut, "Le Jardin de Claude Monet," **Jardinage** 87 (November 1924), p. 58 © Collection Toulgouat

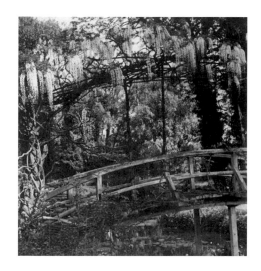

above all on photos and accounts of people who had seen Monet's garden while he still tended it. Among these contemporaries were André de Vilmorin and André Devillers, who later became manager of the firm Georges Truffaut. He had some-times accompanied Truffaut on visits to Claude Monet.[55] The color schemes were retained, but compromises have been made in favor of larger flowers and longer flowering times, since the plants Monet used are increasingly disappearing from nursery lists.

Initially the garden played no great role in Monet's painting—in the eighteen-nineties he mainly painted series of paintings, including the cathedrals, haystacks, and views of the Seine. But he did devote himself to gardening. The water-lily pictures begin in 1897, but it was in particular as of 1903, about one year after the enlargement of the water-garden established in 1893, that water-lilies in the pond and varying light effects on the water became the most important themes of Monet's oeuvre (fig. 38).

A Family Matter: Letters to Alice Hoschedé

Like many other artists of his time, Monet devoted himself to plein-air painting, which the Barbizon School was committed to: artworks were to be created not in the studio, but in the open, the study of nature was to take place in nature. The group of works created in this way on Monet's sometimes very extensive painting trips make up the largest part of his oeuvre. His correspondence with his second wife, Alice Hoschedé, reveals the great efforts which his observation of natural phenom-

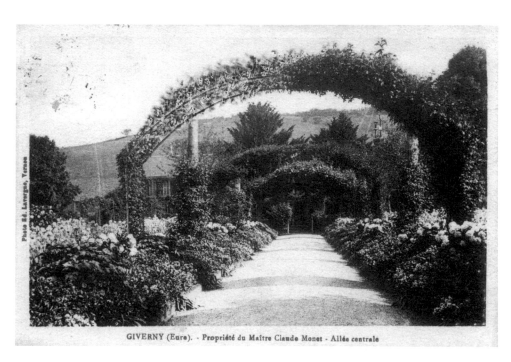

GIVERNY (Eure). - Propriété du Maître Claude Monet - Allée centrale

ena and their reflection in his art often involved on these journeys. A total of 565 letters from Monet to Alice have been preserved between the years 1882 and 1904, a very large number considering they were six to eight pages long and written daily.[56] In these letters Monet reported his plein-air experiences to Alice in detail every day. The necessity of doing this was all the more compelling for Monet because evidently his lover and later wife persistently reproached him for his protracted periods of absence from the family.[57] This correspondence shows particular recurrent problems that Monet was confronted with in plein-air painting and could only overcome with great effort. The following excerpts from letters are intended to show these recurrent difficulties—the dependence on meteorological conditions, the changeability of the weather and the moods of light, and the lack of a central motif. It is remarkable that Monet gradually came to like the idea that the moods of nature that he sought to reflect in his art could perhaps be controlled to an extent, for example in the garden of Giverny. And indeed, after the enlargement of the water-lily pond in 1901/02 Monet hardly went on any more painting trips.

On the dependence on meteorological conditions:

Thursday morning, 6 a.m. [Pourville, April 6, 1882]

... I must get going so I can benefit from this wonderful sunshine and try to rescue as many canvases as possible. I say "rescue"—that is the right word—because in reality I am not satisfied with any single one, I have never had such trouble. To think that I have sometimes worked well in short spaces of time, whereas here most of my studies require ten, twelve, or sometimes twenty sittings. The remaining days are therefore very important for me and I assure you that I am not dawdling, and if I cannot be back in Poissy on Sunday, as I said I would, please do not begrudge me this. In order to do well I need two more sunny days and two or three gray ones, and this of course only if I leave several canvases—otherwise I would never be finished. I won't be back on Sunday in any case, it won't be until Tuesday or Wednesday. (doc. b)

On the changeability of the weather:

[Sandviken], March 12, 9 p.m. [1895]

... I'm working without a break despite all these changes and the snow, but I won't be able to get anything finished; I have to limit myself to capturing a view in one or two sessions, impossible to find the same effect again, especially at this time of the winter. I also had several paintings of sunlight but it's a good ten days now since the sun appeared, when it does it will only melt everything. But what wonderful things I'm seeing, what lovely effects I was blind to in the beginning. (doc. c)

On the search for motifs:

[Belle-Île-en-Mer, Le Palais], Monday evening [September 13, 1886]

I still don't know what to decide—whether to settle here, go to Noir-
moutier, or not to go there and instead continue my journey until I find a place
that captivates me... Now I'm a litlle afraid that, if I get established here, I
might subsequently regret it if I see prettier or more accommodating places
later on ... (doc. d)

On the longing for a fixed place:

Bordighera, 5 March 1884

. . . I'm having more success in capturing that wonderful pink light, as I
see it every day morning and evening; it's glorious, just perfect and more beau-
tiful by the day. My studies are going well, they are all progressing and looking
far better these last few days. . . . You saw the anemones I sent you on your
birthday, the rose and red; they are everywhere to be found, growing wild; my
little Italian boy who carries my baggage makes enormous bunches of them
and masses of other flowers while I work. How happy we'd be here and what a
pretty garden we would have . . . (doc. e)

Alice Hoschedé and Claude Monet had divergent views about what a "pretty garden"
should look like. They argued, for example, about the spruces and cypresses that
lined the main avenue of the garden (figs. 19 and 20). Whereas Monet imagined an
avenue of rambling roses growing over a kind of pergola of metal hoops, Alice
favored monumentality and did what she could for the maintenance of the trees.

The dispute took on epic proportions, compromises had to be made — the cypresses were chopped down, the spruces also had upper branches removed repeatedly so that the flowers beneath them would receive more light. The spruces did not take this well, and, what is more, they were gradually overgrown by climbing roses. After years of toing and froing all that remained were two yew trees on the house side to mark the end of the now mighty rose avenue (figs. 18–21 and 37).[58] Alice Hoschedé's aesthetic feeling for tree-lined avenues and bodies of water was shaped by Château Montgeron and its large park, where she and her first husband, Ernest Hoschedé, lived until 1877/78. Monet had been there and painted motifs for his friend and patron Ernest Hoschedé including **The Garden at Montgeron,** 1876 (W 418), and **The Pond at Montgeron,** 1876 (W 419 and 420).

Emile Varenne: Director of the Jardin des Plantes in Rouen

As an enthusiastic gardener, Monet liked to visit horticultural exhibitions and famous gardens to keep up on developments. When he stayed in Rouen, the capital of Normandy, in 1893 to paint the Cathedral series, he also visited the city's botanical gardens, the Jardin des plantes, where he met Monsieur Varenne:

Fig. 20
The central path in front of Claude Monet's house in Giverny. In this picture all the trees are still standing — the rose arbor was established afterwards.
© Musée Marmottan Monet, Paris and Giraudon-Bridgeman Art Library

Fig. 21
The central path in front of Claude Monet's house in Giverny. The rose arbor has already been established, but all the trees are still standing. Note the overgrown path and the hilly terrain on the right of the picture.
© Musée Marmottan Monet, Paris and Giraudon-Bridgeman Art Library

417 - ROUEN - Jardin des Plantes. Les Serres

Fig. 22
Postcard of the Botanical Garden in Rouen with the greenhouses built under the direction of Emil Varenne between 1883 and 1884, photograph by E.D., undated. In contrast to "Grand Serre," the monumental and richly decorated greenhouse built in 1842, the functionality of these newer, "Dutch" greenhouses is remarkable. They were used for the cultivation of orchids and summer plants for the Botanical Garden.
Courtesy Liliane Flamande and Mairie de Rouen

[Rouen]. Thursday evening 6 o'clock [February 16, 1893]

. . . After work this morning I was able to make my visit to Monsieur Varenne at the Botanical Gardens. He's a very kind man, Monsieur Varenne, and I hope to obtain quite a lot of things from him; he offered me a cutting from that lovely climbing begonia which I'll bring back on Sunday. We visited all greenhouses, really superb, what orchids! They are gorgeous. As for plants for the young botanists, he's going to introduce me on my next visit to the head gardener who is only allowed to give plants away on Monsieur Varenne's orders, but he tells me that it would be a good idea if the children were to draw up some kind of list with the priest. He gave me quite a lot of good advice on a lot of things; he's worth knowing in short. He told me I could go anywhere I wanted and feel at home . . . (doc. f) (fig. 13)

Emile Varenne (1841–94) made a brilliant career for himself — he started off in 1859 as a gardener's assistant in Rouen, became manager of the tree nursery and the public ornamental gardens in 1866, and in 1880 was promoted to director of the promenades and public parks of Rouen. He was frequently called by the Société Nationale d'Horticulture de France, of which he was a member, to sit on panels for competitions, and the government decorated him in 1884 and 1889 for his services to plant cultivation. His many and diverse contacts with plant and garden specialists throughout the world, with whom he exchanged both plants and experience, enriched the botanical gardens in Rouen considerably. One of the first greenhouses in France was built here in 1842 and served to house the exotic plants of the former botanical gardens. It still stands today and is listed as a "Monument historique." Varenne commissioned specialist architects to construct a group of seven more greenhouses, each of which was twenty meters long and adjoined a gallery fifty-three meters in length. Varenne is certain to have showed Monet "his" greenhouses in particular detail.[59] The "young botanists," for whom Monet wanted to bring home plants from the botanical gardens, were his children. Jean-Pierre Hoschedé in particular, who was sixteen at the time, was also very interested in plants. Together with Abbé Anatole Toussaint (born 1863),[60] a family friend of the Monets, Jean-Pierre put together a small list describing the plants of Vernon and the surrounding area: "La Flore de Vernon et de la Roche-Guyon." It was published in 1898 in the **Bulletin de la Société des Amis des Sciences Naturelles de Rouen** and was also obtainable as a separate booklet.[61]

Fig. 23
Heated greenhouses in Claude Monet's garden, with chrysanthemums and hanging orchids, ca. 1895. Monet's greenhouses must be seen in connection with his visit to Emile Varenne (1841–94) at the Jardin des plantes in Rouen in February 1893, but for technical reasons they were not built until the construction of the second studio around 1895.
© Collection Toulgouat

Joseph Bory Latour-Marliac's Water-Lilies

The most famous motif in Monet's oeuvre, both in view of his great passion for flowers and also in absolute terms, are the **Nymphéas** or water-lilies. Many favorable circumstances and different motivations may have led to his decision in 1893 to acquire another piece of land in addition to his existing garden in Giverny in order to establish a pond with water-lilies. Between 1883 and the construction of the "Bassin aux Nymphéas" he was to undertake numerous and—to the regret of his beloved Alice—extensive art tours to Bordighera, Cap Martin in the south of France, Eretat, Holland, Kervilahouen on Belle-Ile-en-Mer, Fresselines in central France, Rouen, and other places. The acquisition of the house in Giverny in the fall of 1890 after Monet's successful exhibition year in 1889 and his marriage to now widowed Alice Hoschedé in the summer of 1892 were certainly decisive biographical events that induced Monet to lead a more settled life.

In January 1893, he visited a Japanese art exhibition staged by his long-standing exhibitor, the gallery owner Paul Durand-Ruel.[62] Shortly afterwards Monet acquired the piece of land on which he was to create the water garden. The temporal coincidence of these two events could be interpreted as an indication that Monet, impressed by Utamaro's and Hiroshige's art, wanted to establish a Japanese-inspired garden. There is no doubt as to Monet's fascination for Japanese culture and his personal contacts with Japan—his large collection of Japanese woodcuts[63] can still be admired in Giverny today, and in later years the artist was friends with the well-to-do Madame Kuroki (fig. 24).[64] The general, rather indiscriminate, fascination for things Japanese, which had wide repercussions since the World's Fair of 1867, was also felt in horticulture. For instance, new plants like tree peonies and particular varieties of iris were often described as "Japanese," although they actually came from other counties.[65] In addition to the bridge, the establishment of the water-lily pond has often been seen as a further component of a garden expansion which was conceivably "Japanese"-inspired, though Monet never referred to it as such. The decoration of his garden in the picturesque style, for example with Japanese buildings, was the last thing he wanted to do; the unique structure of Japanese gardens, as was later emphasized in the modern period, was inconceivable at the time. On the other hand, it is important to emphasize that at that time water-lilies had only been cultivated for a few years, and this was a breakthrough for the systematic arrangement of water-lily ponds. This must have been what motivated Monet to pursue negotiations with the authorities to gain permission to divert a stream.

25

The credit for initiating the cultivation of water-lilies can be given to one person: Joseph Bory Latour-Marliac (1830–1911). Latour-Marliac was born in southwestern France into a well-to-do family, all of whose members were interested in botany. As a young man, Latour-Marliac was interested in finding a way to breed the

26

Fig. 27
Japanese Yellow Dragon chrysanthemum.
Reproduced in Henri de Vilmorin, **Les différentes
cultures de Chrysanthème**, Paris, 1908, p. 45

Figs. 25 and 26
Different types of chrysanthemums after Katsushika
Hokusai (1760–1849). Henri de Vilmorin writes of
these drawings in his introduction to **Les différentes
cultures de Chrysanthème** (1908) that practically all
the European varieties of chrysanthemum of this
kind are descended from the types cultivated around
1815 in Japan. Reproduced in ibid., pp. X, 32, 33

colorfulness of the tropical water-lilies into the hardy varieties. In 1875, he finally succeeded in producing the world's first hybrid water-lily, Marliacea chromatella — it has canary-yellow flowers with a long flowering period, ocher or yellow stamens, and the leaves have bronze marbling. Spurred on by this sensational discovery, Latour-Marliac founded the Etablissements Botaniques in Le Temple-sur-Lot in very same year in order to commercially exploit his research findings. Before long this nursery had gained world renown for the hybridization, production, exhibition, and sale of Nymphaea and other aquatic plants such as Nelumbo (lotus). So it was that Latour-Marliac exhibited at the particularly crowd-pulling World's Fair of 1889 (called "Centenaire de la Révolution" because of the centenary of the French Revolution). He was also involved in the construction of the water-lily pond in the north of the Jardins de Bagatelle in the Bois de Boulogne.[66] It seems that he aroused much attention, in particular with his new hybrid Marliacea rubra punctata — this was a magenta and crimson variety with orange stamens, making it one of the most intense red water lilies.

We can assume that Monet met Latour-Marliac at the World's Fair of 1889. In 1891, this botanist and businessman won the prestigious Grande Médaille d'Or and two orders of merit at the Concours d'Exposition de Paris, which must have finally induced Monet to entrust the next order of water lilies for his garden exclusively to the establishment in Le Temple-sur-Lot. Unfortunately only a few original documents have been preserved, but these show that Monet placed large orders with Latour-Marliac, and these allow us to infer an ongoing business relationship. The three secured documents, all from Latour-Marliac to Monet, are two original carbon copies of bills of delivery (of May 15, 1894, and May 27, 1904) and a reminder (November 4, 1908).[67] The bill of delivery below, transcribed from the handwritten original, shows the wide variety of plants that grew in Monet's pond in Giverny:

B. Latour-Marliac	**15 mai [1894]**	
	31 mars, en quatre colis postaux en gare de Vernon	
		F. C.
	Liste de plantes	
3 Polygonum amphibium, à 50		1 50
3 Trapa natans, à 50		1 50
3 – verbonensis, à		3 00
3 ??? ???,[68] à 40		1 20
3 Caltha polypetala, à 60		1 80
3 Carex folliculata, à 75		2 25
3 Eriophorum latifolium, à 75		2 25
3 – scheuchzesi, à 50		1 50
3 Gymnotheca chinensis, à 50		1 50
3 Hydrocotyle bonariensis, à 75		2 25

3	–	vulgaris, à 50	1 50
3	Hydropyrum latifolium, à 75		2 25
3	Lysimachia vulgaris, à 75		2 25
3	Myriophyllum proserpinacoïdes, à 70		2 10
3	Orontium aquaticum, à 1		3 --
3	Pontéderia montevidensis, à 5		15 --
3	Sagittaria gracilis, à 1		3 --
3	Saururus cernuus, à 50		1 50
3	–	Loureiri, à 50	1 50
		total	50 85

(Second page of the letter)

		report	50 85
3	Scirpus maritimus à 50		1 50
3	–	radicans à 75	2 25
3	Sisyrinchium sulfurea à 50		1 50
3	Typha stenophylla à 50		1 50
2	Nymphæa flora à 1 50		3 --
2	–	Laydekeri rosea[69], à 10	20 --
2	–	sulfurea grandiflora à 3	6 --
	(nous n'avons pu en fournir que 2)		
1	Nelumbium album		5 --
1	–	japonicum roseum	5 --
1	–	luteum	5 --
1	–	osiris	5 --

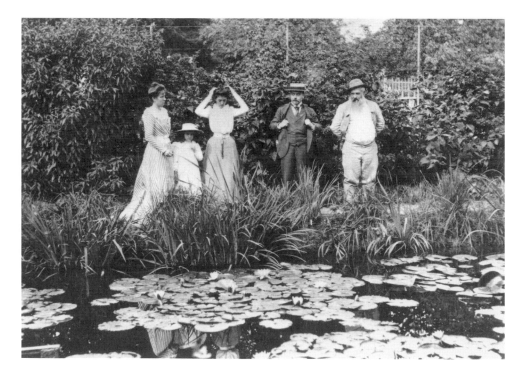

Fig. 28
At the water-lily pond in Claude Monet's garden in Giverny, from left to right: Germaine Hoschedé, Monet's step-granddaughter Alice Butler (1894–1949), Madame Joseph Durand-Ruel, Georges Durand-Ruel (1866–1933), and Claude Monet. Photographed by Joseph (1862–1928), the son of Claude Monet's long-standing exhibitor Paul Durand-Ruel (1831–1922), September 1900. Note the flowering water-lilies and the reflections in the calm water. Telephone or electricity lines are to be seen in the background.
Courtesy Caroline Godfroy
© Archives Durand-Ruel

1	–	speciosum roseum	5 --
	trois colis postaux à 80 – un à 60		3 --
	trois caisses à 75 – une à 50		2 75
		total	117 30

Les Nelumbium peuvent très bien être
cultivés en plein air dans le département de
l'Eure. ainsi qu'il est dit dans le catalogue
Les rhizomes doivent être placés horizontalement et
recouverts de vase dans les bassins ou
récipients destinés à les recevoir. Ils ne doivent
pas être immergés à plus de 50 centimètres de
profondeur.

Les autres plantes que vous aviez demandées
n'ont pu être fournies, n'ayant pas encore
poussée à ???? de la saison ??? ???
??? ??? elles.

Fig. 30
Second page of two-page bill of delivery from the
water-lily breeder Joseph Bory Latour-Marliac
to Claude Monet, May 15, 1894
Courtesy Sylvie Benedetti, Ets Botaniques
Latour-Marliac S.A.
© Ets Botaniques Latour-Marliac S.A.,
Le Temple-sur-Lot, France

27 mai [1904]

 Claude Monet Giverny

 B. Latour-Marliac

26 mai, en un colis postal, en gare de Vernon

1 Nymphæa Atropurpurea[70]		20	
1	–	Arethusa	40
1	–	W Falconer[71]	20
1	–	James Brydon[72]	25
		Port et emballage	1 10
		total	106 10

 Nous n'avons pas de Nymphæa tropicaux disponibles.
 Le nom botanique du Pteris aquatiqua
est Nephrodium thelipteris

(Transcription from the handwritten original
[figs. 29–31] by Sylvie Benedetti, Ets. Latour-
Marliac 2004)

On the bill of delivery of May 15, 1894, Latour-Marliac gives instructions for planting. Since Monet did not obtain the approval of the Prefect for the diversion of the Ru, an arm of the river Epte, until July 1893, it can be assumed that this was the first of the water-lily deliveries. This may also be an indication of why this first order encompasses the names of thirty different plants! Although today there are around two hundred varieties of Nymphaea, Monet only ordered three varieties of water-lilies; five others are lotuses, and the remainder are marsh plants of different kinds. In the order of 1894, Latour-Marliac notes that the lotus (Nelumbium), which originated in Asia and only flowers for a few days each year in summer, can be readily cultivated in the open in the climate of the Departement Eure, and that the water must not be more than fifty centimeters deep. Most water lilies thrive in this depth of water, although some can also tolerate ninety centimeters. Monet's pond fed by the Ru certainly had spots that were somewhat deeper, because it would have silted up too quickly if it had had a uniform depth of only fifty to ninety centimeters. It should be noted that the lotus variety **Nelumbum osiris** ordered by Monet was a strain of Latour-Marliac's, whose pink flowers can grow to be up to twenty-five centimeters in diameter.

Monet ordered a number of other floating-leafed plants such as Polygonum amphibium (water smartweed), Trapa natans (water chestnut), Caltha polypetala (marsh marigold), Carex folliculata (sedge), Eriophorum latifolium (broad-leaved cotton grass), Hydrocotyle bonariensis (marsh pennywort), Orontium aquaticum (golden club), Sagittaria gracilis (slender arrowhead), Saururus cernuus (lizard's tail), Scirpus maritimus (alkali bulrush), and Typha stenophylla (cattail). These plants are important elements of a water garden, if it is to be a balanced biotope. When looking at Monet's water-lily pictures, however, the degree of motif reduction hardly prompts the viewer to think about the complex natural system behind them. Monet, as a gardener, was very well aware of this complexity. It is also remarkable how much money Monet paid for this structured piece of nature—in addition to all the other expenses his garden in Giverny entailed. The sum of 117.30 francs in 1893 and 106.10 francs in 1904 testify to relatively large orders. One franc in 1901 was worth 22 francs in March 2004, or 3.35 euros (4.15 American dollars), which allows us to calculate corresponding totals of 355.43 euros/439.90 dollars (the 1893 order), or 392.96 euros/486.35 dollars (the 1904 order)[73] (figs. 17, 28, 32).

There are further highlights in the history of Latour-Marliac's water-lily breeding—in 1896 he produced **gloriosa,** a variety with crimson, fragrant double flowers and petals tipped with pale pink. Even today it is considered the commercial triumph among his hybridization experiments. In 1898, Latour-Marliac was awarded the prestigious Veitch Memorial Gold Medal of the Royal Horticultural Society (R. H. S.) in London. In 1900 he won the gold medal at the World's Fair in Paris. After Joseph Latour-Marliac's death in 1911, his successors, the Laydecker family, took over management of the business and carried out this task so well that the nursery based in Temple-sur-Lot survived both world wars. It is not really known how Latour-Marliac proceeded with his hybridization experiments, because the pollen of these plants is often sterile, and they also rarely produce seeds. Latour-Marliac evidently protected the secret very well and did not even pass the his methodology on to his family. Consequently the nursery hardly marketed any more new strains after Latour-Marliac's death. The Etablissements Latour-Marliac in Le Temple-sur-Lot are still in business today as suppliers of over two hundred varieties of Nymphaea and Nelumbo and have also become a popular tourist destination for lovers of these plants.[74]

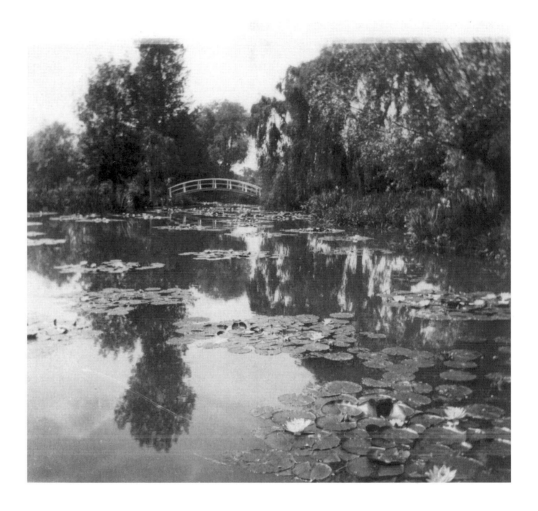

The Iris

A floral motif which occurs frequently in Monet's works in addition to water-lilies, and which often appears alone, are irises. In his garden Monet planted both the irises that prefer dry soils (Iris germanica) and the varieties that grow near water. Their translation into painting can be divided chronologically into the works around 1900 with iris beds of the "clos normand"—varieties that tolerate dry soils grow here—and the larger group of works with the varieties liking moist soils around 1910 or later.[75] The most thorough and detailed description of Monet's iris planting was written by the artist's head gardener in person in an article for the October 1913 edition of the popular garden magazine **Jardinage**.[76] In his introduction to Breuil's article, the editor of this magazine, the garden businessman Georges Truffaut (who we shall focus on later), emphasized the uniqueness of Monet's garden in Giverny. This is remarkable, since this praise comes from a successful plant specialist. Against the background of Monet's significance as an artist, his achievements as a gardener draw the attention of a readership that—we can assume—was less knowledgeable about art. The fact that this report appeared in October, the ideal

time for planting iris, reveals that Truffaut is pursuing subtle advertising for his own deliveries of the plants described:

> In Giverny Monsieur Claude Monet has diverted the small poetic river Epte to make artificial ponds lined with poplars, and along its course he has created flowering riverbank scenes not to be seen anywhere else, except perhaps on very rarely on properties in the south of England, where irises and water lilies play the leading role ... I am publishing it [this article] precisely in this month of October because this is the most favorable time for planting irises ... Our readers will benefit from the experience of those [Monet and his gardener Breuil] who have established one of the most beautiful gardens in France, where bulbous plants, bushes, irises, and rose bushes mix to form harmonious wholes, streaked with monochrome groups of flowers, all cleverly combined by a master of color so as to delight the visitors. (doc. g)

The uniqueness of Monet's garden is heightened in this detailed report by the way in which it is exclusively the gardener whom Truffaut lets speak — the prominence of Monet as the garden's owner is of no import here. It was not until 1924 that Truffaut devoted a more personal article to Monet. Furthermore, it is remarkable that the readership of a publication which had a high circulation for that time received an insight into that private place, considering that Monet was very reserved about the publicity concerning his garden. The first "eyewitness report" about the garden was written as early as 1891 by Octave Mirbeau, but afterwards only few representatives of the press were admitted, and these were as a rule friends of Monet.[77]

Félix Breuil's text, which follows this introduction and contains extensive lists of iris varieties, does not state conclusively whether these really all grew in Monet's garden. But this can safely be assumed since three of the eight photographs in the given edition show the garden of the artist and a fourth presents Iris germanica, whose caption refers to Monet's garden. Two other photographs present the iris collection of Philippe de Vilmorin in Verrières-le-Buisson (Ile-de-France), another significant plant wholesaler in France, known by the name of Vilmorin-Andrieux & Cie. Monet was acquainted with de Vilmorin, who put out numerous different horticultural publications (fig. 33).[78] The article mentions around forty varieties. Breuil's observations allow us to say with certainty that five varieties that prefer dry lawns were to be found in Monet's garden.[79] The description of the thirteen chosen varieties that prefer moist soils is so detailed that it can be assumed that they too were to be found in Monet's garden.[80] Félix Breuil was the practician, who looked after the floral motifs for Monet's paintings with loving care, which explains the plain and pragmatic wording of the article. The first part of this excerpt deals with the varieties that prefer moist soils, the second with those that tolerate dry soils:

Iris de Kæmpfer à fleurs doubles.

Fig. 33
Iris kaempferi. Reproduced in Philippe de Vilmorin, **Les fleurs de pleine terre**, Paris 1909, p. 541

Iris Monieri: This is one of the most beautiful varieties to line the banks with. The flowers are lemon-yellow, are borne on stems one meter long, and open in June-July out of tufts of lancet-shaped leaves. This is very probably a hybrid of the varieties Iris spuria and Iris ochroleuc. . . . Rhizomes are planted in clusters thirty to forty centimeters apart, the distance varying depending on the variety. In Giverny the irises are grown in relatively broad banks around hardy plants, or in groups on the lawns. The irises grow for seven to eight years without having to be replanted.

In the many years that irises have been cultivated here the soil has been improved using loose, gravelly topsoil each time the plantings are renewed. (I didn't use any fertilizer specially for the irises—their position at the edge of beds meant that they benefited from the natural manures given off by the other plants). (doc. h; fig. 34)

Félix Breuil: Monet's Head Gardener in Giverny

In the rare cases, where Félix Breuil (1867–1954) is mentioned in the literature on Monet, he is either described in his overall capacity as a sensitive head gardener or guardian of the water-lilies, but rarely are his many and diverse activities seen in their full complexity—he was in charge of an elaborate garden and a large staff of assistant gardeners.[81] Typically, the significance of the iris as an exceptionally important and horticulturally demanding plant in Monet's garden was later all but forgotten. Because the water-lily motif has become one of the best known of Monet's plant motifs, his gardener is now remembered as the "jardinier des Nymphéas," which is something of a misrepresentation. It is implausible that Breuil as head gardener accomplished the repetitive and laborious task of raking together water-lilies into orderly groups all by himself in a rocking boat. The fact that he himself helps feed the legend is only an indication of the predominance of this motif when people think of the art of the famous Impressionist. For example, a retrospective report in a magazine reads:

Aged 82, but still hale and hearty, Monsieur Félix Breuil is a born gardener. In Regmalard his father looked after the garden of Doctor Mirbeau, the father of the writer [Octave], for over forty years. It was actually Octave Mirbeau, who "passed him on" to his friend Claude Monet. He was entrusted with the garden in Giverny and quickly specialized in the cultivation of water-lilies.

He tells us about the famous garden with its abundance of flowers of every kind, its large rhododendrons and climbing roses. "Monet," he says, "liked all kinds of flowers." His particular task was to look after the "bassin" with its grass-covered, winding bank beneath the Japanese bridge. He assisted with its enlargement and it was he who, at Monet's personal instructions, prepared the magic trick of the aquatic plants flowering in the desired colors . . . Monsieur

Breuil basks in his memories and a whole epoch of French art unfolds before our eyes. An epoch, that has much to thank the "Nymphéas" and their gardener... The latter rarely returns to Giverny. But from time to time he takes the train to Paris. And he never fails to spend a few hours in the orangery. There he finds his beloved water-lilies again, in memory of his master. (doc. i)

Jean-Pierre Hoschedé (1877–1961), Claude Monet's foster son, was the only one to emphasize the diversity of Breuil's work. Here is a detailed notice by this contemporary who had seen Breuil's work first hand (fig. 35):

The garden, that was laid out where an orchard had been, was very large. It was difficult to maintain and tend due to the great diversity of species cultivated there, this diversity itself entailing a diversity of cultivation methods. On the one side there was the greenhouse with a heated section and the hotbed windows, and on the other side the pond. This all demanded a very competent gardener [who was found in Félix Breuil] ... Breuil performed real miracles here with four or five assistants. One of them was entrusted solely with maintaining the pond, which meant constantly cleaning the water surface. This involved keeping it free of water weeds and duckweed as well as removing leaves from the water-lilies, whose luxuriant growth would otherwise soon have overtaken everything. Monet insisted on the surface of the water always being absolutely pure so as to be a better mirror for the sky, the clouds, shadows, and the reflections of their surroundings.

As I mentioned, Monet was compelled to employ a head gardener, Félix Breuil. In this regard I'd like to add a few remarks, because he did much for the splendor of the garden in Giverny. He had great knowledge and, above all, he was able to listen to his "patron" and execute his plans without argument. But that does not mean that he always agreed, or that Monet did not take account of Félix's opinions and suggestions—he knew he was a very experienced gardener. This allows us to conclude that Monet was the designer— I almost said: the painter—of his garden, while Breuil was the perfect executor... After Félix Breuil retired, he was replaced by an able head gardener, Lebret, who skillfully maintained the garden in its magnificence until his death during the Occupation. (doc. j)

And finally the only known letter from Monet to his gardener confirms the complexity of Breuil's work. It is not completely clear that these instructions were addressed to Breuil, but this can safely be assumed given Breuil's position as head gardener at the time.

Giverny [February 1900]

Sowing. Around 300 pots Poppies—60 Sweet pea—around 60 pots white Agremony—30 yellow Agremony—Blue sage—Blue waterlilies in beds (greenhouse)—Dahlias—Iris Kaempferi. From the 15th to the 25th, lay the dahlias down to root, plant out those with shoots before I get back.—Don't forget the lily bulbs.—Should the Japanese peonies arrive plant them immediately if weather permits, taking care initially to protect buds from the cold, as much as from heat of the sun. Get down to pruning: rose trees not to long, except for the thorny varieties. In March sow the grass seeds, plant out the little nasturtiums, keep a close eye on the gloxinia, orchids etc., in the greenhouse, as well as the plants under frames. Trim the borders as arranged; put wires for the clematis and climbing roses as soon as Picard had done the necessary. If the weather's bad, make some straw matting, but lighter than previously. Plant cullings from the rose trees at the pond around manure in the hen huts. Don't delay work on tarring the planks and plant the Helianthus latiflorus in good clumps right away. If anything's missing such as manure, pots etc., ask Madame if possible on a Friday so as to have it on Saturday. In March force the chrysanthemums along as the buds won't open in damp conditions; and don't forget to put the sulphur sheets back over the greenhouse frames. (doc. k)

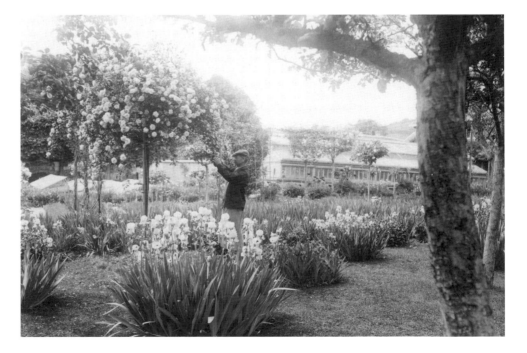

Fig. 34
Félix Breuil (1867–1954) was Claude Monet's head gardener. Here he is looking after the mutabilis rose trees, and the picture also shows Iris pallida and neubronner in the foreground. Photographed by Cl. Pogany (Georges Truffaut).
Published in Félix Breuil, "Les Iris pour bord de rivières, étangs et terrains humides," **Jardinage** 21 (October 1913), p. 2
© Collection Toulgouat

Georges Truffaut-Gardener and Businessman

In the sixteenth century potatoes, or "truffes de terre," were cultivated by "trouffots." The name gradually changed to "truffaut," and around 1750 we pick up the tracks of a certain Claude Truffaut, in the employ of a botanist and gardener. In 1824, Charles Truffaut senior (1795–1864) founded the first Etablissement Truffaut on Rue de Noailles in Versailles. This was the first business in France specialized in the cultivation and sale of rare vegetable species and fresh fruit—a courageous undertaking considering there was still no railroad in those days and mail coaches were very expensive. It was considered a great luxury—if one could afford it—to give friends out-of-season vegetables as presents. Charles Truffaut delighted his rich clientele with strawberries out of season, grapes, melons, pineapples, and other delicacies. In 1834, the firm moved to Versailles-Chantiers, where there was a railroad service. This simplified deliveries to clients, while at the same time reducing prices. In 1855, Charles Truffaut was awarded the Médaille d'Or at the World's Fair. At the same time his garden business began to market excellent orchids, and at the World's Fair of 1878 he started off a real wave of fashion with them. In 1897, Georges Truffaut (1872–1945) gave a decisive stimulus to the family saga by establishing the Georges Truffaut company. He was not only a gardener and businessman, but also a researcher (Laboratoires G. Truffaut) and publisher.

Publications and Publicity Work of the Firm Georges Truffaut

History shows that the Truffaut family successfully used different channels of communication, but Georges Truffaut really revolutionized this. His innovations were numerous and have inspired many after him. In 1896, for example, he published the handbook **Sols, Terres et Composts** with a preface by the chemist and agronomist Pierre-Paul Dehérain.[82] This publication was awarded the Prix Joubert de Hyberderie by the Société Nationale d'Horticulture. In 1911, Georges Truffaut made a name for himself by starting up the above-mentioned magazine **Jardinage,** a guide for amateur gardeners with practical hints and instructions. This lavish review was very progressive in its design and had numerous illustrations, both black-and-white and in color. With a print run of around fifty thousand and ten issues per year, it was a leading example of its kind in the world and enjoyed wide circulation in France, Belgium, and Switzerland. As we have already seen, Truffaut also devoted two articles to Monet. In his report of 1924, which gives a meticulously precise description of a walk through Monet's garden, the gardener and businessman acknowledges the artist's merits:

> Many of the sensationalist pictures, above all the gardens of the Champ de Mars, are but a pale imitation of the designs of Claude Monet. He is a great artist and without doubt one of the prime decorators with flowers, and it would be desirable for many amateur gardeners to have this sense of color, arrange-

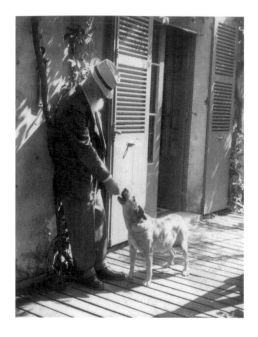

Fig. 35
Jean-Pierre Hoschedé, the youngest son of Claude Monet's second wife, Alice, and author of **Claude Monet: ce mal connu** (1960). He is standing on the wooden veranda at the front of the house in Giverny which has recesses for climbing plants.
© Collection Toulgouat

ment, and love of flowers, combined with a perfect horticultural knowledge of the varieties, their perfection, and the use of different plant types suited to the climate and soil of Giverny. The most beautiful work of Claude Monet, in my opinion, is his garden. It is definitely one that he pursued with real joie de vivre for forty years and in which he experienced his moments of greatest happiness. (doc. l, figs. 24 and 36)

In 1912, Georges Truffaut created the world-famous rose garden at Versailles over an area of ten thousand square meters that today receives up to 1,500 visitors per day. In the same year he published a reply to the numerous studies on plant diseases and pests—the 565-page book **Les Ennemis des plantes cultivées**.[83] This was singled out for special honor by the Société Nationale d'Agriculture and the Société d'Encouragement pour l'Industrie Nationale. In 1914 Georges Truffaut published his first encyclopedia under the title **Comment on soigne son jardin,** which was reprinted time and time again and referred to simply as "Truffaut."

In 1923, he put out the first gardening mail-order catalogue in order to meet nationwide demand. In 1930, he spoke regularly on the radio station "Le Poste Parisien," accompanied by the ditty "Savez-vous planter les choux?" (Do you know how to plant cabbage?), whose popularity became so great that it was even taken up into the repertoire of the scouts. On his program Truffaut gave a gardening tip of the day, and also enchanted his listeners in the weekly program "Causerie." After an instructive visit to the US in 1964 the Truffaut management decided on the slogan

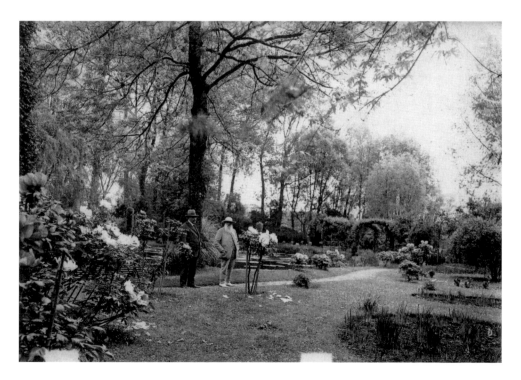

Fig. 36
The garden businessman Georges Truffaut
(1872–1945) visiting his client and friend
Claude Monet; the tree peonies are in bloom.
Photographed by Gouthière (Georges Truffaut).
Published in Georges Truffaut, "Le Jardin de Claude
Monet," **Jardinage** 87 (November 1924), p. 56
© Collection Toulgouat

"everything for your garden under one roof" and established Europe's first "Garden Center" in Chesnay near Versailles. Today the 180-year-old company Truffaut is one of the largest horticulture businesses in France.

Conclusion

At different stages of his life Claude Monet laid out a piece of nature in the form of a garden, which he did with great enthusiasm and increasing expertise. In Giverny he created a complex garden, which is recognized in most general works on garden history.[84] It would not seem possible to separate Monet's achievements as gardener from his fame as an artist. Interestingly, at the end of his life Monet saw his credit as having been to paint by eye, directly from nature, trying to render the impressions of its most ephemeral effects.[85] Was the garden and its seasonally recurring gardening work perhaps also a way of lending these ephemeral effects a moment of duration? The interplay of developments in gardening, technological advances, and professional interest, as shown above, testify to Claude Monet's grandeur as a gardener and also as a painter. In his paintings he succeeded in capturing the ephemeral—what would his garden look like if he were to make it today?

Fig. 37
Postcard of the central path in front of Claude Monet's house in Giverny. The rose arbor has already been established, but the trees are still standing. The photograph presumably dates from between 1904 and 1911.
Courtesy Fonds documentaire du Musée Municipal A. G. Poulain, Vernon

Original Documents in French

(a) "Liste des plantes cultivées par Monet:

plantes vivaces: anémone du Japon, aster, aquilegia, aubrietia, acanthe, aconit, anchusa, bocconia, centaurea, campanule (bordure), delphinium, doronicum, echinops, eryngium, érigeron, gaillarde, helenium, hélianthus, hemerocallis, iris, glaïeuls, crocus, héliopis, lupin, plumbago, rose trèmière, rudbeckia, statice, lilium, papaver, penstemon, gentiane, narcisse, tulipe, sauge, leucanthemum, hydrangea, rosier, pancratium, géranium, dahlia simple et à collerette, polygonum.

plantes annuelles: pois de senteur, capucine, coquelicot simple, reine-marguerite simple, escholtzie, digitale, ipomée, malope, muflier, tabac à fleurs, pavots simples, soucis simple, glaucium, lavatère.

plantes exclues: coleus, pétunia, reine-marguerite double, amarante, balsamine, canna, cinéraire, héliotrope, réséda, immortelle, oeillet d'Inde, oeillet de poète, véronique, coreopsis, agératum, myosotis, calceolaire." Quoted from Jean-Pierre Hoschedé, **Claude Monet: ce mal connu: Intimité familiale d'un demi-siècle à Giverny de 1883 à 1926** (Geneva, 1960), pp. 69–70. Hoschedé's French-Latin plant names have been given in parentheses in several cases for clarity.

(b) Freely translated from: "Jeudi matin 6 heures [Pourville, 6 avril 1882] Chère Madame, ... il faut me mettre en route, profiter de ce magnifique soleil et tâcher de sauver le plus possible de toiles, je dis sauver c'est le mot, car à vrai dire je ne suis content d'aucune, jamais je n'ai eu autant de mal, et quand je pense qu'en si peu de temps j'avais si bien travaillé, tandis qu'ici, la plupart de mes études ont dix et douze séances et plusieurs, vingt. Ces dernières journées sont donc bien importantes pour moi et je vous assure que je ne flâne pas, et si je ne puis être à Poissy pour dimanche juste comme je l'ai dit, ne m'accusez pas, il me faut encore pour bien faire deux journées de soleil et deux ou trois de temps gris et cela, bien entendu, en abandonnant plusieurs toiles, car cela n'en finirait jamais s'il fallait tout terminer. De toute façon, si je ne puis être là dimanche j'y serai mardi ou mercredi." Quoted from Daniel Wildenstein, **Claude Monet, biographie et catalogue raisonné en 5 volumes** (Lausanne, 1974/79), vol. II, p. 218, W 264.

(c) "[Sandviken], 12 mars, 9 heures du soir [1895] ... Je travaille sans arrêt malgré tous ces changements, malgré la neige, mais je ne pourrai arriver à faire des choses terminées; il me faut me borner à faire des aspects en une ou deux fois, impossible de retrouver les mêmes effets, surtout à ce moment de l'hiver. J'avais aussi plusieurs toiles par soleil et voilà bien dix jours qu'il n'a paru, et, quand il viendra, ce sera pour tout fondre. Mais que de belles choses je vois, que de beaux effets que je n'ai pas su voir au début." Quoted from Wildenstein 1974/79, vol. III, p. 283, W 1282.

(d) "[Belle-Ile-en-Mer, Le Palais], lundi soir [13 sept. 86] Je ne sais encore le parti que je vais prendre, si je vais me fixer ici, aller à Noirmoutier, ou renoncer à y aller et continuer mon voyage jusqu'à ce que je trouve l'endroit qui m'empoignera. . . . Maintenant, j'ai un peu peur, si je me fixe ici, de le regretter après, si je vois de plus jolis endroits ou de plus commodes" Original document: Archives Durand-Ruel. Quoted from Wildenstein 1974/79, vol. II, p. 276, W 685.

(e) "Bordighera, 5 mars 84 . . . je saisis mieux cette admirable lumière rose, en la voyant chaque jour du matin au soir; c'est adorable, idéal, et chaque jour plus beau. Mes études vont bien, toutes s'avancent et prennent meilleure façon depuis ces derniers jours. . . . Vous avez vu les anémones que je vous ai envoyées pour votre fête, les roses et les rouges frisées; il y en a partout à l'état sauvage; mon petit Italien qui porte mon bagage m'en fait d'énormes bouquets, pendant que je travaille, et quantité d'autres fleurs. Comme nous serions heureux ici ensemble et quel joli jardin nous y ferions! . . . Il règne ici un ton rose extraordinaire, intraduisible, les matinées sont idéales." Quoted from Wildenstein 1974/79, vol. II, p. 243, W 438.

(f) "[Rouen], jeudi soir 6 heures [16 février 1893] Ma bonne chérie, . . . J'ai pu ce matin, après avoir travaillé, aller faire ma visite à M. Varenne au Jardin des plantes. Très aimable, M. Varenne, et je pense avoir pas mal de choses de lui; il m'a offert un pied de ce beau bégonia grimpant que j'apporterai dimanche. Nous avons visité toutes les serres, c'est superbe, quelles orchidées! c'est épatant! Quant aux plantes pour les jeunes botanistes, à ma prochaine visite, il me présentera au jardinier-chef qui ne doit donner des plantes que sur l'ordre de M. Varenne, mais il me dit qu'il serait bon que les enfants me donnent une sorte de liste des genres et des familles qu'ils désirent; ils pourraient faire cette liste avec le curé. Il m'a donné pas mal de bons conseils sur bien des choses; enfin, ce sera une bonne connaissance. Il m'a dit d'aller partout comme chez moi. Voilà." Quoted from Wildenstein 1974/79, vol. III, p. 269, W 1175.

(g) "M. Claude Monet a réalisé à Giverny, au bord de la petite rivière si poétique, l'Epte, détournée dans des étangs artificiels encadrés de grands peupliers d'Italie, des scènes de berges de rivières fleuries qui ne se voient nulle part ailleurs, sinon peut-être dans de très rares propriétés du sud de l'Angleterre où les Iris et les Nénuphars jouent le rôle principal. . . . Je le [cet article] publie précisément dans ce mois d'octobre qui est l'époque la plus favorable pour planter les Iris. . . . Nos abonnés profiteront ainsi de l'expérience de ceux qui ont créé en France un des plus beaux jardins qui existent, où se mêlent les plantes à bulbes, les plantes vivaces, les Iris et les Rosiers pour former des ensembles harmonieux de masses de fleurs monochromes qui, associés savamment par un des maîtres de la couleur, laissent les visiteurs sous le charme." Quoted from Félix Breuil, "Les Iris pour bord de rivières, étangs et terrains humides," **Jardinage** 21 (October 1913), pp. 2–9.

(h) "Iris Monieri. – C'est un des plus beaux Iris pour border les eaux. Les fleurs sont d'un jaune citron portées par des tiges de 1 mètre, elles sortent de touffes de feuilles lancéolées en juin-juillet. C'est très probablement un hybride entre une variété d'Iris spuria et d'Iris ochroleuc. . . . On plante des divisions de rhizomes à une distance qui varie de 30 à 40 centimètres suivant les variétés. A Giverny les Iris sont cultivés en bordures plus ou moins larges pour encadrer les grandes plates-bandes de plantes vivaces, ou bien encore en groupes sur les pelouses. Les Iris peuvent rester de sept à huit ans sans être replantés. Depuis de longues années que les Iris sont cultivés ici, à chaque renouvellement de plantation, le sol est reconstitué par un apport de terre franche silicieuse. (Je n'ai pas employé d'engrais spécialement pour les Iris, mais la disposition de ces plantes en bordures des plates-bandes fait qu'elles profitent des engrais qui sont distribués aux plantes vivaces)." Quoted from Breuil 1913, pp. 6, 8.

(i) "Agé aujourd'hui de 82 ans, qu'il porte gaillardement, M. Félix Breuil est jardinier de naissance. Son père soigna pendant 40 ans, à Regmalard, le jardin du docteur Mirbeau, père de l'écrivain. C'est d'ailleurs Octave Mirbeau qui le 'passa' à son ami Claude Monet. Il eut la charge du jardin de Giverny, et se spécialisa dans la culture des fameux Nymphéas. Il nous parle du célèbre jardin avec son abondance de fleurs de toutes sortes, ses grands rhododendrons, ses rosières grimpants. 'Monet, nous dit-il, aimait toutes les fleurs.' Il eut à s'occuper tout spécialement du 'Bassin', aux rives herbues et sinueuses, sous l'arc du pont japonais. Il assista à son agrandissement, et c'est lui qui, sur les indications de Monet lui-même, préparait la féerie des floraisons aquatiques, dans les tons demandés. . . . Tandis que M. Breuil égrène ses souvenirs, c'est toute une grande époque de l'Art français qui défile sous nos yeux. Une époque qui doit beaucoup aux 'Nymphéas' et à leur jardinier. . . . Ce dernier n'est guère retourné à Giverny. Mais, de temps en temps, il prend le train pour Paris. Il ne manque jamais d'aller passer quelques heures à l'Orangerie. Où il retrouve, avec le souvenir du Maître, ses chers Nymphéas." Quoted from Françoise Bonnef, "Aux rives de l'Huisne, le jardinier des 'Nymphéas' cultive des roses," **Paris-Normandie** (Edition d'Evreux), November 29, 1949.

(j) "Le jardin, ayant pris la place du verger, étant devenu grand, difficile à entretenir et à soigner du fait de la diversité des espèces qui y étaient cultivées, diversité entraînant elle-même une grande diversité dans les modes de cultures. En effet, d'une part la serre, dont une partie était serre chaude et les châssis et, d'autre part le bassin, exigeaient un jardinier très compétent [qu'on trouva en la personne de Félix Breuil]. . . . Il fit merveille, avec quatre ou cinq aides sous ses ordres, dont un était exclusivement chargé de l'entretien du bassin qui exigeait un nettoyage constant de la nappe d'eau, l'enlèvement des algues et des lentilles d'eau, l'arrachage des feuilles de nymphéas dont l'exubérante végétation l'eût envahi complètement en peu de temps. Monet tenait en effet absolument à ce que

la nappe d'eau fut toujours nette, afin qu'elle pût mieux servir de miroir au ciel et à ses nuages, aux ombres et aux reflets de son pourtour. Je viens de dire que Monet fut contraint de prendre un chef jardinier, Félix Breuil; il me faut donc à son sujet, donner des précisions, car il fit beaucoup pour la splendeur du jardin de Giverny par son savoir qui était grand, mais surtout parce qu'il savait écouter le 'patron' et qu'il savait se limiter à exécuter les plans conçus par celui-ci, sans jamais le contrarier. Ce qui ne veut pas dire qu'ils étaient toujours d'accord, ni que Monet ne tenait pas compte des avis ou des remarques de Félix qu'il savait savant jardinier. On peut donc conclure que Monet fut le créateur—j'allais dire le peintre—de son jardin et que Félix en fut le parfait exécutant. ... Lorsque Félix Breuil se retira, Monet le remplaça par un autre chef jardinier des plus capables, Lebret. Celui-ci, jusqu'à sa mort survenue pendant l'occupation, sut maintenir le jardin dans sa magnificence"Quoted from Hoschedé 1960, pp. 64–65.

 (k) "Giverny, [février 1900?]

Semis: environ 300 pots Pavot—60 [pots] Pois de senteur

 environ 60 pots Argémone blanche—30 [pots Argémone] jaune.

 Sauge bleue—Nymphéas bleu en terrine (serre)—Dahlias—Iris—Kaempferi

—Du 15 au 25, mettre les dahlias en végétation sur couche; bouturer avant mon retour ceux qui sortiront.—Penser aux bulbe de lis.—Si les pivoines du Japon arrivent, les mettre de suite en place si le temps le permet, en ayant bien soin d'abriter pendant les premiers temps les bourgeons du froid, comme de l'ardeur du soleil. S'occuper de la taille: les rosiers pas trop longs, sauf les variétés épineuses. En mars, semer les gazons, bouturer des petites capucines, avoir bien soin dans la serre du gloxinia, des orchidées, etc., ainsi que des plantes sous châssis. Mettre en place les bordures comme c'est convenu; installer les fils de fer pour les clématites et pour les rosiers sarmenteux dès que Picard aura fait le nécessaire. En cas de mauvais temps, faire des paillassons en roseaux, mais plus clairs que les premiers. planter les éclats de rosiers du bassin autour du fumier dans les poulaillers. S'occuper sans retard des planches à goudronner et planter aussitôt les hélianthus laetiflorus en bonnes touffes. Pour tout ce qui manquera comme fumier, poteries etc., le demander à Madame de préférence le vendredi pour l'avoir le samedi. En mars activer la gestation [?] les chrysanthèmes qui ne débourreraient pas par un peu d'humidité; puis ne pas oublier de remettre les toiles sulfatées sur le châssis de la serre.—" Quoted from Wildenstein 1974/79, vol. IV, p. 341, W 1501a.

 (l) "Bien des présentations qui ont fait sensation, en particulier dans les jardins du Champ de Mars, ne sont que des copies très pâles des conceptions de Claude Monet. Il est un grand artiste peintre, et certainement le premier des décorateurs au point de vue floral, et il serait à souhaiter que beaucoup d'amateurs de jardins aient le sens de la couleur et de la disposition et l'amour des plantes elles-mêmes,

caractérisé par une connaissance technique parfaite des variétés, de leur perfectionnement et de l'utilisation des types végétaux appropriés au climat et au mauvais sol des jardins de Giverny. La plus belle œuvre de Claude Monet est, à mon avis, son jardin. Dans tous les cas, c'est celle qu'il savoure avec volupté depuis quarante ans et à laquelle il doit ses joies les plus grandes. — " Quoted from Georges Truffaut, "Le Jardin de Claude Monet," **Jardinage** 87 (November 1924), pp. 54–59, here p. 59.

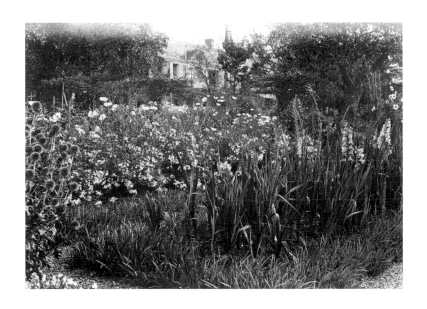

1 The most recent art-historical essay on the reorganization of Paris by Baron Haussmann and its influence on art is Clare P. Willsdon, "'Promenades et plantations': Impressionism, Conservation and Hausmann's Reinvention of Paris," in **Soil and Stone: Impressionism, Urbanism, Environment,** edited by Frances Fowle and Richard Thomson (Hants and Edinburgh, 2003), pp. 107–124. On landscaping in connection with the construction of national identities see Anne Helmreich, **The English Garden and National Identity: The Competing Styles of Garden Design 1870–1914** (Cambridge, 2002).

2 See the overview of publications in Michel Racine et. al., **Créateurs de jardins et de paysage en France de la Renaissance au XXIe siècle,** vol. 2: **Du XIX au XXIième siècle** (Arles, 2002), p. 2. The Societé Nationale d'Horticulture was founded in 1827.

3 "Ces végétaux exotiques ont apporté de la variété et de l'éclat aux plantations, ils ont changé l'aspect des jardins et favorisé le goût de l'étude des végétaux." A. Alphand, **Les Promenades de Paris. Historie—description des embellissements—dépenses de création et d'entretien des Bois de Boulogne et de Vincennes: Champs-Elysées—parcs—squares—boulevards—places plantées. Etudes sur l'art des jardins et arboretum** (Paris, 1867–73), quote p. XXXVII. There is an explanation on pp. XXXI–XXXVIII about how the vast variety of new plants was changing the conventional forms of landscaping, for example by going beyond the scope of the formal garden and also changing the landscape garden.

4 J. C. N. Forestier, **Jardins. Carnet des plans et de dessins** (Paris, 1920), n.p. (only the plans are numbered with Roman numerals).

5 Daniel Wildenstein, **Monet oder der Triumph des Impressionismus: Werkverzeichnis in fünf Bänden** (Cologne, 1996), vol. I, p. 93. Since the eighteenth century Edouard Manet's family owned property in Gennevilliers, which was opposite Argenteuil on the other bank of the Seine but today is part of Argenteuil. His grandfather was mayor there. See Paul Hayes Tucker, **Monet at Argenteuil** (New Haven, 1982), p. 19. Manet's cousin De Jouy still lived in Gennevilliers in the eighteen-seventies, and he visited him often; see Wildenstein 1996, vol. I, p. 113.

6 As described in Tucker 1982, pp. 11–20.

7 Wildenstein 1996, vol. I, p. 93. Madame Aubry's son Eugène adopted the name Aubry-Vitet which the family bore from then on. See Rodolphe Walther, "Les Maisons de Claude Monet à Argenteuil," **Gazette des Beaux-Arts,** 108th year, 6th period, vol. 68 (1966), pp. 333–342, here p. 334. Ludovic Vitet (1802–73) was the first inspector of France's historical buildings and structures, the "Monuments historiques." In the eighteen-sixties he held public disputes with Eugène Emmanuel Viollet-le-Duc (1814–79). His correspondence with Prosper Mérimée (1803–70) is also well known. In 1847, Ludovic Vitet published **Etudes sur l'histoire de l'art,** reprinted in 1864, which contains a section on gardens. See also Monique Mosser, "Jardins 'Fin de siècle' en France: Historicisme, Symbolisme et Modernité," **Revue de l'Art** 3, no. 129 (2000), pp. 41–60, here p. 45.

8 As described in Walther 1966 (see note 7), here p. 334.

9 Daniel Wildenstein, **Biographie et catalogue raisonné en 5 volumes** (Lausanne, 1974/79), here vol. I, p. 58.

10 Théodule Ribot (1823–91) painted in dark colors. His undated picture **Breton Fishermen and their Families** (New York, Metropolitan Museum of Art) is very reminiscent of Gustave Courbet's paintings. Ribot is considered a Realist. The remark ascribed to Claude Monet on January 8, 1927, by Thiébault-Sisson—that in Ribot's studio he first had to take down the black cardboard that had been stuck to the windows, in order to get a view of the Seine—should be treated with caution, Wildenstein recommends (Wildenstein 1974/79, vol. I, p. 58).

11 Wildenstein 1996, vol. I, p. 93: "On January 2 [1872] Boudin went to Monet's house-warming. This was the beginning of the fruitful period in Argenteuil, that was to become the golden age of Impressionism." See also Wildenstein 1974/79, vol. I, p. 58.

12 The Latin names of the plants are generally not given in the text unless contemporary sources use them too.

13 As described in Christopher Thacker, **Die Geschichte des Gartens** (Zurich 1979), pp. 242–245. English version: **The History of Gardens** (London, 1979). Nathan Cole was also responsible for the plantings at the Kensington Gardens. Alphand (1867–73), p. LVII, emphasizes the suitability of this kind of planting too, for example so as to best display the new exotic plants such as "les Wigandia, les Erythrina, les Acanthes, les Bégonias, les Calladium, les Canna."

14 Thacker 1979, p. 244.

15 Ibid., p. 242.

16 Gustave Caillebotte (1848–94) came from a well-to-do family, his father was an estate agent and real-estate dealer. His first known pictures date from 1872. In 1873, after his father's death, he applied for admission to the Ecole des Beaux-Arts and was successful. He soon joined the group of Impressionists and exhibited at the Second Impressionists' Exhibition in 1876. Due to his comfortable background he was not dependant on the sale of his pictures and was also able to support his artist-friends financially, for example he rented a small apartment in Paris for Claude Monet. Caillebotte had a garden of his own in Petite-Gennevilliers, today part of Argenteuil. This garden was ten thousand square meters in size and was first mentioned in 1881. It was a mixture of a decorative and a kitchen garden, but unfortunately has been built over by industrial premises. Caillebotte was an enthusiastic gardener and a member of the Societé d'Horticulture d'Argenteuil. See Pierre Wittmer, **Caillebotte au jardin, la période d'Yerres (1860–1879)** (Saint-Rémy-en-l'Eau, 1990). In his will, Caillebotte bequeathed his collection of sixty-seven Impressionist paintings to the Musée du Luxembourg, that did not want to accept them at first. Today the works of his collection form the centerpiece of the Musée d'Orsay.

17 Wittmer 1990, diagrams pp. 66–67 and 191.

18 For further reading on the issue of movement and the parks of the nineteenth century see Anne Freytag, "When the Railway Conquered the Garden: Velocity in Parisian and Viennese Parks," in Michel Conan, ed., **Landscape Design and the Experience of Motion** (Washington, 2003), pp. 215–242.

19 Heinz-Dieter Krausch, "**Kaiserkron und Päonien rot...,**" Entdeckung und Einführung unserer **Gartenblumen** (Hamburg, 2003), pp. 133–137. See also Eric Bois and Anne-Marie Trechslin, **Wunderwelt der Gartenblumen,** vol. 1: **Zwiebel- und Knollenpflanzen** (Zurich, 1964), p. 108.

20 Philippe de Vilmorin and Edouard André, **Les fleurs de pleine terre: comprenant la description et la culture des fleurs annuelles, bisannuelles, vivaces et bulbeuses de pleine terre,** 5th ed. (Paris, 1909), p. 347: "Dahlia juarezi ... Very large and beautiful variety with vivid scarlet flowers ... This wonderful plant was brought in 1872 from Mexico, the home of most of the dahlias." Freely translated from: "Dahlia juarezi ... Très grande et très belle espèce à fleurs d'un rouge écarlate vif ... Cette magnifique plante nous est venue, en 1872, du Mexique, patrie de la plupart des Dahlias." In addition to Truffaut, to whom a separate section of this publication is devoted, Vilmorin-Andrieux & Cie. were the most significant plant dealers in nineteenth-century France. There is evidence of contact between Vilmorin and Claude Monet, see note 78 below. The history of Vilmorin-Andrieux & Cie. began in 1743 when Madame Claude Geoffroy started business as a "master seed-trader" in Paris, at Quai de la Mégisserie, where there is still a shop today. She married Pierre Andrieux, a dealer in seeds and royal botanist, their daughter Adélaide wedded Philippe-Victoire de Vilmorin in 1774, and in 1775 the business took on the name Vilmorin Andrieux, which it kept until 1986. Today over seventy percent of all amateur gardeners know the brand "Vilmorin." See also notes 48 and 78.

21 Victor Lemoine (1823–1911), flower-grower and florist, settled in Nancy in 1849 after an apprenticeship with Van Houtte, among others, and helped make the city the center of begonia hybrid cultivation. Beginning in 1870 he worked with lilac and his first new varieties Gloire de Lorraine and Jacques Callot were brought onto the market in 1876. In 1890, he launched the fuller white-flowering variety Mme. Lemoine, which is still known today. Lemoine also distinguished himself in the breeding of other plants, for example geranium and gladiolus varieties. In 1889, he received a gold medal at the World's Fair for his floral compositions.

22 Victor Lemoine described his cultivation procedures in **Revue horticole: Journal d'horticulture pratique** (Paris, 1883), pp. 550–551. **Revue horticole** was the leading French garden magazine of the nineteenth century according to Racine 2002, vol. 2, p. 2, and others. Monet subscribed to it in later years, see **Monet the Gardener,** ed. Sydney Eddison and Robert Gordon (New York, 2002), p. 17.

23 "... additionally there was the gardener Lelièvre, who was paid separately." Wildenstein, 1996, vol. I, p. 130.

24 John Rewald, The History of Impressionism (New York, 1946), p. 281. See also Jean-Pierre Hoschedé, **Claude Monet: ce mal connu. Intimité familiale d'un demi-siècle à Giverny de 1883 à 1926** (Geneva, 1960), p. 57.

25 David Joel, **Monet at Vétheuil and on the Norman Coast 1878–1883** (Woodbridge, 2002), p. 195.

26 Wildenstein 1996, vol. I, p. 111. Monet only speaks of moving his studio.

27 John House, **Monet: Nature into Art** (New Haven, 1986), p. 12. This note in the "Carnets," Monet's notebooks, from 1872 through 1875, has definite rarity value. The "Carnets" usually contain the cashing up, but an address list from ca. 1880 is a further exception. The value of this remark is greater still because hardly any of Claude Monet's notes on his gardening have been preserved.

28 Reconstruction of the garden by Colin B. Bailey, in **Masterpieces of Impressionism and Postimpressionism: The Annenberg Collection,** ed. Colin B. Bailey, exh. cat. Philadelphia Museum of Art, 1989, p. 52 and note, pp. 158–159. Other paintings used in the reconstruction of the garden were: W 384–386, W 406–409, W 410–415. In the reconstruction, mallows (rose mallows) and gladioli are assumed to have been the main plants.

29 See Bailey 1989, pp. 158–159.

30 Robert L. Herbert, **Impressionism: Art, Leisure, and Parisian Society** (New Haven and London, 1988), p. 146. Also Mosser 2000, p. 45.

31 Bailey 1989, p. 159, reference to Arthur Mangin, **Histoire des Jardins anciens et modernes,** 2nd ed. (Tours, 1887).

32 Detailed description of the gardens in the fragment of Gustave Flaubert's novel **Bouvard et Pécuchet** (written in 1874 and published posthumously in 1881) in Thacker 1979, p. 241. The two upstarts base their gardens on Pierre Boitard, **Manuel de l'architecte des jardins** (Paris 1854). In previous years this author wrote disparagingly of ornamental gardens, whose only decoration was copious flowering plants, as gardens of people with low income. See also Bailey 1989, p. 159.

33 Hoschedé 1960, p. 60.

34 Mosser 2000, p. 50.

35 Emile Zola, "Les Actualistes," **Mon Salon,** May 24, 1868. "The painters who love their time with all their heart, with all their artist's soul, see reality differently. Above all they take great pains to ascertain the exact meaning of things. They are not content with a ridiculous trompe-l'oeil but interpret their epoch because they feel it alive within them, they are possessed by it and glad to be possessed by it ... Their works are lively because they have taken them from life and painted with all the love they feel for 'modern themes.' Of these painters I would like to name first and foremost 'Claude Monet.' He has imbibed the milk of our time, grown up full of admiration for his surroundings, and will grow to be greater still. He loves the views of our cities ..." French reprint: Emile Zola, **Ecrits sur l'art** (Paris, 1991), pp. 206–211, here p. 207: "Les peintres qui aiment leur temps du fond de leur esprit et de leur cœur d'artistes entendent autrement les réalités. Ils tâchent avant tout de pénétrer le sens exact des choses; ils ne se contentent pas de trompe-l'œil ridicules, ils interprètent leur époque en hommes qui la sentent vivre en eux, qui en sont possédés et qui sont heureux d'en être possédés ... Leurs œuvres sont vivantes, parce qu'ils les ont prises dans la vie et qu'ils les ont peintes avec tout l'amour qu'ils éprouvent pour 'les sujets modernes.' Parmi ces peintres, au premier rang, je citerai 'Claude Monet.' Celui-là a sucé le lait de notre âge, celui-là a grandi et grandira encore dans l'adoration de ce qui l'entoure. Il aime les horizons de nos villes . . ." (Emphasis added by the authors.)

36 The paintings referred to here are: **Houses at Argenteuil** (Maisons d'Argenteuil), 1873, W 277, by the artist, undated; **Spring at Argenteuil** (Printemps à Argenteuil), 1872, W 199, by the artist, undated; and **Flowered Riverbank, Argenteuil** (Argenteuil, la berge en fleurs), 1877, W 453.

37 Wildenstein 1996, vol. I, p. 132.

38 From this time there are a total of three paintings with the title **The Parc Monceau** (Le parc Monceau), 1876, W 398; 1876, W 399 (not dated by the artist); 1876, W 400 (not dated by the artist).

39 House 1986, p. 147.

40 As described in Joel 2002, pp. 33–34.

41 Wildenstein 1974/79, vol. I, p. 139.

42 Wildenstein 1974/79, vol. I, p. 140, reproduces a postcard of Vétheuil around 1900, on which the garden wall can also be seen.

43 As described in Joel 2002, pp. 52–53.

44 1880, W 591 shows a view of Vétheuil, on which Monet's studio boat can clearly be seen. See Joel 2002, p. 21.

45 Edouard André, L'Art des jardins: Traité général de la composition des parcs et jardins (Paris: G. Masson Editeur, 1889), p. 688: "I recommend that exotic plants not be excluded from our parks, but if they were restricted to the immediate environs of the residential buildings and the more distant parts of the garden were planted with native flora, the general impression would be better, and scenes full of enchanting details would result." Freely translated from: "Je ne conseille pas d'exclure de nos parcs la flore exotique, mais si elle était restreinte aux abords de l'habitation, et si la flore indigène était appelée à orner les parties plus éloignées, l'effet général serait meilleur et des scènes pleines de charmants détails en seraient le résultat." Edouard André's book is dedicated to "mon illustre maître" Adolphe Alphand.

46 Vivian Russell, Monet's Garden: Through the Seasons at Giverny (London, 1995), p. 30.

47 This reference is from a lecture given by Adrian Lewis (De Monfort University, Leicester) at the conference Monet and French Landscape Painting in Edinburgh on October 17, 2003, which he has kindly put at our disposal. The conference Monet and French Landscape Painting (October 1–18, 2003) took place in conjunction with the exhibition "Monet: The Seine and the Sea" (August 6–October 26, 2003) in the National Gallery of Scotland, Edinburgh.

48 These new strains are described in Edouard André and Philippe de Vilmorin, Les fleurs de pleine terre: comprenant la description et la culture des fleurs annuelles, bisannuelles, vivaces et bulbeuses de pleine terre, 5th ed. (Paris, 1909), pp. 461–462. See also Krausch 2003, p. 186. Lemoine presented further improvements, including giant gladioli, at the World's Fair in 1889. The depiction of gladioli in Claude Monet's works is a topic little considered in art history but is dealt with in the essay of the Monet-specialist John House: "Monet's Gladioli," Bulletin of the Detroit Institute of Arts, vol. 77, no. 1/2 (2003), pp. 8–17. See also notes 20 and 78.

49 Sunflowers were so fashionable in the early eighteen-eighties in England that a columnist of the magazine Beautiful Houses made the somewhat sarcastic remark that a blue pot and a sunflower at the window were "all that is needed to be fashionably aesthetic" in terms of interior decoration. See Debra N. Mancoff, Sunflowers (New York, 2001), p. 83.

50 The garden designer Russell Page (1906–85), for example, writes: "Many border plants, for example most of the composite flowers, only create an impression en masse and through their color. I only use … Helenium, sunflowers [Helianthus], and similar plants when I am aiming for broad tonality …" Russell Page, The Education of a Gardener (London, 1962).

51 Title deeds after Wildenstein 1996, vol. I: 1890, p. 274; 1893, p. 288; 1901, p. 353.

52 Hoschedé 1960, pp. 69–70.

53 Krausch 2003, pp. 322–329, here p. 329; and pp. 113–115, here p. 115.

54 "The Bretons are pig-headed, the Americans are even more so. But Monsieur Claude Monet outdoes them by far. This landscape painter is very much in fashion on the other side of the Atlantic. At the same time, the Yankee artists have come to Giverny, a small town two hours from Paris and the home of the artist, believing they will be able to emulate him in every conceivable way … One of the consequences of this 'invasion' is that the costs of living have trebled: everything is sold 'à l'américaine,' and the few Frenchmen that still remain there watch the Anglo-Saxon expansion with an uneasy feeling." Freely translated from: "Les Bretons sont têtus; les Américains le sont plus encore; mais M. Claude Monet les bat de plusieurs longueurs. Ce peintre paysagiste est très en vogue et l'autre côté de l'Atlantique; aussi se croyant capable de l'imiter en tous les points, des artistes yankees sont-ils venus à Giverny, petit village à deux heures de Paris, séjour de notre peintre … L'une des conséquences de cet ›envahissement‹ est que la vie à Giverny à triplé de prix: tout s'y vend à l'américaine, et les quelques Français qui habitent encore la petite ville voient et d'un mauvais œil cette nouvelle expansion anglo-saxonne." Anonymous, La République Française, June 7, 1904. Also in Lyon Républicain, June 9, 1904; L'Evénement, June 10, 1904; and Paris, June 11, 1904.

55 Gérald van der Kemp, Ein Besuch in Giverny (Versailles, 2003). See pp. 26–32 for a description of the procedure. A discussion of the restoration of Claude Monet's garden is given by Fred Whitsey, "The Puzzle at Giverny: Claude Monet's Garden Restored," Country Life, vol. 170, no. 4378 (July 16, 1981), pp. 166–168. Whitsey's description of Claude Monet's garden assumes a distinction between English and French landscaping.

56 The letters of Monet's first wife, Camille Doncieux, have been inexplicably lost. The preserved letters to Alice Hoschedé are transcribed in full and published in the original French in the first edition of Wildenstein's works catalog (5 vols., 1974/79). An anthology was published in 1989 by Richard Kendall under the title Monet by Himself. In a letter to Alice of December 10, 1885 (Wildenstein 1974/79, vol. II, p. 270, W 639), Monet mentions that he has written Durand-Ruel a ten-page letter (December 10, 1885, W 638). This served as a reference by which to calculate the average length of Monet's letters to Alice for this essay. The letters to Alice are not numbered separately in Wildenstein's catalogue raisonné.

57 This criticism is not from Alice's letters directly, but from Monet's replies. The authors do not know whether Alice Hoschedé's letters have been archived, let alone transcribed.

58 Hoschedé 1960, p. 58.

59 The authors would like to thank Monsieur Ciais of the Parks and Gardens Authority in Rouen, who put a wealth of unpublished material on Emile Varenne at our disposal.

60 Abbé Anatole Toussaint (born 1863) was present at most of the events of the small artistic community in Giverny. He was a botanical specialist and helped Michel Monet and Jean-Pierre Hoschedé in these matters. See Sophie Fourny-Dargère, Blanche Hoschedé-Monet 1865–1947: Une artiste de Giverny, exh. cat. Musée Municipal A. G. Poulain (Vernon, 1991), p. 20. Toussaint published the following pieces: Etude étymologique sur les flores normande et parisienne, comprenant les noms scientifiques français et normands des plantes indigènes et communément cultivées (1906) and Europe et Amérique (nord-est): Flores comparées comprenant tous les genres européens et américains, les espèces communes aux deux contrées, naturalisées et cultivées (1912).

61 Jean-Pierre Hoschedé and Anatole Toussaint, "Flore de Vernon et de La Roche-Guyon," Bulletin de la Société des Amis des Sciences Naturelles de Rouen (Rouen, 1898).

62 In a letter of January 24, 1893, Monet asks his long-standing exhibitor Paul Durand-Ruel to let him know how long the exhibition of Japanese art would be on for, since he would definitely not like to miss it: "P. S.—Vous seriez aimable de me faire savoir la durée de l'exposition japonaise qui a lieu chez vous et que je tiens absolument à voir." Lionello Venturi, Les Archives de l'Impressionnisme, vol. I (New York and Paris, 1939), p. 347. See also Wildenstein 1996, vol. I, p. 288.

63 See also Geneviève Aitken and Marianne Delafond, **La collection d'estampes japonaises de Claude Monet à Giverny** (Lausanne, 2003). An informative publication on Monet's affinity to formal characteristics of Japanese art is **Monet & Japan,** ed. Pauline Green, exh. cat. National Gallery of Australia, Canberra, and Gallery of Western Australia, Perth, 2001. House 1986 is the first publication ever to deal in depth with Japanese themes in connection with Monet.

64 Madam Kuroki was the niece of Kojiro Matsuka, whose collection is the nucleus of the National Museum of Western Art in Tokyo. See also Haru Matsuka Reischauer, **Samurai and Silk: A Japanese and American Heritage** (Cambridge, Mass., 1986).

65 Henri de Vilmorin, **Chrysanthème** (Paris, 1908), pp. IX–XII; Mosser 2000, p. 57; Fell 1994, p. 132.

66 In addition to the water-lilies, the "Pièce d'eau des **Nymphæas**" has an almost cordate outline and three plots in the center for further aquatic plants such as lotuses and water hyacinths. Lord Richard Seymour Conway, Earl of Yarmouth and Marquis of Hertford, who purchased the property of Bagatelle in 1835, established the pond there prior to 1870. The property of Bagatelle, which was twenty-four hectares in size and had been privately owned since the eighteenth century, was bought in 1905 by the city of Paris and adapted to the needs of the Parisians by the renowned landscape gardener and head curator of the gardens of Paris, J. C. N. Forestier. See also Robert Hénard, "Les Jardins de Bagatelle," **La Grande Revue,** May 10, 1907, p. 459 ff. Robert Joffet, **Bagatelle: histoire et guide** (Paris, 1954).

67 Only the reminder is signed with Latour-Marliac's name. According to the Archives Latour-Marliac, all three manuscripts were written by Latour-Marliac himself.

68 Places marked [???] could not be deciphered. The authors would like to thank Sylvie Benedetti (Ets. Latour-Marliac, Le Temple-sur-Lot) for her labors in deciphering these manuscripts especially for the present exhibition. This was necessitated by the virtual illegibility of the handwritten document.

69 This species was not new, but rare, and was first marketed by Latour-Marliac in 1900. It is one of the smaller kinds of water-lily—depth of planting: fifteen to forty centimeters. Water area covered: 0.5 square meters.

70 A species bred by Latour-Marliac in 1901 with wine-red flowers.

71 A species bred by Dreer in 1899. Goblet-shaped, fuchsia-colored double flower. Purple leaves that turn dark green in the mature plant. Ets. Latour-Marliac still consider it one of the most beautiful species cultivated today.

72 A species bred by Dreer around 1904 with large flowers of pomegranate-red.

73 Many thanks to Mr. Zimmermann of the Zürcher Kantonalbank and also to Sylvie Benedetti who kindly obtained this information for us from the former director of the Banque de France.

74 The business was taken over in 1991 by the Stapeley Water Gardens in Cheshire, England.

75 Irises: W 1622 and W 1623, both c. 1899–1900. **Irises in Monet's Garden,** 1899–1900 (cat. 39), **The Garden,** 1900 (cat. 40). Moisture-loving varieties: W 1831 until 1841, dates from 1914/22. **Water-Lily Pond with Irises,** ca. 1914/22 (cat. 70).

76 Félix Breuil, "Les Iris pour bord de rivières, étangs et terrains humides," **Jardinage** 21 (October 1913), pp. 2–9.

77 Octave Mirbeau, "Claude Monet et Giverny," **L'Art dans les deux mondes,** March 7, 1891. For an analysis of the coverage of Monet and a detailed, annotated bibliography, see Steven L. Levine, **Monet and His Critics** (New York, 1974/76), esp. chapters VII and VIII on the **Nymphéas.** See also the biographical article by Linda Schädler in the present publication.

78 In a letter from Octave Mirbeau to Monet, dated mid July 1890, Vilmorin is mentioned as a supplier; see Octave Mirbeau, **Correspondance avec Claude Monet** (Tusson, 1990), pp. 97–98. Vilmorin's most significant publications are Philippe de Vilmorin. **Manuel de floriculture** (Paris, 1908), and Edouard André and Philippe de Vilmorin, **Les fleurs de pleine terre: Comprenant la description et la culture des fleurs annuelles, bisannuelles, vivaces et bulbeuses de pleine terre** (Paris, 1894). See also notes 20 and 48.

79 Iris pallida, neubronner, flavescens, germanica, Mme. Claude Monet, and stylosa.

80 Iris pseudoacorus, fulva, virginica, ochroleuca, gigantea, aurea, ochraurea, monieri, monspur, spuria, sibirica, guldenstadtiana, and delavayi.

81 Pascal, Eugène, Florimond, and Joseph are mentioned as assistant gardeners and worked for Monet with certainty around 1900. See Wildenstein 1974/79, vol. III, p. 344, W 1527.

82 Pierre-Paul Dehérain (1830–1902) was a member of the Académie des sciences (1887) and founder of the **Annales agronomiques** (1875).

83 Georges Truffaut, **Les ennemis des plantes cultivées: maladies, insectes: détermination rapide et pratique; méthodes de traitement: traité complet de pathologie et de thérapeutique végétales** (Versailles, 1912).

84 Such as Thacker 1979, p. 265; Filippo Pizzoni, **Kunst und Geschichte des Gartens: Vom Mittelalter bis zur Gegenwart,** trans. from the Italian by Ulrike Stopfel (Stuttgart, 1999), p. 256; Racine 2002, pp. 133–135. Claude Monet's garden evidently inspired other artists to create a garden too, Childe Hassam for example. See Bill Laws, **Artists' Garden** (London, 1999). Sometimes Claude Monet's garden serves as a model for designing gardens today. Derek Fell, for example, writes that a garden by the firm Stapeley Water Gardens—modeled on Monet's water garden—won a prize at the Chelsea Flower Show. Fell gives hints and "recipes" about how elements of Monet's garden can be applied one's own landscaping: Derek Fell, **The Impressionist Garden: Ideas and Inspiration from the Gardens and Paintings of the Impressionists** (London, 1995), p. 88

85 Letter to E. Charteris from Giverny, June 21, 1926; in Wildenstein 1974/79, vol. IV, p. 421, W 2626.

All translations of quotations are by Will Firth unless the notes specify other sources. The translations of documents C, E, F, and K are taken from Kendall 1989.

LINUM PUBESCENS SIBTHORPIANUM Planch.

Orient Plein air

Linda Schädler

Biography

This biography focuses in particular on Monet's passionate interest in his gardens — an interest he shared with many friends and a subject of increasing attention in the press in his later years. Penniless and rejected by conservative critics early in his career, Monet earned widespread acclaim as an "Impressionist par excellence" by the mid-eighteen-seventies and was recognized a decade later both in France and abroad as one of the most important painters of this time. Thus this biography is concerned with Monet's successes and failures as well as his family life, his relations with art dealers, and the environment in which Impressionism emerged.

The Early Years: 1840 – 1871

Youth in Le Havre

Claude-Oscar Monet was born in Paris on November 14, 1840. He spent much of his youth in Sainte-Adresse, a town near Le Havre. After the death of his mother in 1857, his aunt Marie-Jeanne Lecadre assumed an important role in his life, as it was she who encouraged him in his efforts to become a painter and paid for private lessons with a local painter. While still in school, Monet began drawing caricatures of friends and acquaintances, works he was able to sell for relatively high prices.[1] During those years, he met Eugène Boudin (1824–98), an artist who, as Monet himself recalled, opened his eyes to visual art[2] and introduced him to plein-air landscape painting.

Early Contacts in Paris

In 1859, the nineteen-year-old Monet traveled to Paris, where Prefect Baron Haussmann had begun to redesign the metropolis in accordance with the wishes of Napoleon III some time before. Sewer systems and street lights were installed, broad boulevards laid out, and spacious squares, parks, and green areas created. In some places, newly introduced exotic plant species, such as the hibiscus, had begun to displace indigenous vegetation.[3] During these years, the imperial government kept close watch on the Salon — the official annual art exhibition — to ensure that only approved works were shown. Monet visited the show and was impressed above all by the paintings of the realists and such plein-air artists as Charles-François Daubigny (1817–78) and Camille Corot (1796–1875). He was interested in contemporary developments in art and met regularly with fellow painters and writers at the Brasserie des Martyrs, where he presumably became acquainted with the publicist and later statesman Georges Clemenceau (1841–1929).[4] Monet enrolled at the Académie Suisse, where students enjoyed relative freedom and were permitted to work from models without formal instruction.

Fig. 39
Claude Monet, photographed by Etienne Carjat in Paris, ca. 1864.
© Collection Toulgouat

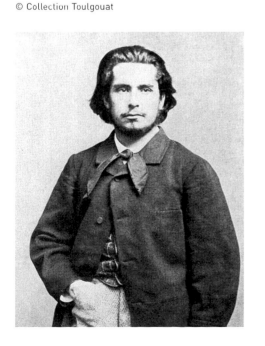

Fig. 40
Claude Monet in his second studio in Giverny (Eure), with the collector Duc de Trévise, ca. 1920. The two are seen examining the middle section of Monet's **Luncheon on the Grass** (1865–1866, W 63/2, Musée d'Orsay, Paris).
© Dukas/Roger-Viollet

His studies were interrupted by military service in 1861, which enabled Monet to circumvent his father's plans to employ him in the family business. He served in Algeria until 1862, when he contracted typhoid fever and returned to France, after which his aunt Marie-Jeanne paid to have him released from service. He spent that summer painting with Boudin on the coast, where he also met Johan Barthold Jongkind (1819–91), but soon returned to Paris. He attended the "atelier libre," a private art school in Paris run by the Swiss artist Charles Gleyre, and became friends with his fellow students Frédéric Bazille (1841–70), Pierre-Auguste Renoir (1841–1919), and Alfred Sisley (1839–99), with whom he painted landscapes in the Forest of Fontainebleau—a region that had attracted the painters of the Barbizon School during the first half of the nineteenth century—during the Easter holidays in 1863.

Monet's financial situation worsened markedly in 1864 when his family reduced his living allowance following a dispute over his long absence from home. His affluent friend and fellow artist Bazille came to his aid and also allowed him to paint in his Paris studio beginning in 1865. That same year, two of Monet's seascapes were exhibited at the Salon[5] and received quite positively by colleagues and the press. After this initial success, Monet turned his attention to new motifs and began painting people—preferably elegantly dressed individuals—in natural outdoor settings. This may be interpreted at least in part as a reaction to the painters Edouard Manet (1832–83) and Gustave Courbet (1819–1877), whose works he had seen in Paris.[6]

Noteworthy works from this period include **Luncheon on the Grass**[7] (fig. 40 and cat. 3) and **Women in the Garden**,[8] for which his friend Bazille and Camille Doncieux (1847–79), his model and lover, posed for several different figures. Monet celebrated a second success at the Salon in 1866 with his full-figure portrait **Camille, or The Woman with a Green Dress**.[9] The art critic and author Emile Zola (1840–1902) praised Monet's paintings in his reviews, prompting his aunt to begin supporting her nephew again. Yet the painter was still plagued by financial difficulties, which were compounded when his partner Camille gave birth to their son Jean (1867–1914) and his family suspended support payments once again. To make matters worse, the two paintings he submitted for the 1867 Salon were rejected by the jury. The art dealers Alfred Cadart (1828–75) and Louis Latouche (1829–84) displayed the rejected **Women in the Garden** in their showcase window. Bazille purchased it for 2,500 francs, which he paid in installments. These monthly payments of fifty francs were often Monet's primary source of income, as he sold few paintings during those years, and usually at very low prices. He asked Bazille for money in every letter he wrote—often quite insistently, as the following example shows:

> I need it now more than ever before. You know why. This is making me sick. If you do not answer, everything will be destroyed. I shall never write you again. Of that you can be sure.[10]

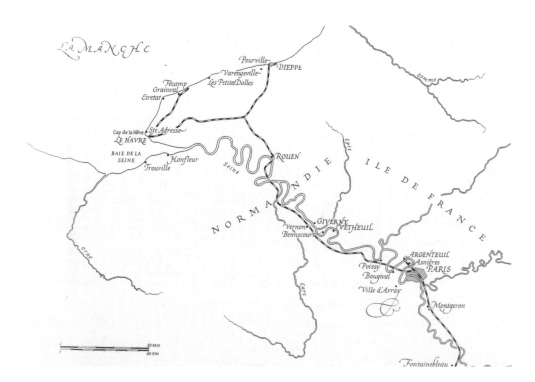

Fig. 41
Argenteuil, Vétheuil, Poissy, Giverny, and the environs of Paris

Monet moved frequently during those years, back and forth between Paris and smaller towns in the Ile-de-France region or Normandy, where rents were not so high. He lived in Ville d'Avray and Louveciennes, among other places. Thanks to the support of painter Charles-François Daubigny, a member of the 1868 jury, he was able to show a painting at the Salon that year, but all of his works were rejected in each of the following two years.

Exile in London and Acquaintance with Gallerist Paul Durand-Ruel

In 1870, Monet married Camille and, like his fellow painters Camille Pissarro (1830–1903) and Daubigny, fled to London after the outbreak of the Franco-Prussian War. His family followed him shortly thereafter. He and Pissarro visited numerous exhibitions and shared an interest in the English artists John Constable (1776–1837) and William Turner (1775–1851). Monet himself painted very little during his nearly eleven months in exile. Through Daubigny, he met the gallerist Paul Durand-Ruel (1831–1922), who had also fled to London. Durand-Ruel had established a gallery in London and eventually became Monet's most important art agent (fig. 42). Given Monet's dire financial situation, this relationship assumed added significance in view of the fact that his aunt and father, who had supported him until then, died during those years and left him virtually nothing. To make matters worse, his friend and patron Bazille was killed in the war.

Durand-Ruel had taken over his parents' gallery only a few years before. His mother and father had originally founded the business as a stationary and art supply shop in Paris in the eighteen-thirties. Since many of their customers were unable to pay for their purchases in cash, they offered paintings on commission instead. It was not long before the Durand-Ruels discontinued the sale of stationary and began to focus completely on the gallery business. Their son Paul joined the family firm in 1846 and took control of it after his father's death in 1865. Paul focused on nineteenth-century art and was especially interested in works by the landscape painters of the Barbizon School, of which he brought several to be exhibited in London. As a friend of Pissarro and Monet, he was able to acquire several of their paintings, which he exhibited alongside works by established artists.

> Shortly thereafter [after having purchased first works by Pissarro and Monet], I began smuggling paintings by these two painters into my exhibitions, and with some effort I was able to sell a few of them.[11]

Durand-Ruel employed this tactic of presenting works by unknown artists together with those of the older generation quite often in later years. In this way, he was able to introduce potential buyers to avant-garde paintings, as well as presenting them in a historical context.

After the end of the war in 1871, Monet returned via Holland to France, where he and Pissarro introduced Durand-Ruel to their fellow painters. The gallerist showed great interest in the work of these younger artists and eventually became the Impressionists' most important promoter. He not only sold their works but also supported them quite often with monthly payments and made their work known to important collectors, such as the famous baritone Jean-Baptiste Faure (1830–1914) and the entrepreneur Ernest Hoschedé (1837–91).[12]

Argenteuil: 1871–1878

A House with Garden: A More Settled Life

In December 1871, Monet moved with his family to Argenteuil, a rural village that was accessible from Paris within fifteen minutes by rail on a line built just twenty years before. The new railway line enhanced the appeal of the town so much that its population quickly doubled, resulting in a rapid increase in construction and a period of industrial bloom in the region.[13]

Monet rented a house with a view of the river at 2, rue Pierre Guienne (figs. 2–4) for one thousand francs per year and hired two maids. This was the first residence at which he remained for an extended period of time since leaving his parents' home. He began designing the large garden behind the house and employed a gardener to assist him. His own garden became a theme in his own painting as well.

Monet, who worked with intensity in 1872 and completed the majority of his paintings in Argenteuil and environs by the end of that year, often painted members of his family in his garden. He depicted them in fashionable clothes, reading, walking, or relaxing in this enclosed idyllic setting. The critic and Monet biographer Arsène Alexandre (1859–1937) did not fail to notice the important role the garden played in Monet's art, as he recollected in his life of Monet published in 1921:

> ... and then the garden! ... Aside from the fact that a garden such as this one is an inexhaustible object of observation, it is also a counselor during hours of reflection, a dictionary during hours of work, a source of comfort during days of depression ... Ultimately, this garden would provide the flowers for the bouquets that were painted in between expeditions into the countryside and serve as a multifaceted cross-section for an attentive and sensitive eye ... We regard this garden as an element of greatest importance, as a crucial point of transition in the artist's oeuvre.[14]

Many of the nearly sixty paintings Monet completed in 1872 were done in the studio boat he had had built for himself, following Daubigny's example of ten years before. In addition to garden scenes, he also painted recreational boats[15] and settings in primarily cultivated natural landscapes around Argenteuil. 1872 and 1873 were also quite lucrative years for Monet. According to his account book, his revenues amounted to 12,100 and 24,800 francs in 1872 and 1873, respectively, considerably more than a physician earned in those years.[16] Payments from Durand-Ruel accounted for roughly two-thirds of these receipts. Despite his substantial income, Monet continued to complain to his friends and ask them for money.[17] Thus he must have regarded it as an especially fortunate turn of events when he met the wealthy painter Gustave Caillebotte (1848–94) after returning from a journey to Normandy and Rouen. Caillebotte purchased a number of his works and provided further financial support.

The First Impressionist Exhibitions

Until the mid-eighteen-sixties, the official Salon held at the Palais de l'Industrie in Paris[18] was virtually the only venue at which artists could present their works to an interested public and to potential buyers. In 1863, the extremely restrictive selection policy adopted by the conservative jury resulted in the exclusion of numerous works from the show, prompting bitter protests by the artists. To mollify the artists, Napoleon III founded the Salon des Réfusés, where these rejected works were exhibited from that year on. Other independent exhibitions—known as the Salons des Indépendants[19]—were also organized. The first of these was the presentation set up by Monet and other artists rejected by the Salon jury in 1874. The exhibition of the Société anonyme coopérative d'artistes peintres, sculpteurs, graveurs, etc.,

took place in the studio of photographer Nadar (whose real name was Gaspard Félix Tournachon, 1820–1910).[20] The show later came to be known as the Impressionist Exhibition. A relatively small number of paintings (165) as compared to the Salon were shown in the homey studio setting. This was the first show organized without public support, without a jury, and without competitive awards. The works were hung in alphabetical order—another departure from Salon practice—which meant that no hierarchical ranking was suggested to viewers. Visitors were expected to judge the quality of the exhibited works themselves.[21] The exhibition attracted numerous visitors, most of whom were displeased with what they saw. Louis Leroy (1812–82), who reviewed the presentation in the satirical journal **Le Charivari**, referred to the painters as "impressionists"—a reference to the title of Monet's painting **Impression, Sunrise**[22]—and thus coined a descriptive term that had strong negative connotations at that time.

Monet took extended journeys to Le Havre and Holland in 1874. Revenues from the sale of his paintings fell dramatically, due not least of all to Durand-Ruel's own financial difficulties, which prevented him from buying as many works as before. Purchases by Faure and Hoschedé were not sufficient to offset this loss, and thus Monet's income decreased to 10,554 francs.[23] Fellow artist Manet provided financial support for Monet during this period. He visited him, accompanied by Renoir, and the two painted together in Monet's garden. Their visit produced **The Monet Family in Their Garden in Argenteuil** (fig. 43),[24] in which Manet painted Monet, his elegantly dressed wife Camille, and their son Jean. In a casual blue shirt, dark pants, and hat, Monet is depicted standing slightly bowed at the edge of the lawn, tending

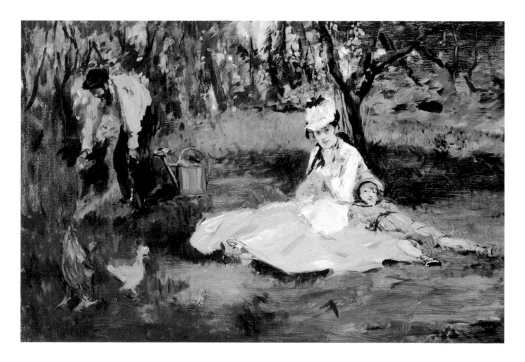

Fig. 43
Edouard Manet
The Monet Family in the Garden in Argenteuil, 1874
LA FAMILLE MONET AU LEUR JARDIN
Oil on canvas
61 x 99,7 cm (24 x 39¼ in.)
Courtesy The Metropolitan Museum of Art,
Bequest of Joan Whitney Payson, 1975
© The Metropolitan Museum of Art, New York

to red flowers, with a watering can next to him. In view of Monet's passion for flowers and shrubbery, it is not at all surprising that Manet would paint his friend at work in his garden.

Plagued by oppressive debt, the artist moved into a new house on boulevard Saint-Denis on October 1, 1874. The house had been built only shortly before and also had a garden (fig. 6). The property bordered that of his first house in Argenteuil, as can be seen in Monet's painting **Camille in the Garden with Jean and His Nanny** (cat. 12) from the preceding year.

The year 1875 was not a lucrative one for Impressionist artists. Instead of a second exhibition by the Société anonyme coopérative d'artistes, a public auction was held at the Hôtel Drouot in Paris, with Durand-Ruel serving as an expert consultant. The works offered at the auction caused such a scandal that the police had to be called to restore order. Although several paintings were sold, purchase prices were very low. The problem was exacerbated by the appearance of numerous paintings by Jean-François Millet (1814–75) and Camille Corot on the market following their deaths and the clearing of their studios. Since their works appealed to much the same clientele as those of the Impressionists, they represented serious competition.[25] Even Durand-Ruel found himself compelled to reduce his support for the artists substantially in view of his own financial worries. In 1875, he was forced to close his gallery in London, the site of several exhibitions featuring works by Monet during the preceding five years.

The Société anonyme coopérative d'artistes organized a second exhibition at Durand-Ruel's gallery in 1876. Each of the participating artists exhibited several works which were grouped into ensembles. Considerably more attention was given to lighting and wall coloration than was generally the case at the Salon. In this way, Durand-Ruel and the artists hoped to create a more intimate atmosphere than that of the official exhibitions, at which more than three thousand works were hung in a crowded arrangement of horizontal and vertical rows in huge halls each year. Their objective was to appeal to a middle-class public in a comfortable, homey atmosphere that would encourage visitors to buy paintings for their own homes.[26] The public rejected the exhibition for the most part. Although the show attracted more press attention than its predecessor, negative comments still outnumbered favorable reviews. Monet was recognized as the group's most important representative, but he was unable to sell a single exhibited work (fig. 44).

Montgeron and Paris

The circle of Monet collectors began to grow appreciably in 1876. New members
included the wealthy Romanian physician Dr. Georges de Bellio (1828–94) and the
customs officer Victor Chocquet (1821–98), whose income was comparatively mod-
est. Monet now spent considerable time in Paris, where he painted the gardens in
the Tuileries as well as other scenes. He spent the second half of the year at Palais
Rottembourg, the home of his patron Ernest Hoschedé, in Montgeron. Hoschedé, who
worked in the textile business run by his father and uncle, was married to Alice
(1844–1911), who came from a wealthy family and had inherited a château near Paris.
Monet was invited to use the garden house located in the park. In addition to the four
large, decorative paintings done as commissioned pieces[27] for the Hoschedés' din-
ing room, he also painted a number of other views before departing for Argenteuil in
December. No more than a year later, his patron, who was known for his excessive
lifestyle, filed for bankruptcy. Hoschedé fled to temporary exile in Belgium, leaving
his pregnant wife and five children behind. His assets were auctioned off, among
them approximately fifty Impressionist paintings from his own collection.[28]

Monet rented a small apartment where he could receive prospective clients
near Saint-Lazare Station in Paris in 1877. During his stay at the apartment, he
painted a number of views of the station, eight of which he presented at the Impres-
sionist Exhibition that same year. This third show—the first to be officially desig-
nated by the artists' group as the "Exposition des Impressionnistes"[29]—added fur-

ther fuel to the fire of critical controversy. Although a small group of critics now viewed the Impressionists with favor, among them Jules-Antoine Castagnary (1830–88) and Georges Rivière (1855–1943), publisher of **L'Impressionniste,** a leaflet that appeared weekly during the exhibition, critical response remained predominantly negative. Although Monet achieved his best sales results since 1873 at this show—paintings of women and children in garden and landscape settings sold quite well—prices were so low that the proceeds failed to alleviate his financial troubles. Once again, he was compelled to ask his friends for support.[30]

After completing the Saint-Lazare paintings, he painted very little before moving from Argenteuil in January 1878. The move was necessitated primarily by the increasingly insistent demands of his creditors. The family lived briefly in Paris, where a second son, Michel (1878–1966), was born. At first, the entire family occupied the small apartment overlooking Saint-Lazare Station, before moving into a larger one near Parc Monceau, which Monet painted on several occasions. This was the time of the World's Fair, but it was also a period in which the market was inundated with paintings following the auctions of the Faure and Leurent Richard collections and the sale of works from Daubigny's studio.

In 1878, Théodore Duret (1838–1927) wrote the movement's first manifesto, entitled **Les Peintres impressionnistes** (fig. 45). To understand Impressionist painting, the author wrote, it is necessary to adopt new habits of seeing. Duret positioned the Impressionists in a historical context by identifying their origins in the Naturalist school and naming Corot, Courbet, and Manet as their forefathers.[31] Like many other authors of those years, Duret also called attention to sources of inspiration in Japanese painting.[32] He regarded Monet as the Impressionist "par excellence," a masterful painter of gardens, parks, small wooded areas, and water:

> His paintings evoke very real impressions; one might say that his snow causes us to freeze and his light-bathed images warm and cheer us ... The artist is attracted by cultivated nature and urban scenes. He prefers painting gardens in bloom, parks, and small wooded areas. Yet water ranks highest in importance in his oeuvre. Monet is a painter of water par excellence.[33]

Fig. 45
In 1878, Théodore Duret (1838–1927) wrote
Les Peintres impressionnistes, the first manifesto of the Impressionist movement. He regarded Monet as the Impressionist par excellence, who painted primarily gardens, parks, and small wooded areas and was a masterful painter of water.
Courtesy Archives du Musée Marmottan Monet, Paris

Vétheuil and Poissy: 1878–1883

The Monet-Hoschedé Household

Following their brief stay in Paris, the thirty-eight-year-old Monet, Camille, and their two children moved to Vétheuil, a country village of six hundred inhabitants (fig. 46). The Monets decided to share their household with the penniless Hoschedés and their six children and to consolidate their staff of domestic servants. The combined family occupied a house on route de Mantes, but moved into a larger home on rue Chatermesle La-Roche-Guyon (figs. 8 and 9) in the late fall of 1878. The estate encompassed a large orchard and flower garden located across a road from the main house.[34] As in Argenteuil, the artist tended his garden in Vétheuil, planting both vegetables and numerous flowers.

Camille, who had been ill for some time, died a year after the family's move to the second house. Care was provided by Alice Hoschedé, who assumed responsibility for all eight children after her death. Monet had incurred considerable debt, and the family was in dire financial need—a situation that was exacerbated by needs of the dual household. Hoschedé spent most of his time in Paris, trying his hand as an art critic, but could not earn enough to support his family. Alice and Monet became lovers.

The artist was almost completely dependant on the support of his friend Caillebotte. Although hesitant, the painter was persuaded by Caillebotte to take part in the Impressionist Exhibition of 1879, but he decided to return to the official Salon the next year. Many of his fellow Impressionists were strongly opposed to his participation at the Salon and regarded it as a betrayal of the new movement. But

Fig. 46
Vétheuil (Seine and Oise), Iles de Moisson, ca. 1900.
The photograph shows the landscape below and outside Monet's garden. On the right is the branch of the Seine where the artist moored his boats.
© Collection Toulgout

Renoir, who also exhibited at the Salon again in 1879, welcomed Monet's decision and kept in closer touch with him from that point on.

Through Renoir, Monet met Georges Charpentier (1846–1905), publisher of the illustrated weekly journal **La Vie moderne,** who operated a gallery of the same name. The first solo presentation of Monet's paintings was held at the gallery in June 1880. The show attracted numerous visitors but received little attention in the press. Duret, who organized the exhibition, wrote the foreword for the catalogue, in which he described Monet as a plein-air painter who retreated into nature until his painting was finished.[35] The observation is not quite accurate, as the artist did not always paint outdoors but instead often used plein-air studies as sources for other paintings.[36] Duret's characterization was reaffirmed in an interview conducted by journalist Emile Taboureux with Monet in Vétheuil printed in **La Vie moderne** a week after the exhibition opened. When asked where his studio was, Monet answered with a broad sweep of his arm, declaring that the landscape before them was his studio.[37] The interview provides early evidence that Monet was well aware of the power of the media and quite willing to exploit it to promote his own image. Beginning in 1880, he subscribed to media monitoring services provided by two different companies, who supplied him with clippings of all articles relating to himself and his art.[38] Monet passed several of these on to Taboureux to help him prepare for the interview.[39]

Monet painted a large number of village scenes, broad fields, and river landscapes in Vétheuil, returning several times to paint the frozen Seine during the unusually hard winter of 1880/81. The artist made several trips to Normandy in September 1880 and the summer of 1881 to paint the rugged cliffs near Fécamp. He usually had several different paintings in progress, and would choose one to place on his easel depending upon the weather conditions at a given time. His financial situation eased somewhat, as he had attracted new buyers, but thanks primarily to Durand-Ruel, who was now in a position to invest in Impressionist art again. Backed by the Banque de l'Union, Durand-Ruel had substantial capital at his disposal, but the bank failed a year later, and he was compelled to repay his loans.

Monet began to employ various different marketing strategies in order to promote the sale of his works. From the mid-eighteen-eighties on, he worked with other art dealers and thus was no longer represented exclusively by Durand-Ruel, much to his first agent's chagrin. One of these new dealers was Georges Petit (1856–1920), who had inherited his father's art dealership in 1877 and organized the first of his "Expositions internationales de Peintures" in 1882—as an alternative to the Salon. These shows became important social occasions for his wealthy clientele (fig. 47). Monet also established contact with Theo van Gogh (1857–91), who joined the firm Goupil & Co.—which later became the Galerie Boussod, Valadon & Co.—in The Hague in 1873 and worked for the company in Paris from 1879 until

Fig. 47
Supplement to the newspaper Le Gaulois
of June 16, 1898
Starting in the mid-eighteen-eighties, Monet worked
with other art dealers and thus was no longer
represented exclusively by Durand-Ruel. One of
these new agents was Georges Petit (1856–1920),
who organized the first of his "Expositions Interna-
tionales de Peintures" in 1882—as an alternative to
the official Salon. These shows became important
social occasions for his wealthy clientele and
enabled Monet to enlarge his customer base.
Courtesy Archives du Musée Marmottan Monet,
Paris

his death. The artist also engaged the services of Bernheim-Jeune, a gallery founded in Jura in 1795, established in Paris in 1863, and run by its third-generation owners, the brothers Josse (1870–1941) and Gaston (1870–1953). These new arrangements expanded Monet's customer base significantly. The painter also sold paintings directly to private collectors and set his own prices for the most part.[40]

A New Home in Poissy

In December 1881, the Monet family moved into the Villa Saint-Louis at 10, cours de 14 juillet in Poissy. The town was situated along the main railway line to Paris and offered better schools for the children. The move caused a scandal because Alice, who was still legally married to Ernest Hoschedé, accompanied Monet along with her six children. Her husband still spent most of his time in Paris, and thus the relationship that had developed between Alice and Claude since the death of Camille now became obvious. While living in Poissy, Monet made several extended trips to Pourville in Normandy to paint coastal landscapes but also to avoid meeting Ernest Hoschedé, who continued to show up from time to time. He wrote to Alice daily — and would also write several-page letters every day during his later painting trips — describing his arduous search for motifs and the unpleasant weather changes that hindered his work and forced him to stay away longer. He continued to work on several different paintings at a time and needed someone to help him carry the works to the various sites.

Monet's last showing at an Impressionist Exhibition took place in 1882. The presentation, which was organized that year in Durand-Ruel's gallery, was well received by the public and the press. Many critics now took a positive view of the movement.[41] Initial response to the solo exhibition of Monet's paintings organized by Durand-Ruel the following year was less gratifying. The show attracted only few visitors, and only isolated reviews appeared in the media at first. Monet wrote to Durand-Ruel, complaining that it was "... no longer possible to accomplish anything today without the press ..."[42] and that inadequate advertising and preparation were responsible for the lack of attention given to his exhibition:

> No, nothing has changed from an artistic point of view. I know my worth, and no one is more demanding of himself than I. But you must approach the matter from a commercial perspective. And failure to recognize that my exhibition was poorly advertised and poorly prepared amounts to refusal to see the truth.[43]

Monet's concern was unjustified, for several lengthy, for the most part positive reviews of the exhibition finally did appear some time later.[44] The reception of his work was no longer restricted to the small group of people who had appreciated his art right along; he had attracted the attention of many more critics and a much

broader public. Gradually, he was coming to be regarded as the leading landscape painter of his time.[45]

Giverny: 1883–1926

A Permanent Home

Monet never felt at home in Poissy. He did not complete a single garden painting there but instead found his subjects on his many trips to Normandy. After only two years in Poissy, he moved with his family (fig. 48) to the small village of Giverny, northwest of Paris, a community of 279 inhabitants. He wrote a letter to Durand-Ruel, asking for financial support for the move, assuring him that "... as soon as I am settled, I hope to create masterpieces, for I like the landscape very much."[46]

Monet rented one of the largest houses in the village, a home Alexandre describes as follows in his Monet biography:

> Monet moved into this rustic house, which was later expanded into a comfortable mansion, in 1883. The building, which was situated between two roads running parallel to one another, stood along the side of one of the roads and was separated from the other by a large, slightly sloping garden that had several different paths and was — due to its sunny location — well suited for every blooming period.[47]

The elongated building (fig. 49) had a pink façade and green-painted window shutters. On the side facing the garden, Monet built a balcony that extended along the

Fig. 48
The Monet-Hoschedé family in the living room of the house in Giverny, no date indicated. The photo shows some of the ten members of Monet's family. The painter had two boys from his first marriage. His second wife Alice — the widow of Ernest Hoschedé, an important collector of Monet's works — brought six children into the marriage. The older man is presumably Claude Monet's brother Léon. These individuals are shown in the salon, where Monet had hung paintings by such artists as Gustave Caillebotte, Paul Cézanne, Camille Corot, Eugène Delacroix, Johan Barthold Jongkind, Berthe Morisot, Camille Pissarro, and Pierre-Auguste Renoir.
Part of Claude Monet's art collection can be seen in the background.
© Collection du Musée Municipal A. G. Poulain, Vernon

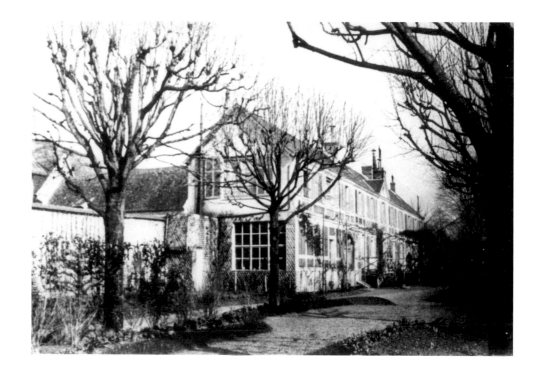

entire long side of the house, where his family was served meals and tea during the warm months of the year. A broad walkway led from the balcony stairway into the spacious garden, which covered roughly a hectare of ground and was enclosed by a wall—the "clos normand." The roads and the railroad line ran parallel to the long side of the garden. The previous occupants had originally planted a kitchen garden with vegetables, potatoes, fruit trees, and berry bushes.[48] Soon after moving in, Monet began redesigning the garden with the help of his children and a gardener hired by the hour, often asking Caillebotte, an avid gardener himself, for advice (fig. 50). These manual tasks often kept the artist away from his easel, which is why he delivered only very few paintings, if any, to Durand-Ruel. He wrote to his agent that he had been unable to paint due to his work in the garden, which demanded all of his time, but that he now had flowers to paint when the weather turned bad.[49]

Travels to the Mediterranean

In December 1883, Monet journeyed with Renoir to the Riviera. He was enthralled with Bordighera and resolved to return there alone the next year. The landscapes and park paintings done in that Mediterranean setting exhibit an unusual choice of colors dominated by pink, orange, and intense blue shades. Monet occasionally reported to Alice that he was satisfied with his work, but he was more frequently unhappy with the results—as so often before in earlier creative periods—and expressed doubt in his ability to capture the colors of the South. In one letter, he complained to Alice that:

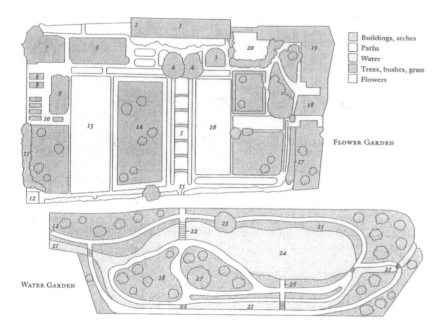

FLOWER GARDEN

WATER GARDEN

Buildings, arches
Paths
Water
Trees, bushes, grass
Flowers

Fig. 50
The garden in Giverny today
 1 House
 2 Monet's bedroom, above the first studio
 3 Crabapple tree (Pyrus malus)
 4 Twin yews
 5 Grande Allée with rose arches
 6 Pleached limes
 7 Second studio (1897)
 8 Small greenhouses
 9 Large greenhouse
10 Warm frames
11 Hedge of horse chestnut
12 Entrance to underground passage
13 Monochromatic and polychromatic flowerbeds
14 Lawn with roses, fruit trees, and rectangular
 flowerbeds
15 Former main gate
16 Paintbox beds
17 Espaliered apple trees
18 House formerly inhabited by Monet's head
 gardener (Félix Breuil)
19 Third atelier (1916)
20 Turkey and chicken yard
21 The diverted stream Ru, an arm of the River Epte
22 Wisteria-covered Japanese bridge
23 Weeping willow
24 Water-lily pond
25 Wisteria
26 Rose arches
27 Copper beech and peonies
28 Bamboo thicket

... I had nightmares the entire time, dreams in which I saw all of my paintings with their wrong colors, and when I took them to Paris, everyone admitted that they found them completely incomprehensible.[50]

Monet had no difficulty finding buyers for his new paintings, however, and he earned over forty-five thousand francs in 1884, after two equally successful preceding years.[51] While in Paris, he was introduced by Durand-Ruel to the writer Octave Mirbeau (1848–1917), editor of the art section of the conservative daily newspaper **La France.**

The painter first began exploring motifs in the region around Giverny in the summer of 1884, for, as he explained to Durand-Ruel in a letter, "... it always takes a while to familiarize oneself with a landscape."[52] He had spent the preceding months working on the paintings he had begun in Normandy and on the thirty-six panels Durand-Ruel had commissioned him to paint for the doors of the salon in his apartment in Paris. The gallerist sent Monet vases in which to place his bouquets for the planned still lifes. Monet, who worked on Durand-Ruel's commission until 1885, drew inspiration from several types of flowers in his garden and painted peonies, dahlias, gladioli, narcissi, chrysanthemums, and other varieties on the door panels. For the panels he painted in Bordighera, he chose Mediterranean motifs such as lemons and oranges.[53] He then turned his attention to the countryside surrounding Giverny, painting the river bank, the village, and members of his family on broad fields and meadows. Inclement weather occasionally prevented him from working, as he mentioned in a letter to Durand-Ruel:

It is true that the weather was seldom favorable, but I have been unable to work outdoors since my return. One would have thought it was winter. So I decided to tend to the garden and prepare some beautiful flower motifs for the summer . . .[54]

In 1885, Monet spent the holidays with his family in Etretat. He extended his own stay in order to paint scenes on the rugged coastline.[55]

Success Abroad

Finding himself faced with financial difficulties once again in the late eighteen-eighties, Durand-Ruel began looking for a market for the works of the Impressionists abroad. In 1886, he opened an exhibition in New York featuring some three hundred works from his own collection. Monet was not thrilled with the idea of presenting his works overseas:

. . . but I must admit that I would regret seeing some of the paintings sent to the land of the Yankees, and I would have preferred to reserve a selection of them for Paris, especially since people still have a little taste there, and only there.[56]

The New York exhibition received enthusiastic reviews, and numerous potential buyers visited the show, which was expanded at its second venue at the National Academy of Design New York to include works from the collections of the very first purchasers of Impressionist art—Louisine Elder Havemeyer (1855–1929)[57] and Alexander Cassatt. Durand-Ruel opened a branch office in New York in 1888. Thanks in large measure to this local representation, Monet and his fellow painters rapidly attracted widespread attention in the United States, and their customer base grew significantly between 1888 and 1890. Noteworthy new collectors included Catholina Lambert (1834–1923), John G. Johnson (1841–1917), Alfred Atimore Pope, John Singer Sargent (1856–1925), Lilla Cabot Perry (1848–1933), and Desmond Fitzgerald (1846–1926). Largely unaware of the revolutionary developments in official salon art and the innovations introduced by the independent groups, American buyers viewed these works without prejudice simply as French art.[58] They were the first to acquire large numbers of Impressionist paintings, although consideration was not always given to the quality of individual works.[59] Monet gained considerable fame in the United States not only for his paintings but as a person as well (fig. 51). Many foreign students enrolled at the Paris Académie traveled to Giverny during the summer. Theodore Robinson (1852–96), Louis Ritter (1854–92), Willard Leroy Metcalf (1858–1925), and others came to the town and stayed at the Hôtel Baudy not far from Monet's house. Other American artists followed, and the late eighteen-eighties witnessed the growth of an artists' colony in the village. As

more and more painters came to Giverny, Monet felt increasingly uncomfortable with the situation. Many of these visitors tried to establish contact with him, but he responded to the overtures of only a few, including Robinson, John Leslie Breck (1860–99), and Theodore Butler (1861–1936).

In 1886, Monet traveled to the island of Belle-Ile off the coast of Brittany. Having originally planned to remain only for a week, he extended the stay by three months, as he was unable to progress as quickly with his painting as he had hoped. Yet he completed some forty paintings during that brief period. He intensified his contacts with Clemenceau, who was now referred to as "Le Tigre" because of his commitment to radical republican political views. He also became friends with Gustave Geffroy (1855–1926)[60] —a journalist who wrote for Clemenceau's journal **La Justice.** Along with Mirbeau, these two men became the painter's most important patrons, and both contributed significantly to his rise to fame through their articles and their political influence (Clemenceau served as Prime Minister of France from 1906 to 1909 and from 1917 to 1920).

In 1886, Monet added an extension to the west wing of his house and referred to it as his first studio. A year later, he painted the first motifs from his own garden.[61]

A Turning Point in Europe

By this time, Impressionist painting had made significant gains in terms of its acceptance. Wealthy clients took the positive reviews of Geffroy and Mirbeau as proof of the value of their purchases, and even conservative critics praised Monet for his very "French" style of painting (figs. 52 and 53). They established his place in the French tradition and drew comparisons to Rococo and to such artists as Corot.[62] Yet other isolated voices suggested that Impressionism had outlived its time. In an article on the Salon des Indépendants of 1887, author Félix Fénéon (1863–1944)[63] ventured the opinion that the heyday of Impressionism had passed, characterizing its representatives as color-blind painters. Fénéon saw the Neo-Impressionists, most notably Georges Seurat (1859–91), Paul Signac (1863–1935), and Lucien Pissarro (1863–1944), as the artists of the future. He was particularly impressed with their analytical approach.[64] Yet such judgments as these did nothing to slow Monet's growing success, to which two important presentations contributed significantly. In 1889, Theo van Gogh organized a solo exhibition at Boussod & Valadon that was shown in London as well as Paris, and Georges Petit presented the show entitled "Claude Monet—A. Rodin" at his gallery. The forty-nine-year-old painter was unhappy with the presentation of his paintings and complained that Rodin's sculptures made it difficult for visitors to view his paintings. Yet the exhibition marked a turning point, after which Monet was widely recognized as a significant painter. Mirbeau wrote an article for **Le Figaro**—which he later used in

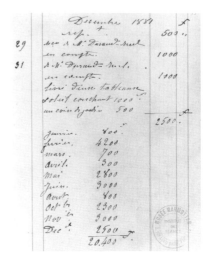

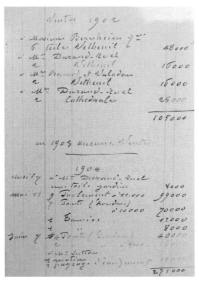

Figs. 52 and 53
A comparison of his earnings in 1881 and 1902/03 reveals that Monet's breakthrough came toward the end of the eighteen-eighties. He celebrated triumphant national and international successes after the turn of the century and was able to demand high prices for his paintings, which enabled him to live a life of luxury in Giverny.
© Musée Marmottan Monet, Paris and Giraudon-Bridgeman Art Library

slightly revised form as the catalogue foreword for the Rodin-Monet presentation — in which he characterized Monet as a plein-air painter:

> He lives in the country in a wonderful landscape and is constantly surrounded by his models; the open air of nature is his only studio.[65]

Following the exhibition, Monet painted very little for about a year. One of the reasons for his sluggish production was his time-consuming commitment to rescuing Manet's **Olympia,** a painting an American collector hoped to purchase. Dedicated to keeping the work in France, Monet decided to purchase it himself and donate it to the Louvre. As the twenty thousand francs needed to acquire the painting could only be collected through a subscription campaign, it took Monet several months to accomplish his objective. Moreover, the representatives of the Louvre and the Ministry of Education and Art remained opposed to the idea for some time, and thus the museum did not take possession of the painting until 1907.

From 1890 to 1892, Monet realized his first true series featuring scenes of haystacks and poplars from the local countryside. He had painted variations on the same motif before, but the serial approach now began to dominate his work. The paintings were often sold before their first exhibition, a tendency that is attributable to a new tactic pursued by Monet. He exhibited only very few of the works he intended to sell, which made them appear all the more exquisite to prospective buyers. His income amounted to roughly one hundred thousand francs in 1891, a considerable sum made up of proceeds from the sale of his paintings and returns on investments in the stock market.

Purchase and Renovation of the House and Garden

Monet now spent more of his time in Giverny. He had developed rheumatism after years of long painting sessions in the outdoors, during which he often worked in the pouring rain or heavy snow. He received numerous visitors, among them the Americans Lilla Cabot and Tom Perry, who later rented a house with a garden adjacent to Monet's lot. He also maintained close ties with Caillebotte, Clemenceau, Geffroy, and Mirbeau as well as contacts with such artists as Berthe Morisot (1841–95), Auguste Rodin (1840–1917), and Stéphane Mallarmé (1842–98). In November 1890, Louis-Joseph Singeot, the owner of the property, offered to sell the house to the Monets. Although the price of twenty-two thousand francs was quite high for a man of Monet's means, he bought the property and paid for it in installments over a period of four years. He immediately began to redesign the garden and the living areas and eventually added a second studio. This work prevented him from taking extended trips to paint, as he explained in a letter to Mallarmé:

> And I must also admit that I am reluctant to leave Giverny, especially now that I am redesigning the house and the garden as I want them.[66]

GIVERNY (Eure) - Pâturages des bords de l'Epte (1)

Fig. 54
Postcard showing a pasture on the banks of the Epte
near Giverny
Courtesy Collection Toulgouat

Monet bought a small island near Giverny, where he could dock his boats, and continued to redesign the garden,[67] replacing apple trees with apricot and Japanese cherry trees, laying out sand paths, and installing trellises for climbing roses. He planted beds on both sides of the main path, composing them with flowers of different types and heights. He took pains to ensure that something was always budding and blooming from spring to late fall. He consulted literature on the subject and subscribed to gardening magazines.[68]

Monet's Garden in the Press

The first detailed description of Monet's garden appeared in **L'Art dans les deux Mondes.** Monet's art agent Durand-Ruel began issuing the journal at regular intervals in 1891, after having published **La Revue internationale d'art et de la curiosité** from 1869 until the outbreak of the Franco-Prussian War in 1870. Mirbeau, who wrote the article, described the appearance of the planted flowers in each of the four seasons in painstaking detail and added the following comment about the garden:

> It is here, amidst this endless feast for the eyes, that Claude Monet lives. And it is precisely the kind of surroundings one would imagine for this extraordinary painter of a life full of beautiful colors, for this extraordinary poet of profoundly moving light and veiled forms; for him, who creates such breathing, enchanting, sweet-scented paintings . . .[69]

The Water-Lily Pond

Monet married Alice, who had been his partner for many years, in 1892, a year after the death of her husband. Shortly thereafter, his step-daughter Suzanne Hoschedé (1868–99)[70] married the painter Theodore Butler, a union to which Monet consented hesitantly, as he had very little reliable information regarding the life of the American painter, as he explained in a letter to Alice.[71] A year later, he purchased a strip of land bordering the Ru, a stream that formed a branch of the Epte. The lot was separated from Monet's other garden by railroad tracks. On the new land, he laid out an aquatic garden, a task that took several months to complete. He worked on the design of the new lot even during his second stay in Rouen, visiting Emile Varenne (1841–94), director of the Botanical Gardens, who showed him the greenhouses, and buying numerous plants from local gardeners, which he sent—along with countless instructions and tips—by the basket to Giverny.[72] While in Rouen, he also submitted his request for a permit for the excavation work and the diversion of the stream to provide water for his pond. The authorities, and especially the local people, feared that Monet's plants might contaminate their streams, much to the painter's annoyance, as is indicated in an excerpt from a letter to Alice:

> These new problems are very disappointing to me . . . I am so angry about all of this that I have no more desire to bother with anything involving these narrow-minded individuals and all the people in Giverny . . . You can't rent anything anymore; you can't order any more trellises, and you're expected to simply toss the flowers into the river, where they would supposedly bloom on their own . . . I'll give the lot to anyone who wants it.[73]

Monet remained persistent and wrote another letter to the prefect in the summer, emphasizing that the aquatic plants posed no danger to the local waters. He pointed out that many species of water-lilies and reeds were already growing wild along the rivers, which meant that there was no need for fear that the water would be contaminated.[74] He finally received approval to divert the stream and was able to begin work on the project (fig. 55). He ordered a variety of aquatic plants for the pond from Joseph Bory Latour-Marliac (1830–1911), a garden supplier who was well known for his hybrid water lillies.[75]

Professional Gardening

Until 1892, Monet tended the garden himself, assisted by the children and several gardeners hired by the hour. That year, he hired head gardener Félix Breuil (1867–1954), who was recommended to him by Mirbeau. Monet and the gardener did not always agree on cultivation methods. Breuil favored using soil that was rich in lime, leaving ample space between plants, and trimming shrubs and trees. Monet was against these measures and wanted to have flowers and leaves grow so densely

Fig. 55
Jacques Hoschedé (1869–1941) and Anna Bergman, the daughter of his future wife-to-be, Inga Joergensen (1862–1944), observing the construction of the basin in the garden in Giverny, ca. 1893.
© Collection Toulgouat

that one could no longer see the ground beneath them. He was intent upon emphasizing the interactions of the various colors and the textures of the different plants. Breuil had several assistants to help him, one of whom was hired solely to attend to the pond. He regularly arranged the water lilies on the water's surface and removed algae, duckweed, superfluous lily pads, and dust. Monet issued instructions daily and checked the work of his employees every few hours (fig. 56).

In September, he began working on a new greenhouse, for which he apparently organized a night watch at first, fearing a heating system failure that would cause damage to the plants.[76] Somewhat later, in 1895, he had an arched footbridge built over the western part of the pond. The bridge was aligned with the main entrance to his house and along the axis of the main walkway. From the bench installed facing the so-called Japanese Bridge, the painter could sit and observe his aquatic garden. Monet was also interested in changes in the environment near his home. He was actively involved in efforts to preserve the wetlands in Giverny and succeeded in blocking the planned construction of a chemical plant by offering the town government five thousand francs on the condition that it refuse to sell its moor.[77]

In 1895, Durand-Ruel organized an exhibition of Monet's paintings of the Cathedral in Rouen in Paris. These works, more than thirty paintings in all, were painted during Monet's two extended stays in the city in 1892 and 1893. The agent was unhappy with the painter's price policy, as Monet wanted to offer the paintings for the high price of fifteen thousand francs. Most of the works were not sold, due in part to Monet's exorbitant price demands but also to the unusually free, vividly colored painting style. Except for the winter village scenes and landscapes painted during his trip to Norway in the spring of 1895 and the first few views of his pond and the Japanese Bridge, Monet completed very few new works during the year. But since his older works were still selling well, he earned more than two hundred thousand francs in 1895. The following two years were more productive. Monet worked on his next series comprising about twenty paintings, entitled **Morning on the Seine**. By this time, he was quite well known abroad and represented at several different exhibitions.

Monet built a second studio with windows facing north and south on the northwest corner of his property toward the end of the eighteen-nineties. The ground floor was reserved for a garage, storage space for garden tools, and a darkroom. On the second floor, the painter put in apartments for Jacques Hoschedé (1869–1941) and his wife Inga and for his recently married son Jean and his wife Blanche Hoschedé (1865–1947). The top floor comprised the studio, where he stored works from all periods of his career.[78] As in the main house, Japanese prints were hung on the walls of the stairways, documenting Monet's interest in art of the Far East.

Fig. 56
Facsimile of the last page of Alice Kuhn's three-page article entitled "Claude Monet à Giverny" in La Femme d'aujourd'hui, August 19, 1904. According to the caption, the top photo shows "Under the bridge, the master's boat," implying that Monet used the boat himself. Actually, however, the boat was used by the assistant gardener, who regularly arranged the water-lilies on the water's surface and removed algae, duckweed, superfluous lily pads, and dust.
Courtesy Archives du Musée Marmottan Monet, Paris
© Collection Michèle Verrier

Fig. 57
Water-lily pond in Claude Monet's garden in Giverny,
from a series of photographs taken by Commandant
Humbert, ca. 1920
Courtesy Musée Municipal A. G. Poulain, Vernon
© Collection Michèle Verrier

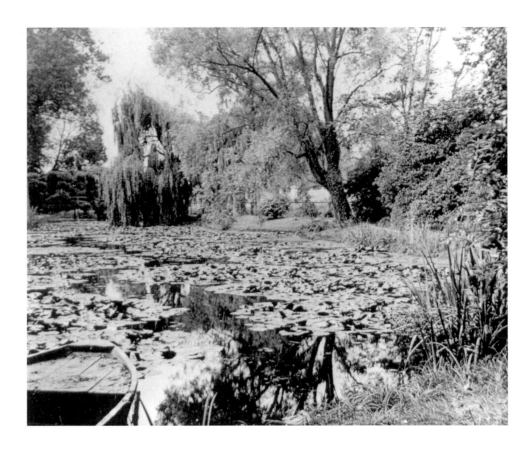

Fig. 58
Water-lily pond in Claude Monet's garden in Giverny,
from a series of photographs taken by Commandant
Humbert, ca. 1920
Courtesy Musée Municipal A. G. Poulain, Vernon
© Collection Michèle Verrier

Monet traveled with his wife Alice to London to visit his son Michel in the fall of 1899 and returned to the British capital in each of the following years as well. From his room at the Hotel Savoy, he painted views of Charing Cross Bridge, Waterloo Bridge, and the Houses of Parliament. He found the subjects difficult to grasp and began countless canvases, none of which satisfied him when they were done. After returning to Giverny, he purchased another strip of meadow on the far bank of the Ru in May 1901, as he planned to enlarge his water-garden. Late that year, the town government approved his request to divert water from the Ru, but he was required to build sluices. He was also permitted to put up trellises at both ends of the garden in order to set it more clearly apart from the railroad line that separated the two lots. This new land purchase enabled Monet to enlarge his pond by roughly one-third in the winter of 1901/02. He built four more bridges over the diverted stream and installed a trellis with glycinia vines on the existing bridge (figs. 58 and 59). The banks were planted with irises, grasses, lilies, and weeping-willows; shrubs, ferns, bamboo, and trees were planted on the new embankments. Traffic along the two roads that ran along Monet's property had increased since he first put in his pond. The water and the lilies were soon covered with dust raised by passing pedestrians and vehicles, a situation that prompted the artist to contribute half of the costs of tarring both roads in the spring of 1907.

Monet's gardening efforts are not the only evidence of his avid interest in botany. He also guided his friends through his garden with great enthusiasm and occasionally used the garden to lure fellow artists and acquaintances who were also interested in gardening to Giverny, as indicated in letters to Clemenceau and Geffroy (fig. 59). The following passage is cited from a letter to Geffroy:

> My dear friend, if you wait too long, all the blossoms will be gone, and I want so much for you to see the garden in its present state. Come soon; I will write to Clemenceau as well, so that he can make arrangements with you. Yours sincerely, Claude Monet.[79]

Monet shared this passion for gardens with the art critic Geffroy, the politician and publicist Clemenceau, the painter Caillebotte, and the writer Mirbeau. The friends exchanged seeds and sprouts and spent hours on end debating issues of garden design. Discussions about art were secondary, as an excerpt from a letter to Mirbeau written before his visit clearly illustrates:

> My dear friend, I am very pleased that you are bringing Caillebotte along with you. We shall talk about gardening, as art and literature are mere antics. Ultimately, the only thing that counts is the earth.[80]

Triumphant Success

Durand-Ruel organized an exhibition for Monet featuring thirty-eight works at his New York gallery in 1902. The artist celebrated triumphant success at various international exhibitions, earning particularly strong acclaim in Germany, where Durand-Ruel maintained a close working relationship with Paul Cassirer (1871–1926), an art dealer and later publisher with whom he was involved in frequent negotiations. In 1907, the French government purchased its first Monet[81] for the Musée du Luxembourg—thanks in part to Clemenceau's efforts to promote the transaction. Now internationally recognized, Monet had become a wealthy man who could now live the life of luxury he had always dreamed of. The professed gourmet had culinary delicacies such as goose liver from Alsace and truffles from Périgord delivered to his home and indulged in a veritable celebration of fine food. Friends and members of his family were invited to gourmet meals prepared by his cook Marguerite, who had worked for him for many years and whom he greatly admired.[82] The son of gallerist Josse Bernheim-Jeune recalled visits by his

Fig. 59
Claude Monet and Gustave Geffroy (1855–1926) in front of the glycinia-covered bridge over the water-lily pond in Giverny. Photograph by Sacha Guitry, ca. 1900. Monet met the journalist Gustave Geffroy in 1886, and the two became close friends. The painter found Geffroy's critical reviews of his works, some of which appeared in the journal **La Justice** edited by the publicist and politician Georges Clemenceau, quite accurate and treasured them more than any others. The journalist often visited Monet in Giverny, where the artist always guided him eagerly through his garden.
© Dukas/Roger-Viollet

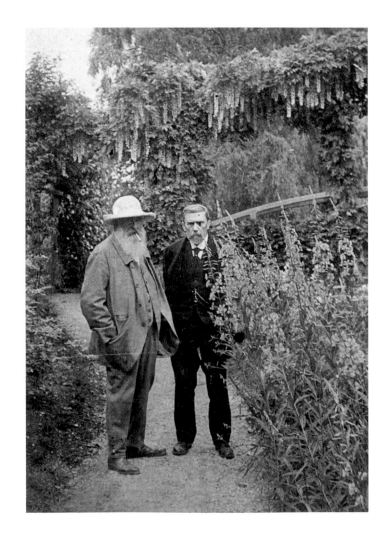

father at which sumptuous meals were served and also described Monet as a
gourmand:

> He was a gourmet indeed and in truth, but even more of a glutton. Even dur-
> ing the years in which he accepted invitations, he always warned that one could
> hardly honor one's hosts with a small appetite. [83]

Monet ordered expensive tailored clothing and exchanged a painting for a Panhard-
Levassor, a French luxury car (fig. 60). The painter, who never learned to drive, hired
a chauffeur and took short trips as well as extended journeys to Spain, Italy, and
Switzerland. The family soon acquired several more cars, were frequently among
the enthusiastic spectators at automobile races in France. Monet enjoyed having
his picture taken in Giverny, and many photographs were taken by his son Michel.
An especially large number of photos of the artist alone and with friends or mem-
bers of his family in his garden taken during the late eighteen-eighties have sur-
vived.

Monet worked intensely on his water-lily paintings in the summer of 1906.
These works were exhibited at Durand-Ruel's gallery in 1909. The artist insisted
that the paintings be hung in the order in which they were completed, and he
replaced the proposed exhibition title, "Reflections" (Réflexions) with "Water-Lilies:
Series of Water Landscapes" (Les Nymphéas: Series de paysages d'eau), thus
emphasizing the serial character of the works. The show was a tremendous popu-
lar and critical success. The painter worked according to a strict daily schedule
while painting these works—a process that took considerable time to complete,

which is why the exhibition at Durand-Ruel's gallery had to be postponed several times. He painted from seven to eleven o'clock in the morning, from one to three in the afternoon, and then again from five o'clock until sundown. The noon break was reserved for entertaining friends and other visitors, who were always invited for the obligatory walk through his garden.

In the fall of 1906, Monet embarked on one of the few journeys he ever took with his wife Alice, for the painter ordinarily traveled alone in search of new motifs. Their destination was Venice (fig. 61), where Monet did nearly forty paintings. After returning to Giverny, he reworked these paintings several times before finally exhibiting them at the Bernheim-Jeune gallery in 1912.

The Connection between the Garden and the Paintings as seen by the Press

Critics noted an interdependence of Monet's paintings and his garden with increasing frequency during the first decade of the twentieth century. One of the first to establish this connection was the art critic and later Monet biographer Alexandre, who visited Monet in 1901. He was truly impressed with the design of the garden and felt like Parcifal in a setting never seen before. Alexandre contended that one could not know Monet without having seen his garden. He characterized the painter as a master gardener whose flowers were his source of inspiration and whose garden was his teacher.[84] Maurice Kahn wrote an equally enthusiastic description of the Monet's property and gardens in 1904, concluding his remarks by saying that it was easy to understand—after having seen Monet's garden—why such a gardener was also such a painter.[85] It was Marcel Proust (1871–1922), one of the most important French authors at the turn of the century,[86] who attributed mythical stature to Monet's garden in a description he wrote in 1907 without ever having visited the site:

> ... I have a sense of what I will see there: a garden that consists more of shades and colors than of flowers, a garden that is less a traditional flower garden than a garden of color, if such a thing can be said, flowers that join to form an entirely natural ensemble because they have been planted in such a way that only those bloom which combine in gradations of color ... this garden (which is more a realization of art than a model for paintings; a painting that has already been executed in nature and is visualized through the eyes of a great painter) is like a first, animated sketch; at the very least, the splendid palette on which the harmonious hues are prepared has already been composed ...[87]

Specialists in plants began to show increasing interest in Monet's garden about this time. In 1908, Jean Claude Nicolas Forestier (1861–1930), a landscape gardener and Chief Conservator of Gardens in Paris, visited the painter and wrote an article on the estate and the gardens for the journal **Fermes et châteaux**.[88] Monet also maintained close contacts with Georges Truffaut (1872–1945), a prominent gardening special-

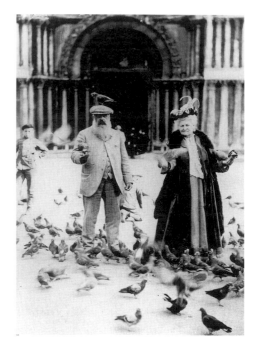

Fig. 61
Claude Monet and his second wife Alice Hoschedé (1844–1911) on Piazza San Marco in Venice, October 1908
© Musée Marmottan Monet, Paris and Giraudon-Bridgeman Art Library

ist and editor of the journal **Jardinage,** beginning in 1913. Truffaut published an article written by Monet's head gardener Breuil on iris varieties and wrote a detailed description of a walk through the grounds of Monet's estate shortly thereafter.[89] Truffaut also printed several photographs of Monet's garden in his journal.

Family Problems and the Realization of the Grandes Décorations

Thanks to Clemenceau's influence, the journalist Geffroy was appointed director of the Manufacture Nationale des Gobelins in 1908. Two years later, he commissioned Monet to paint water-lily motifs as models for tapestry patterns. The artist completed three works for the project by 1913.

The Seine overflowed its banks in the winter of 1910, flooding sections of Monet's garden and damaging some of the plants (figs. 62 and 63). After the water receded, the painter modified the shape of the pond embankment and gave the pond its final form. The death of Alice Monet a year later thrust the seventy-one-year-old painter into a severe crisis. He lost interest in painting and his garden, and it was not until the following year that his creative vitality returned. Despite a diagnosis of cataracts, he continued stubbornly to paint and postponed the eye operation he so urgently needed. Avoiding glaring sunlight as best he could, he did most of his painting before dawn and during the evening hours. When war broke out in 1914, his son Michel was called to the front, causing Monet further suffering. To make matters worse, he lost his other son Jean, who died after a long, agonizing illness. Jean's widow, Blanche—who was also Monet's step-daughter—assumed responsibility for the artist's care from then on.

Fig. 62
Postcard showing the Seine flooding of 1910
Courtesy Collection Toulgouat

The war hindered sales of the artist's works, and money grew scarce. Monet retreated to his garden and painted more than sixty water-lily scenes, most of them in large formats. He began work on the **Grandes Décorations** — huge paintings of his water-lily pond, many of which measured two by three meters. Despite a shortage of workers and material, Monet built a new studio with a skylight and twenty-three by twelve meters of floor space in the northwest corner of his property between July and October 1915 so that he could work on these canvases. Monet stood the panels side by side in a circular arrangement (figs. 64–66) in the new studio. Durand-Ruel and his two sons — both of whom were now working for their father — visited Monet in 1917 and took the first photographs of the **Grandes Décorations** arranged in groups by the painter. The collector René Gimpel described the impression evoked by the arrangement of the paintings a year later after visiting Monet's studio in the company of the art dealer Bernheim:

> ... and he accompanies us along the paths of his garden to a newly constructed studio that is built like a village church. The interior consists of a single, immense room with a glass roof, and there we encounter an astonishing artistic sight: a good dozen canvases standing on the floor, arranged in a circle, side by side, each of them roughly two meters long and one meter twenty high; a panorama of water and water-lilies, of light and sky. Water and sky have neither beginning nor end in this infinite vastness.[90]

After the Armistice in 1918, Monet decided to donate the **Grandes Décorations** to the French nation — a decision supported fervently by Clemenceau. Plans called for the construction of an oval pavilion in the garden of the former Hôtel Biron.[91] Clemenceau was not re-elected in 1920, and could no longer exert significant influence on the project, which was eventually abandoned for lack of funds. In its place, Monet was asked to choose between two existing buildings — the Jeu de Paume and the Orangerie. The artist initially rejected both, but after some hesitation, finally decided that the Orangerie located near the Place de la Concorde would be a suitable setting. The building — originally erected as a storage depot for the orange trees from the Tuileries in 1852 — had belonged to the Musée du Luxembourg since 1921. In the official letter of bequest issued in 1922, Monet specified that he would make nineteen paintings available to the state, which were to be exhibited in two oval rooms. He spent the remaining years of his life reworking works in progress, painting new ones, and selecting paintings to be presented. The **Grandes Décorations** were not presented at the Orangerie until after Monet's death.

Fig. 63
Water-lily pond in Claude Monet's garden during the Seine flooding of 1910
© Collection Toulgouat

Fig. 64
Claude Monet supervising the construction of his third studio in 1916. The photograph was presumably taken by his son Michel Monet (1878–1966).
© Collection Toulgouat

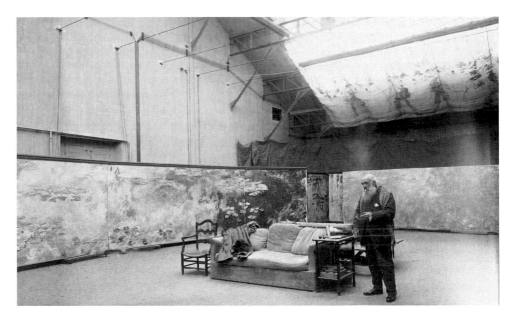

Fig. 65
Claude Monet in his studio, a spacious room measuring twenty-three by twelve meters. In this setting, he painted the **Grandes Décorations**—very large water-lily paintings he ordinarily arranged in groups with combined dimensions of about two by six meters, forming a kind of panoramic view. Claude Monet's decision to make a significant donation of art to the French nation was documented in the letter of bequest signed on April 12, 1922. Nineteen paintings produced specifically for this purpose were bequeathed to the state. They were not hung in the Orangerie until after Monet's death, however. Photograph by Henri Manuel, ca. 1922.
© Musée Marmottan Monet, Paris and Giraudon-Bridgeman Art Library

Fig. 66
Claude Monet's desk; in the background are examples of the **Grandes Décorations**. Photography by Paul Durand-Ruel's son Joseph in November 1917
Courtesy Caroline Godfroy
© Archives Durand-Ruel

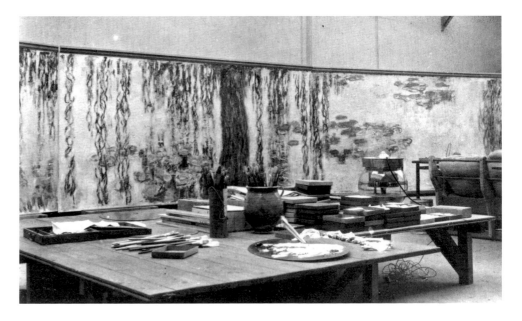

The Eternally Dissatisfied Artist

Although Monet had now earned considerable critical and popular acclaim, he remained highly critical of his own works. Since the eighteen-eighties, he had destroyed many of the paintings he had failed to complete to his satisfaction. The pace of destruction increased after 1900, reaching a level that even attracted attention in the press. The **Washington Post** reported in 1908 that Monet had cut apart works valued at more than one hundred thousand dollars.[92] And even Clemenceau (fig. 67) expressed regret in response to his friend's destructive rage:

> I could see only too well what would happen. Monet had developed the terrible habit of slashing pieces with which he was dissatisfied apart with a palette knife and stomping on the shreds. Today, studies for panels in his studio still show evidence of the damage inflicted during such fits of rage, in which he often cursed himself as well.[93]

Monet's eyesight continued to deteriorate, yet the artist repeatedly postponed the needed cataract surgery until 1923, when two operations were performed to remove some of the cataracts in his right eye. Problems persisted, and a third round of surgery became necessary. The vision in his left eye worsened and his health deteriorated progressively during the last years of his life. Monet painted less and less as time passed. At age eighty-six, he was diagnosed with an incurable lung disease. He retreated into isolation and received only his closest friend Clemenceau during the last days preceding his death on December 5, 1926. The great artist's death was announced in headlines and discussed in lengthy front-page articles in many French newspapers the next day.[94] Several extensive articles on Monet were also published in 1927, most of which also contained references to his garden.[95] Clemenceau discussed the central role the garden had played in Monet's life and work in his **Claude Monet: Les Nymphéas** in 1928:

> Monet's garden must be included among his works of art, because it represented the realization of the magical adaptation of nature to the work of the painter of light. An expansion of the studio into the outdoors, with shades of color lavishly spread out in all directions as exercise for the eye through alluring vibrations from which a feverishly excited retina awaits a joy that can never be extinguished.[96]

As this excerpt clearly shows, the myth of the plein-air painter and the garden-as-studio lived on after Monet's death, even though the artist had worked primarily in his studio after 1900 and his garden was more a source of motifs than the setting in which he worked. The fact that the myth has persisted in the writings of some younger authors is attributable at least in part to Monet's own self-characterization, an image created by a man who consistently exploited the media to his advan-

Fig. 67
Georges Clemenceau (1841–1929) and Claude Monet
in the garden in Giverny, ca. 1920. Dubbed "le Tigre"
for his strong political commitment, the publicist and
radical republican politician was a close friend of
Monet. He was prime minister of France from 1906 to
1909 and 1917 to 1920 and played an instrumental
role in promoting recognition of Monet as the most
important French painter of his time.
© Dukas/Roger-Viollet

tage. He presented himself to the chosen few journalists he received in his garden
as a plein-air painter, posing appropriately in the photographs that accompanied
their articles. The painter is most often seen in his splendidly blooming garden—
particularly in Giverny—positioned with considerable dramatic effect in the midst
of his own favorite motif.

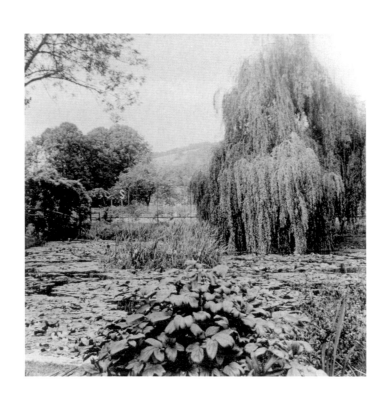

1 According to Virginia Spate, Monet earned about two thousand francs in this way, which was more than the annual salary of a skilled worker. Virginia Spate, **The Colour of Time: Claude Monet** (London, 1992), p. 17.

2 Monet himself referred to the first journey with Boudin to Honfleur in 1859 as a seminal experience, and confirmed in a letter to Boudin in 1892 that he had been the first person who taught him to see and understand. Letter to Boudin, August 22, 1892, in Daniel Wildenstein, **Claude Monet, biographie et catalogue raisonné en 5 volumes** (Lausanne, 1974/79), vol. III, p. 268, W 1162.

3 Clare A. P. Willsdon, "'Promenades et plantations': Impressionism, Conservation and Haussmann's Reinvention of Paris," in Frances Fowle and Richard Thomson, eds., **Soil and Stone: Impressionism, Urbanism, Environment** (Hants and Edinburgh 2003), pp. 107–124, here pp. 108–110.

4 The early years of the friendship between Monet and Clemenceau are poorly documented; it is assumed, however, that they met during the eighteen-sixties at the Brasserie des Martyrs—a place they both visited often. They saw each other more frequently after 1890, as both had close contact with the journalist Gustave Geffroy. See André Wormser, "Clemenceau et Claude Monet, une singulière amitié," in **Georges Clemenceau à son ami Claude Monet. Correspondances** (Paris, 1993), pp. 27–58, here pp. 30 und 33.

5 **Mouth of the Seine at Honfleur**, 1865, W 51, and **The Pointe de La Hève at Low Tide**, 1865, W 52.

6 Paul Hayes Tucker, **Claude Monet: Life and Art** (New Haven, 1995), p. 21.

7 1865, W 63/2.

8 1866, W 67.

9 1866, W 65.

10 Free translation from the French: "J'ai plus que jamais besoin. vous savez pourquoi. j'en suis malade. Si vous ne me répondez pas tout sera rompu. je ne vous écrirai plus jamais. soyez sûr." Letter to Bazille of August 20, 1867, in Wildenstein 1974/79, vol. I, p. 424, W 38.

11 Free translation from the French: "Je commençai, peu de temps après, à glisser quelques toiles de ces deux peintres dans mes expositions et j'en vendis avec peine quelques-unes." "Mémoires de Paul Durand-Ruel," in Lionello Venturi, **Les Archives de l'Impressionnisme**, vol. II (New York and Paris, 1939), pp. 143–220, here p. 180.

12 Jensen calls Durand-Ruel an "ideological art dealer" because he was not only interested in making a profit but also acted as an advocate for a certain kind of art. Robert Jensen, **Marketing Modernism in Fin-de-Siècle Europe** (Princeton, 1994), p. 49.

13 Paul Hayes Tucker, **Monet at Argenteuil** (New Haven, 1982), pp. 125–126 and pp. 151–153.

14 Free translation from the French: "... Et puis il y a le jardin! ... Au surplus un jardinet tel que celui-là est un sujet d'observations inépuisables. Il sera, en même temps, un conseiller aux heures de réflexion, un dictionnaire aux heures de travail, un consolateur aux jours de détresse... Enfin ce jardin fournira des fleurs pour les bouquets à peindre entre les expéditions de paysages; des échantillonnages de tons aussi variés pour un œil attentif et subtil ... Ce jardin d'Argenteuil, nous le considérons comme un élément capital, comme un point de passage décisif, dans l'œuvre du peintre." In Arsène Alexandre, **Claude Monet** (Paris, 1921), p. 65.

15 Although Argenteuil was also an important commercial port linking Paris with the sea, Monet never painted merchant vessels.

16 See Spate 1992, p. 79, or David Joel, **Monet at Vétheuil and on the Norman Coast 1878–1883** (Woodbridge, 2002), p. 195. Joel traces the development of Monet's income over the years in a graph.

17 Examples include letters written on July 26, 1873, and August 29, 1873, to Théodore Duret—an art critic and an early advocate of the Impressionists. Wildenstein 1974/79, vol. I, p. 428, W 66 and 68.

18 The Palais was originally built for the 1855 World's Fair and later became the site of the annual official Salons. The Galeries nationales du Grand Palais (built between 1897 and 1900) stand on the spot today.

19 See also Andrée Sfeir-Semler, **Die Maler am Pariser Salon 1791–1880** (Frankfurt am Main and New York, 1992).

20 The group deliberately chose a neutral name in order to avoid prompting talk of a new school of art. See John Rewald, **Geschichte des Impressionismus** (Zurich and Stuttgart, 1957), p. 203 [English edition: **History of Impressionism**, 1946]. The term "Impressionists" was soon firmly established, however.

21 Critic Jules Castagnary described the form of presentation used at the exhibiton in great detail in his article. Jules Castagnary, "L'exposition du boulevard des Capucines—Les Impressionnistes," **Le Siècle**, April 29, 1874. Reprinted in Martha Kapos, ed., **The Impressionist—A Retrospective** (New York, 1991), pp. 83–86.

22 1873, W 263.

23 Tucker 1995, p. 230.

24 Edouard Manet, **The Monet Family in Their Garden**, 1874, The Metropolitan Museum of Art, New York.

25 Wildenstein 1996, vol. I, p. 117.

26 Marci Regan, **Paul Durand-Ruel and the Market for Early Modernism**, master's thesis, Louisiana State University, 1997/2004, http://etd.lsu.edu/docs/available/etd-03292004-181506.

27 The commissioned works are: **Turkeys (Les Dindons)**, 1876, W 416; **The Garden at Montgeron (Coin de jardin à Montgeron)**, 1876, W 418; **The Pond at Montgeron (L'Etang à Montgeron)**, 1876, W 420; and **Hunting (La Chasse)**, 1876, W 433.

28 Claire Joyes, **Claude Monet: Life at Giverny** (New York and Paris, 1985), p. 17. First published in 1975.

29 Wildenstein 1996, vol. I, p. 128.

30 Nearly all of his letters contain references to his financial problems. See, for example, the letter to Emile Zola dated April 7, 1878: "We don't have a cent in the house, not even enough to heat up a pot today..." Free translation from the French: "Nous n'avons pas un sou à la maison, pas même de quoi faire bouillir la marmite aujourd'hui..." In Wildenstein 1974/79, vol. I, p. 434, W 129.

31 Théodore Duret, **Les Peintres impressionnistes. Claude Monet—Sisley—C. Pissarro—Renoir—Berthe Morisot** (Paris: H Heymann & J. Perois, 1878), pp. 10 and 12.

32 Duret 1878, pp. 14–15. Apart from a general wave of enthusiasm relating to all things Japanese in those years, Duret's reference is quite understandable in view of the fact that he had actually traveled there himself.

33 Free translation from the French: "Ses toiles communiquent bien réellement des impressions; on peut dire que ses neiges donnent froid et que ses tableaux de pleine lumière chauffent et ensoleillent... L'artiste se sent porté vers la nature ornée et les scènes urbaines. Il peint de préférence des jardins fleuris, des parcs et des bosquets. Cependant l'eau tient la principale place dans son œuvre. Monet est par excellence le peintre de l'eau." In Duret 1878, pp. 18–19. Duret noted Monets interest in water as a subject in his art as early as 1878—years before the painter put in his pond in Giverny and began to focus on the subject with increasing intensity.

34 Joel 2002, pp. 33–34 and p. 52.

35 Théodre Duret, ed., **Le Peintre Claude Monet**, exh. cat., Galerie du Journal illustré La Vie moderne (Paris, 1880), pp. 9–10.

36 The image of Monet as a pure plein-air painter persists to some extent even today.

37 Emile Taboureux, "Claude Monet," **La Vie moderne**, June 12, 1880. Reprinted in Kapos 1991, pp. 241–242. Taboureux identified a close relationship between Monet's garden and his painting, even referring to the wildflowers he saw as impressionistic.

38 Tucker 1995, p. 3. The archives of the Musée Marmottan-Monet in Paris has a collection of press clippings covering the years up to 1943. Thus it is evident that Monet's heirs subscribed to these media monitoring services at least until then.

39 Charles F. Stuckey, ed., **Claude Monet: 1840–1926,** exh. cat., The Art Institute of Chicago, 1995, p. 205.

40 Tucker 1995, p. 107.

41 Spate 1992, pp. 150–152.

42 Free translation from the French: "... à notre époque, on ne fait rien sans la presse ..." Letter to Durand-Ruel, March 6, 1883. Claude Monet, "Lettres à Paul Durand-Ruel, 1876–1926," in Lionello Venturi, **Les Archives de l'Impressionisme,** vol. I (New York and Paris 1939), p. 250.

43 Free translation from the French: "Non, au point de vue artistique, cela ne change rien, je sais ma valeur, et suis plus difficile pour moi que n'importe qui. Mais c'est au point de vue commercial qu'il faut voir les choses. Et ne pas reconnaître que mon exposition a été mal annoncée, mal préparée, c'est ne pas vouloir voir la vérité." Letter to Durand-Ruel, March 7, 1883, in Venturi 1939a, p. 251.

44 Thus Geffroy, for example, wrote in Clemenceau's journal **La Justice** that Monet's summary painting style was an appropriate approach to capturing the rapidly changing colors of nature, in consequence of which clearly defined forms are dissolved. Gustave Geffroy, "Claude Monet," **La Justice,** March 15, 1883. Cited here from Spate 1992, p. 160.

45 See Spate 1992, p. 161.

46 Free translation from the French: "... mais une fois installé j'espère faire des chefs-d'œuvre, car le pays me plaît beaucoup." Letter to Durand-Ruel, April 15, 1883, in Venturi 1939a, pp. 253–254.

47 Free translation from the French: "C'est dans une maison rustique, plus tard étendue et enrichie en confortable villa, que Monet vint s'établir en 1883. La demeure, entre deux routes parallèles, s'élevait en bordure de l'une et était séparée de l'autre par un grand jardin en pente douce, permettant tous les tracés et, par son exposition ensoleillée, favorable à toutes les floraisons." In Alexandre 1921, p. 80.

48 Tucker 1995, p. 175.

49 Free translation from the French: "... puis j'ai eu le jardinage qui m'a un peu absorbé, afin de récolter quelques fleurs pour peindre dans les mauvais jours." Letter to Durand-Ruel, June 5, 1883, in Venturi 1939a, p. 255.

50 Free translation from the French: "... j'ai eu tout le temps des cauchemars, voyant tous mes tableaux faux de ton, puis les apportant à Paris, où tout le monde m'avouait n'y rien comprendre." Letter to Alice Hoschedé, February 6, 1884, in Wildenstein 1974/79, vol. II, p. 236, W 409.

51 Despite this substantial income, he complained to his agent and often asked for money, as the following example indicates: "I sent you a telegram asking you to transfer money right away. I don't have a penny to my name — a situation that it highly embarrassing to me ... I don't even have enough to send you a second telegram telling you that you must act as quickly as possible." Free translation from the French: "Je vous télégraphie pour vous prier de m'envoyer de suite de l'argent. Je me trouve absolument sans un sou, ce qui me gêne énormément ... Je n'ai même pas le moyen de vous envoyer une deuxième dépêche pour vous dire de le faire le plus vite possible ...!" Letter to Durand-Ruel, March 21, 1884, in Wildenstein 1974/79, vol. II, p. 245, W 452.

52 Free translation from the French: "... il faut toujours un certain temps pour se familiariser avec un pays nouveau." Letter to Durand-Ruel, July 3, 1883, in Venturi 1939a, pp. 257–258.

53 See Wildenstein 1996, vol. II, p. 344.

54 Free translation from the French: "Il est vrai que le temps n'était guère favorable; depuis mon retour, il ne m'a pas été possible de travailler dehors, c'était à se croire en hiver. Aussi ai-je pris le parti de jardiner et de me préparer de beaux motifs de fleurs pour l'été ..." Letter to Durand-Ruel, May 27, 1885, in Venturi 1939a, p. 291.

55 According to an anecdote, he was surprised by a wave on November 27, 1885 and barely managed to survive drowning. Paintings and painting implements disappeared into the sea. See Wildenstein 1996, vol. I, pp. 213–214.

56 Free translation from the French: "... mais j'avoue que certaines de ces toiles je les verrais à regret partir au pays des Yankees et j'en voudrais réserver un choix pour Paris, car c'est surtout et là seulement qu'il y a encore un peu de goût." Letter to Durand-Ruel, July 28, 1885, in Venturi 1939a, pp. 294–295.

57 Her husband Horace Havemeyer was as interested in botany as Monet and even sent him two large crates of winter-resistant plants in 1895. On the Havemeyer collection, see Frances Weitzenhoffer, **The Havemeyers: Impressionism Comes to America** (New York, 1986).

58 Jensen 1994, p. 8.

59 Frances Weitzenhoffer describes this as a typical American form of self-glorification. See Frances Weitzenhoffer, "The Earliest American Collectors of Monet," in **Aspects of Monet,** ed. John Rewald and Frances Weitzenhoffer (New York, 1984), pp. 73–91, here p. 83.

60 Geffroy was a founding member of the Académie Goncourt, a literary society established following the death of author Edmond de Goncourt (1822–96); it was Goncourt's grandfather who introduced the French to Japanese art. See www.academie-goncourt.fr.

61 One of the earliest paintings is **Peonies,** 1887, W 1142 (cat. 32).

62 See also Spate 1992, p. 202.

63 Fénéon later worked for the Bernheim-Jeune Gallery, which also represented Monet, for more than twenty-five years.

64 Félix Fénéon, "L'impressionnisme," **L'Emancipation sociale,** April 3, 1887. Reprinted in Félix Fénéon, **Au-delà de l'impressionnisme** (Paris, 1966), pp. 81–86.

65 Free translation from the French: "Il habite la campagne dans un superbe paysage en constante compagnie de ses modèles, et le plein air est son unique atelier." Octave Mirbeau, "Claude Monet, élève de personne," **Le Figaro,** March 10, 1889. Reprinted in Octave Mirbeau, **Monet et Giverny** (Paris, 1995), pp. 23–32, here p. 32.

66 Free translation from the French: "Et puis, je dois l'avouer, j'ai beaucoup de peine à quitter Giverny, surtout maintenant que j'arrange la maison et le jardin à mon goût." Letter to Stéphane Mallarmé, July 28, 1891, in Wildenstein 1974/79, vol. III, p. 262, W 1121.

67 According to Mancoff, Monet inspired several newcomers, including Lilla Cabot and Tom Perry to lay out flower beds in their gardens instead of planting only vegetables and fruit trees. The local people stuck to their traditional kitchen gardens, however. Debra N. Mancoff, **Monet's Garden in Art** (London, 2001), p. 105.

68 See the article entitled "Claude Monet the gardener" in the present catalogue.

69 Free translation from the French: "C'est là, dans cette perpétuelle fête des yeux, qu'habite Claude Monet. Et c'est bien le milieu qu'on imagine pour ce prodigieux peintre de la vie splendide de la couleur, pour ce prodigieux poète des lumières attendries et des formes voilées, pour celui qui fit les tableaux respirables, grisants et parfumées ..." Octave Mirbeau, "Claude Monet et Giverny," **L'Art dans les deux Mondes,** March 7, 1891. Reprinted in Mirbeau 1995, pp. 7–21, here p. 11.

70 A year after her untimely death in 1899, her younger sister Marthe (1864–1925) married Theodore Butler.

71 Letter to Alice Hoschedé, March 10, 1892, in Wildenstein 1974/79, vol. III, pp. 264–265, W 1139.

72 Wildenstein 1996, vol. I, p. 290.

73 Free translation from the French: "Je suis désolé de ces nouvelles difficultés ... Cela me met en rage et je ne veux plus m'occuper de rien, avec des Malassis et tous ces gens de Giverny ... Il ne faut rien louer, ne commander aucun grillage et jeter les plantes aquatiques à la rivière; elles y pousseront ... Je donne le terrain à qui le voudra." Letter to Alice Monet, March 20, 1893, in Wildenstein 1974/79, vol. III, p. 271, W 1193.

74 See Monet's letter to the prefect of the Departement of Eure dated July 17, 1893, in Wildenstein 1974/79, vol III, pp. 274–275, W 1219.

75 See also the section on Bory Latour-Marliac's water-lilies in the article entitled "Claude Monet the Gardener" in the present catalogue.

76 Stuckey 1995, p. 224. He built another heatable greenhouse in 1897.

77 See the letters to the prefect of the Departement of Eure dated May 21, 1895, W 1300; June 3, 1895, W 1301; June 11, 1895, W 1303; June 14, 1895, W 1305, and August 21, 1895, W 1313, all in Wildenstein 1974/79, vol. III, pp. 286–288.

78 Joyes 1985, p. 91.

79 Free translation from the French: "Cher ami, Si vous tardez, le jardin sera défleuri et je voudrais tant que [vous] le voyiez tel qu'il est. Venez vite; j'écris à Clemenceau pour qu'il s'entende avec vous. Amitiés, Claude Monet." Letter to Geffroy, May 29, 1900, in Wildenstein 1974/79, vol. IV, p. 348, W 1559. See also a similar letter to Clemenceau, May 29, 1900, in Wildenstein 1974/79, vol. IV, p. 348, W 1558.

80 Free translation from the French: "Cher ami, je suis très content que vous ameniez Caillebotte. Nous causerons jardinage, comme vous dites, car pour l'art et la littérature, c'est de la blague. Il n'y a que la terre." In Octave Mirbeau, Correspondance avec Claude Monet (Tusson 1990), p. 111.

81 The Portal, Harmony in Brown, 1892, W 1319, from the Rouen Cathedral series.

82 A cookbook is now available containing recipes for the dishes served in the Monet household: Claire Joyes, ed., Monet's Table: The Cooking Journals of Claude Monet, foreword by Joël Robuchon (New York and London, 1989). Originally published in French: Les Carnets de Cuisine de Monet (Paris, 1989).

83 Free translation from the French: "A la vérité il était gourmet, plus que véritablement gourmand; aussi à l'époque où il acceptait des invitations, il prévenait toujours qu'ayant peu d'appétit il ne pourrait guère faire honneur à ses hôtes ..." In Henry Dauberville, La Bataille de l'Impressionnisme (Paris, 1967), p. 198.

84 Arsène Alexandre, "Le Jardin de Monet," Le Figaro, August 9, 1901. Reprinted in Charles F. Stuckey (ed.), Monet—A Retrospective, exh. cat. (New York, 1985), pp. 219–223.

85 Maurice Kahn, "Le Jardin de Claude Monet," Le Temps, June 7, 1904. Reprinted in Stuckey 1985, pp. 241–245. Quite similar are the comments made by Louis Vauxcelles, accompanied by photos by Ernest Bulloz, the first views of the garden ever published. Louis Vauxcelles, "Une après-midi chez Claude Monet," L'Art et les Artistes, December 1905. Reprinted in Stuckey 1985, pp. 245–249.

86 For the second volume of his A la recherche du temps perdu, Proust was awarded the Prix Goncourt by the Académie Goncourt in 1919. One of the founding members of the Académie was Gustave Geffroy, a journalist and a close friend of Monet's. Proust was also named a Knight of the Legion of Honor in 1920. On Proust, see also www.marcel-proust-gesellschaft.de. His novel was published in seven volumes between 1917 and 1923.

87 Free translation from the French "... je sens bien que j'y verrai, dans un jardin de tons et de couleurs plus encore que de fleurs, un jardin qui doit être moins l'ancien jardin-fleuriste qu'un jardin coloriste, si l'on peut dire, des fleurs disposées en un ensemble qui n'est pas tout à fait celui de la nature, puisqu'elles ont été semées de façon que ne fleurissent en même temps que celles dont les nuances s'assortissent ... ce jardin (vraie transposition d'art plus encore que modèle de tableaux, tableau déjà exécuté à même la nature qui s'éclaire en dessous du regard d'un grand peintre) est comme une première et vivante esquisse, tout au moins la palette est déjà faite et délicieuse où les tons harmonieux sont préparés ..." Marcel Proust, "Les éblouissements," Le Figaro, June 15, 1907. Reprinted in Marcel Proust, Œuvres complètes, vol. 10 (Paris, 1936), pp. 199–200.

88 Jean Claude Nicolas Forestier, "Le jardin de M. Claude Monet," Fermes et châteaux, September 1, 1908, pp. 13–16. On Forestier, see also Bénédicte Leclerc, ed., Jean Claude Nicolas Forestier. 1861–1930. Du jardin au paysage urbain, actes du Colloque International sur J. N. C. Forestier (Paris, 1994), in which, among other things, the restoration of the Parc Bagatelle is discussed with reference to Monet's garden.

89 Félix Breuil, "Les Iris pour bord de rivières, étangs et terrains humides," Jardinage 21 (October 1913), pp. 2–9; and Georges Truffaut, "Le Jardin de Claude Monet," Jardinage 87 (November 1924), pp. 54–59.

90 Free translation from the French: "... et il nous conduit par les allées de son jardin jusqu'à un atelier nouvellement construit, bâti comme une église de hameau. A l'intérieur ce n'est qu'une pièce immense avec un plafond vitré et, là, nous nous trouvons placés devant un étrange spectacle artistique: une douzaine de toiles posées à terre, en cercle, les unes à côté des autres, toutes longues d'environ deux mètres et hautes d'un mètre vingt; un panorama fait d'eau et de nénuphars, de lumière et de ciel. Dans cet infini, l'eau et le ciel n'ont ni commencement ni fin." In René Gimpel, Journal d'un collectionneur, marchand de tableaux—1918–1939 (Paris, 1963), p. 68.

91 The building has been the home of the Musée Rodin since the end of the war.

92 Anonymous, "Destroys His Painting," The Washington Post, May 16, 1908. Reprinted in Stuckey 1985, p. 250.

93 Quoted and translated from Georges Clemenceau, Claude Monet, Les Nymphéas (Paris, 1928), pp. 25–26: "Je prévoyais trop bien ce qui arriva. Il avait pris depuis longtemps la redoutable habitude de lacérer à coups de râcloir, de déchirer à coups de pieds, les morceaux qui ne lui donnaient pas satisfaction. Des ébauches de panneaux, dans son atelier, nous offrent encore les blessures distribuées en des accès de fureur où il ne s'épargnait à lui-même aucune injure."

94 On Monet and the press, see also Steven Z. Levine, Monet and His Critics (New York, 1976).

95 In an article by François Thiébault-Sisson, for example, "Les Nymphéas de Claude Monet," La Revue de l'art ancien et moderne, June 1927. Reprinted in Kapos 1991, pp. 300–317.

96 Clemenceau 1928, p. 46: "Le jardin de Monet compte parmi ses œuvres, réalisant le charme d'une adaptation de la nature aux travaux du peintre de la lumière. Un prolongement d'atelier en plein air, avec des palettes de couleurs profusément répandues de toutes parts pour les gymnastiques de l'œil, au travers des appétits de vibrations dont une rétine fiévreuse attend des joies jamais apaisées."

1089

IRIS TECTORUM Maxim.

Chine-Japon. Plein air.

Appendix

Exhibition Checklist

The titles in parentheses correspond to those of the owners. All other titles are taken from Wildenstein.

1
Spring Flowers, 1864
FLEURS DE PRINTEMPS
Oil on canvas, 116.8 x 90.5 cm (46 x 35⁵/₈ in.)
The Cleveland Museum of Art,
Gift of the Hanna Fund, 1953.155
W 20

2
Jar of Peaches, 1866
BOCAL DE PECHES
Oil on canvas, 55.5 x 46 cm (21⁷/₈ x 18¹/₈ in.)
Galerie Neue Meister, Staatliche Kunstsammlungen Dresden, 2525 B
W 70

3*
Luncheon on the Grass, Central Panel, 1865
DEJEUNER SUR L'HERBE, PARTIE CENTRALE
Oil on canvas, 248 x 217 cm (97⁵/₈ x 85³/₈ in.)
Paris, Musée d'Orsay, 1987.12
W 63/2

4
Portrait of Victor Jacquemont Holding a Parasol,
1865 or 1867
(Man with Parasol)
PORTRAIT DE VICTOR JACQUEMONT AU PARASOL
Oil on canvas, 100 x 61 cm (39³/₈ x 24 in.)
Kunsthaus Zürich, 2334
W 54

5
Forest of Fontainebleau, ca. 1865
FORET DE FONTAINEBLEAU
Oil on canvas, 50 x 65 cm (19⁵/₈ x 25⁵/₈ in.)
Kunstmuseum Winterthur,
Geschenk des Galerievereins, Freunde des Kunstmuseums Winterthur, 1934, 632
W 59

6
The Bodmer Oak, Forest of Fontainebleau, 1865
(The Bodmer Oak, Fontainebleau Forest)
UN CHENE AU BAS-BREAU (LE BODMER)
Oil on canvas, 96.2 x 129.2 cm (37⁷/₈ x 50⁷/₈ in.)
The Metropolitan Museum of Art, New York,
Gift of Sam Salz and Bequest of Julia W. Emmons,
by exchange, 1964, 64.210
W 60

7
Green Park, 1870 or 1871
(Green Park, London)
GREEN PARK
Oil on canvas, 34.3 x 72.5 cm (13¹/₂ x 28¹/₂ in.)
Philadelphia Museum of Art,
Purchased with the W. P. Wilstach Fund, 1921,
W. 1921-1-7
W 165

8
Jean Monet on His Horse Tricycle, 1872
(Jean Monet [1867–1913] on His Hobby Horse)
JEAN MONET SUR SON CHEVAL MECANIQUE
Oil on canvas, 60.6 x 74.3 cm (23⁷/₈ x 29¹/₄ in.)
The Metropolitan Museum of Art, New York,
Gift of Sara Lee Corporation, 2000, 2000.195
W 238

9
The Red Kerchief, Portrait of Madame Monet, 1873
LA CAPELINE ROUGE, PORTRAIT DE MADAME
MONET
Oil on canvas, 99 x 79.8 cm (39 x 31³/₈ in.)
The Cleveland Museum of Art,
Bequest of Leonard C. Hanna, Jr., 1958-39
W 257

10
The Artist's House at Argenteuil, 1873
LA MAISON DE L'ARTISTE A ARGENTEUIL
Oil on canvas, 60.2 x 73.3 cm (23³/₄ x 28⁷/₈ in.)
The Art Institute of Chicago,
Mr. and Mrs. Martin A. Ryerson Collection,
1933.1153
W 284

11
Monet's Garden at Argenteuil (The Dahlias), 1873
(The Artist's Garden at Argenteuil [A Corner of the
Garden with Dahlias])
LE JARDIN DE MONET A ARGENTEUIL (LES DAHLIAS)
Oil on canvas, 61 x 82.5 cm (24 x 32¹/₂ in.)
National Gallery of Art, Washington, DC,
Gift of Janice H. Levin, in Honor of the 50th Anniversary of the National Gallery of Art, 1991.27.1
W 286

12
Camille in the Garden with Jean and His Nanny, 1873
CAMILLE AU JARDIN, AVEC JEAN ET SA BONNE
Oil on canvas, 60 x 81 cm (23⁵/₈ x 31⁷/₈ in.)
Private collection
W 280

13
Apartment Interior, 1875
UN COIN D'APPARTEMENT
Oil on canvas, 81.5 x 60.5 cm (32$\frac{1}{2}$ x 23$\frac{7}{8}$ in.)
Paris, Musée d'Orsay,
Legs de Gustave Caillebotte, 1894, RF 2776
W 365

14
Camille Monet and a Child in the Garden, 1875
(Camille Monet and a Child in the Artist's Garden
in Argenteuil)
CAMILLE MONET ET UN ENFANT AU JARDIN
Oil on canvas, 55.3 x 64.7 cm (21$\frac{3}{4}$ x 25$\frac{1}{2}$ in.)
Museum of Fine Arts, Boston,
Anonymous gift in memory of Mr. and Mrs. Edwin
S. Webster, 1976.833
W 382

15
The Park Monceau, 1878
LE PARC MONCEAU
Oil on canvas, 72.7 x 54.3 cm (28$\frac{5}{8}$ x 21$\frac{3}{8}$ in.)
The Metropolitan Museum of Art, New York,
Mr. and Mrs. Henry Ittleson, Jr., Fund, 1959,
59.142
W 466

16
At the Parc Monceau, 1878
AU PARC MONCEAU
Oil on canvas, 65,5 x 54,5 cm (25$\frac{3}{4}$ x 21$\frac{1}{2}$ in.)
Private collection
W 467

17
Plum Trees in Blossom at Vétheuil, 1879
(Plum Trees in Blossom)
LES PRUNIERS EN FLEURS A VETHEUIL
Oil on canvas, 64,5 x 81 cm (25$\frac{3}{8}$ x 31$\frac{7}{8}$ in.)
Szépművészeti Muzeum, Budapest, 266 B
W 520

18
Poppy Field near Vétheuil, 1879
CHAMP DE COQUELICOTS PRES DE VETHEUIL
Oil on canvas, 70 x 90 cm (27$\frac{1}{2}$ x 35$\frac{3}{8}$ in.)
Stiftung Sammlung E. G. Bührle, Zurich
W 536

19
Field of Corn, 1881
CHAMP DE BLE
Oil on canvas, 64.6 x 81 cm (25$\frac{3}{8}$ x 31$\frac{7}{8}$ in.)
The Cleveland Museum of Art,
Gift of Mrs. Henry White Cannon, 1947.197
W 676

20
Monet's Garden at Vétheuil, 1880
(The Artist's Garden at Vétheuil)
LE JARDIN DE MONET A VETHEUIL
Oil on canvas, 151.5 x 121 cm (59$\frac{5}{8}$ x 47$\frac{5}{8}$ in.)
National Gallery of Art, Washington, DC,
Ailsa Mellon Bruce Collection, 1970.17.45
W 685

21
Flower Beds at Vétheuil, 1881
MASSIFS DE FLEURS A VETHEUIL
Oil on canvas, 92 x 73.3 cm (36$\frac{1}{4}$ x 28$\frac{7}{8}$ in.)
Museum of Fine Arts, Boston,
The John Pickering Lyman Collection. Gift of Miss
Theodora Lyman, 19.1313
W 693

22
Nasturtiums in a Blue Vase, 1879
CAPUCINES DANS UN VASE BLEU
Oil on canvas, 46 x 38 cm (18$\frac{1}{8}$ x 15 in.)
Private collection, Switzerland
W 547

23
Bouquet of Sunflowers, 1880 or 1881
BOUQUET DE SOLEILS
Oil on canvas, 101 x 81.3 cm (39$\frac{3}{4}$ x 32 in.)
The Metropolitan Museum of Art, New York,
H. O. Havemeyer Collection, Bequest of Mrs.
H. O. Havemeyer, 1929, 29.100.107
W 628

24
Vase of Flowers, 1882 or 1888
VASE DE FLEURS
Oil on canvas, 80 x 45.1 cm (31$\frac{1}{2}$ x 17$\frac{3}{4}$ in.)
Philadelphia Museum of Art,
Bequest of Charlotte Dorrance Wright, 1978,
1978-1-23
W 810

25
Dahlias, 1883
DAHLIAS
Oil on canvas, 128.5 x 37 cm (50$\frac{5}{8}$ x 14$\frac{5}{8}$ in.)
Private collection, Switzerland
W 937

26
Winter Landscape at the Val de Falaise, 1885
PAYSAGE D'HIVER AU VAL DE FALAISE
Oil on canvas, 65 x 81 cm (25$\frac{5}{8}$ x 31$\frac{5}{8}$ in.)
Private collection, Switzerland
W 975

27
A Cottage in Normandy, 1885 or 1888
CHAUMIERE NORMANDE
Oil on canvas, 65 x 81 cm (25$\frac{5}{8}$ x 31$\frac{7}{8}$ in.)
Kunsthaus Zürich,
Johanna und Walter L. Wolf Sammlung, 1984/14
W 1023

28
View of Bordighera, 1884 or 1883/84
VUE DE BORDIGHERA
Oil on canvas, 65 x 81 cm (25$\frac{5}{8}$ x 31$\frac{7}{8}$ in.)
UCLA Hammer Museum, Los Angeles,
The Armand Hammer Collection. Gift of the
Armand Hammer Foundation
W 853

29
Springtime, 1886
Le printemps
Oil on canvas, 65 x 81 cm (25$\frac{5}{8}$ x 31$\frac{7}{8}$ in.)
Lent by the Syndics of the Fitzwilliam Museum,
Cambridge,
Bought from the Museum's Funds with a Contri-
bution from the National Art Collections Fund,
P. D.2-1953
W 1066

30
The Meadow at Giverny, 1888
LA PRAIRIE A GIVERNY
Oil on canvas, 73 x 92 cm (28$\frac{3}{4}$ x 36$\frac{1}{4}$ in.)
Victor Fedotov
W 1194

31
Sunlight Effect under the Poplars, 1887
(Fields in Spring)
SOUS LES PEUPLIERS, EFFET DE SOLEIL
Oil on canvas, 74.3 x 93 cm (29$\frac{1}{4}$ x 36$\frac{5}{8}$ in.)
Staatsgalerie Stuttgart, GVL 16
W 1135

32
Peonies, 1887
PIVOINES
Oil on canvas, 73 x 100 cm (28³/₄ x 39³/₈ in.)
Private collection
W 1142

33
Monet's Garden at Giverny, 1895
LE JARDIN DE MONET A GIVERNY
Oil on canvas, 81 x 92 cm (31⁷/₈ x 36¹/₄ in.)
Stiftung Sammlung E. G. Bührle, Zurich
W 1420

34
Morning on the Seine, 1897
(Branch of the Seine near Giverny [Mist] from the
"Mornings on the Seine" series)
MATINEE SUR LA SEINE
Oil on canvas, 89.9 x 92.7 cm (35³/₈ x 36¹/₂ in.)
The Art Institute of Chicago,
Mr. and Mrs. Martin A. Ryerson Collection,
1933.1156
W 1475

35
Water-Lilies, 1897–99
NYMPHEAS
Oil on canvas, 130 x 152 cm (51¹/₈ x 59⁷/₈ in.)
Private collection
W 1508

36
Water-Lily Pond, 1897–99 or 1899
(Waterlilies and Japanese Bridge)
LE BASSIN AUX NYMPHEAS
Oil on canvas, 90.5 x 89.7 cm (35⁵/₈ x 35⁵/₈ in.)
Princeton University Art Museum,
From the Collection of William Church Osborn,
Class of 1883, Trustee of Princeton University
(1914–1951) Given by his Family, Y 1972-14
W 1509

37
Water-Lily Pond, 1899
(The Water-Lily Pond)
LE BASSIN AUX NYMPHEAS
Oil on canvas, 88.3 x 93.1 cm (34³/₄ x 36⁵/₈ in.)
The National Gallery, London, NG 4240
W 1516

38
Water-Lily Pond, 1899
(Bridge over a Pool of Water Lilies)
LE BASSIN DES NYMPHEAS
Oil on canvas, 92.7 x 73.7 cm (36¹/₂ x 29 in.)
The Metropolitan Museum of Art, New York,
H. O. Havemeyer Collection, Bequest of Mrs.
H. O. Havemeyer, 1929, 29.100.113
W 1518

39
Irises in Monet's Garden, 1899 or 1900
(The Garden of the Artist in Giverny)
LE JARDIN DE MONET, LES IRIS
Oil on canvas, 81 x 92 cm (31⁷/₈ x 36¹/₄ in.)
Paris, Musée d'Orsay, RF 1983–6
W 1624

40
The Garden, 1900
LE JARDIN
Oil on canvas, 81 x 92 cm (31⁷/₈ x 36¹/₄ in.)
Private collection
W 1625

41
Main Path through the Garden at Giverny, 1901–02
(Path in Monet's Garden in Giverny)
UNE ALLEE DU JARDIN DE MONET, GIVERNY
Oil on canvas, 89 x 92 cm (35 x 36¹/₄ in.)
Österreichische Galerie Belvedere, Vienna, 540
W 1650

42
Water-Lilies, 1907
NYMPHEAS
Oil on canvas, ⌀ 81 cm (31⁷/₈ in.)
Musée d'art moderne, Saint-Etienne, 924
W 1701

43
Water-Lilies, 1908
NYMPHEAS
Oil on canvas, ⌀ 90 cm (35³/₈ in.)
Musée municipal A. G. Poulain, Vernon, 25.4.1.
W 1724

44
Water-Lilies, 1908
NYMPHEAS
Oil on canvas, ⌀ 80 cm (31¹/₂ in.)
Dallas Museum of Art,
Gift of the Meadows Foundation Incorporated,
1981.128
W 1729

45
Water-Lilies, 1905
NYMPHEAS
Oil on canvas, 89.5 x 100.3 cm (35¹/₄ x 40¹/₂ in.)
Museum of Fine Arts, Boston,
Gift of Edward Jackson Holmes, 39.804
W 1671

46
Water-Lilies, 1907
(Pond with Water Lilies)
NYMPHEAS
Oil on canvas, 107 x 73 cm (42¹/₈ x 28³/₄ in.)
The Israel Museum, Jerusalem,
Bequest of the Sam Spiegel Collection, B 97.0483
W 1710

47
Water-Lilies, 1907–08
NYMPHEAS
Oil on canvas, 105 x 73 cm (41³/₈ x 28³/₄ in.)
Göteborgs Konstmuseum, Gothenburg, Sweden,
GKM 2232
W 1716

48
Weeping Willow, ca. 1919
SAULE PLEUREUR
Oil on canvas, 100 x 120 cm (39³/₈ x 47¹/₄ in.)
Private collection,
Courtesy Galerie Beyeler, Basel
W 1874

49
Weeping Willow, 1918–19
SAULE PLEUREUR
Oil on canvas, 100 x 120 cm (39³/₈ x 47¹/₄ in.)
Kimbell Art Museum, Fort Worth, Texas
W 1876

50
Weeping Willow, 1920–22
SAULE PLEUREUR
Oil on canvas, 110 x 100 cm (43¹/₄ x 39³/₈ in.)
Paris, Musée d'Orsay,
Collection particulière; donation sous réserve
d'usufruit à l'Etat français, 2000, RF 2000-27
W 1942

51
The Water-Lily Pond at Giverny, 1918–19 or 1917
COIN DE L'ETANG A GIVERNY
Oil on canvas, 117 x 83 cm (46¹/₈ x 32⁵/₈ in.)
Musée de Grenoble, MG 2168
W 1878

52

The Water-Lily Pond, 1918–19
COIN DU BASSIN AUX NYMPHEAS
Oil on canvas, 119.5 x 88.5 cm (47 x 34⁷/₈ in.)
Musée d'art et d'histoire, Ville de Genève, Geneva,
1990-46
W 1879

53

The Water-Lily Pond, 1918–19 or 1918
COIN DU BASSIN AUX NYMPHEAS
Oil on canvas, 130 x 88 cm (51¹/₈ x 34⁵/₈ in.)
Private collection
W 1880

54

White and Yellow Water-Lilies, ca. 1916
(Water-Lilies)
NYMPHEAS BLANCS ET JAUNES
Oil on canvas, 200 x 200 cm (78³/₄ x 78³/₄ in.)
Kunstmuseum Winterthur,
Geschenk des Galerievereins, Freunde des Kunst-
museums Winterthur, 1952, 813
W 1801

55

The Water-Lily Pond, 1918–19
LE BASSIN AUX NYMPHEAS
Oil on canvas, 130.5 x 200.5 cm (51³/₈ x 79 in.)
Museum Folkwang, Essen
W 1883

56

The Water-Lily Pond, 1917–19
LE BASSIN AUX NYMPHEAS
Oil on canvas, 100 x 200 cm (39³/₈ x 78³/₄ in.)
Musée des Beaux-Arts de Nantes, 2233
W 1886

57

Wisteria, 1917–20
(Study of Wisteria)
GLYCINES
Oil on canvas, 100 x 200 cm (39³/₈ x 78³/₄ in.)
Musée d'art et d'histoire Marcel Dessal, Dreux,
France, 286
W 1905

58

The Water-Lily Pond, 1917–19
LE BASSIN AUX NYMPHEAS
Oil on canvas, 100 x 200 cm (39³/₈ x 78³/₄ in.)
R. und H. Batliner Art Foundation
W 1899

59

Self-Portrait, 1917
(Portrait of the Artist)
AUTOPORTRAIT
Oil on canvas, 70 x 55 cm (27¹/₂ x 21⁵/₈ in.)
Paris, Musée d'Orsay,
Don de Georges Clemenceau, 1927, RF 2623
W 1843

60

The Japanese Bridge, ca. 1918–24
LE PONT JAPONAIS
Oil on canvas, 89 x 115.5 cm (35 x 45¹/₂ in.)
Fondation Beyeler, Riehen/Basel
W 1921

61

The Japanese Bridge, 1918–26
(Nympheas, Japanese Bridge)
LE PONT JAPONAIS
Oil on canvas, 88.9 x 92.7 cm (35 x 36¹/₂ in.)
Philadelphia Museum of Art,
The Albert M. Greenfield and Elizabeth M. Green-
field Collection, 1974, 74.178-38
W 1930

62

The Japanese Bridge, 1923–25
LE PONT JAPONAIS
Oil on canvas, 88.9 x 116.2 cm (35 x 45³/₄ in.)
The Minneapolis Institute of Arts,
Bequest of Putnam Dana McMillan, 61.36.15
W 1931

63

The Japanese Bridge, ca. 1918
LE PONT JAPONAIS
Oil on canvas, 89 x 100 cm (35 x 39³/₈ in.)
Musée Marmottan Monet, Paris, 5091
W 1924

64

The Path under the Rose Arches, ca. 1920
L'ALLEE DES ROSIERS
Oil on canvas, 92 x 89 cm (36¹/₄ x 35 in.)
Musée Marmottan Monet, Paris, 5104
W 1938

65

The Path under the Rose Arches, Giverny, 1920–22
L'ALLEE DE ROSIERS
Oil on canvas, 73 x 106,5 cm (28³/₄ x 41⁷/₈ in.)
Private collection, Switzerland
W 1940

66

The Path under the Rose Arches,
1918–24 or ca. 1920–22
L'ALLEE DE ROSIERS
Oil on canvas, 89 x 100 cm (35 x 39³/₈ in.)
Private collection, Switzerland
W 1936

67

The Artist's House, Seen from the Rose Garden,
1922–24
LA MAISON DE L'ARTISTE VUE DU JARDIN
AUX ROSES
Oil on canvas, 89 x 92 cm (35 x 36¹/₄ in.)
Musée Marmottan Monet, Paris, 5108
W 1944

68

Water-Lily Pond, Evening, ca. 1916/22
LE BASSIN AUX NYMPHEAS, LE SOIR
Oil on canvas, diptych, each panel 200 x 300 cm
(78³/₄ x 118¹/₈ in.)
Kunsthaus Zürich, 1952/64
W 1964, 1965

69

Water-Lily Pond, ca. 1917–20
LE BASSIN AUX NYMPHEAS
Oil on canvas, triptych, each panel 200.5 x 301 cm
(78⁷/₈ x 118¹/₂ in.)
Fondation Beyeler, Riehen/Basel
W 1968, 1969, 1970

70

Water-Lily Pond with Irises, ca. 1914/22
LE BASSIN AUX NYMPHEAS AVEC IRIS
Oil on canvas, 200 x 600 cm (78³/₄ x 236¹/₄ in.)
Kunsthaus Zürich, 1952/10
W 1980

71

Green Reflections on the Water-Lily Pond, 1920–26
LE BASSIN AUX NYMPHEAS, REFLETS VERTS
Oil on canvas, 200 x 425 cm (78³/₄ x 167³/₈ in.)
Stiftung Sammlung E. G. Bührle, Zürich
W 179

* Not in the exhibition.

Selected Bibliography on Impressionism and Landscape Painting

Assouline 2002
Assouline, Pierre. Grâces lui soient rendues: Paul Durand-Ruel, le marchand des impressionnistes. Paris, 2002.

Bätschmann 1989
Bätschmann, Oskar. Entfernung der Natur: Landschaftsmalerei 1750–1920. Cologne, 1989.

Baumüller et al. 1997
Baumüller, Barbara, Ulrich Kuder, and Thomas Zoglauer, eds. Inszenierte Natur: Landschaftskunst im 19. und 20. Jahrhundert. Stuttgart, 1997.

Benes and Harris 2001
Benes, Mirka, and Dianne Harris, eds. Villas and Gardens in Early Modern Italy and France. New York, 2001.

Benezra 1999
Benezra, Neal, and Olga M. Viso, eds. Beauty Now: A View of the Late Twentieth Century. Exh. cat., Hirschhorn Museum and Sculpture Garden et al. Ostfildern-Ruit, 1999.

Boehm 1986
Boehm, Gottfried. "Das neue Bild der Natur: Nach dem Ende der Landschaftsmalerei." In Manfred Smuda, ed., Landschaft, Frankfurt am Main, 1986, pp. 87–110.

Boime 1976
Boime, Albert. "Entrepreneurial Patronage in Nineteenth-Century France." In Edward C. Carter, Robert Forster, and Joseph N. Moody, eds., Enterprise and Entrepreneurs in Nineteenth- and Twentieth-Century France, Baltimore and London, 1976, pp. 207–237.

Bourdieu 1987
Bourdieu, Pierre. "L'institutionnalisation de l'anomie." In Les Cahiers du Musée National d'Art Moderne, Paris 1987, pp. 6–19.

Busch 1997
Busch, Werner, ed. Landschaftsmalerei. Berlin, 1997.

Castagnary 1874
Castagnary, Jules. "L'exposition du boulevard des Capucines—Les Impressionnistes." Le Siècle (April 29, 1874). Reprinted in Martha Kapos, ed., The Impressionists—A Retrospective, New York 1991, pp. 83–86.

Clark 1985
Clark, Timothy J. The Painting of Modern Life: Paris in the Art of Manet and his Followers. London and New York, 1985.

Dauberville 1967
Dauberville, Henry. La Bataille de l'Impressionnisme. Paris, 1967.

Distel 1989
Distel, Anne. Les collectionneurs des impressionnistes. Düdingen, 1989.

Durand-Claye 1882
Durand-Claye, Alfred, ed. Réponse à l'article dans la Revue des deux Mondes par M. Aubry-Vitet sur la question des égouts de Paris. Paris: Préfecture de la Seine, 1882.

Eberle 1980
Eberle, Matthias. Individuum und Landschaft: Zur Entstehung und Entwicklung der Landschaftsmalerei. Giessen, 1980.

Fénéon 1966
Fénéon, Félix. Au-delà de l'impressionnisme [anthology containing essays from the years 1883–1923]. Paris, 1966.

Fer 1993
Fer, Briony, ed. Modernity and Modernism: French Painting in the Nineteenth Century. New Haven, 1993.

Gerdts 1993
Gerdts, William H. Monet's Giverny: An Impressionist Colony. New York, 1993.

Herbert 1987
Herbert, Robert L. "Impressionism, Originality, and Laissez-Faire." Radical History Review 38 (Art and Ideology, April 1987), pp. 7–15.

Herbert 1988
Herbert, Robert L. Impressionism: Art, Leisure, and Parisian Society. New Haven and London, 1988.

Isaacson 1980
Isaacson, Joel. The Crisis of Impressionism 1878–1882. Exh. cat., The University of Michigan Museum of Art. Chicago, 1980.

Klien 1990
Klien, Wolfgang. Der Siegeszug der Landschaftsmalerei: Eine Entwicklungsgeschichte der Landschaftsmalerei in Europa. Hamburg, 1990.

Lethève 1959
Lethève, Jacques. Impressionnistes et symbolistes devant la presse. Paris, 1959.

Merleau-Ponty 2000
Merleau-Ponty, Maurice. "Le doute de Cézanne." Fontaine, 4th year, vol. VIII, no. 47 (December 1945), pp. 80–100. English translation: "Cézanne's Doubt," chap. 1 of Sense and Non-Sense, Evanston, Ill., 1964.

Paradise 1985
Paradise, JoAnne. Gustave Geffroy and the Criticism of Painting. New York and London, 1985.

Regan 1997/2004
Regan, Marci. Paul Durand-Ruel and the Market for Early Modernism. Master's thesis, Louisiana State University, 1997/2004, http://etd.lsu.edu/docs/available/etd-03292004-181506.

Reischauer 1986
Reischauer, Haru Matsukata. Samurai and Silk: A Japanese and American Heritage. Cambridge, Mass., 1986.

Riout 1998
Riout, Denys, ed. Théodore Duret: Critique avant-garde. Paris, 1998.

Ruskin 1904
The Complete Works of John Ruskin. Ed. E. T. Cooks and Alexander Wedderburn. London, 1904, vol. 15.

Schama 1995
Schama, Simon. Landscape and Memory. London, 1995.

Schiff 1978
Schiff, Richard. "The End of Impressionism: A Study in Theories of Artistic Expression." The Art Quarterly, vol. 1, no. 4 (fall 1978), pp. 328–378.

Sfeir-Semler 1992
Sfeir-Semler, Andrée. **Die Maler am Pariser Salon 1791–1880.** Frankfurt am Main and New York, 1992.

Silbermann and König 1974
Silbermann, Alphons, and René König. "Künstler und Gesellschaft." **Kölner Zeitschrift für Soziologie und Sozialpsychologie** (special issue 17, 1974). Opladen, 1974.

Vaisse 1995
Vaisse, Pierre. **La Troisième République et les Peintres.** Paris, 1995.

Venturi 1939b
Durand-Ruel, Paul. "Mémoires de Paul Durand-Ruel." In Lionello Venturi, **Les Archives de l'Impressionnisme,** vol. II, New York and Paris, 1939, pp. 143–220.

Weitzenhoffer 1986
Weitzenhoffer, Frances. **The Havemeyers: Impressionism Comes to America.** New York, 1986.

Wildenstein and Stavridès 1999
Wildenstein, Daniel, and Yves Stavridès. **Marchands d'Art.** Paris, 1999.

Willsdon 2003
Willsdon, Clare P. "'Promenades et plantations': Impressionism, Conservation and Haussmann's Reinvention of Paris." In **Soil and Stone: Impressionism, Urbanism, Environment,** edited by Frances Fowle and Richard Thomson, Hants and Edinburgh, 2003, pp. 107–124.

www.academie-goncourt.fr

www.marcel-proust-gesellschaft.de

Zola 1991
Zola, Emile. "Le naturalisme au Salon." **Le Voltaire,** June 18–22, 1880. Reprinted in Emile Zola, **Ecrits sur l'art,** Paris, 1991, pp. 409–438.

Monet and Impressionism

Acquavella and Forge 1976
Acquavella, Nicholas M., and Andrew Forge. **Claude Monet.** New York, 1976.

Adhémar 1980
Adhémar, Hélène, ed. **Hommage à Claude Monet.** Exh. cat., Grand Palais. Paris, 1980.

Aitken and Delafond 2003
Aitken, Geneviève, and Marianne Delafond. **La collection d'estampes japonaises de Claude Monet à Giverny.** Exh. cat., Fondation de l'Hermitage, Lausanne, 2003.

Alexandre 1898
Alexandre, Arsène. "Exposition Claude Monet." **Le Gaulois** (Paris), June 16, 1898 (supplement), pp. 1–2 (Archiv Musée Marmottan Monet, Paris).

Alphant 1993
Alphant, Marianne. **Claude Monet—Une vie dans le paysage.** Paris, 1993.

Anonymous 1985
"Destroys his Painting." **Washington Post,** May 16, 1908. Reprinted in Charles F. Stuckey, ed., **Monet—A Retrospective,** New York, 1985, p. 250.

Arnold 1998
Arnold, Matthias. **Claude Monet.** Hamburg, 1998.

Bailey 1989
Bailey, Colin B., ed. **Masterpieces of Impressionism and Postimpressionism: The Annenberg Collection.** Exh. cat., Philadelphia Museum of Art, Philadelphia, 1989.

Baudelaire 1989
Baudelaire, Charles. "Le Peintre et la vie moderne." **Le Figaro,** November 1863. Reprinted in Charles Baudelaire, **The Painter of Modern Life and Other Essays,** New York, 1978.

Belloli 1984
Belloli, Andrea P. A., ed. **A Day in the Country: Impressionism and French Landscape.** Exh. cat., Los Angeles County Museum of Art et al., Los Angeles 1984.

Besson 1951
Besson, Georges. **Monet.** Paris, 1951.

Brettell 1999
Brettell, Richard R. **Monet to Moore: The Millennium Gift of Sara Lee Corporation.** Exh. cat., The Art Institute of Chicago et al. New Haven and London, 1999.

Cabot Perry 1966
Cabot Perry, Lilla. "Reminiscences of Claude Monet from 1889 to 1909" [1927]. Reprinted in Linda Nochlin, ed., **Impressionism and Post-Impressionism 1874–1904 (Sources and Documents in the History of Art),** Prentice Hall, 1966.

Clemenceau 1928
Clemenceau, Georges. **Claude Monet: Les Nymphéas.** Paris, 1928.

Clemenceau 1993
Clemenceau, Georges. **Georges Clemenceau à son ami Claude Monet: Correspondances.** Paris, 1993.

Delafond and Daulte 1993
Delafond, Marianne, and François Daulte. **Claude Monet et ses amis.** Exh. cat., Fondation de l'Hermitage, Lausanne, 1993.

Dumont 1992
Dumont, Françoise. **Claude Monet.** Exh. cat., Salle St. Georges, Lüttich, 1992.

Duret 1878
Duret, Théodore. **Les Peintres impressionnistes: Claude Monet—Sisley—C. Pissarro—Renoir—Berthe Morisot.** Paris, 1878.

Duret 1880
Duret, Théodore, ed. **Le Peintre Claude Monet.** Exh. cat., Galerie du Journal illustré La Vie moderne, Paris, 1880.

Elder 1924
Elder, Marc. **A Giverny, chez Claude Monet.** Paris: Editions Bernheim-Jeune, 1924.

Fels 1925
Fels, Florent. **Claude Monet.** Paris: Gallimard Collection Les peintres Français nouveaux 22, 1925.

Fénéon 1887
Fénéon, Félix. "L'impressionisme." **L'Emancipation sociale,** April 3, 1887. Reprinted in Félex Fénéon, **Au-delà de l'impressionnisme** (anthology of texts from the years 1883–1923), Paris, 1966, pp. 81–86.

Fischer 2003
Fischer, Hartwig, ed. Orte des Impressionismus. Exh. cat., Kunstmuseum Basel, 2003.

Fourny-Dargère 1991
Fourny-Dargère, Sophie. Blanche Hoschedé-Monet 1865–1947: Une artiste de Giverny. Exh. cat., Musée Municipal A. G. Poulain, Vernon, 1991.

Fourny-Dargère 1992
Fourny-Dargère, Sophie. Monet. Paris, 1992.

Geffroy 1924
Geffroy, Gustave. Monet: Sa vie, son œuvre [1924]. Paris, 1980.

Gordon and Stuckey 1979
Gordon, Robert, and Charles F. Stuckey. "Blossoms and Blunders: Monet and the State." Art in America (January–February 1979), pp. 102–117 (part 1) and (September 1979), pp. 109–125 (part 2).

Gordon and Forge 1985
Gordon, Robert, and Andrew Forge. Monet. Cologne, 1985.

Green 2001
Green, Paulina, ed. Monet & Japan. Exh. cat., National Gallery of Australia, Canberra and Art Gallery of Western Australia, Perth. Canberra, 2001.

Heinrich 1997
Heinrich, Christoph. Monets Vermächtnis: Serie, Ordnung und Obsession. Exh. cat., Hamburger Kunsthalle, Hamburg. Ostfildern-Ruit, 1997.

Herbert 1979
Herbert, Robert L. "Method and Meaning in Monet." Art in America (September 1979), pp. 90–108.

Hoog 1984
Hoog, Michel. Les Nymphéas de Claude Monet au Musée de l'Orangerie. Paris, 1984.

Hoschedé 1960
Hoschedé, Jean-Pierre. Claude Monet, ce mal connu: Intimité familiale d'un demi-siècle à Giverny de 1883 à 1926. 2 vols. Geneva, 1960.

House 1981
House, John. Monet. Revised and expanded edition, Oxford, 1981.

House 1986
House, John. Monet: Nature into Art. New Haven, 1986.

House 2003
House, John. "Monet's Gladioli." Bulletin of the Detroit Institute of Arts 77, nos. 1/2 (2003), pp. 8–17.

Jensen 1994
Jensen, Robert. Marketing Modernism in Fin-de-Siècle Europe. Princeton, 1994.

Joel 2002
Joel, David. Monet at Vétheuil and on the Norman Coast 1878–1883. Woodbridge, 2002.

Joyes 1989
Joyes, Claire, ed. Les Carnets de Cuisine de Monet. Foreword by Joël Robuchon. Chêne, 1989. English edition: Monet's Table: The Cooking Journals of Claude Monet, New York and London, 1989.

Kalitina 1984
Kalitina, Nina, et al. Claude Monet: Bilder aus den Museen der UdSSR. Leningrad, 1984.

Kapos 1991
Kapos, Martha, ed. The Impressionists— A Retrospective. New York, 1991.

Kendall 1989
Kendall, Richard, ed. Monet by Himself: Paintings, Drawings, Pastels, Letters. London, 1989.

Koja 1996
Koja, Stephan. Monet. Exh. cat., Österreichische Galerie Belvedere Wien, Vienna and Munich, 1996.

Leipzig 1996
Von Monet bis Corot: Werke der Schule von Barbizon und ihrer Nachfolge aus der Sammlung Marion und Hans-Peter Bühler. Exh. cat., Museum der bildenden Künste Leipzig. Leipzig 1996.

Levine 1976
Levine, Steven Z. Monet and His Critics. Ph.D. diss., Cambridge 1974. New York, 1976.

Levine 1994
Levine, Steven Z. Monet, Narcissus, and Self-Reflection: The Modernist Myth of the Self. Chicago, 1994.

Mancoff 2003
Mancoff, Debra N. Monet: Nature into Art. Lincolnwood, Ill., 2003.

Mauclair 1924
Mauclair, Camille. Claude Monet. Paris: Éditeurs D. Rieder et Cie, 1924.

Maupassant 1886
Maupassant, Guy de, "La vie d'un paysagiste." Gil Blas, September 28, 1886. Reprinted in Guy de Maupassant, Au Salon—Chroniques sur la peinture, Paris, 1993, pp. 129–139.

Mirbeau 1990
Mirbeau, Octave. Correspondance avec Claude Monet. Tusson, 1990.

Mirbeau 1995
Mirbeau, Octave. "Claude Monet, élève de personne," Le Figaro, May 10, 1889. Reprinted in Octave Mirbeau, Monet et Giverny, Paris, 1995, pp. 23–32.

Morgan 1996
Morgan, Geneviève. Monet: The Artists Speaks. San Francisco, 1996.

Olmer 1927
Olmer, Pierre. "Le Musée Claude Monet à l'Orangerie des Tuileries." L'Architecture, vol. XL, no. 6 (1927), pp. 183–186.

Patin 1991
Patin, Sylvie. Monet: "un œil . . . mais bon Dieu, quel œil!" (Découvertes Gallimard Nr. 131), Paris, 1991.

Patin and Tinterow 1997
Patin, Sylvie, and Garry Tinterow. La Collection Havemeyer: Quand l'Amérique découvrait l'Impressionnisme. Exh. cat., Musée d'Orsay, Metropolitan Museum of Art. Paris and New York, 1997.

Petrie 1979
Petrie, Brian. Claude Monet: The First of the Impressionists. Oxford, 1979.

Pissarro 1997
Pissarro, Joachim. Monet and the Mediterranean. Exh. cat., Kimbell Art Museum, Fort Worth and New York, 1997.

Rewald 1946
Rewald, John. The History of Impressionism. New York, 1946.

Rewald and Weitzenhoffer 1984
Rewald, John, and Frances Weitzenhoffer, eds. **Aspects of Monet**. New York, 1984.

Rey 1972
Rey, Jean-Dominique. **Nymphéas ou les miroirs du temps**. Paris, 1972.

Rouart 1950
Rouart, Denis, ed. **Correspondance de Berthe Morisot**. Paris, 1950.

Rouen 1994
Rouen, les Cathédrales de Monet. Exh. cat., Musée des Beaux-Arts, Rouen. Rouen and Paris, 1994.

Ryuzaburo 1970
Umehara, Ryuzaburo, et al. **L'Art Moderne du Monde, No. 2: Monet**. Tokyo, 1970.

Sagner-Düchting 1985
Sagner-Düchting, Karin. **Claude Monet: Nymphéas. Eine Annäherung**. Ph.D. diss, Munich, 1983. Hildesheim, 1985.

Sagner-Düchting 2001
Sagner-Düchting, Karin. **Monet in Giverny**. Munich, London, and New York, 2001.

Schmid 1999
Schmid, Gabriele. "Claude Monets Nymphéas in der Orangerie in Paris." In **Illusionsräume**, Ph.D. diss., Berlin, 1999, pp. 81–144.

Schuck 1992
Schuck, Ulrike. **Claude Monet: Das Alterswerk— Von Licht zu Farbe, von der Erscheinung zum Wesen**. Ph.D. diss., 1991, Konstanz, 1992.

Seitz 1960
Seitz, William C. **Claude Monet—Seasons and Moments**, Exh. cat., Museum of Modern Art, New York, 1960

Seitz 1988
Seitz, William C. **Claude Monet**. Cologne, 1988.

Spate 1992
Spate, Virginia. **The Colour of Time: Claude Monet**. London, 1992.

Stuckey 1985
Stuckey, Charles F., ed. **Monet—A Retrospective**. New York, 1985.

Stuckey 1995
Stuckey, Charles F., ed. **Claude Monet: 1840–1926**. Exh. cat., The Art Institute of Chicago, Chicago, 1995.

Taboureux 1991
Taboureux, Emile. "Claude Monet." **La Vie moderne**, June 12, 1880. Reprinted in Martha Kapos, ed., **The Impressionists—A Retrospective**, New York, 1991, pp. 241–242.

Thiébault-Sisson 1991
Thiébault-Sisson, François. "Les Nymphéas de Claude Monet." **La Revue de l'Art ancien et moderne**, June 1927. Reprinted in Martha Kapos, ed., **The Impressionists—A Retrospective**, New York, 1991, pp. 300–317.

Thornton 1983
Thornton, Lynne. **Les Orientalistes: Peintres voyageurs 1828–1908**. Paris, 1983.

Tucker 1982
Tucker, Paul Hayes. **Monet at Argenteuil**. New Haven, 1982.

Tucker 1989
Tucker, Paul Hayes, ed. **Monet in the '90s: The Series Paintings**. Exh. cat., Museum of Fine Arts, Boston. New Haven, 1989.

Tucker 1994
Tucker, Paul Hayes, ed. **Monet: Late Paintings of Giverny from the Musée Marmottan**. Exh. cat., New Orleans Museum of Art und The Fine Arts Museum of San Francisco. New Orleans and San Francisco, 1994.

Tucker 1995
Tucker, Paul Hayes. **Claude Monet. Life and Art**. New Haven, 1995.

Venturi 1939a
Monet, Claude. "Lettres à Paul Durand-Ruel, 1876–1926." In Lionello Venturi, **Les Archives de l'Impressionnisme**, vol. I, New York and Paris, 1939, pp. 219–465.

Walther 1966
Walther, Rodolphe. "Les Maisons de Claude Monet à Argenteuil." **Gazette des Beaux-Arts**, 108th year, 6th period, vol. 68 (1966), pp. 333–342.

Weiss 1997
Weiss, Susanne. **Claude Monet: ein distanzierter Blick auf Stadt und Land, Werke 1859–1889**, Ph.D. diss., Frankfurt am Main. Berlin, 1997.

Weitzenhoffer 1984
Weitzenhoffer, Frances. "The Earliest American Collectors of Monet." In John Rewald and Frances Weitzenhoffer, eds., **Aspects of Monet**, New York, 1984, pp. 72–91.

Wildenstein 1974/79
Wildenstein, Daniel. **Claude Monet, biographie et catalogue raisonné en 5 volumes**. Lausanne, 1974/79.

Wildenstein 1996
Wildenstein, Daniel. **Monet oder der Triumph des Impressionismus**. 4 vols. Cologne, 1996.

Wittmer 1990
Wittmer, Pierre. **Caillebotte au jardin: La période d'Yerres (1860–1879)**. Château de Saint-Rémy-en-l'Eau, 1990.

Wormser 1993
Wormser, André. "Clemenceau et Claude Monet, une singulière amitié." In **Georges Clemenceau à son ami Claude Monet: Correspondances**, Paris, 1993, pp. 27–58.

Zola 1991
Zola, Emile. "Les Actualistes." **Mon Salon**, May 24, 1868. Reprinted in Emile Zola, **Ecrits sur l'art**, Paris, 1991, pp. 206–211.

Zurich 1952
Claude Monet. Exh. cat., Kunsthaus Zürich. With a foreword by Georges Besson and René Wehrli. Zurich, 1952.

Monet's Garten* and General Garden Literature

Alexandre 1901
* Alexandre, Arsène. "Le Jardin de Monet." Le Figaro, August 9, 1901. Reprinted in Charles F. Stuckey, ed., Monet—A Retrospective, New York, 1985, pp. 219–223.

Alexandre 1904
* Alexandre, Arsène. "Un Jardinier." Le Courrier de l'Aisne, June 9, 1904, and Le Populaire, June 11, 1904 (Archiv Musée Marmottan Monet, Paris).

Alexandre 1921
* Alexandre, Arsène. Claude Monet. Paris: Editions Bernheim-Jeune, 1921.

Alphand 1867–1873
Alphand, Jean Charles Adolphe. Les Promenades de Paris. Historie—description des embellissements—dépenses de création et d'entretien des Bois de Boulogne et de Vincennes: Champs-Elysées—parcs—squares—boulevards—places plantées. Etudes sur l'art des jardins et arboretum. Paris: J. Rothschild Editeur, 1867–73.

André 1889
André, Edouard. L'Art des jardins: Traité général de la composition des parcs et jardins. Paris: G. Masson Editeur, 1889.

André and de Courtois 2001
André, Florence, and Stéphanie de Courtois. Edouard André (1840–1911): un paysagiste botaniste sur les chemins de monde. Paris, 2001.

Bazin 1988
Bazin, Germain. Paradeisos—l'art du jardin. Paris, 1988. Published in German: DuMont's Geschichte der Gartenbaukunst. Cologne, 1990.

Bittner 2001
Bittner, Regine, ed. Urbane Paradiese. Zur Kulturgeschichte modernen Vergnügens. Frankfurt am Main, 2001.

Bois and Trechslin 1964
Bois, Eric, and Anne-Marie Trechslin. Wunderwelt der Gartenblumen. Vol. 1: Zwiebel- und Knollenpflanzen. Zurich, 1964.

Breuil 1913
* Breuil, Félix. "Les Iris pour bord de rivières, étangs et terrains humides." Jardinage 21 (October 1913), pp. 2–9.

Bumpus 1990
* Bumpus, Judith. Impressionist Gardens. London, 1990.

Charageat 1930
Charageat, Marguerite. L'Art des Jardins: précis historique sur l'art des jardins. With a foreword by Edouard André. Paris, 1930.

Conan 1999
Conan, Michel, ed. Perspectives on Garden Histories (Dumbarton Oaks Colloquium on the History of Landscape Architecture, XXI). Dumbarton Oaks, 1999.

Conan 2002a
Conan, Michel. "The Coming of Age of the Bourgeois Garden." In John Dixon Hunt and Michel Conan, eds., Tradition and Innovation in French Garden Art: Chapters of a New History. Philadelphia, 2002.

Conan 2002b
Conan, Michel, ed. Bourgeois and Aristocratic Encounters in Garden Art 1550–1850 (Dumbarton Oaks Colloquium on the History of Landscape Architecture, XXIII). Dumbarton Oaks, 2002.

Conan 2003
Conan, Michel, ed. Landscape Design and the Experience of Motion (Dumbarton Oaks Colloquium on the History of Landscape Architecture, XXIV). Dumbarton Oaks, 2003.

Fell 1994
* Fell, Derek. The Impressionist Garden: Ideas and Inspiration Form the Gardens and Paintings of the Impressionists. London, 1994.

Forestier 1908
* Forestier, Jean Claude Nicolas. "Le jardin de M. Claude Monet." In Fermes et châteaux, September 1, 1908, pp. 13–16.

Forestier 1920
Forestier, Jean Claude Nicolas. Jardins: Carnet des plans et de dessins. Paris, 1920.

Georgel 1999a
Georgel, Pierre. Monet: Le Cycle des Nymphéas, Exh. cat., Musée national de l'Orangerie, Paris, 1999.

Georgel 1999b
Georgel, Pierre. Claude Monet: Nymphéas. Paris, 1999.

Gimpel 1963
Gimpel, René. Journal d'un collectionneur, marchand de tableaux—1918–1939. Paris, 1963.

Goldin 2001
Goldin, Marco. Monet: I luoghi della pittura. Exh. cat., Casa dei Carraresi, Treviso and Conegliano, 2001.

Gordon and Eddison 2002
* Gordon, Robert, and Sydney Eddison, eds. Monet the Gardener. New York, 2002.

Graber 1943
Graber, Hans. Camille Pissarro, Alfred Sisley, Claude Monet. Basel, 1943.

von der Haar 2000
* von der Haar, Regine. Der Garten Claude Monets als Malergarten des späten 19. Jahrhunderts. Ph.D. diss., Hanover, 2000.

Helmreich 2002
Helmreich, Anne. The English Garden and National Identity: The Competing Styles of Garden Design 1870–1914. Cambridge, 2002.

Hobhouse 2002
Penelope Hobhouse, The Story of Gardening. London, 2002.

Holmes 2001
* Holmes, Caroline. Monet at Giverny. London, 2001.

Hoschedé and Toussaint 1898
Hoschedé, Jean-Pierre, and l'Abbé Anatole Toussaint. "Flore de Vernon et de La Roche-Guyon." Bulletin de la Société des Amis des Sciences Naturelles, Rouen, 1898.

Van Houtte 1877
Flore des serres et des jardins de l'Europe: annales générales d'horticulture. Ed. Louis van Houtte, vol. 22. Ghent, 1877.

Hyams 1971
Hyams, Edward. A History of Gardens and Gardening. London, 1971.

Joffet 1954
Joffet, Robert. Bagatelle: histoire et guide. Paris, 1954.

Joyes 1985
* Joyes, Claire. **Claude Monet: Life at Giverny.**
New York and Paris, 1985. First published in 1975.

Kahn 1904
* Kahn, Maurice. "Au jour le jour—Le Jardin
de Claude Monet." **Le Temps,** June 7, 1904.
Reprinted in Charles F. Stuckey, ed., **Monet—
A Retrospective,** New York, 1985, pp. 241–245.

Keller 1982
* Keller, Horst. **Ein Garten wird Malerei.
Monets Jahre in Giverny.** Cologne, 1982.

van der Kemp 2003
* van der Kemp, Gérald. **Monet: Ein Besuch
in Giverny.** Versailles, 2003.

Krausch 2003
Krausch, Heinz-Dieter. "**Kaiserkron und Päonien
rot . . .,**" Entdeckung und Einführung unserer
Gartenblumen. Hamburg, 2003.

Kuhn 1904
* Kuhn, Alice. "Claude Monet à Giverny." **Femme
d'aujourd'hui,** August 10, 1904, pp. 454–456
(Archiv Musée Marmottan Monet, Paris).

Latour-Marliac 1888
Latour-Marliac, Bory. **Notice sur les Nymphéas
et Nelumbium rustiques, leur culture et celle
d'autres plantes aquatiques.** Le Temple-sur-Lot,
1888.

Laws 1999
* Laws, Bill. **Artists' Gardens.** London, 1999.

Leclerc 1994
Leclerc, Bénédicte, ed. **Jean Claude Nicolas
Forestier. 1861–1930. Du jardin au paysage
urbain** (Actes du Colloque International sur
J. C. N. Forestier, Paris 1990). Paris, 1994.

Lévêque 1982
Lévêque, Jean-Jacques. **Jardins de Paris.**
Paris, 1982.

Mancoff 2001a
* Mancoff, Debra N. **Monet's Garden in Art.**
London, 2001.

Mancoff 2001b
Mancoff, Debra N. **Sunflowers.** New York, 2001.

de Mancon 1992
de Mancon, Patrice. **Les Jardins du Baron Hauss-
mann.** Exh. cat., Le Louvre des Antiquaires,
Paris, 1992.

Mille 1909
Mille, Pierre. "En passant—Ecrits sur l'Eau."
Le Temps, May 18, 1909 (Archiv Musée Marmottan
Monet, Paris).

Mirbeau 1891
* Mirbeau, Octave. "Claude Monet et Giverny."
L'Art dans les deux Mondes, March 7, 1891.
Reprinted in Octave Mirbeau, **Monet et Giverny,**
Paris, 1995, pp. 7–21.

Morgan 1909
Morgan, Jean. "Causeries chez quelques maîtres."
Le Gaulois, May 5, 1909 (Archiv Musée Marmottan
Monet, Paris).

Mosser 2000
Mosser, Monique. "Jardins 'Fin de siècle' en
France: Historicisme, Symbolisme et Modernité."
Revue de l'Art 3, no. 129 (2000), pp. 41–60.

Mosser and Nys 1995
Mosser, Monique, and Philippe Nys, eds.
Le Jardin, Art et Lieu de mémoire. Besançon,
1995.

Mosser and Teyssot 2002
Mosser, Monique, and Georges Teyssot, eds.
Histoire des Jardins de la Renaissance à nos jours.
Paris, 2002. First published in 1991.

Page 1962
Page, Russell. **The Education of a Gardener.**
London, 1962.

Proust 1907
* Proust, Marcel. "Les éblouissements."
Le Figaro, June 15, 1907. Reprinted in Marcel
Proust, **Œuvres complètes,** vol. 10. Paris, 1936,
pp. 199–200.

Racine 2001–02
Racine, Michel, ed. **Créateurs de Jardins et de
Paysages en France de la Renaissance au XXIe
siècle.** 2 vols. Arles, 2001–02.

Revue Horticole
Revue horticole: journal d'horticulture pratique.
Paris: Librairie Agricole de la Maison Rustique,
1829–1974.

Russell 1995
* Russell, Vivian. **Monet's Garden: Through the
Seasons at Giverny.** New York, 1995.

Shore 2000
* Shore, Stephen. **The Gardens at Giverny: A View
of Monet's World.** With an introduction by John
Rewald, and essays by Daniel Wildenstein and
Gerald van der Kemp. New York, 2000. First pub-
lished in 1983.

Sorel 1995
Sorel, Philippe. **Le guide du promeneur 8e
arrondissement: Faubourg Saint-Honoré, Champs-
Élysées, Madeleine, Europe, Parc Monceau,
Quartier François 1er.** Paris, 1995.

Thacker 1979
Thacker, Christopher. **The History of Gardens.**
London, 1979.

Truffaut 1924
* Truffaut, Georges. "Le Jardin de Claude Monet."
Jardinage 87 (November 1924), pp. 54–59.

Vauxcelles 1985
* Vauxcelles, Louis. "Une après-midi chez
Claude Monet." **L'Art et les Artistes** (December
1905). Reprinted in Charles F. Stuckey, ed.,
Monet—A Retrospective, New York, 1985,
pp. 245–249.

de Vilmorin 1908
de Vilmorin, Henri. **Chrysanthème.** Paris, 1908.

de Vilmorin and André 1909
de Vilmorin, Philippe, and Edouard André.
**Les fleurs de pleine terre: Comprenant la descrip-
tion et la culture des fleurs annuelles, bisannuelles,
vivaces et bulbeuses de pleine terre.** Paris:
Vilmorin-Andrieux & Cie., 1909.

Whitsey 1981
* Whitsey, Fred. "The Puzzle at Giverny:
Claude Monet's Garden Restored." **Country Life**
Nr. 4378, vol. 170 (July 16, 1981).

Woudhuysen-Keller and Schoeller 2001
Woudhuysen-Keller, Renate, Manfred Schoeller,
et al. **Die Rosenallee: Der Weg zum Spätwerk
Monets in Giverny.** Aachen, 2001.

Index

A

Académie Julien 64
Académie Suisse 159–160
Alexandre, Arsène 164, 172, 184
Alphand, Jean-Charles Adolphe 113–114
André, Edouard 122
Argenteuil 22–29, 114–120, 163–168
Art dans les deux Mondes, L' 178
Atelier libre 16
Aurore, L' 88

B

Barbizon, School 33, 127, 160
Bazille, Frédéric 16, 160–162
Bernheim-Jeune, Gallery 90, 171, 186
Bordighera 47, 129, 132, 174–175
Boston 50
Boudin, Eugène 115, 159
Boussod, Valadon & Co. 52, 170, 176
Breuil, Félix 66, 140–143, 179
Butler, Theodore 176, 179

C

Cadart, Alfred 161
Caillebotte, Gustave 26, 29, 44, 52, 55–56, 117, 118, 125, 164, 169, 173, 177, 182
Cassirer, Paul 182
Castagnary, Jules 31, 168
Cézanne, Paul 45, 55
Charpentier, Georges 170
Château de Rottembourg 33, 167
Chicago 50
Choquet, Victor 167
Chrysanthemums 131–133, 143
Clematis 56, 126, 143
Clemenceau, Georges 78, 88, 100, 159, 176–177, 182, 186–189
Clos normand 52, 55–56, 59, 64–68, 90, 91–99, 173
Constable, John 162
Corot, Camille 19, 55, 159, 166, 168, 176
Courbet, Gustave 16, 160, 168
Cyanopsy 98

D

D'Orléans, Philippe 29
Dahlias 59, 118, 120, 122, 175
Daubigny, Charles-François 22, 159, 162, 164, 168
De Bellio, Georges, Dr. 167
Degas, Edgar 55
Durand-Ruel, Paul 22, 33, 37, 40–44, 50, 52–55, 61, 88, 132, 162–163, 164, 166, 170–175, 178, 182, 184
Duret, Théodore 36, 168

E

Epte 46, 59, 79, 137, 179
Eure 59, 179

F

Fallières, Armand 50
Fantin-Latour, Henri 55
Faure, Jean-Baptiste 163, 165
Fécamp 44, 170
Fénéon, Félix 176
Fermes et châteaux 184
Figaro, Le 176
Flore des Serres et des Jardins d'Europe, La 90
Forestier, Jean Claude Nicolas 114, 124, 184
Fuchsias 116

G

Gauguin, Paul 44
Gaulois, Le 37
Gazette des Beaux-Arts 19
Geffroy, Gustave 45, 56, 69, 100, 176–177, 182, 185
Geraniums 116
Gimpel, René 186
Giverny 13–14, 46–107, 124–146, 172–189
Gladioli 24, 39, 120, 122–123, 174
Gleyres, Charles 16, 160
Grandes Décorations 88, 100, 186
Greenhouses 117, 130–131, 143
Guitry, Sascha 90

H

Haussmann, Baron 29, 39, 159
Haystacks 177
Hiroshige 52, 133
Hokusai 52, 133
Honeysuckle 116
Horticultural magazines 58, 89, 113, 178
Hoschedé, Blanche 59, 180, 185

Hoschedé, Ernest 14, 34–35, 55, 112, 130, 163, 165, 167, 171
Hoschedé, Jacques 180
Hoschedé, Jean-Pierre 90, 122, 142
Hoschedé, Suzanne 179

I

Iris 68, 125, 132, 139–141, 181

J

Japanese Bridge 61–64, 91, 141
Jardinage 139–141, 185
Jongkind, Johan Barthold 55, 160
Justice, La 88, 176

K

Kahn, Maurice 184
Kuroki 71, 132

L

Latouche, Louis 19, 161
Latour-Marliac, Joseph Bory 59, 132–138, 179
Lecadre, Marie-Jeanne 159–160
Lemoine, Victor 124
Lilacs 117
London 22, 162, 181
Louveciennes 29, 162

M

Mallows 119
Manet, Eduard 16, 114, 118, 160, 165, 168
Mantz, Paul 19
Matsukata, Takeko 71
Millet, Jean-François 166
Mirbeau, Octave 50, 56–58, 140–142, 174, 176–177, 179, 182
Monet, Jean 14, 161, 180, 185
Monet, Michel 14, 34, 59, 90, 120–121, 168, 181, 185
Monet-Doncieux, Camille 14, 120–121, 124, 161–162, 165–166, 169, 171
Monet-Hoschedé, Alice 14, 36–37, 52–55, 79, 121, 124, 127–128, 167, 171, 179, 181, 184–185
Monte Carlo 47
Montgeron 33, 99, 130, 167
Morisot, Berthe 55, 177

N

Nadar, Félix 31, 165
Nasturtiums 122, 125, 143
New York 47, 50, 175, 182
Normandy 44–45, 162, 171–172

O

Oleander 116
Orangerie 100–102, 144, 186

P

Panhard-Levasser 90, 183
Parc Monceau 29–31, 120, 168
Peonies 56, 126, 132, 143
Petit, Georges 36, 45, 52, 55, 170, 176
Pissarro, Camille 44, 50, 55, 162
Poissy 44–45, 128, 171–172
Poplars 47, 177
Proust, Marcel 184

R

Renoir, Pierre-Auguste 16, 44, 160, 165,
 170, 173
Ribot, Théodule 115
Rivière, Georges 168
Robinson, Theodore 175–176
Rodin, Auguste 55, 99, 176–177
Roses 91–99, 126, 129–130, 141, 143, 145
Rouen 46, 60, 179
Ru 46, 59, 137, 179

S

Saint-Lazare, Station 167
Salons 14, 31–32, 159–162, 164–166
Salons des Indépendants 14, 31–32, 37, 44,
 164–166, 171, 176
Seine 46, 170
Singeot, Louis-Joseph 177
Sisley, Alfred 16, 33, 50, 55, 160
Society of French Artists 22
Still lifes 40–44, 174
Studio boat 36, 164
Sunflowers 39, 125

T

Taboureux, Emile 170
Toussaint, Anatole 90
Trévise, Duc de 96
Truffaut, Georges 113, 127, 140–141,
 145–146, 184
Turner, William 162

U

Utamaro 52

V

Varenne, Emile 59, 130–131, 179
Vétheuil 36–40, 120–123, 169–171
Vie moderne, La 36, 170
Ville d'Avray 29, 162
Vilmorin-Andrieux & Cie. 113, 140
Vitet, Ludovic 115, 119

W

World War I 86, 100, 186
Water-lilies 13, 29, 59–61, 64, 68–87, 125, 127,
 132–138, 142, 179, 185–186
Water-lily pond 13, 61, 64, 68–79, 100–103,
 124–125, 132, 139, 179–181, 185–186
Weeping willow 64, 71, 78–79, 181
Wildenstein, Daniel 87
Wisteria 126, 181–182
Wolff, Albert 44
World's Fair Paris 60, 119, 132, 133, 138, 144
World's Fair London 60

X

Xanthopsy 98

Z

Zola, Emile 19, 45, 120

Photo Credits

This catalogue is published in conjunction with the exhibition
"MONET'S GARDEN"
October 29, 2004–February 29, 2005
Kunsthaus Zürich

Exhibition and catalogue: Christoph Becker
Project assistant: Linda Schädler,
 Judith Wahl-Schöpf
Research assistants: Catherine Hug,
 Monika Leonhardt, Linda Schädler

Catalogue
Issued by Kunsthaus Zürich

Copyediting: Tas Skorupa

Translations: Fiona Elliot (Becker), Will Firth
 (Hug/Leonhardt), John S. Southard (Schädler)

Graphic design and production:
Saskia Helena Kruse, Munich

Typesetting: Setzerei Max Vornehm, Munich

Reproductions: Pallino Media Integration,
 Ostfildern-Ruit

Typeface: DIN
Paper: LuxoSamtoffset

Printed by Dr. Cantz'sche Druckerei,
 Ostfildern-Ruit

Binding: Conzella Verlagsbuchbinderei,
 Urban Meister GmbH, Aschheim-Dornach

© 2004 Kunsthaus Zürich; Hatje Cantz Verlag,
 Ostfildern-Ruit

Published by
Hatje Cantz Verlag
Senefelderstrasse 12
73760 Ostfildern-Ruit
Germany
Tel. +49 / 711 / 4 40 50
Fax +49 / 711 / 4 40 52 20
www.hatjecantz.com

Hatje Cantz books are available internationally at selected bookstores and from the following distribution partners:

USA/North America – D.A.P., Distributed Art Publishers, New York, www.artbook.com
UK – Art Books International, London, sales@art-bks.com
Australia – Towerbooks, French Forest (Sydney), towerbks@zipworld.com.au
France – Interart, Paris, commercial@interart.fr
Belgium – Exhibitions International, Leuven, www.exhibitionsinternational.be
Switzerland – Scheidegger, Affoltern am Albis, scheidegger@ava.ch

For Asia, Japan, South America, and Africa, as well as for general questions, please contact Hatje Cantz directly at sales@hatjecantz.de, or visit our homepage www.hatjecantz.com for further information.

ISBN 3-7757-1439-1 (English edition)
ISBN 3-7757-1438-3 (German edition)

Printed in Germany

CREDIT SUISSE

A contribution to culture by Credit Suisse

Cover illustration: Detail of cat. no. 11
Back Cover: Claude Monet as gardener, photograph attributed to Theodore Robinson (1852–96), ca. 1887
© Musée Marmottan Monet, Paris and Giraudon-Bridgeman Art Library

Illustrations
Page 6: Portrait of Claude Monet, August 1905
© Musée Marmottan Monet, Paris and Giraudon-Bridgeman Art Library

Page 108: Claude Monet on the main path of his garden, ca. 1920
© Collection Toulgouat

Page 153: View of Monet's garden toward the house, photograph by Jacques Ernest Bulloz, before 1920
© Photo RMN – Ernest Bulloz

Page 190: Water-lily pond in Claude Monet's garden in Giverny, from a series of four photographs taken by Commandant Humbert, ca. 1920
Courtesy Musée Municipal A. G. Poulain, Vernon
© Collection Michèle Verrier, Vernon

Page 11: orchid; page 12: rhododendron; page 112: sea lavender; page 158: flowering flax; page 194: iris, from **Flore des serres et des jardins de l'Europe: annales générales d'horticulture**, ed. Louis van Houtte, vol. 22, Ghent 1877. Monet had a copy of this publication in his library.

Exhibition
Head of technical staff: Robert Sulzer
Insurance and transports: Gerda Kram
Conservation: Paul Pfister
Public relations: Björn Quellenberg,
 Kristin Steiner
Sponsoring: Monique Spaeti